I'D FIGHT THE WORLD

I'D FIGHT ★ THE ★ WORLD

A Political History of Old-Time, Hillbilly, and Country Music

Peter La Chapelle

THE UNIVERSITY OF CHICAGO PRESS

CHICAGO AND LONDON

The University of Chicago Press, Chicago 60637
The University of Chicago Press, Ltd., London
© 2019 by The University of Chicago
Published 2019
Printed in the United States of America

28 27 26 25 24 23 22 21 20 19 1 2 3 4 5

ISBN-13: 978-0-226-92299-7 (cloth)
ISBN-13: 978-0-226-92300-0 (paper)
ISBN-13: 978-0-226-92301-7 (e-book)
DOI: https://doi.org/10.7208/chicago/9780226923017.001.0001

Portions of chapter 2 appeared previously as "'Dances Partake of the Racial
Characteristics of the People Who Dance Them': Nordicism, Antisemitism,
and Henry Ford's Old Time Music and Dance Revival," in Bruce Zuckerman,
Josh Kun, and Lisa Ansell, eds., *The Song Is Not the Same: Jews and American
Popular Music* (West Lafayette, IN: Purdue University Press, 2011).

Portions of chapter 5 appeared previously as "Senator Glen H. Taylor: Radio's Utopian
Singing Cowboy," in Mark Allan Jackson, ed., *The Honky Tonk on the Left: Progressive
Thought in Country Music* (Amherst: University of Massachusetts Press, 2018).

Library of Congress Cataloging-in-Publication Data

Names: La Chapelle, Peter, author.
Title: I'd fight the world : a political history of old-time, hillbilly, and country music /
Peter La Chapelle.
Description: Chicago : The University of Chicago Press, 2019. | Includes
bibliographical references and index.
Identifiers: LCCN 2019005334 | ISBN 9780226922997 (cloth : alk. paper) |
ISBN 9780226923000 (pbk. : alk. paper) | ISBN 9780226923017 (e-book)
Subjects: LCSH: Country music—Political aspects—United States—History. |
Country music—Political aspects—Southern States—History. | Musicians as
politicians—United States—History.
Classification: LCC ML3524 .L24 2019 | DDC 781.6420973—dc23
LC record available at https://lccn.loc.gov/2019005334

♾ This paper meets the requirements of ANSI/NISO Z39.48–1992
(Permanence of Paper).

For Samuel and my parents

CONTENTS

The Ghost
of Tom Watson

C ountry music was political even before it became country
music. When nineteenth-century Americans came together
at camp meetings, medicine shows, mountain hoedowns, and plan-
tation gatherings to dance and make music, the resulting satire,
grudges, visions, and desires couldn't help but spring up. American
politics, too, couldn't help but take on a show-business air with its dra-
matic stump speeches, lurid smear campaigns, and theatrical torch-lit
parades. Indeed, for many rural Americans, a passing political cam-
paign was the only entertainment in town, metaphorically and liter-
ally.

Perhaps more than others, Tom Watson, a fiddler-politician who
would later emerge as a leading populist, seemed to sense that po-
litical campaigns and musical performances appealed to common
aspirations: a desire to escape one's woes, to indulge fantasies about
vanquishing tormenters and foes, and to find fellowship with like-
minded individuals who dreamed of brighter times. "In the old days
long ago, when I was as poor as a church mouse, struggling to earn
enough to keep myself fed and clothed, the evenings were almost in-
tolerably lonesome," Watson said about his bleak beginnings in the
1870s as a country lawyer.

So I bought me a fiddle and I can never tell you how much comfort and consolation and satisfaction I got out of it. When the outlook was gloomy and clients were few once in a while I would strike a bright chord which would fill me with hope and the vexations and trials of the day would vanish.[1]

A decade later, when Watson was running for a seat in Georgia's House, he performed a few songs at a debate. He realized that his fiddling could speak to similar longings in others and that this might make it a potent political weapon against his opponent: "You should have seen the look of silent despair on that good man's face as he stood in the corner of a room, while I sat on a box, like a king on his throne, and made my own fiddle talk, while the boys and the girls danced to my music," Watson said. "I tell you a fiddle is a big help in a fight."[2]

Watson was to become a household name for his fiery brand of populist politics. He railed against the bullies of the day—monopolist railroads; banks; rich, corrupt politicians—and worked with the Colored Farmers Alliance to promote the idea that blacks in the South should be allowed to vote. He argued that poor whites and blacks had been set against each other by the ruling classes to keep them both economically disenfranchised.[3] Later, in the face of consumerism and modernism's invasion of the quiet rural wood, Watson would make a 180-degree turn, setting his wrath against Jews and blacks and making conspiratorial accusations against Catholics, even as he drew closer to pacifist and socialist thinkers. Watson's life yields a story like none other.

What is most stunning about his story is its resonance with the themes that arose when country music became involved in politics across the twentieth century and into the twenty-first. Watson's early overtures of racial harmony were echoed in the mid-twentieth century by racially liberal performer-politicians such as Idaho's singing cowboy senator Glen Taylor, and Alabama governor "Big Jim" Folsom, who rarely ventured out on the trail without a string band. Watson's defense of the poor and the disempowered reverberated in the 1930s in a groundswell of "country music campaigners" such as promoter-

songwriter W. Lee "Pappy" O'Daniel, who fought for pensions for the elderly and attacked poll taxes for holding back poor whites. Senatorial candidate and car manufacturer Henry Ford—who financed a revival of old-time music and square dancing in the late 1920s partly with the aim of curtailing Jewish influences on American culture—seemed to draw much of his own playbook from Watson's antisemitic screeds and conspiratorial yellow journalism. Watson's penchant for scapegoating African Americans and defending segregation during his 1920 campaign for Senate went places that segregationist candidate George C. Wallace and his Grand Ole Opry campaigners did not in his gubernatorial and presidential races in the 1960s and '70s, but the same spirit seemed to animate both men. Near the end of his career, Watson seems to have hired others to play on his behalf, and he was memorialized in a recorded song (Fiddlin' John Carson's "Tom Watson Special"). Today, recorded music is the norm at rallies. Campaigns seem incomplete without appearances and endorsements by superstars such as Willie Nelson, Hank Williams Jr., and Ralph Stanley, who sometimes find that, yes, a fiddle can still be big help in a political fight. Country music politics is still haunted by Tom Watson.

That specter continues to hang over those who use country music to further their political careers. In the twentieth century, country music was not just a campaign tool but a valuable political asset and, at times, a central component of a politician's image and identity, not just among Southern politicians, but also westerners, midwesterners, and an even a few fleeting easterners, such as hair tonic salesman Edward "Doc" Bowen, who ran for Congress in the 1930s in the counties just north and east of New York City.[4] In the wrong hands, though, country music could be used by opponents to assail a candidate's seriousness or fitness for office.

Scholars have filled volumes on the connections between "cultural politics," political activism, and genres and subgenres ranging from early Tin Pan Alley to late hip-hop. Some have dismissed country music as largely parochial and conservative or even apolitical, while extolling the political messages of these other forms.[5] Yet the actual historical record shows that, when politicians have used music to get

elected and push issues, country music was by far the most politicized. Between 1878 and the turn of the twenty-first century, country music and its predecessors and related genres—old-time fiddle, cowboy, hillbilly, and bluegrass music—were central aspects of campaigning for more than a dozen major-party governors, several congressmen, at least seven US senators, a Senate minority and a Senate majority leader, as well as major third-party candidates. Watson and Senator Glen Taylor were vice presidential candidates for the Populist and Progressive parties, respectively, and Governor George Wallace was the presidential nominee of the American Independent Party.[6] By the 1970s, Richard M. Nixon officially welcomed country music into the White House when he inaugurated a National Country Music Month, and country music influenced one of his television commercials in his bid for reelection. Every president since has used country music or associations with country music in some way or another during their campaigns.

Understanding the connection between country music and electoral politics gives us a glimpse into how politicians used celebrity long before the rise of the "movie-actor president" and the "Twitter president," and it offers both lessons and warnings about the way politics and entertainment interact in our ever-expanding media universe. Indeed, several generations before the rise of Hollywood performer-politicians such as Helen Gahagan Douglas, Ronald Reagan, and George Murphy in the mid-1940s and 1950s, country music politicians had become an established part of the national political system, especially in the West and the South.

The use of country music on the campaign trail has changed over time. Transformations in technology are an important part of this story. The earliest practitioners, like Watson, were country lawyers with dreams of high political office who also happened to have amateur fiddle skills. They were country politics' experimental pioneers, relying on word of mouth and the sound of a fiddle to draw or hold a crowd. Over time, new technologies such as phonograph recording and radio created opportunities for performers to professionalize; some of these performers then sought to capitalize on their celebrity

and run for office. Other new technologies, such as the sound truck in the 1930s, provided opportunities for politicians to draw larger and more enthusiastic crowds.

By the 1940s, the growth of a national country music industry allowed nonperforming candidates to latch on to particular hit songs to sell their message, or to hire nationally renowned stars from the Grand Ole Opry to pitch for them at rallies and campaign stops. Television, too, reshaped the way candidates used country music, allowing them to not only celebrate the genre but also use recorded songs at broadcasted rallies. Specially prepared slogan songs in TV spots became part of their media barrage.

Though technological advances opened new ways to campaign with country music, politicians and performer-politicians have shaped American history with their policies. Some country music politicians made courageous policy decisions. There is also much to regret— choices that were made for political expediency, prejudiced reasons, and personal benefit, and not for profound moral or ethical reasons. What marked them all was combativeness. Indeed, the title of this book stems from a 1962 country song by top Nashville songwriters Hank Cochran and Joe Allison, in which the singer pledges he would "fight the world" for the woman he loves, regardless of how others see him. That song, first popularized by Jim Reeves and later covered by a host of country and soul performers, has a kind of inward-looking domestic focus, like many songs of the period (perhaps with a thought toward the threat of an atomic attack that might, as the song says, turn the moon to ashes). Yet it also embodies defiance, not backing down, standing up for one's views but also being obstinate—a quality present among many country music politicians. Some politicians have pushed forward with risky, courageous, forward-looking stances, while others clung to positions that now seem vindictive, incendiary, and callous.

Hollywood has inflamed other prejudices by disseminating stereotypes about Southerners to warn that country music could be used deceitfully. In *O Brother, Where Art Thou?* (2000), the rural electorate is painted as gullible fools, taken in by the country bands of a white-suited Southern kingpin (an amalgam of Huey Long, Pappy O'Daniel,

and maybe Jimmie Davis) and of a Ku Klux Klansman who disguises himself as a political reformer. Robert Altman's *Nashville* (1975) doesn't offer much better, with its omnipresent and enigmatic sound truck that drives around belting out seemingly disconnected attacks on targets as varied as farm subsidies, the legal profession, and tax exemptions for religious groups. Particularly prickly were Altman's depictions of Music Row royalty, such as a morally sketchy older performer, perhaps based on a real-life figure such as Tex Ritter or Hank Snow, who records a ridiculously trite patriotic number. A generation earlier, *A Face in the Crowd* (1957) suggested that country music was so powerful it could gull voters into electing an ostensible fool and wannabe tyrant. It is a shame that the motion picture industry hasn't also told the stories of Big Jim Folsom and Glen Taylor, who used the genre to try to open a new chapter in politics, especially in regards to civil rights. Big Jim's real-life mop and bucket for scrubbing the capitol clean of corruption are referenced in *O Brother* as a broom "of reform," ready to "sweep this state clean," but they are attached to a candidate who is secretly a prude, a bigot, and a Klansman. Wouldn't it be just as compelling to see a singing-cowboy senator arrested for attending an interracial civil rights–oriented gathering in Birmingham, Alabama, as Taylor was in 1948? Or Big Jim facing death threats for inviting a black congressman into the governor's mansion?

Many believe that the rise of country music in post–World War II national political campaigns demonstrates the Southernization of politics. There is certainly truth to this contention, but history shows us that "country music politics" is not solely a product of the South. Henry Ford in the upper Midwest and John R. Brinkley in the central Midwest formidably shaped the role of country music in political campaigns. Western performer-politicians such as Stuart Hamblen and Glen Taylor also made their mark, reflecting an almost genre-wide obsession with old-age pensions or (as Taylor pushed) progressive internationalism. The larger Southern diaspora certainly ensured a welcome reception for country music politics, but Ford and Taylor in particular produced manifestations that were uniquely linked to their home regions.

That said, the extent to which country music campaigning became the norm by midcentury in Alabama and Tennessee, and perhaps to a lesser extent in Georgia, Mississippi, and Florida, cannot be overlooked. Alabama politicians especially had so taken to using country bands on the campaign trail by the early 1960s that country had begun to have national repercussions in presidential campaigns.

Though the genre influenced the course of political history in many ways, this book is chiefly concerned with three types of country music politicians:

- Amateur musicians, such as Watson and Tennessee's Taylor brothers (and, later, senators William C. Byrd and Al Gore Sr.), who used their musicianship to attract voters or shape their public image
- Professional musicians and promoters of hillbilly and country music who used their celebrity to seek office, performing music on the campaign trail
- Nonmusician politicians, such as Folsom and Wallace, who employed country musicians to perform at rallies and media events and who used the genre to create public images that they believed resonated with voters

Nearly all these political actors were white "outsiders" who railed against the abuses of more powerful and more entrenched white elites. Some, such Paul B. Johnson, Jimmie Davis, and Glen Taylor, stemmed from truly destitute backgrounds. Some hailed from the wrong side of town or wrong region of the state, or were attacked by opponents for being frivolous performers unfit for political office. Nearly all these figures singled out their opponents as untrustworthy and undemocratic power brokers. Many depicted their opponents as wealthy fat cats, while others portrayed their enemies as overly connected, arch-conservative-party regulars or as dupes misled by eastern, liberal, or "foreign" elites.

Country music campaigns in the conservative, "Solid South"—so called because of the grip the Democrats held there for some eighty years—offer particularly valuable insight into the region's politi-

cal history. Despite its reputation, the one-party South did undergo fits and stages of rebellion in which outsider figures challenged the elite for control within the Democratic Party. Many of these outsiders used old-time, hillbilly, and country music to signal their connection with poorer and less powerful constituencies who sought to take on the elite. Often these intraparty rebellions were put down, but when they were successful, the ostensible outsiders restored political peace by putting aside their more egalitarian notions about race and class, and embracing the narrative of a Confederate "lost cause" as well as a heightened nostalgia for the Old South. When it came to issues of enfranchisement and African American rights, several Southern country music politicians ended up siding with the very power structure that they generally opposed.

These ironies and contradictions abounded among performer-politicians and nonperformer country music campaigners in terms of the traditionalism or crossover appeal of the music styles they deployed. Folsom—probably the most liberal governor in the South—adhered to a traditional string band lineup, whereas the Alabamians, the band of right-wing Wallace, sometimes employed trumpets and pop songs. Left-wing Glen Taylor borrowed much from the Bing Crosby cowboy repertoire and sought a crossover sound, while conservative Pappy O'Daniel preferred traditional Texas fiddle. These choices could raise hot-button concerns about authenticity.[7] Some musical performances were pounced on by opponents—for example, Jimmie Davis, whose early recordings were attacked as too bawdy and, by insinuation, too "black"; and George Wallace's Alabamians, who tended to be too pop and therefore not authentic enough for some critics' tastes. Others, such as Huey Long and Glen Taylor, deliberately poked holes in this binary by mixing and matching and trotting out a wide variety of musical styles and racial and ethnic influences.

Because much of the political history of the United States has been relegated to candidates and figures who were white and male, most of the politicians and performers profiled here are white men. This does not mean, though, that African Americans, women, and others were unaffected or uninvolved these developments. We see inklings

of early black-white musical interaction and interchange in Tom Watson's stories about playing fiddlesticks with black musicians. Bona fide black stars of country music such as DeFord Bailey did not follow their peers on the Opry in making political endorsements, being either too weary of the toll that taking a political stand in the South might require of a black man, or too smart to risk the end of a career for some quick cash. Charley Pride was one later figure who avoided formal politics, even if he was conscientious and brave in frankly spelling out many of the injustices facing blacks. One exception perhaps was O. B. McClinton, a recording star known for chart climbers such as "Don't Let the Green Grass Fool You," who campaigned for Edmund Muskie in Florida in 1972. Systems of racism and oppression made an impact on the white politicians as well. White Glen Taylor, a sitting US senator, was arrested for trying to speak to an integrated audience in Alabama in 1948. Segregationist governor George Wallace used his connections with Jim Crow in the South as means of attracting angry white voters nationally at the very same time that important figures such as Freddy Fender and Charley Pride were beginning to challenge the racial boundaries of the genre.

A few female performers and politicians are also part of this story. Like the white male politicians she supported, Opry comedian Minnie Pearl achieved a certain status and position of her own, but in endorsing racist candidates she also shares some of the blame for perpetuating the ugly system of "separate but equal." Country music opened doors to female politicians, helping promote the first elected woman senator, Arkansas's Hattie Caraway, and the second female governor elected in a general election, Alabama's Lurleen Wallace. Though some have depicted Caraway and Wallace as damsels in distress who were rescued or shepherded by powerful political men, both women broke barriers and maneuvered themselves into coveted positions on the national political stage, despite the obstacles posed by powerful male political patrons and traditional notions about women's roles. Both, too, share in the blame for encouraging "separate but equal" policies. Other politically minded women—National Barn Dance star Lulu Belle Wiseman, for instance—put their faith in Southern moderates who

hoped to forge a path out of discrimination and poverty (even if, later as a politician, Wiseman found herself caught in an uproar about the Equal Rights Amendment).

Country music in American politics has embraced a tremendous array of powerful themes. Some early politicians in this vein were populists. Many styled themselves as outsiders. Some were antisemites and some were political kingpins. What they all held in common was a belief that stylistic choices in music could be used to establish authenticity. Politicians who used fiddlers and cowboy and hillbilly bands to attract crowds signaled that they were themselves political outsiders and thus well equipped to understand the problems of common people. This initially resonated with liberal policies such as support for old-age pensions and opposition to poll taxes. The apotheosis of this left-wing politics was a poor young radio cowboy singer from Idaho named Glen Taylor, who used his performance of pop-influenced country songs to raise public awareness about a range of issues. But influence was a two-way street: agrarianism—one of the most prominent political and intellectual ideologies to arise out of Southern literary and academic circles—criticized the commercial aspects of the genre, but also heightened tensions over authenticity and reinforced a hard line regarding rights and race. Over time, populism began to give way to scapegoating, xenophobia, and segregation, even if elements of the original vision remained. In the process, country music attained a new level of cultural and political significance—one we can only begin to understand by examining its roots.

Fire on the Mountain

*The Initial Surge of Old-Time and
Hillbilly Music Campaigns*

Fire on the mountain, run, boys, run;
Fire on the mountain till the day is done.
Fire on the mountain, water down below;
Never get to heaven 'less you jump Jim Crow.

VARIANT OF "FIRE ON THE MOUNTAIN,"
TRADITIONAL FIDDLE TUNE

★1★

"Like Orpheus"

The Nineteenth Century Encounters the Twentieth

In the beginning, it was amateur fiddlers who introduced what would become known as country music to the American political campaign. Robert Love Taylor—known as "Bob" to his supporters— was most probably the first, in 1878. Using the fiddle to entertain his guests after giving lengthy political speeches, Taylor would win a congressional seat representing his East Tennessee district partly on the merits of his ability to play fiddle. "Like Orpheus," one paper would later proclaim somewhat exaggeratedly, "he owes his success to his musical powers."[1] Taylor would go on to be elected governor of Tennessee, helping to create a legend about campaign fiddling with his politician brother, Alf.

Four years later, in 1882, Tom Watson (the former country lawyer mentioned in the opening of this book) performed fiddle at barn dances in his efforts to win votes in his bid for seat in Georgia's state House; the *Atlanta Constitution* noted that Watson demonstrated "how potent the fiddle is."[2] Watson would eventually shed his early affiliations with the Democratic Party, becoming known nationally as a perennial candidate and firebrand for the Populist Party.

The evidence surrounding these early campaigns is fragmentary, but we can make some generalizations. We know Taylor and Watson

came from the upper economic echelons of their rural hometowns but had experienced at least some poverty, and had used music to attract a wider and more economically diverse audience. For Watson in particular, his music seemed to be linked, at least tangentially, with efforts to win over black voters. Both men seem to have been self-taught in their fiddling, and, though accounts vary, neither was a virtuoso. We also know that, regardless of how much or how often they actually played during these early campaigns, fiddling became an important part of their image—so much so that writers and journalists frequently invoked the image of their youthful fiddle playing even after they had long given up public performances and settled into more established, traditional roles as statesmen and career politicians.

Beyond these basic facts, there is something peculiarly modern about the way Taylor and Watson fused entertainment, celebrity, and politics, despite the fact that their issues—reining in the power of the railroad and standing up for sharecroppers, as Watson pledged to do, or fighting for the rights of small-scale moonshiners, as Taylor promised—might seem anachronistic to modern observers. Both quickly realized that their musicianship was a double-edged sword which could help them win votes but also opened them up to criticism that they were not serious candidates. Both sought at times to emphasize, and at other times to downplay, connections that might be made between their politics and the music. Both realized that even a few performances on the campaign trail could go a long way in creating a public image that connected them with a hardscrabble upbringing and an authentic rural life, and that, once unleashed, associations between themselves and their music might be difficult to shrug off when critics attacked them for their musicality. Their stories also demonstrate that association with performance on the campaign trail could connect them with voters from specific regional affiliations and from backgrounds often lower on the socioeconomic scale than they themselves came from. And finally, their stories provide evidence that country music politics, even at its birth, could be used to buttress a variety of political positions even if it also was susceptible to falling into a pattern of use by politicians of a more specific political stripe.

Bob Taylor, like many of the figures explored in this book, focused on painting his opponent as an elitist and used his music to entertain his constituents as well as to connect himself with a rustic identity that appealed to voters. Taylor was not, however, a rough mountain boy, as later press might bill him, but rather an adult of almost thirty who was the son of a prominent eastern Tennessee figure, Nathaniel Greene Taylor, a Congressman and Methodist preacher who had owned slaves and who had served as US Commissioner of Indian Affairs.[3] Bob Taylor had in fact attended private schools for much of his early life and was exposed to cities and experiences most poor Appalachian boys could only dream of. Born in his father's home district, Happy Valley, Tennessee, Bob himself had attended the Pennington Seminary, a prestigious private elementary school near Trenton, New Jersey, while his father, a Whig and a Unionist, took refuge there during the Civil War.[4] After his family returned to East Tennessee, he attended Buffalo Male and Female Institute, a private secondary school in the foremost northeastern Appalachian corner of the state. In their affectionate 1918 biography of Bob, his brothers claimed he taught himself fiddle while attending the institute, but that his skills were not noteworthy:

> He lacked almost everything of being a good, common mountain fiddler, save in the rendition of a limited number of tunes, such as "Hole in the Kettle," "Turkey Buzzard," "Sally Ann," "Shoot Old Davy Dugger," and the old version of "Turkey in the Straw," or "Natchez Under the Hill." . . . But to any audience cultivated in music, or to any musical artist of great merit, our performances would have been exceeding crude. Of course, Bob could "saw" on the fiddle, but that was about the extent of his proficiency, except as stated above.[5]

After his time at Buffalo, Bob Taylor attended East Tennessee Wesleyan University. While in his twenties, Taylor had experienced some indebtedness and some poverty, never entirely succeeding at his attempts at farming or lumber and iron production after college. By the time he ran for Congress in 1878, he was studying law.[6]

Watson's family, in contrast, had seen its fortunes decline dramati-

cally and knew poverty well. Born on his grandfather's plantation in Thomson in central eastern Georgia, Watson was a member of a well-to-do family of slaveholders. After the Civil War, Watson's father, a Confederate veteran, could not keep the grandfather's cotton plantation afloat financially and in 1868 was forced to sell, moving to a much smaller house and farm on the outskirts of town. The family eventually lost that property, too, and ended up running a boardinghouse and bar in nearby Augusta. Watson nevertheless attended a local grade school and end up briefly attending Mercer College to the south in Macon, Georgia, after his mother borrowed and scraped together funds (fig. 1.1).[7]

Watson's father had fiddled and called dances, but Tom apparently did not pick up the instrument from his father, who may have been depressive and who, according to Tom's journals, was emotionally abusive.[8] Watson told a newspaperman years later that he taught himself to play during a period after college when he was struggling as a country lawyer and the evenings out in the woods were lonely and boring:

> I had no taste for dissipations and amusements with which men ordinary dispose of time which hangs heavily on their hands. So I bought me a fiddle. . . . It was always a faithful friend alike in gray days and sunshine, and I grew to love it and appreciate its companionship.[9]

Though this later account suggests he did not pick up the instrument until he was practicing law, he noted in his journal that he was playing the instrument well before then, occasionally being called on to play waltzes, cotillions, quicksteps, and hornpipes and his own special "Watson's Medley" at dances and barbecues while teaching school in Screven County. Fiddling at night alone also seemed to provide solace during a particular bleak period in his life in 1876 when his school job ended and he was trying to make a living as a plow hand. Whatever the case, by 1879 Watson established his own fairly law lucrative practice back in his hometown of Thomson in McDuffie County.[10]

Once running for office, both Watson and Taylor seem to have in-

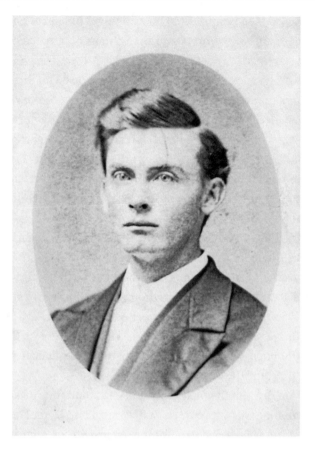

1.1 Thomas E. Watson as a young man. Thomas E. Watson Papers, no. 755, Southern Historical Collection, Wilson Library, University of North Carolina at Chapel Hill. Image used by permission of the Watson-Brown Foundation.

stinctually decided that fiddling might be a good way to entertain the people who gathered to hear them speak. Wanting to sell copy, friendly newspaper editors and reporters followed up by describing their use of the instrument on the trail and making arguments that it connected them with average rural people—the mountain people of Taylor's East Tennessee and the poor whites, and to some degree the poor blacks, of Watson's rural Georgia. That the fiddle would have appeal to nonwhites is not surprising, considering that the South already had strong African American and Cherokee fiddling traditions.[11] Wat-

son and Taylor then reciprocated by using their images as performer-politicians to appeal to voters and brand their opponents as out-of-touch elitists.

In his 1878 race for Congress, Bob Taylor had used fiddling at some of his campaign events, mostly as a way of keeping the crowd entertained after speeches and other festivities took place. Taylor—by then a twenty-eight-year-old Democrat and former farmer who was exploring ambitions in law—had been urged to run after his brother Alf, a Republican, had been defeated in the Republican convention for the East Tennessee district, an area like many in the Appalachian South that tended to be pro-Union during the Civil War and Republican in politics. Eastern Tennessee had been influenced by early Quaker proselytizing and one of the first abolitionist movements in the United States. Thus it proved something of stronghold to the Whigs and then later to the Republican Party, even though it was located in a state that was largely in the hands of the Democrats. During the Civil War, several East Tennessee counties went so far as to break with the Confederacy and announce their loyalty to the Union and Republican president Abraham Lincoln.[12]

Urged on by opportunistic Republicans and his disappointed brother's Democratic supporters, Bob, a registered Democrat and the younger of the two, ended up running against Major Augustus Pettibone, a Union army veteran and the chosen candidate of the powerful local Republican establishment. In running against a candidate who hoped to use the might of the East Tennessee Republican Party against him, Bob Taylor faced an uphill battle, but he found ways to capitalize on his outsider status. For instance, he charged Pettibone with being in league with the hated federal revenuers, who sought to collect taxes on small-scale distillation of liquor throughout Appalachia. Taylor, according to his own accounts, also had the fiddle on his side:

Many a time have I ridden horseback twenty miles to the place of speaking, spoke for two hours and then began to mix with the people. I had my fiddle hid out and as soon as night came some of the boys got up a dance. I would play fiddle and let the boys and girls

dance. Sometimes I handed over the fiddle to some other fellow and then I danced with the girls on the puncheon floor. I had every woman in the district and every young man on my side.[13]

His three brothers, who chided him for not really being a very great fiddler in their sentimental 1913 biography, nevertheless conceded that he "made good use of his fiddle" in the 1878 campaign. "The sovereigns would gather around him in large numbers at night, and he would mimic Brignoli, the Italian opera singer, and play the fiddle for them until the cocks crew for day," his brothers wrote. "The crowds would actually yell and launch themselves into a state of physical exhaustion."[14]

Though it is difficult to establish how often Bob played on the trail or what he played, the press of the era took notice of Bob's aptitude for fiddling and used it to present the argument that he was not the son of a middle-class politician and bureaucrat, but a down-to-earth nature boy. The pro-Taylor *Morristown Gazette*, for instance, explained to readers (with a whiff of exaggeration) that Taylor was poor and that he was "one of our Mountain boys" who deserved support. "You are on a cold trail," the *Gazette* warned a third candidate who entered the race late and appeared to be a spoiler for Pettibone. "You can't play fiddle and we won't vote for you this time. Hurrah for Bob Taylor!"[15] The *New Orleans Daily Democrat* similarly celebrated Bob Taylor's victory over Pettibone as another win in the effort to drive Republicans out of the South. "The young man proved to be just suited for his district, jovial and frolicsome, and so expert in the fiddle that in a very short time he had completely won over the rough mountaineers of East Tennessee."[16]

Bob Taylor served his term but did not win reelection. Nevertheless, in September 1886 Democrat Bob and his brother Alf—also a fiddler, and by then a representative in the state House and a rising star in the state Republican Party—were nominated by their respective state party conventions and ended up running against each other for governor. This gubernatorial battle between brothers has gone down in history as "Tennessee's War of the Roses" in homage to the

fifteenth-century British conflict because supporters wore a red or a white rose, as with the Lancaster or York supporters of old, depending on whether they favored Alf or Bob. Legend holds that Bob and Alf fiddled on the stump, dueling out their differences on stage. What really happened was that two had met up with a reporter at Chattanooga's Read House inn during their own respective campaign stops. Two fiddles were set on a table; the men "instinctively" picked up the instruments and began playing together in harmony.[17] A news article about the event began to get some traction with the national press, although the follow-up stories often tended to jumble the particulars.[18] By October, a cartoonist from *Frank Leslie's Illustrated Newspaper* got a hold of the story and depicted what has become legend since: two brothers playing fiddle on a stage in front of throngs of cheering and adoring voters who throw roses in support of their favored fiddler (fig. 1.2).[19] Though one could interpret the Leslie image as depicting the political rivals in harmony, as the original newspaper reporter had, it could also be interpreted as portrayal of two brothers dueling it out in front of an audience of voters. Though entirely inaccurate, the image of the two brothers fiddling away on stage in front of voters served them well in politics, well beyond 1886. Bob won that election and then went on to represent Tennessee in the US Senate. Alf would serve in Congress later that decade and eventually became governor of Tennessee himself in the 1920s.

Like Taylor, Watson decided to introduce fiddling during his very first bid for office for the Georgia state House in 1882 as a means of simply entertaining those who gathered to hear him speak. However, there were important undertones of his home district's racial politics in his performing. Georgia, at this point, had not fully embraced Jim Crow laws that prevented blacks from voting. Watson, then a Democrat, saw it in his interest to approach the largely black local Republican executive committee for an endorsement that might very well sway the election. Impressed by Watson's promises to establish free schools for blacks and to end the convict lease system that especially victimized black inmates, the committee gave him its endorsement. His opponent, however, used the endorsement to accuse Watson of

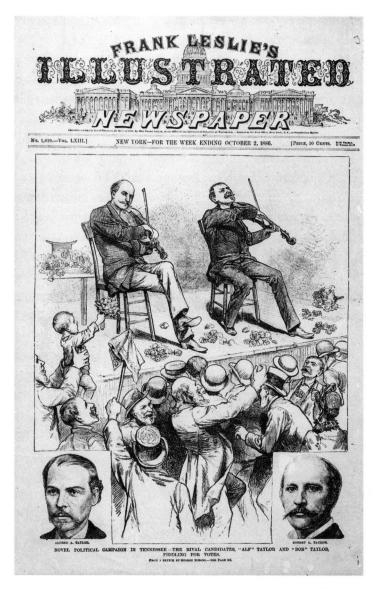

1.2 *Leslie's Illustrated Newspaper* cover featuring Bob and Alf Taylor "fiddling for votes," October 2, 1886. Tennessee State Library and Archives.

supporting the Republican platform and of using the black vote to overrun the will of white voters. Watson ended up having to defend himself at a public meeting shortly thereafter, where, according to historian C. Vann Woodward, he successfully walked a fine line between maintaining black Republican support and disassociating himself with the official Republican Party platform. He won that election by a slim margin of 392 votes.[20]

Watson's use of music on the campaign invoked the more accepting vision he expressed to black Republicans. In his personal diaries, the young politician mentioned playing the fiddle at barn dances—sometimes with an interracial group of backing musicians—as a way of locking in votes during the 1882 race. Watson recalled one characteristic incident in Wrightsboro, Georgia, when he "played the fiddle for the girls." To set the scene, his young female acquaintances would promise to dance with a potential male voter "as long as he promised to vote for" Watson. Watson then took to playing, recalling that it was "a sight to see me standing up fiddling away for dear life" while a friend pounded out rhythm across the strings of his fiddle with thin sticks, a technique known as "beating the straw" or "fiddlesticks" that was used to add a bit more beat to dance songs. Rounding out the ensemble at the Wrightsboro barn dance were also "one negro playing 2nd fiddle, and another negro knocking the agony out of a tambourine."[21]

Watson did not hide his musical exploits from the press. A few months after the Wrightsboro event, he crowed to the *Atlanta Constitution* that he had defeated his opponent in the race for a seat in Georgia's House by pointing out the opponent could not play fiddle.

> "I tell you a fiddle is a big help in a fight, where you have young folks in the question. . . . The best vote-making tune," said the Hon. Tom, reflectively, "that ever come out of fiddle is 'Mississippi sawyer'; next to this I think is 'Yaller gal come out to-night.'"[22]

Watson went on to explain to the *Constitution* that dancing was a big draw and that politicians who could fiddle were almost guaranteed a

crowd. The two songs that Watson mentioned by name in this interview became standards among country fiddlers in the twentieth century. "Mississippi Sawyer" dates at least to the 1830s and is probably one of the most popular fiddle tunes of all time. Though an instrumental number, the sawyer in question may refer to a popular saw mill or to a dangerous tree snagged on the Mississippi River bottom that bobs up and down, threatening boats as they pass by.[23] The second tune was one of several adaptations of the rowdy drinking song known today as "Buffalo Gals," a song with roots in the blackface minstrelsy of the 1840s and that originally mentioned a girlfriend with comically big feet, but which also hints at street dancing, secret lovebirds, racial miscegenation, and prostitution.[24]

Watson's early embrace of the fiddle as a campaign tool seems a natural choice in many ways. His constituents were small farmers, poor whites, and blacks who looked forward to barn dances and musical entertainment as a welcome respite from difficult lives. Besides his opposition to the convict lease system and advocacy for free black schools, Watson also sought to strengthen tenant farmers' rights and rein in railroads, which were seen as taking advantage of farmers and the poor.[25] In some ways, his efforts during the 1882 race foreshadow his later racially liberal public political stances as a Populist congressman and vice presidential candidate, even if he, as scholars note, failed at times during this period to live up to his ideals. For instance, he publicly stated as a national Populist candidate that black and poor whites were made to hate each other to keep the wealthy in power. "You are deceived and blinded that you may not see how this race antagonism perpetuates a monetary system which beggars both," he argued.[26] Furthermore, in 1892 he summoned two thousand white Populists to defend a Populist black preacher from a lynch mob in Thomson, Georgia. Despite these actions, historian Omar Ali maintains that Watson strove more for "political equality" than "social equality," and that Watson's record on race relations even at this point was spotty. Ali notes that Watson made the threatened black minister, Rev. Henry S. Doyle, sleep in a shed near the back of his house and that Watson repeatedly voted against funding for black schools.[27]

The songs Watson mentioned to the *Atlanta Constitution* in 1882 tend to reflect this focus on ordinary workers and rural people, and perhaps even flirt with the idea that blacks and whites might find some degree of peaceful coexistence. The sawyer in "Mississippi Sawyer" is a deckhand's term, and the breakdown's rhythm may refer to the natural ebb and flow of the river, or more generally to the rhythms of nature. "Yaller Gal/Buffalo Gals," on the other hand, evokes humor and images of youthful abandon, consensual dancing, and private (although perhaps also paid) encounters between couples, possibly of different races ("yellow" a code word for a light-skinned black person), under the light of the moon.[28]

Though both Watson and Bob Taylor found some success in using music in their earliest campaigns, they also had something of an on-again, off-again relationship with campaign performance, often choosing to shed their campaign-stop performances once they attained higher office and became better known for their political identities than the music. They also found that their fiddling could at times be used against them. During Taylor's 1878 bid, the opposition *Knoxville Tribune* argued that his fiddling made him a "gut scraper and a clown"; he easily shrugged off those accusations and pointed the finger at opponent Pettibone for being too tied in with hated federal officials such as revenuers.[29] After the campaign with his brother for governor in 1886, however, Taylor seemed to rarely if ever perform at campaign events, according to press reports. Nevertheless, journalists at nationally oriented papers had begun to use the fiddling metaphor as a means to assess his performance as a politician. The *New York Sun* argued that his fiddling of "soft, soothing airs" and his sunny disposition in earlier campaigns was evidence of his inadequacy as a candidate in the 1896 race for governor of Tennessee—a race that he actually ended up winning. "Bob Taylor is too mild for this campaign, and too many of his strains will have to die with all their music in them."[30] Others noted that his decision to hang up the fiddle was evidence that he had evolved into a more seriously minded politician. "'Bob' Taylor will probably not bring his fiddle to Washington," noted the *Baltimore Sun* after the state legislature elected him to the US Senate in 1907.

"He will probably bring his more serious self into the Senate, using his talents for entertainment sparingly and at appropriate times after he is established as a statesman."[31] By then, he had nevertheless linked himself in the public mind with his famous oration, "The Fiddle and the Bow," which imagines the wide variety of emotions and life experiences that the music of a single master fiddler might evoke over a lifetime.[32] Taylor may have also used his public appearances to promote the career of young John Carson, a fiddler from Georgia who thereafter emerged as a recording and radio trailblazer (as "Fiddlin' John") as well as a frequent performer at political rallies.[33]

As time went on, Watson, too, seemed to have stopped taking the fiddle out on campaigns; but the fiddle as a symbol continued to be part of his appeal, including as a fiery Populist congressman who attacked the power of the railroads and corruption in politics. In 1896, a writer for the *Atlanta Constitution* published an article that tried to cajole Watson into taking up the fiddle on the trail again in his campaign as a vice presidential candidate for the Populists. The writer, who corresponded with Watson, painted the scene of his early days as such:

> Imagine if you can see the populist candidate for the vice-presidency of the United States standing at the end of a hall in a country house, sawing away at an old-fashioned breakdown, keeping time on the floor with his foot and calling the numbers in a stentorian voice, while the rustic lads and lassies swing around the room, and you have Tom Watson as he appeared fifteen years ago.

However, the article lamented that Watson had apparently put up the fiddle for good. Watson, it speculated, had come to the conclusion that the "catgut platform will hardly do for a national campaign." The newspaper urged him to reconsider, suggesting that playing a few selections like "I Dreamt I Dwelt in Marble Halls" (a popular aria from English ballad opera) might stir voters to envision him in a seat of power.[34]

Another newspaper article from the 1896 campaign also noted the lack of fiddle on the trail but nevertheless linked him with the instru-

ment by dwelling on a late-night conversation between Watson and reporter. During this conversation, Watson spoke wistfully about how he preferred a $40 fiddle to a Stradivarius and how the instrument had entertained him when he was poor and lonely, leaving the reporter to wonder how his soft touch toward the instrument reconciled with his "intensely bitter and bitterly intense" speaking style. Unsuccessful in his bid, Watson continued to enjoy playing his fiddle in private but did not use it in the 1896 campaign; nor did he become involved in old-time fiddle conventions that became popular in the state in the twentieth century.[35]

Though Watson appears to have given up the fiddle (at least, at public appearances), his reputation of once having embraced the instrument probably did not hurt him with the Populists, who were known for singing hymns and other songs in their rallies.[36] Much later, and after a long political drought, Watson may have hired musicians of the new recording age, such as Fiddlin' John Carson, to campaign for him during his successful 1920 campaign for US Senate.[37] Whatever the exact details of Carson's involvement in the 1920 race, Watson was successful, winning on an eclectic platform that combined Watson's lingering opposition to World War I with socialist ideals and notions of white and Protestant supremacy. Watson in particular emphasized intraparty opposition to Woodrow Wilson's League of Nations and the continued deployment of troops in Europe after World War I; but he flirted with elements of Eugene Debs's Socialist Party, all the while trumpeting his newfound hatred of blacks and Jews.[38] Senator Watson did not make it through his term, dying in office at the age of sixty-six. Shortly after Watson's death, Carson recorded and released a tribute, "Tom Watson Special," which speaks positively of Watson and downplays his opponents, suggesting it may have been used on the campaign trail.[39]

By then, Watson had reneged on his earlier racial and ethnic egalitarianism and was expressing a new kind of populism that emphasized fearmongering and conspiracies and viciously attacked blacks, Jews, and Catholics.[40] Though still linked to some degree in the public mind with his fiddle playing, Watson had given up not just on the fiddle but

on his more general political strategy of coalition building. Instead, he used his popular *Tom Watson's Magazine* and *Watson's Jeffersonian* to tear the nation apart, becoming what one historian labels "one of the South's most vocal opponents of black political rights," as well as a leading American purveyor of conspiracy theories against Catholics, who he claimed ran sex rings in nunneries, and against Jews, who he claimed ran a "secret organization" that could "permeate the whole European world and the United States" with its intended beliefs and messages.[41]

Carson himself had by then developed a reputation for his membership in the Klan, which itself had started sponsoring fiddling contests. Even more so, Carson became associated with antisemitism because of his role in the lynching of Leo Frank, a Jewish pencil factory manager who was convicted of the murder of teenager Mary Phagan on trumped-up charges in 1915. Indeed, both Watson's emphatic editorials against Frank and Carson's performances of his "Ballad of Mary Phagan" outside the courthouse were leading factors in fomenting public resentment in days leading up to the lynching.[42] According to the *Atlanta Constitution*, Carson had "turned up with his fiddle at every Frank development within a 30 mile radius of Marietta [Georgia] since the day Mary Phagan's body was discovered," and further, upon Frank's death, had entertained crowds—disappointed that they could not get a glimpse of Frank's lifeless body—by standing in front of the courthouse and fiddling "a symphonic jubilee."[43]

Bob Taylor's death in 1912 and Watson's death ten years later marked the end of an era of amateur fiddlers dominating country music politics. Nearly all the performer-politicians who followed Taylor and Watson and who populate the pages of this rest of this book were professional musicians and paid promoters of country music before they ran for office. Yes, there were a few important amateurs, such as senators Al Gore Sr. and Robert C. Byrd, who found some success performing on the trail (see chapter 8); but all the rest of the country music politicians after Watson and Taylor had made names for themselves as radio or recording performers or were simply nonperformers who

hired radio and recording professionals to play for them. Neverthe-less, there is much that binds these later performer-politicians with the legacies of Watson and Taylor. Country music on the campaign con-tinued to be associated with efforts to connect with common people and with snubbing one's nose at the elite. Watson's left-wing volleys at the railroads and the convict lease system foreshadowed the ways in which Senator Glen Taylor (chapter 5, no relation to Bob) would later use his singing-cowboy image to attack profiteers and restrictive voting laws in the South. Glen Taylor and Watson were even united in their opposition to lynching at points in their careers. Watson's latter day decision to reverse course and embrace racism and other hatreds also prefigured the ways in a which country music politicians from "Cotton Tom" Heflin (chapter 2) and Paul B. Johnson (chapter 3) to Jimmie Davis (chapter 4) and George C. Wallace (chapter 7) have either deliberately chosen to defend Jim Crow as means of staying in power or surrendered earlier ideals to the larger systems of oppression that surrounded them.

Country music also continued to give political outsiders (including the notable Roy Acuff, featured in chapter 4) a means of sidestepping the traditional paths to power or overcoming disadvantages related to party affiliation or home region. Though country music could be used to unite, it could also be used to sow hatred, as in the segregationist politics of the 1960s or, more contemporarily, as in the antisemitic efforts of unsuccessful Senate candidate and car magnate Henry Ford (chapter 2). Though not fond of playing the instrument publicly, Ford not only embraced Watson's revered fiddle and cotillion, but, with his antiblack and viciously antisemitic *Dearborn Independent*, became something akin to Watson's successor in news publishing as a leading American purveyor of hate.

★2★

Antisemitism and Henry Ford's Old-Time Music Revival

Henry Ford is remembered for many reasons: for his revolutionary role as an automaker and mechanizer of factories, for his business practices and philanthropy, for his stint as a politician in Michigan's US Senate race in 1918 and the speculation that he might run for president in 1924, and even for his antisemitism. What is often forgotten is that Ford also served as leading voice for an antiquarian vision that involved the deliberate re-creation of nineteenth-century culture in 1920s America. Ford was passionate about collecting antiques: the old-time furniture, machinery, and farm equipment that would eventually fill the halls of his Henry Ford Museum and populate his reconstructed nineteenth-century utopia in the form of Greenfield Village.[1]

His obsession with old-time music, however, easily outweighed his thirst for other aging artifacts. Ford yearned to revive forms of "old-time" music and dance that he believed were central to reclaiming the ways of a forgotten but vital "Old America." From 1923 until his death in 1947, he poured hundreds of thousands of dollars into the enterprise, buying and restoring three historic inns to serve as dance venues, building an elegant dance hall in Dearborn, and hiring a full-time dance master who stayed on his payroll for some twenty years.

He underwrote the salaries of an old-time dance orchestra and paid for old-time dance education for hundreds of university students and thousands of Michigan schoolchildren, helping in part to make folk dancing something of a national public school pastime. He covered costs for the writing and distribution of a dance manual and even extended his reach into the media, financing more than twenty old-time music recordings, two coast-to-coast radio relays, a network radio series, and motion picture shorts of favorite old-time fiddlers.[2]

Ford's old-time music and dance campaign came immediately on the heels of two other obsessive pursuits that had made major splashes in the national media: his politics and antisemitism. In 1918, supporters attempted to draft Ford into national office by placing his name on both the Democratic and Republican rolls for US Senate in Michigan. Ford did little campaigning for the seat at all, but seemed to genuinely want the position. He easily won the state's Democratic nomination, but was outflanked and outspent by anxious Republicans and conservatives who put forward former Navy Secretary Truman H. Newberry as a competitor. In the general election, Newberry attacked Ford's patriotism because of the carmaker's efforts to keep the US out of World War I. Newberry squeaked by with a win, but was dogged by accusations that his run was buoyed only by large, corrupt campaign contributions. Indeed, the Newberry campaign is used today as a textbook example of how money sullies politics.[3]

Ford's response to this loss, on the other hand, might serve as a textbook example of how electoral affairs succumb to conspiracy-mongering and rage. Almost from the moment he lost, Ford became mired in a vengeful politics of personal grievance that involved not just a lawsuit against Newberry, but a campaign to spread antisemitic libels. Ford blamed Jews for everything from baseball corruption to influence in promoting both bolshevism and banker capitalism to his own electoral loss. Ford's public connection with antisemitic conspiracy began in earnest in 1919 but continued well into 1920s, when supporters trumpeted him as a possible presidential contender and when he became most devoted to preserving old-time music and

dance. By the 1921, he had replaced the recently departed Tom Watson in many ways as a dominant national voice for antisemitism.[4]

Ford's antisemitic tirades and his musical antiquarianism shared more than just chronological proximity. Much as the national media characterized his antisemitism as a "drive" or a "mania" in the early 1920s, the press reacted to Ford's passion for an earlier generation's sound and footwork at mid-decade with terms associated with re-vered pastime or religious fervor: it was a "missionary labor," a "hobby," and a "revival."[5] Before long, the metaphors sounded down-right militaristic. The *New York Times* labeled his promotion of old-time music and dance a "campaign," while *Literary Digest* preferred the less subtle "crusade."[6] The *Los Angeles Times* was more blunt: "Ford Wars on Jazz."[7]

Even the children's press got into the fray. *Youth's Companion*, a hundred-year-old magazine that would later merge with the *American Boy*, applauded the media blitz that occurred when Ford invited old-time Maine fiddler Mellie Dunham to play for large audiences and intense press scrutiny in Michigan in 1925. Dunham's arrival in Dear-born, the magazine argued, was

> a step in Mr. Ford's campaign against the ugliness of present-day dances and the tyranny of the jazz band. He [Ford] is for Money Musk, against the Blues of whatever tinge; for the dignified Lancers or the romping Portland Fancy, against the acrobatic Charleston; for the jollity of the fiddle against the moan of the saxophone. Mel-lie Dunham is the first wave of Mr. Ford's shock troops advancing against the entrenched atrocities of Jazz-mania.[8]

The use of so many martial metaphors—the "shock troops" of *Youth's Companion*, the *Los Angeles Times*' notion of Ford warring on jazz—over so short a time was odd, seemingly out of character for the bil-lionaire tinkerer and carmaker. Sure, his factories eventually pro-duced vehicles and airplane engines for the American effort in World War I; but Ford was, after all, best known politically in the 1920s for his

pacifism, especially his support of the League of Nations and his char-
tering of the ill-planned and much ballyhooed 1915 Peace Ship mission
to Europe in an idealistic effort to end that war.[9]

But perhaps the martial language was accurate in a way. Ford's pro-
motion of old-time music and his opposition to jazz were not isolated
or compartmentalized cultural skirmishes. They were, in many ways,
a rechanneling of the political impulses that led to his Senate run in
1918 and his presidential considerations in 1922 and 1923 into a more
culturally focused campaign to transform the larger social climate
in expressly political ways. More important, his promotion of anti-
quarian dances and music were closely associated with the ongoing
rhetorical war that he and his public relations machine were already
waging against Jewish Americans. Indeed, Ford's twin obsessions with
music and antisemitism became a new kind of political program for
influencing the national destiny—a stand-in, in many ways, for what-
ever legislation he might have created or thwarted as a member of the
Senate had he been elected. Unlike other figures surveyed in this book,
Ford did not seek to use music to prop up a political campaign. Rather,
he used a specific kind of music as a kind of substitute for politics, a
way to effect change and remain a player on the cultural scene in the
wake of a stinging electoral defeat.

Numerous writers have documented how Ford used his newspaper,
the *Dearborn Independent*, in the early 1920s to accuse Jews in finance,
government, and entertainment of undermining Anglo-Saxon cul-
ture.[10] Less known is how this antisemitic worldview permeated Ford's
attempts to promote old-time fiddling contests—important in the de-
velopment of the hillbilly and country music genre—and "traditional
American" dances such as reels, rounds, and squares. Ford went to
considerable expense to support these nineteenth-century art forms
as an alternative to commercial venues and genres such as dance halls
and mass-produced jazz and Tin Pan Alley. Editorials in his *Indepen-
dent*, in fact, claimed that jazz and song publishing were fields de-
spoiled by Jewish influence.[11] Furthermore, substantial evidence sug-
gests that William J. Cameron, the Ford publicist, ghostwriter, and
editor who spearheaded the *Independent*'s antisemitic campaign on

behalf of the carmaker, was also the ghostwriter of the introductory essay of Ford's popular old-time dance manual *Good Morning*, an essay that served as a kind of founding manifesto of his old-time dance and music movement.

Ford and Cameron's antisemitism was coupled with Nordicism, a belief about the racial destiny of Northern European peoples that borrowed liberally from the scientific racism and eugenic thought of the era. Ford and his staff's explanations of why they promoted old-time music and dance often built on Nordicist and antisemitic ideas disseminated in earlier Ford-produced literature; the overall old-time campaign kicked off right in the middle of Ford's ongoing antisemitic publicity campaign. As an early unpublished draft of *Good Morning* argued, modern forms of popular music and dance—especially those deriving from jazz and Tin Pan Alley—drew fire from moral authorities because they were racially foreign to Protestant Anglo-Saxon America. "Dances partake of the racial characteristics of the people who dance them," it argued, fretting about the groundswell of "foreign" musical styles and dances being hawked by the American music industry. The manual nevertheless predicted a demise of these influences and the resurgence of the "type of dancing that has survived longest among the northern peoples."[12]

Besides Ford's old-time music and dance effort promising a renaissance of some sort of Nordic American identity, it also played a critical and perhaps underexamined role in how major commercial genres of American music such as country and folk emerged and came to be defined.[13] By reaching out to the public and dovetailing with Ford's earlier antijazz and antisemitic campaigns, the old-time campaign denoted a circling of the wagons around specific notions of whiteness and Americanness that already were being pushed by the recording industry through the creation of genres that segregated people and musical styles by race, region, and socioeconomic status: blues and jazz as "black" "race music"; hillbilly or old-time as a poor, usually Southern, and almost always "white" music; "legitimate," popular, and classical music linked to the larger mass of white, middle-class Americans. Most accounts of this bifurcation of genres focus on how indus-

try figures such as Victor's Ralph Peer and Columbia's Frank Buckley Walker reacted to various social and marketing pressures by inventing genre categories that made artificial distinctions that either mirrored existing racial segregation in the South or fit within existing national patterns of production and consumption. By doing so, the recording industry sanctioned a process of separating music and people into genres, despite the fact that blacks and whites had long been involved in "a creolized synthesis of European and African influences."[14]

Ford went a step further than Walker or Peer. He not only hoped to advance one genre over another but sought to dig deeper trenches around that divide by adding religion and national origin to old-time and hillbilly's unofficial list of racial, class, and regional requirements. Ford's promotional endeavors for old-time music and his effort to safeguard the kind of white "Nordic" Christendom that he believed old-time and old American music represented, then, are key to understanding how events outside of the South and outside of recording-industry marketing practices might naturalize notions that old-time or hillbilly music was not only white and American, but also antithetical to groups such as immigrants and Jews. In Ford's case, this involved engineering and financing a large, sustained national media campaign centered in the northern Midwest. Ultimately, Ford's efforts reflect a pointed agenda where promotion of one musical and dance style over another was used to shape the debate about who is or who is not a proper citizen of the American republic.

Ford's "old-time" or "old American" dances were for the most part resurrected nineteenth-century ballroom dances, some of folk and some of courtly origin, but all with European roots and many with important regionalized American variations. The sources for these dances, Richard Nevell tells us, were not original folk dances but "updated, sophisticated versions of the country dances that really emphasized morality and manners."[15] As time pressed on, Ford inevitably sought musicians who could not only play the old "authentic" music to accompany them, but who could also make phonograph records, thereby "extending the effect of his ideas on dancing," according to

one executive close to Ford.[16] This led Ford and the growing portions of his staff charged with maintaining his antiquarian pursuits to venture into what at the time was called "old-time music"—an important forerunner of what would become known as hillbilly or country music.

Ford's efforts helped maintain the emerging old-time and hillbilly genre's popularity in the years between the earliest recordings of fiddlers such as Eck Robertson and Henry C. Gilliland for Victor Records in New York in 1922 and 1923 and the emergence of bona fide stars of the hillbilly genre such as Jimmie Rodgers and the Carter Family in the summer of 1927. Ford's full-fledged media campaign for old-time fiddling and dance, in fact, neatly filled that gap between Robertson and Rodgers by beginning in October 1923 and ending near the close of 1927. Though not intentional, Ford also helped repopularize the fiddling contest, which had been revived in earliest years of the twentieth century by Confederate veterans such as Gilliland and made into annual affairs, but which still lacked a large national following outside of the South. Ford's attention helped sparking a spate of a well-publicized, fiercely fought fiddling contests not just in the South but throughout the nation in 1926.[17]

Ford's interest in old-time dance and music appears to have started gradually in the 1910s and from within his immediate social circle in Dearborn. Although Ford reportedly enjoyed social dancing at the Joseph Coon Hotel and Tavern outside Detroit in the 1880s during his youth, it is difficult to pin down when exactly the adult Ford first began promoting old-time dancing. Materials in the Benson Ford Research Center suggest that he was involved in smaller scale promotion among his close friends in Dearborn as early as 1910. Ford had been a member of a group called the Greenfield Dancing Club of 1882 and had sponsored a dance for the group at one of his properties in January 1910. According to the invitation, the event was to feature an "Old Time Dancing Party consisting of Square Dances, Virginia Reels, and old fashioned Polkas."[18]

Ford's first public declaration of curiosity about traditional music in the national press appears to have taken place nine years later, during

eight days of court testimony that would rank among the most humili-
ating in his life. Not long after his electoral defeat, in the summer of
1919, Ford took the stand in a libel trial his attorneys had filed against
the *Chicago Daily Tribune* after that newspaper criticized Ford's World
War I–era pacifism and claimed Ford was an "Anarchist" and "ignorant
idealist." His attorneys hoped that putting Ford on the stand would dis-
prove the charge of ignorance, but the plan backfired. Defense attor-
neys were unable to make hay out of Ford's infamous and, until then,
mostly unknown three-year-old quote in the *Tribune* that "history is
more or less bunk," as well as Ford's testimony that he did not care
much for art or music.[19] Worse, Ford appeared woefully ignorant of
basic facts of American history: in his testimony, he could not identify
the nations that fought in the War of 1812, and he misidentified Revo-
lutionary War traitor Benedict Arnold as a writer of some sort.[20] Be-
tween these embarrassing missteps, Ford tried to retract his dismissals
of art and music, noting especially his interest in the banjo—a fact
that was widely carried by Associated Press wire stories.[21] Although
not matching his later fondness for the fiddle, the cimbalom, and the
dulcimer, Ford's early penchant for this instrument—which could be
used to play jazz and Tin Pan Alley as well as traditional Appalachian
and Euro-American music—would later result in the purchase of his-
torically significant banjos, especially those related to traditional
music genres, for his growing collection of Americana.[22]

After the *Tribune* trial, the Ford name would not be connected
again nationally with traditional music and dancing until October
1923, when the *New York Times* noted that Ford had given a new auto-
mobile as a gift to Jasper E. "Jep" Bisbee, a traditional fiddler from
Paris, Michigan. The article explained that Bisbee, a well-known local
fiddler, had played for Ford and two VIP guests—inventor Thomas
Edison and tire magnate Harvey Firestone—during a camping trip
the three had made to western lower Michigan that summer. The new
automobile was simply Ford delivering on a promise of repayment.[23]
Ford's patronage of the white-haired, mustachioed, eighty-eight-year-
old Bisbee continued to get much press over the next three months,

with Ford arranging for Bisbee to travel to New Jersey so Edison could record and film him, and with Ford hiring Bisbee to play at a well-publicized "old fashioned house-warming" for Ford's brother-in-law in Traverse City, Michigan. In one article, Traverse City's old-timers characterized Ford as "mighty spry for a city feller."[24]

Ford's very public courting of the fiddler coincided with a final flurry of speculation that the Michigan carmaker might run for president. The highlight of this speculation occurred in late November when a third-party "People's Progressive Party" convention consisting of what the Associated Press identified as "Progressives, Farmer-Laborite, Independents, and Liberals" independently nominated Ford to top their presidential ticket.[25] Ford, however, disappointed supporters and confounded liberal endorsers when he announced in late December 1923 that he was supporting the candidacy of conservative Republican Calvin Coolidge in the 1924 election.[26]

Over the next year, Ford quietly sponsored more musicians and made more headlines by organizing well-publicized dances at the Wayside Inn in Sudbury, Massachusetts, the first of three historic tavern-inns he acquired in the 1920s in part because of his love of old-fashioned dancing in authentic historic ballrooms.[27] At the Sudbury functions, Ford occasionally fiddled himself, and in August 1924 he had hired a dance master, Benjamin B. Lovett, to better acquaint himself with the ripple, polkas, the Money Musk, quadrilles, schottisches, reels, and the varsovienne.[28] Lovett, who had taught in nearby Hudson, Massachusetts, returned with Ford to Dearborn later that year and stayed on as Ford's personal dancing teacher for some twenty years.[29]

By July 1925, the trickle of publicity Ford received for sponsoring Bisbee and the Wayside Inn dances had turned into a great tidal wave of coverage that would result in a far-reaching national old-time fiddling and dancing craze. The big news was that Ford had ordered a manual of old-time dances to be put together. Advance copies of the book, *"Good Morning": Being a Book on the Revival of the Dance*, caught the eye of the press. First, Pulitzer's New York *World*, then *Literary Di-*

gest magazine, and finally the *New York Times* featured lengthy articles on the forthcoming manual, noting Ford's general disdain for jazz and the "modern dances" of commercial dance halls.[30] In its press preview, the *Literary Digest* quoted the *Good Morning* manuscript at length and noted the anticommercialism of his music and dance revival:

> The characteristic of modern commercial dance is determined by commercial considerations. The older form of dancing requires room. Room in cities, especially in cabarets, is expensive. Hence a form of dancing that has been encouraged that enables the largest possible number of paying couples to dance together in the smallest possible in the smallest possible space.[31]

Although Lovett reportedly traveled to research the dances, most of the sixty-seven actual dances in the manual were lifted from nineteenth-century dance manuals. In fact, Allison Robbins notes that, of the nineteen contra dances outlined, all but three had a "corresponding melody in Elia Howe's nineteenth-century compilations of dance tunes."[32]

This is does not mean the dances were not researched or adapted to Ford's tastes. Indeed, Ford and his staff were paradoxically involved in a substantial amount of modern interpretation in their efforts to preserve what they believed was pristine and historical. Ford's longtime general secretary recalled:

> Mr. Lovett went into the older types of dances and developed them and applied them in the way that Mr. Ford wanted. They would make changes in the old scheme. Of course, the old-fashioned dances were characteristic of certain localities. For instance, they would dance a square dance a certain way in certain locations and differently in others. The farther [the dances] were away from each other the greater they differed. Mr. Ford's idea was to standardize it to one form of a dance. In doing that he discussed the matter with Lovett, and they decided how they were going to proceed on it.[33]

Lovett, however, was perhaps more direct about the aims of the manual in a later radio interview: "We teach social deportment, poise, carriage, and courteous behavior along with the early American dances."[34] Indeed, it seemed the dances themselves were an afterthought compared to the lessons in proper behavior and instilling an almost aristocratic set of social mores around courting rituals.

On the heels of *Good Morning*'s release came a second barrage of press attention when Ford began inviting elderly musicians again to play for him in Michigan. The first highly publicized musician to arrive in Detroit to play was Dunham, the fiddler from Norway, Maine, followed by seventy-one-year-old dulcimer player Jesse Martin of Frewsburg, New York.[35] Dunham's trip to Detroit, however, outshone Martin's. It started with a send-off that drew much fanfare and dozens of Norway's children, including several who held rally signs wishing Dunham—a seventy-seven-year-old snowshoe maker who had recently won the Maine state fiddling championship—a safe return.[36] Dunham inexplicably also drew large crowds when he arrived at the Ford laboratories, even though a *New York Times* article noted that thirty-eight other old-time fiddlers had already performed for Ford in Dearborn by that time.[37]

Ford's championing of the "picturesque, white-haired" Dunham sparked ire and challenges from several other champion fiddlers around the country.[38] The most publicized of these, however, involved Uncle Jimmy Thompson of Tennessee. In early January 1926, a Boston newspaper reported that Dunham had not only challenged Thompson—a southern fiddling champion who performed on the Nashville-based barn dance radio broadcast that would become known as *The Grand Ole Opry*—but had bragged openly of his superiority over Southern fiddlers in general.[39] Quick to realize the public relations bonanza, both the show's manager and Uncle Jimmy responded.[40] The contest, however, never took place, and Thompson never played for Ford. Nevertheless, the publicity drummed up by the episode, coupled with the media-fed notion that Ford was anointing national fiddle champions, helped increase interest to the point that some thirty

thousand people took part in local fiddling contests sponsored several weeks later by enterprising Ford dealers in Tennessee, Indiana, and Kentucky. The winners of these contests then went on to compete in a regional championship in Louisville.[41]

Ford and his dealers were neither the first to promote competitions among fiddlers, nor the first to use contests for political and cultural aims. In fact, Southerners had been organizing fiddling contests and conventions since the 1730s and had begun in to use them in more recent decades to promote a rosy type of nostalgia toward the old Confederacy.[42] Many of these eighteenth- and nineteenth-century contests took place in parts where enslaved laborers with fiddling skills were fairly common. With the arrival of the twentieth century, black fiddlers competed at contests in separate divisions, while Cherokee and Creek musicians took part in the main contests.[43] While fiddling contests attracted interest from rural Southerners, by the late nineteenth century, Jewish American fiddlers — mostly in urban areas — formed what Henry Sapoznik has called the "cornerstone of Jewish ensembles," where they joined with other musicians to play celebratory *sher* quadrilles as well as circle dances such as *freylekhs* and *bulgars* at wedding receptions.[44] Given this folk history and a similarly long history of Jewish involvement in classical violin, it is perhaps not surprising that the two Jews who achieved early prominence in the country music industry were both fiddlers: Maurice Blumen of the band Cousin Wilbur and His Tennessee Mountaineers in the 1940s; and Gene Lowinger, who played for Bill Monroe's Blue Grass Boys in the 1960s.[45]

Although early Southern fiddle conventions were episodic affairs, by the early twentieth century, many communities began to hold more regular contests and conventions, which often dovetailed with commemorations of Confederate life.[46] A group calling themselves the Old Fiddlers' Association was organized by three Confederate veterans and began holding regular contests in Texas around 1900.[47] Similar old-time fiddle contests and conventions emerged in Mississippi, Georgia, Kentucky, Alabama, and Tennessee around this time. The United Daughters of the Confederacy were often involved in

hosting competitions such as those in Tennessee. Others, such as the Georgia Old-Time Fiddlers' Convention in Atlanta in the 1910s, became large community-supported affairs during which elite citizens paradoxically broke down damaging stereotypes about poor Appalachian whites while also heralding the music as a means of repelling racial mixing and racial degeneracy.[48] Victor fiddle recording pioneer Henry C. Gilliland, one of the leaders of the Texas-based group, even went so far as to link the growing passion for fiddle competitions with his activism in the United Confederate Veterans (UCV), an organization devoted to fighting for veteran's pensions and shaping the way the history of Confederacy played out in school texts. Researcher Kevin Fontenot argues that Gilliland, a small-town Oklahoma politician who believed music could instill social peace and a respect for the past, booked performances of fiddlers at Confederate reunions and intricately involved the UCV and its aging veterans in his fiddling conventions.[49]

One politician, J. Thomas "Cotton Tom" Heflin—perhaps the most outwardly white supremacist of Alabama's congressmen—had even taken to delivering political addresses at Southern fiddling contests. In 1912, Heflin, who had tested out his rhetoric about black inferiority at Confederate veteran gatherings for some time, spoke at one such reunion and picnic in Stanley, North Carolina, that also featured a competitive old fiddlers' convention. Heflin had made the papers a few years earlier for firing shots at a black man on the street in Washington, DC. He was now was touted in advance stories as a "silver-tongued orator."[50] Five years later, organizers of a UCV-sponsored fiddlers' convention in West Blocton, Alabama, promised attendees they would be treated to a "rousing address" by Heflin, whom they promoted as "The Orator of the South."[51]

Accounts of Heflin's life suggest he was indeed a colorful dresser and talented orator and storyteller who also harbored a mean streak of antiblack and anti-Catholic bigotry. As a young man, not only did he pattern much of his speaking style after the vaudevillian antics of Tennessee governor Bob Taylor, but he had worked to put down Populist challengers, defended his state's abusive convict lease system, and

helped draft the infamous 1901 constitution for Alabama that effec-
tively disenfranchised blacks and poor whites by the way it appor-
tioned representation to certain regions of the state.[52] In the 1920s,
Heflin was elected to the US Senate, where he combined support
for temperance and opposition to women's suffrage with frequent
speeches that spread conspiracies about Catholics.[53] One prankster—
perhaps noting Heflin's affinity for fiddle contests—sent him a pur-
portedly antique violin and mailed other senators an announcement
claiming that Heflin, a twentieth-century "Nero," would fiddle away
as Catholics suffered. Heflin retaliated with claims that Catholics were
trying to kill him by sending a poisoned fiddle.[54]

While figures such as Gilliland and Heflin brought visibility to
fiddle contests in the South, Ford with the help of Dunham and his
auto dealers, expanded interest in places outside of the South that had
their own fiddling traditions, such as Upstate New York and New En-
gland, as well as places where black and white Southerners had settled
to take advantage of industrial jobs as a part of a wider Southern di-
aspora.[55] Indeed, within weeks of the first spate of dealer-sponsored
competitions in the South in 1926, the fiddling contest grew into a
national fad. Similar fiddling contests took place in Pennsylvania,
Iowa, New England, and Canada, spurred by publicity surrounding
Ford and local boosters' pride in their own musicians.[56] The extent to
which Ford's fiddling promotion reached the entire nation is perhaps
best demonstrated by the media coverage that surrounded a fiddling
contest in faraway Southern California. Radio station KHJ broadcast
numerous installments of the local contest, and a large photo of the
nine top finalists—seven men and two women—accompanied a front-
page story in the Los Angeles Times on January 25. Loving cups were
awarded to the top male competitor (age 80 and older) and female
competitor (age 70 and older).[57] "Mellie Dunham please write," opined
a later Los Angeles Times caption accompanying a photo of one of the
winners. "Stephen Gilley, 80 years of age, and seven other Southland
fiddlers, all Civil War veterans, propose East-West fiddling match."[58]

Broadcasting was also central to the Ford publicity push. In con-
junction with dealers who picked up a portion of the costs, the Ford

Motor Company relayed an "'old time dance' program" to sixteen radio stations nationwide, including San Francisco's powerful KPO. The company's internal organ, the *Ford News*, reported on the reach of KPO rebroadcast:

> Many Western dealers' showrooms were crowded with people sway-ing to good old tunes. In fact, in Carson City, Nevada, twenty-five per cent of the population (400 people) accepted the invitation of the Carson City Garage, and several of the most distinguished state officials and their wives participated.[59]

Ford repeated the relay again in 1927, this time to stations in nine states and the District of Columbia; again, the program was aired in Ford dealer showrooms.[60]

Ford's promotion of traditional fiddling and reels, squares, and rounds over other forms of music and dance was consistent with the criticism that his newspaper, the *Dearborn Independent*, had long made of jazz—a criticism Ford himself began to make in his own remarks to the press.[61] Shortly before *Good Morning*'s release in 1925, for in-stance, he noted that his dancing campaign was seeking to oust jazz, a musical form he argued that had only taken root in the cities.[62] A year and half later, while promoting old-time dance classes he had financed for several groups of Michigan schoolchildren, he noted his distaste again. "In Detroit and surrounding towns," he told a writer on assignment for the *Los Angeles Times*, "there are thousands of school children dancing old-fashioned dances to old-fashioned airs. Jazz has no melody."[63]

Exactly when antisemitism became a prevalent aspect of Ford's thought remains a bit murky. Much speculation suggests that Ford's precon-ceptions were cemented by the allegations of two Jewish members of his 1915 Peace Ship mission who purportedly claimed that wealthy Jews in Europe were behind the war.[64] Others suggest that Ford was pushed over the line by his loss in the 1918 Michigan senatorial race to Truman Newberry; Ford reportedly fumed that high-placed Jews were

responsible for his defeat.[65] Still others point as far back to his youth, noting the ways in which Ford's beloved McGuffey Reader textbooks naturalized antisemitic notions about Jewish greed, or to the "Populist anti-Semitism" that might have confronted him as young man the late nineteenth century, or, perhaps, the "pseudo-Agrarian" movements that were springing up in the twentieth.[66] Ford's own political trajectory in the 1920s remained enmeshed in Progressive reform, but seem to have moved stridently to the right without completely breaking with that tradition. A radical-leaning La Follette Republican who favored women's rights and Wilsonian notions about peace in the teens, Ford apparently approved of his publicity team referring to him as a conservative by 1924.[67] Today's political historians might label him a "political insurgent" who, along with Hiram Johnson, Burton K. Wheeler, and others, had moved rapidly from Progressive reformism to—or perhaps blended their Progressivism with—xenophobia and an ardent opposition to the New Deal. The difference perhaps was that Ford's transformation occurred much more quickly.[68]

Whatever the case, Ford and Ford Motor Company executives such as Ernest G. Liebold, his personal secretary, and William J. Cameron, the *Dearborn Independent*'s editor, clearly were the forces behind the *Dearborn Independent*'s publication of the International Jew series. Ford had bought the paper in 1919, filling its pages with the type of writing that readers of Tom Watson's newspapers and magazines would have been quite familiar with: light features, ethnocentric travelogues, western Americana, and editorials preaching hard work and Ford's own unique brand of reform. In 1920, the International Jew series began with extravagant claims about Jewish economic and political power, continued with attacks on Jews in entertainment and cultural industries, and finally, offered an updated, rewritten, serialized version of the claims made in the conspiratorial antisemitic hoax text *The Protocols of the Elders of Zion*.[69] Each week for twenty-one months, the *Independent* featured a new article on the evil enterprises of Jews, most of which appeared on the newssheet's front page. Jews were blamed for everything from low harvest prices to smut in movies to corruption in baseball to the lack of religious themes in Christmas cards.[70]

The International Jew series was particularly critical of Jews in the music business, blaming them for the rise of jazz and arguing that a trust of "Yiddish song manufacturers" on Tin Pan Alley completely controlled the music business. "Jazz is a Jewish creation," the *Independent* opined. "The mush, the slush, the sly suggestion, the abandoned sensuousness of sliding notes, are of Jewish origin." The newspaper went on to quote an unnamed source that described how the "Oriental, especially the Jewish, infection in our music" was more "virulent" than earlier German and French influences on the American music culture:

> The insidiousness of the Jewish menace to our artistic integrity is due partly to the speciousness, the superficial charm and persuasiveness of Hebrew art, its brilliance, its violently juxtaposed extremes of passion, its poignant eroticism and pessimism. . . . The Anglo-Saxon group of qualities, the Anglo-Saxon point of view, even though they are so thoroughly disguised in a people descended from every race . . . are nevertheless the vital nucleus of the American temper. And Jewish domination of music, even more than Teutonic or Gallic, threatens to submerge and stultify them at every point.

The article went on to describe an incident where a strong "non-Jewish" song was defeated by "Jewish manager" who purposefully introduced it to the public with a non-English-speaking singer who was not only overly "Yiddish in appearance" but "sang through his nose."[71]

Jewish songsmiths were also accused of delivering smut and repackaging degenerate black music. Irving Berlin's "I Like It," for instance, put "unashamed erotic suggestions" on the lips of children.[72] A follow-up article noted that, under presumed Jewish control, Tin Pan Alley had transformed from an entity that emphasized "sentiment" and promoted communal singing to one that promoted showmanship and degenerate "Congo" themes, "seductive" ragtime, and "slimy" jazz.[73] Indeed, such writing seemed to play on centuries-old notions that Jews were a mongrel race or possessed a "blackness" that

was symptomatic of a potentially infectious disease.[74] One might note that Ford and company preferred "unobjectionable" or "clean" songs from the folk tradition and the early "non-Jewish period" of Tin Pan Alley such as "Turkey in the Straw," also known by its derogatory minstrelsy name, "Zip Coon," and Charles K. Harris's bestselling hit, "After the Ball," which themselves had questionable adaptations and lineages. "Turkey in the Straw" was a fiddle tune from blackface minstrelsy tradition that was regularly paired in the nineteenth century with the highly suggestive lyrics "Sugar in the gourd / Honey in the horn / I was never so happy / Since the hour I was born."[75] Harris's "After the Ball," on the other hand, bristles with what Jon Finson calls "an undercurrent of frustrated sexuality" and, after all, is about an elderly uncle seating a very young niece on his lap and regaling her with stories of his teenage love life.[76]

The International Jew series was eventually collected and republished in a four-volume set by Ford's Dearborn Publishing Company—the same subsidiary company in charge of publishing *Good Morning* and the *Dearborn Independent*. The book set was then promoted within the pages of the *Independent*. The four volumes were organized into general thematic sections, focusing collectively on Jewish power and cultural influence.[77]

Professional historians and other writers have documented the wide reach of the series, both in Europe and America. Hitler was certainly a fan of Ford and the German-language edition of *International Jew*, hanging a large photo of Ford in his private office and keeping a well-stocked collection of Ford's books in his library. While the *Independent* often disagreed about tactics, it carried generally positive coverage of the nascent National Socialist movement in Germany and the National Fascist Party of Italy. A 1923 article in the *Independent* praised the Italian Fascist Party and its forced feedings of cod liver oil to Socialists. A 1926 editorial criticized some of Mussolini's methods but praised his purported ability to restore order. Finally, a 1927 piece criticized the Fascist role in assassinations but argued that Mussolini lifted Italy from the bottom of nations to a nation "of first rank." German National Socialists were likewise justified in the article "Ger-

many, Prey of Alien, Faces Complete Ruin," a 1922 antisemitic piece that claimed "alien" Jews controlled Berlin financially but cared little for ordinary Germans, and 1925's Jewish-baiting "Anti-Semitism in Germany: Who and Why?"[78]

Ultimately, the International Jew series came to an end in January 1922, but the newspaper continued to publish antisemitic articles until 1927, when Jewish farm cooperative organizer Aaron Sapiro brought Ford and the newspaper to trial for libel and successfully brokered a settlement that led to a formal written apology to American Jews, an end of the antisemitic content, and ultimately the end to the *Independent* itself. The settlement also stipulated that Ford fire the newspaper's editor and Ford's personal secretary—conditions that, as we shall see, were never entirely honored.[79]

Although the initial wave of the *Dearborn Independent*'s antisemitic reporting concluded nearly two years before Ford's invitation to Jep Bisbee, the newspaper continued to print articles touting antisemitic stereotypes and, especially, Nordicist content throughout the span of Ford's old-time music and dance revival. Nordicism was the early twentieth-century race theory which argued that Northern Europeans formed a master race and that their fall from supremacy would inevitably lead civilization to crash. The theory built on assertions by American anthropologist William Z. Ripley that one could find three distinct European racial groups—Teutons, Mediterraneans, and Alpines—as well as arguments by French diplomat Joseph-Arthur de Gobineau that all great civilizations of the past had a northern Teuton, or "Aryan," leadership component.[80]

Ford and the ghostwriters and executives who staffed his publicity machine, however, were more likely influenced by Nordicist thought of eugenicist Madison Grant, as expressed in his 1916 book, *The Passing of the Great Race*, and by Grant acolyte Lothrop Stoddard in his 1920 book, *The Rising Tide of Color: The Threat against White World-Supremacy*. Grant in particular argued that the United States had been founded by Nordics and that it owed much of its success to its Nordic leadership. Grant believed this leadership was being threatened by

blacks and alien Eastern European Jews, who retained a "ruthless con-
centration on self interest."[81] Stoddard, building on Grant's theories,
focused on the foreign "Asiatic elements" of American Jews, lump-
ing them in with Mediterraneans and Alpines, who he argued thrived
better than Nordics in the densely populated cities and cramped facto-
ries of the modern world.[82] Nordicist thought seemed especially pres-
ent in the *Independent*'s original International Jew series, especially in
the argument that Jewish aa posed a greater threat to American music
than Nordic "Teutons" (German composers) and the Mediterranean-
Alpinic "Gauls" (the French).[83]

Antisemitic, Nordicist, and racist articles, in fact, ran in the *Inde-
pendent* concurrently with the old-time music and dance revival. They
did not cease with the end of the initial "International Jew" series
in January 1922 but continued on—less regularly, but no less vehe-
mently—throughout the music and dance craze until Ford's public
antisemitic campaign was curtailed by the Sapiro agreement. During
1923 and 1925 (two very active years in the old-time music and dance
craze), the *Independent* published an article praising the Ku Klux Klan,
another article claiming Jews were not the real biblical chosen people,
an article claiming powerful Jews purposefully portrayed themselves
as "martyrs" in the media, and an article by one Walter M. Wolff in
Berlin who wrote that rising antisemitism in Germany was the result
of Jewish control of corporate boards of directors at a supposed ratio
of 24 to 1.[84]

Often such reporting occurred more or less simultaneously with
new developments in Ford's old-time music and dancing promotions.
Less than a month after Bisbee made recordings for Edison and Ford
in New Jersey, for instance, the *Independent* ran an article claiming
that Jews were attempting to introduce bolshevism to African Ameri-
cans.[85] And two weeks before Ford invited Lovett to teach dance in
Detroit, the *Independent*'s "Mr. Ford's Page" editorial made a not-too-
thinly-disguised attack on Jews as "money brokers."[86] A week before
the *Independent* began serializing individual old-time dances and sheet
music, it ran an article titled "Are We a Shylock Nation?"[87]

In fact, starting in January 1926, the *Independent* continued to ad-

vertise the four-volume International Jew book series every single week in the very same issues that carried articles promoting old-time dance steps and music, most of which were reprinted from the *Good Morning* manual. In the March 20, 1926, edition of the *Independent*, for instance, an ad for the "International Jew in 4 volumes" appeared on page 24, while the "A Dance a Week" feature focusing on the steps of the Money Musk, appeared on pages 28 and 29. Usually the ad for the International Jew volumes was centered amid text within the weekly "I Read in the Papers That—" digest, a section of abbreviated news blurbs from legitimate news organizations (and a placement that would seemingly bolster the credibility of the contents of the book set).

Ford's own comments in the press throughout this period—but particularly at the height of media attention over the fiddling craze in early 1926—included backhanded compliments that perpetuated anti-semitic stereotypes and reinforced the *Independent's* screeds against Jewish songwriters and moneymen. In January, Ford was interviewed by the *New York Times* during one of his old-time dance affairs at the Wayside Inn. He recanted a bit on his earlier criticisms of jazz, arguing that some jazz was needed in order to compete with traditional music, just as Jewish business acumen was needed to keep non-Jews on their toes:

> And so the conversation went on until it got on the subject of music. Somebody spoke of jazz and somebody else spoke of the impetus Mr. Ford's movement to revive old-fashioned dancing and music had gained.
>
> "Well, you have to have different movements," said Mr. Ford. "You have to have them to keep things stirred up. You have to have an explosion now and then. It's just like the Jews in this country. We couldn't get along without them. They keep things stirred up by their business ability."[88]

Fifteen days later, without mentioning music, Ford clarified his statement for the Associated Press, arguing that Jews as a whole were

smarter than many Gentiles and a good social influence because they prompted "the boob Gentiles" to "hustle to keep up"—the implication here being that, if Jews continued to find financial success, they might inadvertently spur a Nordic resurgence. During the same interview, Ford also repeated early *Independent* diatribes against "international Jewish money power," arguing it was involved in every war.[89]

Although researchers since the 1970s have briefly noted the connections between Ford's distaste for jazz and his antisemitic campaign, and less regularly the chronological connections and general affinity between Ford's antisemitism and his promotion of old-time music, only recently have scholars argued that Ford's antisemitism and his industrial philosophy were primary underlying motivations for Ford's promotion of old-time dance in the *Good Morning* manual.[90] Important in this research is the manual's introductory chapter, "The Return of the Dance," which appears in the widely distributed 1926 second edition of the book:

> Denunciation of the dance by the protectors of public morals has usually been occasioned by the importations of dances which are foreign to the expressional needs of our people. With characteristic American judgment, however, the balance is now shifting toward that style of dancing which best fits with the American temperament. There is a revival of that type of dancing which has survived longest amongst the northern peoples. The tide has swung in favor of such dances as are described in this book.[91]

Observers have noted that "foreign" in this section might have been connected in Ford's mind with corrupting Jewish or black and Latin influences. One might go further, though, and argue that the introduction's prediction of a renaissance of the forms of dancing that have "survived longest amongst the northern peoples" also seems to invoke the Nordicism that eugenicist Grant had hoped would stave off a collapse of civilization, while the language of the final sentence "the tide has swung" seems a not-too-veiled homage to Stoddard's *The Rising Tide of Color: The Threat against White World-Supremacy*.

However, an analysis of the earliest typescript manuscript of the manual in Ford's papers archived at the Benson Ford Research Center demonstrates an even deeper connection between the dance manual and the Nordicisim that Ford and his executives professed. This early manuscript of *Good Morning*, in fact, contained additional lines, noted below in bold, that were apparently redacted from later published editions:

Denunciation of the dance by the protectors of public morals has been usually occasioned by the importations of dances which are foreign to the expressional needs of our people. **Dances partake of the racial characteristics of the people who dance them. There have been imported into the United States of recent years dances that originated on the African Congo, dances from the gypsies of the South American pampas, and dances from the hot-blooded races of southern Europe. Wave after wave of foreign importations in dancing styles have swept the country. The result is a reaction against the character of the dances themselves.**

With characteristic American judgment, however, the balance is now shifting toward that style of dancing which best fits with the American temperament. There is a revival of dancing which has survived longest amongst the northern peoples. The tide has swung in favor of such dances as are described in this book.[92]

This version of the text, in fact, appears to be the same text that was released to the press in July 1925 and quoted verbatim in widely circulated publications such as *Literary Digest* and the popular Sunday edition of the New York *World*.[93] In particular, the *World*—the new daily incarnation of Joseph Pulitzer's popular weekly newssheet, the *New York World*—emphasized the racial component of *Good Morning*'s text, titling the first subheading of its copyrighted press preview "A Nordic," and noting that the manual stemmed from

Mr. Ford's belief in the permanent value of things American. Or, to make it broader, things Nordic. Modern dances of devious origin

which specialize in equatorial wriggling and leaping, may suit the Congo or the South American gypsies, but Ford holds they are not native to the minds of Americans.[94]

Despite the early coverage, this elongated and much publicized version of the introduction apparently did not make it into the first edition of *Good Morning* in 1925, the more widely distributed 1926 second edition, or subsequent printings of the book.[95]

By mentioning specific geographic regions, this early manuscript not only set up *Good Morning* as a possible opponent to such South American, southern European, and African American dances as the tango, the tarantella, the fandango, the bolero, the Black Bottom, and the Charleston, but put forward Nordicist notions about racial hierarchy.[96] To use Madison Grant's language, placed at the bottom were dances of "Negroid" racial origins ("dances that originated in the African Congo"), followed by those that originated from the mixed "race bastards" and "suspiciously swarthy" Mediterranean-Alpinic peoples of Argentina ("dances from the gypsies of the South American pampas"), and finally, those created by the sub-European "Mediterraneans" ("dances from the hot-blooded races of Southern Europe").[97] Furthermore, the use of the term *Congo* alluded to an assertion made in the International Jew series that Tin Pan Alley's newer Jewish songsmiths had introduced a "jungle motif, the so-called 'Congo' stuff into popular pieces" that "swiftly degenerated into a rather more bestial type than the beasts themselves arrive at."[98]

The line about dances partaking "of the racial characteristics of the people who dance them" now takes on new urgency. By promoting tangos and the Charleston, it would appear, Nordics and even Alpines might be downgrading themselves within the racial hierarchy. The notion that undesirable racial characteristics might "rub off" onto a superior race via cultural absorption also seemed to have some precedence in Nordicist literature. Grant himself made little distinction between race and culture, arguing that "higher cultures" had been "threatened" periodically throughout history with "absorption by a lower civilization."[99] Ford himself was reportedly so appalled by

Latin dances that his dance master Benjamin Lovett had to secretly steal away just to learn them from Doris Eaton Travis, a *Ziegfeld Follies* dancer who had trained under prominent ballroom dance teacher Arthur Murray.[100]

There were inconsistencies in all this. Despite the original manuscript's disdain for "the hot-blooded races of Southern Europe," among Ford's featured dances was the Sicilian circle, a dance that probably does not have any real connection to Sicily, but which *Good Morning* and the later *Independent* serialization made no effort to clarify.[101] One might also presume a Nordicist worldview might entertain an anti-Slavism, but both *Good Morning* and the *Dearborn Independent* promoted Slavic-origin dances such as polkas.[102] Indeed, *Good Morning* waxed poetically (if also not a bit pejoratively) about the polka dance originating with a "Bohemian servant girl's joyous steps, artlessly executed, upon receiving good news of her lover."[103]

The fact that *Good Morning* would employ Nordicist language is perhaps not surprising given the most likely author of the introductory portions of the text was Ford's chief antisemitic journalist, William J. Cameron, the author of much of Ford's International Jew diatribe. Although no smoking-gun document survives to verify, Cameron seems most poised to have ghostwritten the introductory "Return of the Dance" section of the book because of his relationship to Ford regarding ghostwriting and because of the original appearance of the introductory section in the official editorial column in the *Dearborn Independent*—a segment that Cameron would have normally written as the newspaper's editor in chief.

At first glance, *Good Morning* seems to have a simple authorship: the "Mr. and Mrs. Henry Ford" mentioned on the frontispieces of the first edition and in the subtitle of the second. The deeper one goes into the sources, however, the more *Good Morning* seems to be the work of a collective effort and less a product of the Fords' writing much at all. Ford's dance master, Benjamin Lovett, for instance, seemed to have played a pivotal role in putting together the actual dance portions of the manual, based on surviving correspondence between Lovett and music publisher Otto Zimmerman & Son about a new edition in

1931. In his correspondence with the Cincinnati-based firm (which the Ford Motor Company apparently hired out to print copies of the book under the Dearborn Publishing Co. name), Lovett approved proofs, corrected typography, grammar, and layout, and forwarded photographs as though he were the original author of those sections.[104] Other known contributors were Clayton Perry, leader of Ford's old-fashioned dance orchestra, who assisted Lovett in traveling and researching the dance steps; and Alfred Hards, a draftsman who was paid to learn and teach the dances and who sketched illustrations for *Good Morning*.[105]

Cameron, as a member of Ford's unofficial brain trust on such matters and as his dominant ghostwriter of the period, would seem a very logical choice to be tapped to write the book's guiding principles in "The Return of the Dance." Indeed, much of the language of this chapter—including the "Dances partake of the racial characteristics" section quoted in bold above—first appeared in an official staff editorial in the *Independent* in June 1925, just prior to the release of advance manuscript copy to the press and the subsequent media blitz that followed.[106] As editor in chief of the *Independent*, Cameron not only solicited and edited articles but served as the unbylined ghost author of the staff "Editorials" page and of a weekly feature of "Ford" ideas, titled first "Mr. Ford's Own Page," and then later simply "Mr. Ford's Page."[107]

Cameron and Ford had even developed a system for this sort of ghostwriting. First, Cameron talked with Ford, gleaning what Ford Motor Company production manager Charles E. Sorensen would later call Ford's "sudden flashes of intuition." He would then sit down and clothe them in words he "believed were Henry Ford's thoughts" before finally getting the OK from Ford's general secretary, Liebold.[108] Although some six books appeared under Ford's name, he rarely, if ever, wrote his own published work.[109] Over the years, most of the Ford-attributed literature was the result of the pens of others—either ghostwriters such as Cameron (who wrote the *Independent*'s "Mr. Ford's Page" edited and reprinted in a volume titled *Ford Ideals*), or as officially recognized collaborators such as Samuel Crowther (credited

as such on Ford's *My Life and Work, Today and Tomorrow*, and *Moving Forward*).[110]

A Canadian by birth, Cameron had grown up in Hamilton, Ontario, and later in Detroit. College educated, he had some background as a lay preacher but was never ordained. In 1904, he began writing for the *Detroit News*, and had moved up to the rank of columnist. In 1918, he left the *Detroit News* following his boss, managing editor E. G. Pipp, over to Henry Ford's newly purchased *Dearborn Independent*.[111] When Pipp left the *Independent* in 1920 over a dispute with Ford about whether to print the International Jew series, Cameron was named editor.[112]

Early historical researcher Leo Ribuffo and, more recently, political scientist Michael Barkan have argued that Cameron became independently connected by the 1930s with an antisemitic faction of British Israelism, a Protestant theological strain that viewed Anglo-Saxons as direct descendants of the ancient Israelites. While some early British-Israelites and American Anglo-Israelites practiced a philosemitism that idealized modern-day Jews, Cameron aligned himself with the antisemitic religious group the Anglo-Saxon Federation, making speeches about Anglo-Israelism at a Dearborn church as early 1933. Barkan argues that Cameron later wrote how an evil "Esau race" had "amalgamated with the Jews, and began the terrible work of corrupting the Jewish religion from within." Barkan postulates that Cameron's exposure to antisemitic Anglo-Israelism took place well before then and that he was mixing British-Israel theology with antisemitism as early as the International Jew series in the early 1920s.[113] Cameron's later ghostwriting for Ford on "Mr. Ford's Page" bears witness to this. As late as July 1926, Cameron there invoked the old antisemitic chimera, criticizing the human "parasite" who persuaded those with "old American names" into "business practices that are the antithesis of American."[114]

Cameron was close to Ford—one of the few executives who lunched daily in Ford's private dining room at the Dearborn Engineering Building.[115] The two seemed to especially share an affinity for old-time music. Cameron recalled in his official company reminiscences:

I've heard him [Ford] play the fiddle. He would play some of the old tunes in my office. Of course, he had a very great, fine, valuable collection of violins but he would take a fiddle from any of the old orchestra men from his little orchestra that he kept there, tune it up and play it.[116]

Furthermore, Ford protected Cameron, refusing to send him a pink slip even after he had agreed to fire him as part of the Sapiro settlement.[117] Cameron would stay on to serve as an interpreter of Ford to the press, and to write and deliver a weekly sermon-like talk on the music-oriented *Ford Sunday Evening Hour* on the national CBS radio network in the 1930s.[118]

Cameron was also involved in promoting old-time dance as editor of the *Independent*. The *World*'s 1925 press preview of *Good Morning* noted the close emotional and, in this case, physical proximity between Ford's dancing efforts and his antisemitic newspaper:

It is an amazing environment. Liberty airplane motors piled high on the waxed floor, printing presses exhaling the next issue of the Dearborn Independent, a wooden dirigible, men bent over blue-prints—and twenty-five yards away an orchestra playing music to the Badger gavotte or the Varsovienne for an afternoon class of children.[119]

At the very least, Cameron edited the *Independent*'s serialized article versions of the manual content that began appearing in January 1926 as "A Dance of the Week."

In that feature's inaugural release, the newspaper ran a three-color lithograph cover illustration of an earnest yet modern-looking group of young white people trying to wake a white-mustached elderly fiddler, an apparent relic of the frontier who sits snoozing, propped back on a chair in western riding boots, a simple cravat, and plain black lapel-less vest (fig. 2.1). The fiddler sleeps below a nineteenth-century wooden mantel clock whose hands signal three o'clock (it is unclear whether it is 3 p.m. or 3 a.m.—a reference perhaps to the ten-

2.1 "Waking Up the Old American Dances," cover of the *Dearborn (MI) Independent*, January 16, 1921. Henry Ford simultaneously carried out his antisemitic campaign while popularizing old-time fiddling and dancing with publications such as this. Image from Collections of the Henry Ford.

dency of Ford's actual dances to run into the early morning).[120] The clock is emblazoned with an oak tree, a favorite symbol among eugenicists for hereditary wellness. The four youths in the forefront all seem to possess what Madison Grant would have identified as Nordic traits: "wavy brown or blond hair," "fair skin," and high and narrow "aquiline noses."[121] The teaser, "Waking Up the Old American Dances," itself seems a vindication of Ford's claims to American identity, almost acting as an eight-year-old rejoinder to Truman H. Newberry's mudslinging that Ford was unpatriotic. The text inside is also instructive:

> The word "dance," when seen in print, conveys different things to different people. Some think of it as a jazzy rout from which they would themselves shrink and from which they would protect their children if possible. Others think of it as a monotonous round of steps, endlessly the same.
>
> But those who know the old American dances, the dances which were part of the life of the pioneers from the Atlantic to the Pacific, have an entirely different conception of the dance.[122]

In the cover especially, we see Cameron forging a marriage of convenience between Grant's Nordicism and Frederick Jackson Turner's mythologizing about the special properties of the frontier and the uniqueness of the American character. Indeed, the illustration seems a visual representation of *Good Morning*'s assertion that there was "a revival of dancing which has survived longest amongst the northern peoples," coupled with the concerns of the text inside about restoring the hardiness and character that once stemmed from frontier life.

Although Cameron's role in promoting dance was essential to Ford's efforts, Ernest G. Liebold, the other Ford executive most closely linked with Ford's antisemitic efforts, was also heavily involved in promoting old-time music and dance in variety of ways. In his company reminiscences, Liebold not only explained how he was the one who arranged for the first edition of *Good Morning* to be printed for distribution, but also relayed how Lovett was having trouble meeting Ford's expectation that some recordings of the old-time orchestra be

made. Lovett asked Liebold to take over this enterprise, especially the technology, and Liebold agreed, making sure they were eventually released by Victor and Columbia. "It was very, very trying work and it was very monotonous," he recalled. "We eventually produced twenty or twenty-four records, or something of that number."[123] In 1942, Liebold appears to have outright taken over the editing of the final galleys of a later edition of *Good Morning*.[124]

After 1927, Ford's efforts to publicize old-time music and dance fell from the national limelight, perhaps stunted by the grim economic news of Ford's labor troubles during the Depression.[125] Old-time music did occasionally get some play on CBS's *Ford Sunday Evening Hour* in the 1930s, and Lovett and other Ford employees continued to work on various new editions of *Good Morning* until 1943.[126] Surviving documents in the Benson Ford Research Center suggest that Lovett and key staff members also put together an *Early American Dance* program on radio's Blue Network in 1943 and 1944. But with Ford's death in 1947 and little interest among his heirs, promotion efforts effectively ended.[127] The Ford revival nevertheless provided an important stepping-stone for the continuity and long-term survival of what would become known as contra dance and, to a lesser a degree, provided impetus for the standardization and popularization of western square dances.[128]

So what to make of the revival? Writing for *Sing Out!* Magazine in the 1970s, Estelle Schneider and Bob Norman argued that Ford's revival, coupled with his racism and antisemitism, was "nothing less than a historical and cultural blueprint for a native American Fascism."[129] Leo Ribuffo, on the other hand, has argued that Ford's antisemitic muckraking was closer to Protestant minister Josiah Strong's "assimilationist ethnocentrism"—which promoted the idea that Jews would be fine Americans if only they learned to adapt Anglo-Saxon ways—than Grant's hardline "biological determinism." Certainly, there is no evidence from Ford's music and dance revival that he or any of his writers or interpreters favored the sustained eliminationist approach that Grant seems to favor: "the sterilization . . . of the criminal, the diseased and the insane and extending gradually to types which may

be called weaklings rather than defectives and perhaps ultimately to worthless race types."[130]

The evidence about Ford directly and financially supporting European fascism, at least so far, seems inconclusive, although the very real feelers Ford put out for the presidency in 1922 and 1923—just after the publication of the International Jew series and just before the old-time revival—makes one wonder about the potentiality for the kind of nightmare scenario that novelist Philip Roth depicts in *The Plot against America*, only with lots of moralistic sermonizing, fiddling, and quadrille dancing.[131] Ford certainly did his own legacy no favors in 1938 when he choose to accept the Grand Cross of the Order of the German Eagle, a prize for leading industrialists, from the Nazi consuls to Cleveland and Detroit, Karl Kapp and Fritz Heiler, on his seventy-fifth birthday (fig. 2.2).[132]

Though several sources argue convincingly that the four-volume International Jew series was used in support of Nazi racial ideology, the influence of Ford's promotion of old-time music and dance on the Nazis remains less certain. Although folk music and dance fit with Nazi concerns about Völkisch-ness, dance historian Marion Kant and dancer Lilian Karina argue that the Nazi state primarily used German folk dancing for rhetorical benefit, providing irregular support or commitment outside of a few specific instances such as annual harvest festival at Bückeburg or as, Joshua Hagen argues, the *Schäfertanz* (shepherds' dance).[133] And though the Nazis followed the *Dearborn Independent*'s lead in claiming that jazz music and dance was a degenerate Jewish creation, the Nazis embraced modern dance, a form for which Ford apparently had little use.[134]

Similarly, there seems to be little evidence that the American Far Right has ever entirely monopolized the use of country or traditional music and dances. One can, however, argue that Ford built on the ways Tom Watson and Fiddlin' John Carson used country music for antisemitic ends, and that Ford's traditional music and dance campaign definitely anticipated country music's use in racist or xenophobic movements related to figures such as Eugene Talmadge and George C. Wallace in later decades. In some regards, Ford's effort at

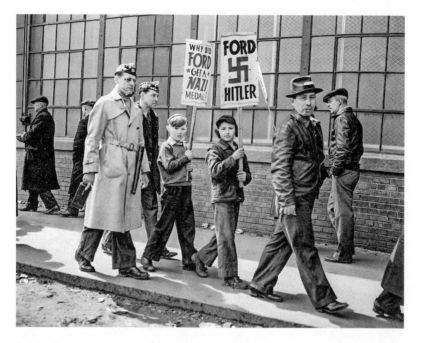

2.2 Workers, veterans, and children protest Ford, 1941. Ford's antisemitic campaign in the *Dearborn Independent* in the 1920s and his acceptance of the Grand Cross of the German Eagle from Nazi consuls on his seventy-fifth birthday in 1938 were later used as fodder to question his character when workers struck at Ford's River Rouge plant. Detroit News Photograph Collection, Walter P. Reuther Library, Archives of Labor and Urban Affairs, Wayne State University.

the least set the ground work for the rise of pro-Klan and antiblack "hate country music" records associated with small labels coming out of Crowley, Louisiana, in the 1960s.[135] Disturbing, too, is the fact that a third-party convention of "Progressives, Farmer-Laborites, Independents, and Liberals" could nominate Ford for the presidency a little more than a year after he carried out probably the most concentrated publicity campaign of accusatory antisemitism in the history of the American nation. Indeed, there is much to indict about both the right and the left when it comes to Ford's legacy and his popularity as a potential candidate.

The question that arises, then, is one of reception. Did readers of *Good Morning,* dancers at Ford-sponsored affairs, and listeners of the

radio relays necessarily understand the Nordicist premise? Did they understand that the revival might be a way of trimming back the supposed cultural influence of Jews? It seems unlikely that all or even most participants consciously made the connections, but some did, as evidenced by a folder of fan letters in the Ford family's Fair Lane papers. One fan from Whitinsville, Massachusetts, wrote to thank Ford personally for *Good Morning*, imbuing his missive with the same coded antisemitism that often passed for copy on "Mr. Ford's Page": "The American people will take this work up in no uncertain way. Under your great leadership, the styles of the heathen horde will disappear from the country."[136] Most letters, however, were happy to merely praise Ford's quadrilles and grumble about jazz. Indeed, both star fiddler Mellie Dunham and dance master Lovett spent the better part of their fifteen minutes in the limelight complaining about jazz (although one wonders how heartfelt Lovett's griping really was, based on his sneaked lessons in the tango).[137] Broadway showman Billy Rose perhaps encapsulated an important Jewish response to all of this when he penned the comic number "Since Henry Ford Apologized to Me," which joked about the very slim chance that Jews would ever vote for Ford should he run for president.[138]

Ford's rhetoric in the 1920s also paved the way for important scholar-promoters of folk music in the 1930s such as John Powell, who argued that Anglo-Saxon and Appalachian music needed to be cultivated because it was superior to other folk traditions and in danger of being drowned out. Powell, a concert composer who helped organize the White Top Folk Festival in Southwest Virginia, may or may not have read the *Dearborn Independent*, but he certainly seemed to draw from what scholar David Whisnant has called "a grab bag of half-baked racial-cultural ideas" that earlier figures such as Ford and Grant promoted. Powell helped found the antiblack Anglo-Saxon Club of America in Virginia in 1922, and he presided over the White Top festival during a period in the 1930s when the event prohibited black musicians and audiences.[139] Beyond that, the Ford revival added fuel to an already existing campaign of violent stereotyping once exemplified by Tom Watson.

Ford, of course, was not the only 1920s-era politician to realize that what would become country music could be used to make inroads with the larger public. In chapter 3, we open the lens to examine the wider role of nonperformer politicians using music and bands to reach out and energize their constituents in more traditionally political ways.

★ 3 ★

Sound Trucks
and Radio Stars

The Arrival of the Nonperformers

A lthough Henry Ford was a pioneer in combining celebrity with political ambitions and merging country music with a political agenda, the years between World Wars I and II were marked not just by the carmaker's old-time dances and antisemitic incitement, but by a dramatic upsurge of traditional politicians hiring individual performers and country bands to stump for office. These candidates ranged in political outlook from the mildly socialistic to the hard right, and counted among their ranks political bosses, medical quacks, and independent upstarts. Generally, though, they shared an outsider status that stood in contrast to more traditional opponents who primarily moved in mainstream political circles. They also used their connections with the seemingly rural music of the old-time and hillbilly genre to assert that their brand of politics was representative of "the people."

The earliest of these were humble performances — a jazz band playing some fiddle tunes or a campaign organizer showing off his fiddling skills on the trail. By the 1930s, however, candidates took advantage of new technology to reach large crowds at rallies with their own specially organized campaign performers and bands, and to drum up

audiences with music and announcements amplified from specially outfitted vehicles. Several politicians also used radio to advertise their rallies and employed local radio performers of hillbilly, old-time, and western music as a means of attracting crowds. By the onset of the First World War, politicians were hiring nationally recognized radio stars to play country music at campaign stops, hoping to ride the genre's popularity to electoral success.

Although Southern politicians were among the earliest experimenters with hired country entertainment, they by no means dominated the sphere of country music politics at the time. Westerners and midwesterners and even one New Yorker were actively involved in using hillbilly and western varieties of country music to try to get elected—or, at least, noticed by the press. Important, too, is that the first woman to be elected to the US Senate, Hattie Caraway of Arkansas, was one of these performers who employed country bands. And like many of the first women to serve in that body, she balanced an unwieldy combination of populist and liberal political aspirations with a dedication to preserving the segregationist status quo in the South.

Despite the wide range of political viewpoints among these early nonperforming but country music–using candidates, certain themes emerge that help us understand the kind of connections that would emerge between country music and politics even among performer-politicians who already attained stardom or were amateur musicians themselves. First of all, the early 1930s proved an important time period for connections between the genre and politicking. Indeed, one could reasonably deduce that whatever seeds Tom Watson and Taylor brothers had sown in the prior century suddenly took root and began to sprout. A certain shape to country music politics also began to arise. One politician in particular—radio quack and country music sponsor John R. Brinkley—pledged to take care of the elderly as part of his campaign. This promise would later be taken up by prominent country music personality–politicians such as Pappy O'Daniel of Texas and Jimmie Davis of Louisiana. More noticeably, nearly all the politicians who hired old-time fiddlers and hillbilly bands during the 1920s and '30s positioned themselves as outsiders who would fight against

the traditional establishment. Most also used the music to suggest that they were closer and more connected to the average person.

Beyond that, the year 1938 proved an especially important year not just for nonperformers to launch political careers with country bands, but also for existing stars of radio and recording to declare their candidacy, as well as regionally known amateurs (such as Albert Gore Sr., as will be discussed in later chapters of this book). In many ways, the landscape of country music politics was as irregular as the images these politicians tried associate themselves with, but in certain regions it was clear that politicians using hillbilly music to get elected had become much more than a passing fad.

That nonmusical or nonperformer politicians would seek to associate themselves with music is not unusual in American political history. Thomas Jefferson famously played the violin until he shattered his wrist in 1786—possibly jumping over a fountain or a fence to meet his rumored lover Maria Cosway in Paris—although he never appears to have used the instrument as a tool for vote-getting.[1] Campaign songs had been a big part of American politics since Jefferson's hotly contested election of 1800. Early political songs tended to be patriotic numbers in which a candidate's name was merely inserted. Mass singing at rallies seemed to become popular at campaigns for Andrew Jackson in the late 1820s. By the mid-nineteenth century, politicians had begun to opt for specially written, candidate-specific songs that often relied on existing tunes, such as "Tippecanoe and Tyler Too," which took its tune from the minstrelsy song "Little Pigs." Fiddling must have entered the political lexicon at some point, too, for quicksteps, up-tempo syncopated fiddle tunes, were written during the Civil War in honor of both Lincoln and Jefferson Davis. By the turn of the century, politicians hired the professional songsmiths of Tin Pan Alley to crank out slogan songs—original ditties that generally referred to the candidate's dominant sloganeering. Songs might appear in special party songbooks, be sung by supporters at rallies and lecture halls, or performed by well-known performers from radio and vaudeville, such as Al Jolson.[2]

By the 1920s, some Southern and Western politicians were beginning to explore the possibility of linking their fortunes with fiddlers who had made names for themselves in contests, radio broadcasts, or the recording industry. Tom Heflin, of course, had already taken to speaking at fiddling contests in the teens as means of increasing his regional political profile. Other politicians in the 1920s sought out fiddlers who could win over voters with popular tunes from folk traditions, minstrelsy, and published broadsheets, but who, like the Tin Pan Alley tunesmiths, could also turn out candidate- and campaign-specific material. In 1920, the aging and increasingly reactionary Tom Watson, as mentioned in the first chapter of this book, may have been among the first to hire a professional fiddler, Fiddlin' John Carson, who hadn't yet become a recording star but was well known for his paid performances and for his slew of victories in Georgia's popular old-time fiddling contests.

Watson was followed in 1922 by liberal Oklahoma City mayor John C. "Jack" Walton, who hired a jazz band that appears to have performed some old-time and hillbilly numbers as part of his successful campaign for governor. Walton, a prolabor, left-wing Democrat who took on the state's powerful Klan, employed the five-member Dinty Moore's Jazz Orchestra, complete with banjo player, mandolinist, and trombonist, to play at rallies. Bandleader Moore played not just jazz violin, but also "fiddle" to please crowds, the *Muskogee Times-Democrat* noted.[3] Though we know for certain that Walton held fiddling and banjo contests for entertainment at his large and boisterous inauguration barbecue, it also appears likely that at least one of his volunteer campaign leaders (Ed Crossland, whom the *Tulsa Daily World* identified as "the only political fiddler in the state") played old-time music at pro-Walton rallies before that.[4] Though connections with fiddle and old-time music may have helped Walton get elected, it did not protect him once in office. Walton used the state militia to go after the region's growing Ku Klux Klan, and action that drew ire from legislators; he ended up being impeached some eight months into office.[5]

Heflin's orations at fiddle contests and the use of fiddling and old-time music at Walton and Watson's rallies and inaugurations fore-

shadowed in some ways the process by which the larger country music genre was gaining ground as a national phenomenon and commercial force. By the end of the 1920s, record company scouts such as Frank Buckley Walker and Ralph Peer were not just scouring the South for blues, old-time, and hillbilly talent, but holding historically significant recording sessions in cities such Johnson City and Bristol, Tennessee, and Atlanta, Georgia. As a result of these sessions, new performers such as Jimmie Rodgers and the Carter Family came to the attention of the public, recording companies, and radio managers, helping to launch old-time and hillbilly music into something of a national craze. By the early 1930s, Rodgers, who combined a hillbilly-blues sound with his characteristic yodel, and the Carters, who popularized traditional Appalachian melodies and their own traditional-sounding creations, met with unparalleled commercial success and began to reach an even larger audience over the airways—though none expressed an interest in delving too deep into the political realm.[6] Rodgers would experiment with western wear as part of his style, but cowboy ballads remained popular, too, with figures such as Vernon Dalhart and Carson Robison recording popular renditions of folk-origin, new, and novelty western songs.[7]

One might argue, however, that the modern age of country music campaigning—complete with sound trucks, radio broadcasting, and staged musical appearances—was ushered in before the emergence of these recording stars by radio quack John R. "Doc" Brinkley. In 1930, Brinkley, known for his bombastic commercial radio broadcasts and fraudulent "goat gland operations," ran a write-in campaign for governor of Kansas and almost ended up winning. Brinkley had already made a name for himself by becoming something of a national pioneer in country music broadcasting by employing hillbilly musicians to perform regularly on air at his KFKB radio station and then later at his Mexican-border superstation, XER. Key to his early country radio programming was "Lonesome Cowboy" Roy Faulkner, a singing-cowboy performer at KFKB whom Brinkley had helped make into something of star just as the careers of the Carters and Jimmie Rodgers began to skyrocket. Faulkner in turn proved important to

Brinkley's political ambitions: although Brinkley did most of his campaigning from KFKB headquarters, he flew his own private monoplane to a small number of rallies in 1930, where crowds were regaled with performances from Faulkner and his classic cowboy numbers, such as his signature song, "Strawberry Roan."[8]

Faulkner, an orphan, had been adopted by a Kansas City couple who moved to Garnett, Kansas, to farm. As a youth, he lost an eye to an errant splinter while chopping wood. In his teens he learned to play guitar and sing nineteenth-century parlor songs about unrequited love and death—weepers such as the intercultural-themed "Little Mohee" and "Fair Charlotte," a warning about the dangers of winter sleigh rides and unescorted courting. He also began to pick up cowboy ballads such as those recorded by Dalhart and Robison in the 1920s and those collected and publicized by Texas folklorist John Lomax in the teens. In 1928, at the age of eighteen, a friend convinced Roy to go to Dr. Brinkley's station to audition, and he ended up being hired to perform on an early-morning slot.[9] The young singer soon took on the "Lonesome Cowboy" moniker and moved to the coveted noon timeslot. Although "Strawberry Roan" would become his signature tune and a favorite at rallies, Faulkner also had a theme song that drew on nostalgia for an earlier, easier-going West:

> Lonesome as can be
> I sing this melody
> And ride the range in memory
> Back home again it seems
> Where the Golden sunset gleams
> That's the end of every cowboy's dream.[10]

At the height of his popularity on Brinkley's KFKB and XER stations, Faulkner pulled in five thousand letters a day over a three-week period.[11] During Brinkley's 1930 and 1932 campaigns, he reportedly performed in every count seat in Kansas and frequently rode in, or drove, Brinkley's fancy sixteen-cylinder Cadillac to rallies.[12] Faulkner would later go on to become a fixture on western and midwest-

ern radio stations, as well as a member of traveling groups such as Harry Fletcher's Purple Sage Riders, a band that featured film actor and future Sons of the Pioneers member Shug Fisher.[13] Brinkley's successes with Faulkner on KFKB and XER in many ways provided a blueprint for Brinkley's postpolitical efforts to popularize the genre and publicize such stars as the Carter and Pickard families and singing cowgirl Patsy Montana on Mexican-border radio.[14]

In addition to Faulkner, Brinkley also campaigned with a whole troupe of KFKB performers, amplified over Brinkley's own specially designed stage and sound trucks, each emblazoned with a number and the martial designation of "ammunition train." A populist who drew from the left and the right and who later in life embraced antisemitic political figures such as Gerald L. K. Smith, Brinkley campaigned on a platform that combined Christian piety and hostility toward regulatory boards with promises to pave roads, build artificial lakes, provide pensions for the elderly and the blind, and provide free medical services to the poor.[15] Although vague in his description of what such pensions would entail, Brinkley's promise to establish a state program for old-age compensation in Kansas preceded by three years the launch of a more nationally known pension movement by California physician Francis Townsend. Townsend's much more widely known movement, in turn, would inspire several Southern country music personalities turned politicians to promote pensions as part of their campaigns for office in the late 1930s.[16]

The importance of introducing sound trucks to the political campaign—especially to a campaign featuring hillbilly and western music—cannot be overstated. Although Brinkley and Louisiana governor Huey Long each claimed to be the first American politician to use sound trucks for political purposes in their respective fall 1930 gubernatorial and senatorial races, Long was "traveling with a truck with amplifiers and music" as early as mid-August, well before Brinkley had even declared his candidacy.[17] Press coverage, however, indicates that Long was using his "motor 'sound wagon'" primarily to gather crowds, to amplify speeches, and to play a recording of a popular Broadway song, "Indian Love Call," likely a jazz-flavored cover of

the tune by either the Paul Whiteman or Leo Reisman orchestras.[18] Long himself linked his claim to being the first to use sound trucks to the assertion that he was the first to amplify speeches in this way.[19] Brinkley, on the other hand, was carving out new ground by October, realizing that live country entertainment, not just speeches and canned jazz and pop music, might turn the minds of potential voters. In doing so, Brinkley helped usher in an age when mobile sound amplification became a necessity for nearly all politicians seeking to attract and entertain crowds with musicians.

Brinkley's "ammunition train" sound trucks offered another layer of meaning and gravity to Tom Watson's assertion that a fiddle was big help in a political fight; a sound truck amplifying a cowboy singer, it turned out, was an even bigger help. One local newspaper publisher noted that, with this tool, Brinkley and Faulkner could attract an enormous audience that might have been unheard of in an earlier age— a conglomeration of people, cars, and buses that filled a huge pasture to capacity during a rally between Wichita and Augusta, Kansas. "No one ever knew how many people were in that jumping, whooping, yelling enthusiastic log jam of people," he wrote. "I have always been convinced it was the biggest rally in the history of the state."[20] By some estimates, that rally drew twenty thousand people.[21]

After a close but unsuccessful election, Brinkley would repeat this pattern (including appearances by Faulkner) as an official independent candidate on the ballot for governor in 1932. No longer a sideshow, Faulkner's act now featured front and center in Brinkley's appeals to voters, as in one ad in the *Iola Register* (fig. 3.1): "Dr. Brinkley will be accompanied by Ammunition Train No. 1 equipped with loud speakers and ROY FAULKNER, the Singing Cowboy from Radio Stations KFKB and XER who will entertain."[22] Although Brinkley fared well in both elections and many observers contend his 1930 stint was foiled only by his write-in status, he finished third in both races, behind the Democratic and Republican candidates.[23]

Powerful Louisiana governor, senator, and political boss Huey Long's tastes probably ran more toward jazz and marching bands, especially

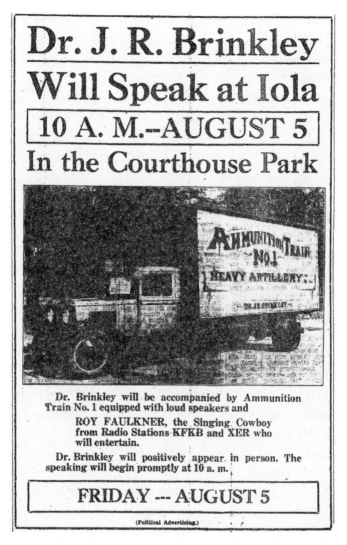

3.1 Political advertisement for John R. Brinkley in the *Iola (KS) Register*, August 3, 1932. Singing cowboy Roy Faulkner and Brinkley's Ammunition Train sound trucks figured prominently in Brinkley's gubernatorial campaigns. Image used by permission of the *Iola Register*.

the Louisiana State University Tiger band that he lavished much attention and money on; but he, too, found ways of using hillbilly and traditional fiddle music for political purposes. There have been apocryphal stories since the 1960s about Long using a Mississippi-based "hillbilly" string band, the Leake County Revelers, in his 1927 gubernatorial run. One observer noted in 1935 that "country musicians" played at his 1928 inauguration ceremonies, but records from the era suggest that Long, like other Louisiana politicians, was more involved with church choirs and jazz, dance, and marching bands during this stretch of time.[24] Period accounts of the actual inauguration, in fact, suggest that the "country musicians" mentioned were a nonhillbilly band from a rural area—most likely Robard's Serenaders, a woman-led dance band from Ponchatoula, Louisiana, that played jazz, minstrel tunes, and Tin Pan Alley, not hillbilly.[25]

Whatever the case with his 1927 run, Long officially brought hillbilly music into the fold in early August 1932 by dispatching staff and several sound trucks to Arkansas to help an embattled Hattie Caraway, who had been appointed to temporarily replace her husband, Senator Thaddeus Caraway, after he died in office. Long had sat next to Hattie in the Senate and sympathized with her plight as a widow trying to hold onto her husband's legacy; he also saw her candidacy as good way to strike back at political enemy Joseph T. Robinson, the senior senator from Arkansas. For her part, Caraway had impressed Long by emerging as an early supporter of his "Share Our Wealth" income-redistribution scheme. Long also saw her candidacy as good way to get back at political enemy Robinson who sought to elect his own anointed candidate to the junior senatorial seat.[26] Out on the campaign for Caraway, Long's sound trucks blared canned hillbilly and jazz music as they made their stops. According to several later accounts, Long also hired an "Ozark mountain 'hill-billy band'" to warm up the crowd before he made live appearances for her.[27]

A Southern moderate who found common cause with FDR's New Deal, Caraway made the most of situation and proved herself a strong campaigner on radio and on the stump with Long. Although criticized

for being short-spoken or often remaining silent during her politi-
cal life, she skillfully interrupted Long at times during the 1932 cam-
paign to correct him on finer points and projected the image of a mod-
est but capable public servant who held particular appeal for women
voters.[28] Although Georgia suffragette, journalist, and white su-
premacist Rebecca Latimer Felton was the first woman to serve in the
Senate as a briefly seated appointee after Tom Watson's death in 1922,
Caraway was the first woman to be elected the Senate and the first
to serve as a senior senator when she won reelection in 1938. Cara-
way, however, seems to have discontinued the sound truck tradition
in that campaign, fielding instead what the press deemed a quieter,
"unspectacular handshaking" train tour of the state.[29] Caraway gen-
erally supported labor, federal spending on education, preparedness
regarding the Nazis, and other elements of Roosevelt's New Deal. She
was also the first woman to cosponsor the Equal Rights Amendment.
But her liberalism did not extend to racial politics—she sided almost
ubiquitously with Southern Democrats on issues of voting and state's
rights.[30]

Long wasn't the only Southern populist to use hillbilly music on the
campaign trail. In Mississippi's 1931 gubernatorial race, former con-
gressman and judge Paul B. Johnson hired the Leake County Revelers
(the same string band reportedly hired by Huey Long in the late 1920s)
to stump for him at a political rally and barbecue. The Mississippi-
based string band was led by fiddler Will Gilmer had in 1927 recorded
"Wednesday Night Waltz," a romantic courting-oriented instrumen-
tal dominated by Gilmer's fiddle. That recording became one of the
bestselling records of the old-time and hillbilly era, with sales nearly
topping two hundred thousand.[31] Johnson hailed from a poor farming
background in hilly Central Mississippi but had also befriended FDR
during his time in the Capitol. During his race for governor, he faced
off against Mike Conner, a state representative who, incidentally, had
obtained the endorsement of Huey Long; Long by then had become
something of a regional power broker. In its coverage of the Johnson
rally, one newspaper gushed that all 130 voters in Johnson's home-

town of Hillsboro, Mississippi, had pledged to vote for Johnson, and that the Revelers had a "reputation as musicians that extend[ed] over the entire nation."[32]

Paul Johnson proved a fiery populist but also one who represented his state's prevailing attitudes about the rights of black people in some ways. In the 1931 race, Johnson proclaimed himself champion of "the runt pigs"—the poor white farmers, sharecroppers, and day laborers who he argued were starved of advantages, but might emerge as fully developed and productive citizens if given enough sustenance and re-sources.[33] Conner ended up winning that year, but in 1939, Johnson turned the tables by running again and defeating Conner in the race for governor.[34] As governor, Johnson was ill much of his term and ended up dying in office in 1943. During that time, he nevertheless represented the liberal edge of Mississippi politics by cultivating po-litical enemies such as staunch segregationist Theodore Bilbo and in-viting controversy by increasing state old-age pensions and signing a law that provided free textbooks to schoolchildren.[35] Johnson initially took a hawkish stance in 1942 toward the lynching of Ernest Green and Charlie Lang, two African American teenagers, by cooperating with the FBI and sending prosecutors to aggressively investigate the case, a stance that hurt him significantly in state political circles. But he also personally confided to an NAACP investigator about his frus-tration with outside "agitators," who he believed had one goal: to en-courage race mixing.[36]

Not to be outdone by Johnson, Long continued to connect his image with music as the 1930s wore on and likely used hillbilly bands to sup-port his anointed candidates in northern and southwestern Louisi-ana parishes, where the music would have most effect.[37] Out of all the nonperformers who used hillbilly music for campaign purposes in the 1930s, Huey Long was perhaps unusual in that he never stuck entirely to one genre but instead switched freely between black- and white-associated genres such as jazz, show tunes, hillbilly, old-time fiddling, Sousa marches, and even pop.[38] Such genre-hopping was particular evident in the tunes that Long—in his exuberance or ex-travagant sense of self-confidence—began to publicly sing himself by

the mid-1930s, even if naysayers wondered if "too many of his notes were sort of decentralized."[39] In spring 1933 at a fancy soiree at Washington, DC's Mayflower Hotel, Long shocked partygoers by hijacking the baton of the conductor of the Paul Specht jazz orchestra and belting out the Tin Pan Alley waltz "Let Me Call You Sweetheart" and "Old Man River," a show tune made famous by black stage performer Jules Bledsoe.[40] The next year, he branched out into hillbilly and cowboy by singing two songs, "The Whole Dam Family" and a parody of the traditional cowboy song "Git Along Little Dogie," over a New Orleans radio station when stumping for his own chosen ticket of candidates in that city's municipal races. Long used "The Whole Dam Family," a Tin Pan Alley number that was gaining attention from professional hillbilly performers to drive home an accusation that one opponent was dispersing perks to family members. Similarly, he fashioned "Git Along" into something of a taunt toward the other ticket: "anti-Long, little bogey, anti-Long, little bogey, anti-L-O-O-ONG."[41]

Long furthered his hillbilly image later that year when newspapers around the country ran a wire photo of him posing on vacation in Hot Springs with a trio of Arkansas "hill-billy musicians": Murray Lucas on guitar, Ralph Pearson on mandolin, and Earl Wynn on steel-resonator guitar.[42] In 1935, Long gained national attention for cowriting and singing "Every Man a King," his own self-promoting jazz-pop slogan song, which took its title and message from his 1933 autobiography of the same name.[43] That song was later slowed down and turned into a dirge that was played at Long's funeral after he was assassinated in September of that year.[44] Long's propensity to switch from marches to jazz to hillbilly as it pleased him or suited his public relations needs certainly resonated with the public image he liked to project to the press: a renegade and outsider who could not care less what good taste or the authorities favored, preferring instead to align himself with the proclivities of the people.[45] Long publicly embraced segregation and white supremacy—perhaps as a matter of conviction, or perhaps as what biographer T. Harry Williams calls "a strategy." But his musical eclecticism can also be seen in conjunction with his efforts to extend free textbooks, better educational and health services, and tax breaks

of homeownership to black as well as white Louisianans, whatever his motives might have been.[46]

Other Southern political bosses followed suit, although most were not as eclectic in their musical tastes. During the same summer that Long sent his entourage to Arkansas, Georgia agriculture commissioner Eugene Talmadge hired Fiddlin' John Carson to play at rallies in his successful campaign for governor of the Peach State. Talmadge — a Democrat who had idolized the aging Tom Watson as a young man — ran on a twelve-point platform that included a better-organized highways department and increased payments to teachers and Confederate veterans. Already popular with small farmers as a state agricultural commissioner for his efforts to make sure that fertilizer companies did not rip farmers off by adulterating their product, Talmadge also sought to lower freight and utility rates and reduce vehicle license fees, or "tags," to $3 — all popular issues with tenant farmers, share croppers, and the poor.[47] If his platform appealed to agrarian impulses once tapped by Watson and the Populists, his rallies usually held "in wooded groves" were veritable celebrations of rural and hillbilly identity, according to the picture painted by the Associated Press:

> Hill billy bands render the ballads of the mountains and two "fiddlers" well known to Georgia audiences are regular attractions. One, "Professor" John Anderson, sings an original ditty about "how the opposition lies" and "Fiddlin' John" Carson plays and sings a song, one verse of which goes like this: "I've got a Eugene dog, I've got a Eugene cat, I'm a Talmadge man, From my shoes to my hat." After this introduction, Talmadge steps up to the loud speaker, shucks his coat and, waving the red bandanna handkerchief and snapping the red suspenders . . . launches into a vigorous defense of his record and a denunciation of his two opponents.[48]

The song Carson performed at these rallies ("I've got a Eugene dog") was nothing more than slightly bowdlerized version of the "Tom Watson Special" that Carson wrote twelve years earlier. Nevertheless, Carson — often appearing and performing with his daughter "Moon-

shine Kate"—did add in a Talmadge-specific line about how you "kain't put a thirty-dollar tag on a three-dollar car."[49]

Talmadge ended up winning the summer 1932 race and serving two more terms as governor, installing himself as one of the state's most powerful, angry, and divisive figures. Despite his early populist appeals, Talmadge governed as an anti–New Deal, probusiness Southern Democratic conservative and as a diehard segregationist who fought tooth and nail to keep blacks disempowered as a means of appeasing his rural, poor white "wool hat" supporters. He imprisoned striking textile workers in barbwire camps in 1934, fired state university professors for voicing support for integration in 1941, and used the state militia to oust the state highway board when it refused to rule in his favor.[50] "No contemporary politicians except Louisiana's Huey Long and Mississippi's Theodore Bilbo had appealed so successfully to ignorance and bigotry," *Time* magazine claimed in his obituary in 1946.[51] Carson, for his part, would go on to remake his political image yet again in 1934 by cutting a pro–Franklin Delano Roosevelt version of the song "Honest Farmer" for Bluebird.[52]

These early experiments with hillbilly music by Brinkley, Long, and Talmadge quickly attracted emulators on the national mainstream. Inspired by the Caraway-Long effort and angered by Long's opposition to FDR, Senate minority leader and sitting Arkansas senator Joseph T. Robinson hired a hillbilly jug band group called the Original Arkansas Hillbillies in fall 1932 to stump in his state for Roosevelt's first presidential campaign. Robinson, a political foe of Long who had been the Democratic Party's vice presidential nominee four years earlier, was ostensibly a Southern New Deal liberal with a reputation for defending religious tolerance toward Catholics and for backing such economic uplift programs as the Civilian Conservation Corps, although he was criticized by some for favoring large landowners over the farmworkers of his state's Southern Tenant Farmers Union. At several rallies throughout the state, Robinson and local politicians such as Brooks Hays cajoled the audiences to vote for Roosevelt, while Robinson's hillbilly quartet—composed of professions and nonprofessionals alike, including a working journalist—played on "washboards, hand-

saws, broomsticks, insect spray guns and other articles not necessarily associated with music."[53] Robinson was not the only figure to support Roosevelt in this way. Several hillbilly bands and performers including Fiddlin' John Carson, the Skillet Lickers, the Allen Brothers, the Light Crust Doughboys, and Milton Brown and his Musical Brownies took it upon themselves to support Roosevelt with specialized recordings or endorsements of other kinds—a stance that staked out not just the traditional Democratic tendencies of the South but also the affinity with which many Southerners, poor or not, had for FDR and his social programs for farmers and the distressed.[54]

The late 1930s (and the year 1938 in particular) would usher in an unprecedented level of interest in hillbilly music among politicians. Several politicians would launch candidacy for office in 1938 with hillbilly bands in tow, a trend that coincided with actual country music personalities turned politicians such as Pappy O'Daniel, Jimmie Davis, and Albert Gore Sr. in the South and Glen Taylor and Stuart Hamblen out West starting careers that year with their own campaign country music or bands. Many performer-politicians won their races in 1938; however, nonperformers—many who seemed to jump on the country music wagon after O'Daniel's widely publicized race for Texas governor—did not do as well, perhaps suggesting that voters preferred authentic performers in 1938, not conventional politicians who appeared to resort to gimmickry. Nevertheless, there was a spate of activity in 1938 that would not be rivaled for decades. Indeed, if the recording sessions held by scouts in the late 1920s in cities such as Bristol, Tennessee, served as a "big bang" that led to the creation of modern country music, 1938 served as a benchmark year for a national "big bang of modern country music politicking."

Even New Yorkers were not immune. In Franklin Roosevelt's home district, which included Poughkeepsie, hair tonic maker and salesman Edward J. "Doc" Bowen ran an unsuccessful bid in the Democratic primary for a congressional seat representing Poughkeepsie with his "Rainbow Mountaineers hillbilly band." In press photos, the band appeared to include an accordionist, a fiddler, and a guitar player, all dressed in western wear.[55] Press coverage of the race suggests that

Bowen ran a campaign based largely on reaction to the policies put forward by his opponent—the more liberal Ben Martin, an associate editor at *Judge* magazine whom Democratic leaders had anointed to challenge the longtime Republican officeholder. Before losing the primary, Bowen—who ran on a platform that largely seem to consist of him being an anticommunist—attacked Martin for his membership in the ACLU, which Bowen claimed "rated as 90 percent Communist"; he also pledged to stop the sale of "salacious literature," which he claimed was "corrupting the moral fibre of our youth and ultimately leading in sequence to the spread of Communism."[56]

Western candidates, too, threw their hats into the ring in 1938. Out in Utah, Republican Dr. Arthur C. Wherry, a former president of the American Dental Association, ran unsuccessfully for Senate with a sound truck and a cowboy band.[57] "With him went a cowboy orchestra—violin, bull fiddle, and accordion—a pretty girl singer, a stack of handbills, and a great sheaf of songs of the range," noted an Associated Press reporter.[58] In Washington state, unsuccessful Republican congressional hopeful Norman Ericson—an attorney and supporter of the Townsend pension plan—ran a race with a "four piece hill-billy band" and "a placarded trailer."[59]

Though less country music campaigning appears to have taken place in the initial years of World War II, by the end of the war, hill-billy bands proved popular again with politicians in the South and Midwest. In 1944, *Billboard*'s "cowboy and hillbilly tune" columnist noted that all this activity had "provided many pleasant engagements for scores of artists."[60] By then, politicians opted less for local musicians and more for national country music figures anointed by the nation's two leading radio barn dances—programs that reached thousands over growing national radio networks: Nashville's *The Grand Ole Opry* on NBC's premiere Red Network and Chicago's *National Barn Dance* on NBC's regionally focused Blue Network. Facing a crowded field of contestants for Arkansas' US Senate race, oil tycoon and candidate Thomas H. Barton hired several members of the Grand Ole Opry cast—including Minnie Pearl, Eddy Arnold, and Uncle Dave Macon—to play at least five rallies that year as his campaign faced off

against competitors such as Hattie Caraway. According to the Nashville *Tennessean*, Barton even tried to hire star fiddler Roy Acuff to perform, but Acuff declined, noting he would devote himself to politics only in his home state.[61] That same year, cowgirl singer and *National Barn Dance* star Patsy Montana and "several other Western and folk tune artists" sang and pitched for incumbent Republican governor Dwight H. Green of Illinois at a rally at Chicago's Hotel Sherman before Green was reelected to a second term.[62]

Nonperforming politicians achieved mixed results, sometimes finding that hillbilly and cowboy performers enhanced a campaign, and sometimes finding that hiring such a band made little difference. Nevertheless, these attempts to woo voters—especially in the 1920s and early 1930s—created a window in which actual performers and country music personalities began considering running for office. In the next chapter, the political careers of two successful personalities, Pappy O'Daniel and Jimmie Davis, and one unsuccessful politician with a highly successful musical career, Roy Acuff, will be considered in more detail.

★ 4 ★

Pensions and Poll Taxes

Identifying a Style of Hillbilly Music Politics

L ocated some twenty miles southeast of Fort Worth, the city of Corsicana, Texas, had hosted some big political rallies in its time, but none as big as the one on June 28, 1938. "All available space on the courthouse grounds were packed with standing people," wrote a local journalist.

> Hundreds were sitting on fire escapes and cornices of the building in addition to all windows being crowded. The speaker's platform was crowded to capacity while many had vantage points in the trees and on automobiles. Hundreds drove by in automobiles, unable to find parking places within blocks and blocks of the courthouse and were unable to see or hear. It was conservatively estimated that there were 10,000 people here.

The paper even went so far as to label it "Biggest Crowd in Political History" in its headline about the packed courthouse lawn.[1]

The attraction in this case was a gubernatorial candidate, W. Lee "Pappy" O'Daniel. But O'Daniel wasn't just any candidate. He was known as the voice, poet, and moral compass of the *W. Lee O'Daniel and His Hillbilly Boys* radio program, heard around the state on the

Texas Quality Network, and before that of the Burrus Mill's famous and extremely popular *Light Crust Doughboys*. O'Daniel—a flour salesman who didn't actually play an instrument himself—promised Corsicana voters that he, as the "representative and exponent of the poor and common people," would "rid the state government of professional politicians and give Texas an honest and fair business government." O'Daniel, of course, wasn't on stage alone. The Hillbilly Boys—a jazz-influenced and fiddle-focused hillbilly band that included two of his sons—were a big part of the attraction. "The Hillbilly Boys received much applause while the speaker on numerous occasions was greeted with 'amens' and cheering."[2] The spectacle of people risking life and limb to climb trees to view a political candidate may seem strange to a twenty-first-century audience used to jumbotrons and flat screens at rallies, but the event in Corsicana was decidedly modern in the ways it married showmanship, celebrity, political discourse, sound trucks, and popular discontent with career politicians. Furthermore, O'Daniel wasn't the only performer to venture into politics in 1938. That spring, hillbilly recording star and future governor Jimmie Davis ran for public safety commissioner position in Shreveport, Louisiana, and used country music at his campaign stops. In Tennessee, friends coaxed amateur fiddler Al Gore Sr. into regaling voters with performances in an effort to liven up his political talks in his first political race for the US House.[3] Out West, a young cowboy radio singer who eventually would become a US senator, Glen Taylor, ran for and lost a bid to represent Southern Idaho in the House, while in Glendale, California, radio hillbilly singer Stuart Hamblen ran unsuccessfully for a seat in the same body.[4]

This chapter focuses on the inaugural campaigns of the three Southern performer-politicians who not only put aside successful music careers to run but who were most successful in capturing the national limelight for their campaigns: O'Daniel, who ran successfully for governor of Texas in 1938 and eventually became a US senator; Louisiana governor Jimmie Davis, who was first elected to executive office in 1944; and gubernatorial candidate Roy Acuff, who campaigned unsuccessfully for Tennessee's state spot in 1948. One other political

figure, Senator Glen Taylor, shared this background as a professional showman, but Taylor never achieved the same sort of acclaim for his broadcasting career. (Because of Taylor's regional connections to the far Mountain West instead of the South and his strident left-wing politics, he stands in contrast to the middle-of-the-road and conservative politics of O'Daniel, Davis, and Acuff, making him something of an outlier; thus he will be considered in chapter 5).

Although Tom Watson and the Taylor brothers had found success in introducing fiddling to the campaign trail in the nineteenth century, by the early twentieth century, stereotypes that rural people and their music were backward and "hillbilly" often eroded the kind of credibility a professional performer might need to start a career in politics.[5] By the late 1930s, however, radio cowboys and hillbillies had become enough of a fixture in many Westerners' and Southerners' homes, and the medium itself had grown enough in audience and public acceptance, that performing or promoting hillbilly music over the air had become more of an advantage than a disadvantage. O'Daniel even went so far as to joke that hillbilly performers had a leg up over others in the political realm by refashioning the Hoosier Hot Shots' "Them Hillbillies Are Mountain Williams Now" into something of a parody and having his Hillbilly Boys perform it:

> The came to town with their guitars
> And now they're smoking big cigars
> Them Hillbillies are politicians now . . .[6]

This does not mean, as the O'Daniel parody implies, that one simply hit the airwaves with a guitar or banjo and got elected. Powerful forces, in fact, were already aligned to keep political outsiders out of office. National radio networks, federal radio policy, corporate fair use policies, and advertising prices and decision-making created a situation where, for the most part, only mainstream candidates with substantial financial backing and support from the two dominant parties could dominate political uses of radio during the medium's golden age.[7] Local and regional markets were not always dominated

by the same forces, however. In fact, when given an opportunity, as we will see in the cases of Senator O'Daniel and Governor Davis, hillbilly performers effectively used local stations, regional radio networks, jukebox rotation, and record sales to bypass the ways in which local party officials, powerful businessmen, and newspaper editors had traditionally used their clout to anoint and help elect preferred candidates. Indeed, performers broadcasting over these local stations and smaller networks confronted more of a patchwork of policy enforcement from the federal government, as well as station managers who allowed them to kick off their campaigns without necessarily having to go through traditional means of seeking the favor of local and party establishments and holding a lower office to gain political clout. O'Daniel, Davis, and Acuff, in fact, successfully used their visibility as radio and recording stars to overcome their status as political outsider. All three used this publicity to launched campaigns that, if not completely effective, were at least relatively successful in challenging the more politically entrenched.

Although it is easier to assess the obstacles candidates faced, isolating and locating a specific style of country music politics during this era of radio's golden age is more difficult. Southern country music candidates of the 1930s and '40s represented a spectrum of viewpoints that eventually included everything from a moderate labor-friendly Republicanism (Acuff) to a more than passing flirtation with the segregationist far right (O'Daniel in later years). Nevertheless, among these candidates emerged some common platform issues that united them in what I call a "hillbilly political style." One such issue was support for state-funded old-age pensions, in the style of Francis Townsend's Old-Age Revolving Pension Plan or other similar movements—an idea that had already been tapped even before Townsend by country music–supported, nonperforming Kansas gubernatorial candidate John R. Brinkley. The focus on old-age payments was partially a product of country music tradition, which had a long history of producing lyrical paeans to dear old graying Mom and Dad. Also important was the fact this new country music industry had deep connections with audiences who themselves were aging and with sponsors who hawked

products geared toward the elderly. Writing in the heat of election season in 1938, one Associated Press reporter probably summed up what he saw around him best:

> The idea men of politics are re-enforcing old fashioned oratory in this year's scramble for votes with new appeals in music, "message," and machinery:
> The Music—Hillbilly bands.
> The "Message"—Old-age pensions.
> The Machinery—Motorized loudspeakers.[8]

Performer-politicians also tended to favor an end to the poll tax—that Southern tradition of requiring a fee in order to vote—and often positioned themselves as enemies of urban political machines. Although an anti–poll tax position might suggest in today's terms that one was a racial liberal who favored expanding the franchise to African Americans in the South, these performers largely sought to end the practice because they believed it hobbled the political power of poor whites. As time went on, however, O'Daniel and Davis aligned with platforms that pushed traditional or right-wing politics within conservative Southern Democratic circles and, despite their initial saber-rattling with the establishment, ended up supporting entrenched powers and a brutal system of race segregation.

Though they were from different regions and represented a spectrum of political viewpoints, O'Daniel, Davis, and Acuff shared several characteristics in terms of personal history. All three were relative outsiders within their respective political establishments. O'Daniel and Davis both came from poor backgrounds and were able to leverage their success in the business world and the music industry into platforms for their political aspirations, often challenging the traditional ways one goes about entering politics. Acuff, on the other hand, came from a more well-connected and political East Tennessee family, but his notoriety as a radio fiddler on the most popular national radio barn dance, his regional connections with the mountainous eastern part of

the state, and his Republican Party affiliation in a largely Democratic state positioned him, too, as outsider in the political process.

Among these three, O'Daniel was the first to use a combination of hillbilly music and broadcasting to launch a national political career. Though not a musician himself, he was intricately involved in bands that promoted his political career by writing songs, organizing stage productions, and directing song choices. Elected governor twice and then elected to the US Senate, O'Daniel was arguably the most successful country music personality-politician of all time.

Though he later grew quite wealthy because of his connections to flour sales, Wilbert Lee O'Daniel was no son of economic royalty. He was born in a small town in eastern Ohio in 1890, the son of poor worker at plow factory. O'Daniel's father, William, had fought for the Union in the Civil War; he died in a construction accident when Wilbert Lee was very young. His mother married cattle rancher and tenant farmer Charles Baker and moved the family to a 640-acre ranch in Arlington, Kansas. The young O'Daniel worked on the ranch and attended local public schools. At the age of sixteen, he finished high school, briefly ran a restaurant, and then moved on Hutchinson, Kansas, to attend business college. He worked his way through the two-year stenography and bookkeeping program, delivering papers and clerking at a local hotel. After graduating, he took a job as a stenographer at flour mill in Anthony, Kansas, and worked his way up to sales manager. He remained in the flour business and in 1922 took an offer to become sales manager of the large Burrus Mill and Elevator Company of Fort Worth, Texas, where he eventually became general manager.[9]

Although reluctant at first, in the early 1930s O'Daniel became associated with a hillbilly radio band that included performers Milton Brown, Bob Wills, and Herman Arnspiger and that had once shilled for a local lamp retailer on the air. The three performers, renamed the Light Crust Doughboys, appeared on the small, local station KFJZ, where they represented Burrus Mill's Light Crust Flour. However, the Light Crust Doughboys were more than just a band with a named aimed at product placement. The band emerged as a powerful

proving ground for aspiring regional musicians who gave birth to an entirely new way of playing country music. The earliest incarnation of the Doughboys spawned two major bands: Milton Brown and His Brownies and Bob Wills and His Texas Playboys, both of which helped generate the jazz- and fiddle-focused western swing subgenre and dramatically changed the style and sound of country music.[10]

O'Daniel was originally a somewhat distant potentate, and many band members resented what they viewed as his cheapness. As time went on, he came to be intimately involved with the band and with the broadcasts. He read his own poetry and wrote songs for the band, including the homage "Memories of Jimmie Rodgers" and the booster-ish "Beautiful Texas," a catchy but dewy-eyed number that became a sort of unofficial Lone Star State song. Under O'Daniel's direction, the *Light Crust Doughboys* program moved from the weak-signaled KFJZ to WBAP, a more powerful Fort Worth station. Within months, the program was picked up by four more stations in Dallas, San Antonio, and Houston, which, with WBAP, eventually merged into the Texas Quality Network (TQN), an important early regional radio network. O'Daniel estimated that his performance went from reaching perhaps a thousand at KFJZ to reaching more than a million through TQN.[11] O'Daniel eventually became the Doughboy's full-time spokesman and evidently had a talent for radio, often peppering his broadcast with advice for parents and couples, homey recollections of Mom and the good old days, and homilies with religious overtones. Nevertheless, at heart O'Daniel remained a businessman, using his newfound celebrity to climb his way to the presidency of the Fort Worth Chamber of Commerce and helping inaugurate expansion and other changes at Burrus Mill.[12]

In 1935, O'Daniel left Burrus and became a flour broker, collaborating with national powerhouse General Mills to launch his own Hillbilly brand of flour. Borrowing from his background in using the Doughboys at Burrus, O'Daniel quickly formed his own band, the Hillbilly Boys, and instituted the *W. Lee O'Daniel and His Hillbilly Boys* program on WBAP, complete with the memorable tagline "Pass the biscuits, Pappy."[13] O'Daniel eventually moved the Hillbilly Boys to

XEPN, a far-reaching Mexican-border station, where they performed three times daily. They also continued to broadcast on Sundays over TQN.[14] The noontime show was most popular, prompting one reporter to note, "At twelve-fifteen sharp each day a fifteen-minute silence reigned in the State of Texas, broken only by mountain music, and the dulcet voice of W. Lee O'Daniel."[15] On the *Hillbilly Boys* program, O'Daniel continued to sharpen his oratory. A campaign manager for one of his opponents in 1938 remarked: "The most striking thing about his voice was that it contained a tremolo. O'Daniel could make his voice sob when he read emotional passages in a script. It was this quality that made him effective."[16]

O'Daniel's *Doughboys* and *Hillbilly Boys* programs spoke to a regional audience that was already aware of the wide variety of hillbilly and country talent it could hear on the radio barn dances that had become national fixtures by the mid-1930s. If Texas and Oklahoma listeners were tuning in weekdays at 12:15 sharp to hear swinging fiddles and O'Daniel pontificating about biscuit flour, they were probably already used to switching the dial on Saturday nights to the *National Barn Dance* on the national NBC Blue Network and *The Grand Ole Opry* barn dance on Tennessee powerhouse WSM. Both originating in the mid-1920s, these two programs also featured a combination of musical and nonmusical entertainment and had started out on regional radio stations that increasingly expanded their reach and wattage until NBC's large national networks acquired their programming. Unlike O'Daniel's programs, however, these shows featured skits, comedy, regular casts of talented singer and performers, and a variety of rotating acts that appealed to national network executives and paved the way for performers such as Roy Acuff to think politics seemed something within reach.[17] Though these national barn dances were increasingly able to reach a much wider swath of listeners, O'Daniel was able to give his programs a personal touch with longer homespun homilies that no barn dance cast member could dream of. In this way, O'Daniel's regional network program served as a perfect platform in many ways to start a political career.

Although O'Daniel had probably considered jumping into politics

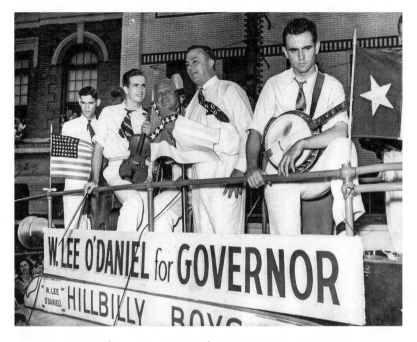

4.1 Pappy O'Daniel (second from the right) with his Hillbilly Boys band, campaigning at an unknown location, 1938. Son Pat (right) plays banjo while son Mike (left) plays fiddle. Photographer unknown; author's personal collection.

for some time, he saw an opening in spring 1938, when some thirteen candidates filed paperwork to run in the all-important Democratic primary for governor of Texas. O'Daniel stepped gingerly into the race, first asking his listeners on his radio program if they would support his candidacy. When they responded overwhelmingly in the affirmative, he entered with promises that he would use the Ten Commandments as a model for governance and that he would fight for the poor and the elderly.[18] During the campaign O'Daniel created a sensation by taking his Hillbilly Boys—which now included his sons Pat on banjo and Mike on fiddle—on the road with him, sparking something of a tradition where music became an almost expected part of Texas elections (fig. 4.1).[19] O'Daniel would go on to win the governor's seat twice, once that year and then again in 1940, and would also end up serving in the US Senate from 1941 to 1949.

Jimmie Davis's upbringing was probably the humblest of the three. Although no year is recorded, he was born near the turn of the twentieth century. His family were poor sharecroppers from rural northern Louisiana. Davis was one of eleven children, all of whom shared a stiflingly crowded three-room cabin with his parents and paternal grandparents.[20] He managed to attend elementary school and then graduate from high school, balancing a heavy load of chores, sports, school singing recitals, and odd jobs for neighbors. He earned a bachelor's degree in history at the Baptist-affiliated Louisiana College in Pineville by washing dishes, doing yard work, busking on street corners with his guitar, and working as a farmhand. Davis then taught school in his hometown of Beech Springs, saving up to pursue a master's degree in education within the psychology department at Louisiana State University in Shreveport. He finished that degree in 1927 and took a job as a history instructor at Dodd College, a short-lived Baptist women's college also in Shreveport.[21]

While teaching college at Dodd, Davis began moonlighting by singing pop and hillbilly songs on Shreveport's KWKH as something of a hobby. In 1928 and 1929, in the wake of famous spate of Southern recording sessions that resulted in the rise of Jimmie Rodgers, the Carter Family, and Charlie Bowman as national stars of the genre, Davis recorded tracks for Columbia and Victor and continued to work on his musical career. A scout who worked for several companies heard Davis's KWKH broadcasts, and that contact eventually led Davis to recordings in Chicago and a two-year contract at Decca.[22] His early music focused on covers of hillbilly songs, yodeling in the Jimmie Rodgers style, and to some extent raunchier blues-influenced songs replete with sexual double entendre such as "Red Nightgown Blues" and "High Behind Blues."[23] Davis ended up having a hit with one of his Chicago recordings, "Nobody's Darling but Mine," a 1935 Decca release that went on to be recorded by Gene Autry, Bing Crosby, and the Andrews Sisters. Davis, of course, achieved even greater fame in 1940 with his release of "You Are My Sunshine," the copyright of which he owned (although the origins are murky).[24] That song earned Davis considerable royalties and fame, becoming "one of the most com-

mercially programmed numbers in American popular music."[25] Once Davis established himself as something of a fixture on the charts, he received offers from Hollywood to appear in musical westerns such as the 1941 B-lister *Strictly in the Groove*.[26]

As Davis's fortunes and musical career began to take off, so too did his political callings. Still struggling financially after his first hit, Davis had taken a job as a court clerk. In 1938, he decided to run for the higher-paying public safety commissioner post in Shreveport, hitting the campaign trail with what the press referred to as a "cowboy band."[27] Davis researcher Kevin S. Fontenot argues Davis did not play music at his rallies at first, but changed his mind after his buddies pointed out that his refusals suggested he was becoming too "high hat" to indulge them with a song.[28] After winning that election, it was clear that the political bug had bit. He ran again successfully for the state's utility regulatory body, the Public Service Commission, in 1942, even though he had started to make considerable money from recording.[29] Finally, in 1944, he was elected to his first term as governor of Louisiana. Davis found that his country music background suited him well for the campaign trail, and he regularly included musical performances of "You Are My Sunshine," "There's a Chill on the Hill Tonight," and "That's What I Like about the South" at rallies and campaign stops.[30]

Davis's political career was linked inextricably with the larger issue of Longism in Louisiana politics. Huey Long, a figure many historians identify as a political strongman and voice of populist, working-class dissent, sought to build up Louisiana via spending on large-scale governmental projects, hospitals, and old-age pensions as he established a powerful electoral machine. After Long was assassinated in 1935, politicians supported or controlled by the Long machine—including governors Richard Leche and Earl Long (Huey's brother), and New Orleans mayor Robert Maestri—continued to institute his vision. When Davis, who was a neighbor and acquaintance of Long from his time at Dodd College, ran for governor the first time in 1943, he positioned himself in the all-important Democratic primary as an independent reformer who sought to keep the excesses of Longism at

bay. Davis cut spending strategically in some areas and did institute some governmental reform, but was also criticized by both Longites and reformers for often being absent from the governor's mansion to pursue aspects of his hillbilly career.[31] Earl Long biographers Michael Kurtz and Morgan Peoples perhaps best sum up Davis's first term as combining "a Longite commitment to heavy state spending on social programs with an anti-Long respect for governmental ethics."[32]

Compared to O'Daniel and Davis, Roy Acuff was born into considerable comfort. His father, Neill, was a Missionary Baptist preacher and attorney. One grandfather was a state legislator and the other one was a doctor. When Roy was born in 1903, his family was living in a three-room house in a town in East Tennessee's Great Smoky Mountains. Acuff later referred to that house in song as an "Old Three Room Shack." His family actually moved several times as his father's preaching and legal careers took off. While Roy was a teenager, his father served as pastor of the local church; by the time Acuff was in his thirties, his father had been elected judge and played a prominent role in the county.[33]

Despite his family's mostly middle-class upbringing and political connections, Acuff was an outsider in state politics because of his show-business career and his family's party allegiances. Before breaking into music full time, Acuff had played minor league baseball for a couple of years, but in 1932 he took a job performing fiddle for the Mocoton tonic traveling medicine show. After hawking patent medicines, soaps, and salves for several months, he eventually joined a band and started performing on Knoxville stations WROL and WNOX. In 1936, Acuff and his Crazy Tennesseans scored a contract with the American Record Company and created his hit "The Great Speckled Bird." Two years later, Acuff and the band, eventually renamed the Smoky Mountain Boys, had scored a regular spot on WSM's barn dance and the Grand Ole Opry, and continued on with the Opry until it was broadcast nationally by NBC's behemoth Red Network.[34] Recording hits such as "Wabash Cannon Ball," "Wreck on the Highway," and "Fireball Mail," Acuff went on to become one of the most prominent

figures in the history, the "king of country music," according to many admirers. He cofounded the Acuff-Rose Publications in 1942, helping to bring the music publishing industry to Nashville.[35]

Like many East Tennesseans, the Acuff clan were mountain Republicans. Influenced by early Quaker proselytizing and one of the first abolitionist movements in the United States, eastern Tennessee had proved something of stronghold to the Whigs and then later to the Republican Party, even though it was located in a state that was largely in the hands of the Democrats.[36] During the Civil War, Acuff's county was one of several East Tennessee counties that tried to break off from the Confederacy and remain loyal to the Union.[37] Mountain Republicans, too, had some history working with black Republicans after the war.[38] Such independence continued to influence political culture in the region in the late twentieth century. As most of the South coalesced around a one-party conservative, prosegregation Democratic Party establishment, East Tennessee Republicans such as Henry Clay Evans enjoyed a degree of independence and could stake out moderate or even liberal positions when their leaders were not involved in vote-trading deals with conservative Democrats from the middle and west to keep liberal Democrats from attaining power.[39]

Like O'Daniel, Acuff had become firmly established in his recording career before ever giving politics a thought. In fact, it was a slight hurled at his hillbilly music image by a sitting governor that prompted him to even consider running in 1943 (discussed later in this chapter). Acuff, however, showed little interest and practically had to be drafted into running by a stranger who filled out paperwork for him in 1948. Acuff ended up running as something of a Republican moderate, tough on the Soviets but in favor of veterans benefits, Roosevelt's Tennessee Valley Authority (TVA) project, and school repairs; and supportive in general ways of organized labor. He certainly ran to the left of his campaign companion, US Senate candidate B. Carroll Reece—also an East Tennessee Republican, but one who more openly embraced his state's general conservatism with his stridently anticommunist politics. Reece and Acuff had campaigned together to save costs and to take advantage of Acuff and his musicians' stage perfor-

mances.[40] Acuff, of course, would lose to reformist Democrat Gordon Browning, while Reece was defeated by Estes Kefauver, a relatively liberal politician who apparently had taken note of Acuff's successes in attracting crowds with music.[41]

Hillbilly Radio as Alternative Campaign Media

Local political party structures in the South were typically insular groups that sought leadership from within their own. In rural regions, "courthouse rings" of the small-town elite—doctors, lawyers, planters, businessmen, and, eventually, industrialists—had particularly strong control over who ran for office and what sort of policies were promoted. Such cliques also often had disproportionate leverage over state-level politics because of how rural districts were apportioned.[42] Even in larger Southern cities such as Fort Worth, Shreveport, and Nashville, the print media was entwined with a similar professional, business, and industrial elite because publishers "simply could not afford to alienate the leading businesses in town."[43] Although Southern newspaper editors, like their Northern counterparts, had increasingly come to the embrace notions of objectivity and impartiality, in reality the dominance of the Democrats as a monolithic single party in the South and the region's reluctance to entirely uproot the old partisan press made it difficult for political upstarts to gain the kind of exposure needed for statewide office.[44]

Radio performers such as O'Daniel and Acuff and recording artists such as Davis instead used the unparalleled access that their broadcasting and recording pursuits gave them to sidestep local elites and newspapermen. Prior celebrity, campaign-time broadcasting, and musical performances at rallies served as alternative forms of media outreach that could completely bypass formidable institutionalized apparatuses. This does not mean that such performers did not sometimes make use of the traditional establishment. O'Daniel, as noted earlier, got himself elected as the local chamber of commerce presi-

dent in 1933, which might have given him an excellent launching pad to run for mayor.[45] However, he had considerably steep hill to climb in taking on opponents with such statewide recognition and political clout as Texas attorney general William McCraw and Amarillo mayor Ernest O. Thompson in the all-important Texas Democratic primary. O'Daniel nevertheless made a pitch to his radio listeners about whether he should run for governor in May 1938 and claimed that 54,499 people wrote him, begging him to launch a campaign. Official recognition of his campaign was much slower. It took a week before the local Fort Worth paper noted his candidacy. By then, he had already taken to the road with his band and sound truck.[46]

Soon thereafter, O'Daniel's use of and background in radio helped attract live audiences at his rallies in towns such as Jacksonville, Yoakum, Waco, and San Angelo. Some commentators noted that, though radio had considerable drawing power, many audience members did not own radios but had come because they'd heard about the combination of entertainment and politics from family and neighbors. The affairs remained humble, and O'Daniel even resorted to having his daughter pass around a miniature flour barrel to collect for campaign expenses. "No local dignitary introduces him," noted the Fort Worth Star-Telegram. Still, the crowds kept getting larger and larger.[47] Even Hollywood took notice. By August, the newspapers were reporting that Republic Studios was planning a picture, Hillbilly Governor, with Gene Autry portraying O'Daniel, although that production appears to have not been brought to fruition.[48]

O'Daniel did pick up a few newspaper endorsements, but he failed to get even his "hometown" paper in Fort Worth to endorse him. Nevertheless, radio appearances and word of mouth about his unconventional, entertaining rallies and his established celebrity as a broadcaster allowed him to more than double his closest opponent's vote count, taking 231 of the state's 254 counties and allowing him to win the primary without a runoff. Texas political historian Seth Shepherd McKay argued in 1944 that demographic data on county-by-county voting patterns suggest that radio was a large factor in O'Daniel's appeal as a first-time candidate. McKay noted that all the twenty-three

counties that failed to give O'Daniel a plurality were on or near the state's border or hundreds of miles away from Fort Worth. "A study of the returns will show that the O'Daniel plurality counties are in all cases those which were served most efficiently by the radio stations over which the successful candidate had been broadcasting his programs regularly for ten years immediately prior to the campaign," McKay wrote.[49] My own attempt to recreate McKay's study with data on voting from the 1939 *Texas Almanac* too suggests that those areas farthest from stations broadcasting O'Daniel's music radio programs were among the twenty-three counties that voted against him. They were grouped in three clumps: one in the Texas Panhandle where one of O'Daniel's stronger opponents, Ernest O. Thompson, lived; one in the faraway western portions of West Texas that may have received a poor signal; and a third grouping on the western side of South Texas, where perhaps the signal was poor, or perhaps his message hit cultural barriers.[50] Nevertheless, that did not keep him from campaigning in those spots. "Certainly, nearly all the candidates speak on the radio, but he (O'Daniel) seems to have a corner on the theory that he is the radio," noted one South Texas newspaper.[51]

Already serving as a Louisiana state public service commissioner, Jimmie Davis had less of a hurdle to overcome. But it was largely his popularity as a performer that helped him surface as a candidate and win the 1944 gubernatorial election. Davis, in fact, ran because outgoing governor Sam Houston Jones, a reformer, had been term-limited and wanted a credible, well-known candidate to take his place and keep the Huey Long machine out of the governor's office, according to Davis biographer Gus Weill. Jones personally courted Davis because "he had few if any political scars and was widely known through his music on almost every jukebox in the state."[52] Jones offered little in terms of financial backing, however, leaving Davis on his own to face tough opponents, including Congressman James H. "Jimmy" Morrison, a one-time farm union activist from southeastern part of the state, and Congressman Lewis Morgan, who was backed by three political powers: the Long organization, the conservative Old Regular

elite of New Orleans, and New Orleans mayor Robert Maestri's political machine.

Like O'Daniel, Davis also had little home-court advantage in Shreveport since the city's mayor, Samuel S. Caldwell, had entered the race and had begun using the *Shreveport Times* against him.[53] Instead, Davis turned his image as a reformer and his media exposure—as local dance bandleader, as a one-time performer on KWKH, and as a national recording star—into attention that helped him gain endorsements from all three New Orleans–based daily papers, the *Times-Picayune*, the *States*, and the *Item-Tribune*.[54] The *Times-Picayune* in particular linked the endorsement of Davis with its own "historic fight to overthrow a state political dictatorship" of the Longite faction and followed up with a biographical sketch that featured pictures of Davis singing before a crowd and performing with his "Cowboy Band." In all, the *Times-Picayune* devoted about a third of its endorsement coverage to discussing how Davis's musical career made him a strong candidate.[55] The endorsements, as well as support from the city's Uptown elite who resented the Long machine, gave him advantages in important districts of the voter-rich city.

Davis also used radio performances effectively to attract audiences to rallies where he was less well known. Though the voters in Northern Protestant parishes were familiar with recordings such as "You Are My Sunshine," many in the French-speaking south were unaware of him, and his rallies there dwindled. In reaction, Davis appeared on WJBO in Baton Rouge, doing much more singing than speaking. Thereafter his outreach to francophone voters improved, especially after he add French numbers, including "Big Mamou" and "Jolie Blon," to his band's repertoire.[56]

Although Acuff was not successful in his bid for governor of Tennessee, his ability to put up even a reasonable fight as a moderate Republican in the conservative Southern Democratic state can be largely attributed to his name recognition as a star on a well-known national radio program, as a performer on *The Grand Ole Opry*'s "Prince Albert Show" segment, and a host of the Royal Crown Cola segment. Since

1883, only two Republicans had actually been elected to the four-year position.[57] A newcomer, Acuff garnered about 33.1 percent of the vote—10 percent more than the next two Republican gubernatorial candidates would.[58] That accomplishment was significant, considering that his Democratic opponent, Gordon Browning, had also cast himself as a reformer who was critical of the power of the Memphis machine, thereby by giving disaffected Democratic voters a more likely outlet for their displeasure.[59]

Defining a Hillbilly Style of Politics

If one were to define the politics of performer-politicians emerging out of the still-youthful hillbilly industry, support for old-age pensions and similar schemes for the elderly formed the most solid, consistent core. O'Daniel, Davis, and Acuff made pension politics part of their platforms early, and made them consistent and central themes to their campaigns. Though demands for pensions and the national movement for Social Security attracted hundreds of thousands of followers during this era, these three men were particularly creative in linking pension politics to central themes about care for the aging in the country music repertoire and important commercial and demographic issues related to their radio and recording listenership.

Opposition to the poll tax and a general aversion to urban political machines were secondary though still strong points in the entertainers' inaugural campaigns. The poll tax, which became a central issue for O'Daniel and Acuff especially, was seen as discriminating not against blacks, but against large parts of the poorer white electorate and was attacked by both performer-politicians as being yet another way for political insiders to maintain unfair advantages. To varying degrees, Davis and Acuff also faced off against the two powerful political machines in their states—the combined Huey Long–Old Regular machine in rural Louisiana and New Orleans for Davis, and the Ed Crump machine in Memphis and surrounding Shelby County for Acuff. In O'Daniel's first statewide election in 1938, he, too, ran more

vaguely against the abuses of the "monied interests and professional politicians" and managed to be overwhelmingly elected without the "boss-ruled" counties of southern Texas.

Combined, these three issues suggest the emergence of what I define as a "hillbilly style of politics": general lines of agreement among the Southern performer-politicians that involved a largely white, nominally class-conscious politics reflecting lyrical themes in music about taking care of the elderly, poverty as a painful but noble path in life, and the anxieties faced by rural migrants who resettle in cities. Because musical performances were a major component of nearly all these candidates' campaign stops, all three found ways to integrate the major themes present in hillbilly radio and lyrical elements in the genre to undergird and highlight their stances on pensions, poll taxes, and political machines. They also used these issues and their connections with music culture to paint themselves as outsiders of the political establishment and friends of the common people.

Right from the start, O'Daniel drew support from Texas voters in his 1938 bid for governor by promoting an old-age pension plan of $30 a month for those over sixty-five that would be funded by increasing the state's industry and using the taxes from that expansion. According to O'Daniel's plan, the state would contribute $15 a month, which would be met with $15 a month from the federal Social Security Act, although critics noted that the federal plan would pay out only to those who met financial eligibility limits so many elderly Texans would receive just a state allotment.[60] O'Daniel, though, maintained that all elderly deserved some compensation. "I believe in the age limit being the deciding factor in the payment of a pension," he declared. "I think the old age pension commission should be taken from the hands of the professional politicians and placed in the hands of competent, honest business men and women, who would deal fairly and squarely with these people who are entering the evening of their lives. The monied interests and the professional politicians know that it takes a lot of money to pay off the old age pensions and they hate to shell it out."[61]

Though O'Daniel was likely aware of Kansas gubernatorial candi-

date and radio quack John R. Brinkley's vague gestures toward a state pension plan and Brinkley's use of cowboy music to entertain the throngs in the early 1930s, O'Daniel's pension plan seems much more inspired by the national movement associated with Long Beach doctor Francis Townsend's Old-Age Revolving Pension (OARP) plan, which Townsend first put forward in a letter to the editor to his local paper in 1933. That plan called for a monthly pension of $200 to be paid to those sixty and older, which would be paid for by a national sales tax of 2 percent. Townsend's theory was that this pension (later amended to $60 a month) would stimulate spending during the Depression and help pull the rest of the economy out of the doldrums. The aging doctor's initial letter generated considerable excitement, and soon volunteers around the nation had banded together to create a nationwide movement supporting the OARP plan. Though he never saw his plan come to pass, Townsend's movement spurred demand for a Social Security Act.[62] The plan also generated regional emulators such as the Ham and Eggs movement in California and was adapted and adopted by leading national politicians such as Louisiana's Huey Long and his Share Our Wealth clubs.[63]

Once in the governor's mansion, O'Daniel continued to use music and his radio programs—to push for his vision of an old-age pension and a transaction tax that would pay for it. That battle, however, would rage on during his first and second two-year terms as governor, until finally in 1941 he acceded to the legislature to pass an omnibus bill that funded the pensions through a natural resources tax. Though it was not the way he wanted to fund the pensions, he compromised with legislators so that he could use the momentum to run for an open seat in the US Senate. Throughout that time, O'Daniel used weekly music-filled radio broadcasts from the governor's mansion to harangue state legislators for not falling in line with his plan for funding; typical of his pleas was a suggestion that the people bombard legislators with calls and mail. "It is my honest opinion that if you folks back home want this problem settled, you had better get in touch with your representatives," he told his listeners in March 1941.[64]

Likewise, when campaigning for governor in 1943, Jimmie Davis

supported the expansion of Louisiana's old-age pension plan, which was originally established by indicted Longite governor Richard Leche in 1936. That plan, which was to serve as a supplement to the federal Social Security program, paid elderly citizens $10 per month.[65] Davis promised during the campaign to find ways to increase this amount, but, faced with what he called a "considerable out of balance" budget, it was ultimately his successor, Earl Long, who increased the monthly payment to $50 $in 1949, after Davis's first term.[66] Nevertheless, in 1943, Davis pledged to a crowd who had come out to hear him speak and sing in Abbeville that he was in favor of an "adequate" old-age pension: "I don't like to make promises but I know what the average person wants or needs and I will do all that is in my power to help the citizens of the state."[67]

Although Davis made pleas for pensions during his campaign, his support of them was in many ways a byproduct of running for office in 1940s Louisiana, where Longism still stirred the electorate. Senator Huey Long, in fact, had borrowed elements from the platforms of Cajun entrepreneur and politician Dudley J. LeBlanc and the Townsendite movement and made the idea of $30 a month for those over age sixty a part of his national Share Our Wealth campaign in 1934.[68] (LeBlanc himself had links to the hillbilly music industry in that he frequently used performers to advertise and promote his Hadacol patent medicine.[69]) Long proposed a national program, but after his assassination in 1935, the idea of a state old-age pension remained popular. Davis campaigned as a reformer who opposed the "dictatorship" and corruption of the Longite faction. He nevertheless incorporated the pension pledge into his platform, partly as a means of fending off attacks from his gubernatorial opponents, especially Huey's brother, Earl, who was at that time endorsing a $20 increase to the existing $10 monthly pension.[70]

Davis's commitment to the elderly, however, should not be underestimated, especially given the central role he played in extending retirement benefits to bus drivers, school cafeteria, and other state employees not covered under the state's fragmentary system of teacher, law enforcement, and state employee benefits. In 1946, he introduced

a bill pledging retirement allowances for those with disabilities or those who were sixty-five and older, and providing a voluntary retirement option at age sixty. The state's sixteen thousand employees would contribute 5 percent of their pay, with the state making a matching contribution.[71] During deliberations, legislators heard dramatic testimony about how twenty-five employees of the New Orleans dock board were over 70 and still working because they had no means of livelihood.[72] With a tripartisan coalition of clean government reformers, "Old Regular" conservatives, and pro-pension Longites in the legislature, that bill was made law later that year, passing 73 to 15 in the Louisiana House. The legislature appropriated $725,000 to fund the program into 1948, and the program ultimately served as the basis for the comprehensive state employee retirement program that exists even through today.[73]

Acuff also supported old-age pensions in his unsuccessful 1948 run for governor of Tennessee. In October when campaigning in the Cumberland Plateau, he outlined five platform planks, including one that called for adequate old-age pensions to supplement Social Security. "Our old folks should be taken care of in their old age," he said.[74] In a November ad for Acuff and Reece, the performer went even further, pledging "increases for the aged, more aid for dependent children and the blind."[75] Acuff's biographer notes that the fiddler complained how some retirees were receiving as little as $8 to $12 a month, and that Acuff had also campaigned for more benefits for retired teachers. Though he lost the election and did not run again, Acuff had hoped to pay for the program through better use of state resources.[76] "Maybe an increase in old age pensions can be financed from the surplus which the sales tax is bringing in," he told an audience in Elizabethton, Tennessee. "Maybe it can be done through the use of simple economy in the state's affairs. One way or another, it has got to be done."[77]

O'Daniel, Acuff, and Davis were not unusual in supporting pension plans or programs seeking to supplement Social Security. Tens of thousands nationally were part of movements either in their own states or as part of national groups such as Townsend's Old Age Revolving Pensions organization. Nevertheless, the fact that all three

prominent hillbilly performer-politicians took decisive stands in favor of pensions plans in the 1930s and '40s suggests that the early 1920s-era notion that the authenticity of the genre was "located in old performers playing what was taken to be traditional music" continued on and had become a fertile seedbed for pension politics.[78] Connections between concern for the elderly and country music had in many ways started with the old-time fiddle conventions of the early twentieth century and with Henry Ford's focus on old-time round and square dances and on Mellie Dunham, the septuagenarian fiddler, in the late 1920s. Hillbilly music lyrics had also come to embrace the figure of the elderly person as benevolent and revered, but also financially and culturally besieged.

In fact, lyrics pining for the departed and the dear "old folks at home" had been a part of the country music repertoire since the very beginning, often owing much in style or sentiment to the original 1851 Stephen Foster minstrel song of that name. That song, often known by its lyrics about the "Swanee River," sanitized the South and its slave past with a mix of nostalgia for a simple cabin home and the natural world ("the birds make music all the day") and inaccurate sentimental renderings of slavery ("where the darkies all are gay"); as a favorite among old-time, hillbilly, and country performers, it also became a way to romanticize the aged.[79] Although folk tradition had sometimes portrayed the deaths and travails of parents and elders as just punishment for past sins, sentimental parlor songs and Tin Pan Alley offerings of the late nineteenth and early twentieth century—such as Charles K. Harris's "'Mid the Green Fields of Virginia," another hillbilly band favorite—often obsessed about neglected older loved ones.[80] Not surprisingly, the recording touted as one of the first hillbilly music recordings, Fiddlin' John Carson's 1923 "The Little Old Cabin in the Lane," arouses nostalgia and concern for an aging enslaved manservant and "ol' massa and ol' missus," later revealed to be laying side by side in the grave.[81]

In the radio age, the Carter Family became the standard-bearers for this sort of fare. Their 1929 "My Clinch Mountain Home," which has become a central component of the bluegrass and country reper-

toire, reads as though it were a mountain-focused reinterpretation of the themes of the Foster number, sans references to slavery. In the song, A. P. Carter mixed longing for the old mountain cabin with concern that Mother is becoming "old and feeble" and Father is "getting gray."[82] Another song that would become a country favorite, Jimmie Rodgers's "Dear Old Sunny South by the Sea" hits several emotional buttons, connecting nostalgia for an "old shack" with concern that "my mother and dear old dad" are heartbroken by the narrator's long absence.[83] In 1931, one of the biggest-selling records since the birth of hillbilly genre was western singer Gene Autry's "That Silver-Haired Daddy of Mine," attributed to Autry and cowriter Jimmy Long. The song speaks wistfully of an aging father who has given his best years to his children and now lives alone in a vine-covered mountain shack, forgotten by society and time.[84]

Sponsorship of hillbilly radio programs was also closely aligned with appeals to the elderly. By the 1930s, the hillbilly radio industry had also developed a particularly cozy relationship with patent medicine makers seeking to cultivate older customers. In the 1930s, the Texas-based Crazy Water Crystal Company enticed Southerners with hillbilly music programs featuring figures as Bill Monroe and J. E. and Wade Mainer. On the shows, the company's laxative mineral salts were advertised as having "wonderful eliminative effects," and testimonials were often offered about the salt crystals curing all kinds of ailments.[85] Although its appeals were aimed at listeners of all ages, Crazy Waters shows such as *Colonel Jack and Shorty's Crazy Hillbillies* included testimonials from an unnamed doctor that "faulty elimination" caused or aggravated a number of conditions facing the elderly including arthritis, aches, stiffness, and overtaxed kidneys.[86] Peruna tonic—another cure-all that had once promised to cure rheumatism but in the 1930s claimed only to ward off colds—sponsored border-radio programs by Woody Guthrie and the Carter Family.[87] By the end of the era, the connection between pension politics and patent medicines was made even more secure when Dudley J. LeBlanc, the Cajun politician instrumental in envisioning and promoting what became Louisiana's old-age pension plan, began selling Hadacol, a B vitamin

complex elixir that testimonial advertisements hinted would cure such age-related conditions as cataracts, rheumatism, diabetes, and chronic fatigue.[88] LeBlanc, who frequently hired hillbilly musicians to hawk his product, went so far as to have himself identified as "a leading advocate of old age pensions" on a major advertising blitz in 1950.[89]

Even O'Daniel and Acuff were intimately tied to these products. Though they later had a falling out, O'Daniel considered Carr Collins, president of Crazy Water Crystals, to be one of his closest advisers in 1938, campaigned on air on one of Collin's Texas-based Crazy Water programs, and would later try to appoint him as chair of the state highway commission. Acuff, of course, had hawked Mocoton tonic early in his career. Later in life, he ended up performing on stage in support of LeBlanc's high-profile Hadacol Caravan country music shows in the 1950s.[90]

Research from the era also indicates that the elderly were particularly loyal listeners of hillbilly music. For instance, in a 1947 survey of radio listeners throughout the country, researchers Paul Lazarsfeld and Patricia Kendall found that 38 percent of those over the age of fifty with a grade school–level education listed "hillbilly and western music" programs among their preferences for evening listening. Although more highly educated listeners were less likely to select the genre, listenership among older people with higher levels of education remained strong. In fact, college-educated listeners over age fifty identified "hillbilly and western" shows as among their evening radio preferences at nearly twice the rate of younger college-educated listeners.[91]

None of this was lost on political-minded performers such as O'Daniel, Davis, and Acuff. O'Daniel more than the others seemed positively obsessed with the figure of dear old aging Ma. Although he had branched out into political songwriting with his 1931 "On to Victory, Mr. Roosevelt" in support of FDR, O'Daniel had proved particularly adept at playing the aging mother card on his *Doughboys* and *Hillbilly Boys* radio programs. Favorites included such songs as "The Boy Who Never Grew Too Old to Comb His Mother's Hair," penned by O'Daniel, and "Mother's Crazy Quilt," a sentimental Ruth Etting

cover.[92] Another song, "Marvelous Mother of Mine," was played pianissimo by the Doughboys as O'Daniel spoke syrupy prose: "Hello there, mother, you little sweetheart. How are you, you little bunch of sweetness? This is your big boy, W. Lee O'Daniel."[93] O'Daniel also wrote poetry:

> Mother, you fashioned me—bore me, and rationed me
> I am your blossom—your flesh, blood and breath
> From unknown, you discovered me, recovered me.[94]

Musician Roy Lee Brown, brother of Doughboy Milton Brown, noted that O'Daniel would often tell a sad story on the air "about some poor old mother" and then follow it up by having the band reverse the gender of Autry's hit into "That Silver-Haired Mother of Mine." The response startled even him. "And I mean people just ate up," Brown remembered.[95]

Given such circumstances, it seems almost natural that O'Daniel would combine stories and songs about the elderly with pension politics on his campaign for governor in 1938. *Collier's Weekly* reported that, at a typical O'Daniel rally, the former flour salesman would make pledges about the $30-per-month plan while the Hillbilly Boys played a song titled "Thirty Bucks for Mamma," which was set to the tune of "Let Me Call You Sweetheart," a turn-of-the-century Tin Pan Alley tune that Bing Crosby repopularized in 1934.[96] At their rally in Corsicana, O'Daniel had the band butter up his audience by playing several such numbers before launching into a knockdown defense of pensions and an attack on a "pussy-footing" old-age pension inspector who, if he found a piece of chewing gum stuck overnight under Grandma's bedpost, would cut the aging lady's pension:

> Why I have here a letter from an old gentleman who says that he
> paid the mortgage off on his little home and when the inspectors
> found it out—they cut off his pension entirely. . . . So my advice to
> you folks who have reached the age in life when you want to take
> things easy—if you owe an honest debt—don't pay it—because the

"pussy foots" will find it out and take your pension away. . . . The monied interests and the professional politicians know that it takes a lot of money to pay off the old age pensions and they hate to shell out.[97]

After he was elected, O'Daniel again put his radio skills to work in a series of broadcasts from governor's mansion in Austin aimed at supporting the pension plan. Critics have argued that the primary focus of these broadcasts—which included appeals to Christian brotherhood and attacks on "racketeers," "pikers," and "pussy footers"—were to bully state legislators into supporting O'Daniel's version of the pension and associated tax plan.[98]

Jimmie Davis, too, provided musical accompaniment to his pitches for his plan to augment Social Security with a state-funded pension. Typical of the Davis campaign were the back-to-back rallies in Jonesboro and Ruston, Louisiana, held in the morning and afternoon of October 23, 1943. Davis gave a speech at each outlining his interest in expanding the old-age pension, improving hospitals, and fixing rural roads, followed by his string band giving a concert and Davis joining in to sing a few songs. In Jonesboro, his band appeared on stage with what the *Times-Picayune* described as "big heeled boots, ten gallon hats, and traditional Hillbilly instruments." Davis spoke for forty-five minutes and sang two songs, the biggest hit being his signature tune "You Are My Sunshine," which he used to reinforce campaign promises of a brighter future for Louisianans regardless of age. However, pianist Moon Mullican—himself a rising talent in the hillbilly music industry—"literally stopped the show," according to the paper, with his version of the racy country song "The Baptizing of Sister Lucy Lee," the paper reported. That afternoon, twenty-two miles away, after what must have been an exhausting day for Davis and the band, Davis spoke again in Ruston and then "sang several songs and his band gave a concert."[99]

Davis in particular was often attacked by opponents for his connections to the music industry. Longites tried to tar him by noting that Davis's early bluesy recordings such as "Bed Bug Blues" and "High-

Geared Mama" were suggestive and obscene. Another opponent, Congressman Jimmy Morrison, even went so far as to play Davis's "Red Nightgown Blues" at a rally in Shreveport, hoping the salacious lyrics would bring voters to his side. The stunt backfired, however, as many of those in attendance started forming partners and dancing along to the music. Davis later revealed that his campaign had paid the dancers to couple up.[100] In response, the New Orleans *Times-Picayune* sounded an ominous warning to others in its endorsement of Davis: "It would, for instance, be a sorry blunder if a Davis recording were broadcast in error from a rival's sound truck. His melodies are so popular that this faux pas might very well occur."[101] Davis responded skillfully to these attacks by using them as fodder for his campaign's "Sunshine" and "Unity and Harmony" themes and his pledge to rise above Longite–Old Regular factionalism. "I think we should have more music and song and less bickering and fighting," he told one crowd. "When people are singing, they are not fighting."[102]

Despite his later support for such measures, some nine years before running for office, Acuff had recorded a song, "The Old Age Pension Check," lampooning the fever surrounding pensions. The lighthearted 1939 song, credited to Ralph Fulton and Sam "Dynamite" Hatcher, took jabs at the inflated expectations some had for the Townsend plan, Huey Long's Share Our Wealth program, and Social Security; but it also implicitly endorsed the movement toward some kind of retirement measure. The first verse, in fact, is almost entirely optimistic, speaking about how a pension will keep poorhouse at bay and the "good times will be back to stay." Subsequent verses, however, turn toward satire, outlining in increasingly zany fashion how the pension will ensure that newfangled cosmetics will go out of style while grandmothers in old-fashioned hoopskirts will be in demand by suitors. "Songs like this are not received one hundred percent," Acuff told music writer Dorothy Horstman decades later. "There are some words in it that are a little touchy for some people: 'Send your dime to Washington—get on relief.' It was more of a comedy song for me, but it was taken a little bit politically by some."[103]

When it came to Acuff's own gubernatorial campaign in Octo-

ber 1948, however, pension politics were front and center. After a twenty-minute program of what the Nashville *Tennessean* described as "boogie-woogie, religious, melancholy and folk songs" by him and his Smoky Mountain Boys in Huntsville, Tennessee, he gave a short speech in which he pledged his support of an increase in the old-age pension and free textbooks for children. The audience of three thousand, the paper noted, was "patient during the speeches and loud in its applause of the musical entertainment."[104]

Although retirement and pension plans seemed to form the common core connecting the country music candidates, opposition to poll taxes also united O'Daniel and Acuff's inaugural campaigns. Though O'Daniel highlighted a need to end the poll tax from the beginning, a series of attacks and tactical mistakes by his opponents made it easier for him to use the poll tax as an effective campaign issue. O'Daniel, in fact, had outlined his support for ending the poll tax and the death penalty in May 1938 when he first announced his campaign for governor. "I think the sixth commandment ["Thou shall not kill"] clearly states my position on capital punishment," he later told voters in San Antonio.[105] O'Daniel, however, did not emphasize his position on executions much during the campaign, and it was his poll tax activism that stirred the most controversy. Weeks after he announced his platform, the press discovered that O'Daniel had not paid his poll tax for 1938 and began printing a barrage of stories questioning whether he had paid the tax in recent years.[106] One opponent, state attorney general William McCraw, excoriated him, saying his lack of payment showed O'Daniel to be a "Yankee carpetbagger" who did not care that a portion of the poll tax was used to fund public schools. "I really don't know why he didn't pay the poll tax, but I do know that 45,000 children wouldn't be able to go to school if every man and woman in Texas were political slackers."[107]

O'Daniel turned the attacks to his favor, realizing that voters were sympathetic to those who could not afford or who forgot to pay, and that there was considerable populist anger at the way the tax disenfranchised poor middle-age and younger people, even if Texas did not require the elderly to pay the tax. "They charge $1.75 poll tax in

order to cut the number of votes in half, and make it easier for the professional politicians to pick the officials," he said during a campaign stop in June. By July, the tide had turn so far against the poll tax that O'Daniel began purposefully admitting to audiences that he had not paid the tax, usually to supportive cheers or chuckles from the crowd.[108]

Acuff made abolition of the poll tax an early feature of his campaign platform as well. "If you folks will pay your poll taxes this time and vote for me, I'll do everything in my power to see that you don't have to pay another poll tax," he told an audience at his campaign kickoff in Crossville, Tennessee, in August 1948.[109] Acuff, in fact, not only opposed the poll tax, but even went so far as to turn his opposition to the tax into a kind of "get out the vote" campaign, by ordering his campaign workers to conduct research so that they could inform unaware voters about whether they already paid the poll tax because of complexities in how the poll tax law worked in Tennessee.[110]

Opposition to the poll tax should not necessarily be read as racial liberalism, even though O'Daniel and Acuff shared with the civil rights movement a dislike of such taxes. Certainly, O'Daniel's later stance in the Senate in 1944 as a prosegregation, anti–New Deal "Texas Regular" leader suggests that his opposition had nothing to do with racial liberalism. Davis was not forced to take a stand on the poll tax, because Louisiana's Longite leaders had successfully eliminated it nearly seven years before Davis ran for governor. Nevertheless, even there, it had been eliminated not just because it might allow blacks to vote, but because it allowed poorer whites to take more of a role in the political process.[111]

Although opposition to the poll tax has not historically made much of a splash in the country music repertoire, the genre has long looked kindly on the poor. Country music's stance toward politics has been varied and sometimes quite muted, but, as Bill C. Malone has noted, it has never shied from documenting wrongs. In the 1930s, songs such as "All In Down and Out Blues" chastised those who would take advantage of the poor, while others, such as "Tramp On Street," preached compassion to the less fortunate.[112] As with pensions, it isn't much of

a leap to connect this sort of compassion for the poor with opposition to a tax that kept the impoverished from voting.

A final area where O'Daniel, Davis, and Acuff shared campaign goals was in their general opposition to established political machines. O'Daniel didn't intentionally square off with the bosses who dominated the political establishment in southern Texas counties, but he managed to carry his state in the 1938 election without significant support there. Davis billed himself as a reformer and anti-Longite even as he adapted many Longite platform planks and later tried to make peace with Long supporters. As a mountain Republican in a largely Democratic state, Acuff had to wrestle with the Crump machine, which dominated statewide politics by using West Tennessee voting districts as bargaining chips.

O'Daniel, of course, went to great lengths to argue that he was not controlled by machines or interests of any kind. During the 1938 campaign, at least, outside sources such as the Associated Press seemed to agree: "So far as the naked eye can see, O'Daniel has had little support among men who have long been in politics. He has waged war on 'professional politicians.'"[113] Once in office, he continued his blistering attacks on entrenched elites, representing his plan to fund the old-age pensions with a transaction tax as an important struggle in a larger battle for moral authority. One observer likened these efforts to "a kind of holy war" in which O'Daniel "sought to eliminate corruption in state politics and to guarantee the constitutional rights of the common citizens of Texas against exploitation by unscrupulous and self-seeking professional politicians."[114]

Although O'Daniel did not appear to have explicitly called out the southern "boss-ruled" counties of Texas in his 1938 campaign, demographic data on his win suggest that these counties were among the very few he did not win in that election. Boss rule was a system in which a largely white ranching elite dominated the economic, social, and legal order while dispensing assistance and patronage to lower-income Mexican Americans. The system, which relied on bribes and political fraud, kept many Mexican Americans from exercising their voting rights freely since bosses, many of them Anglos, controlled

their votes. Although O'Daniel successfully campaigned in the Rio Grande Valley and won votes there in boss-controlled Hidalgo County, he lost the bastions of Duval, Starr, and Zapata counties. Historians have noted that some of the opposition in South Texas came directly from local political machines that sought to curry favor with other candidates for pet projects. Perhaps even more significant, though, was the possibility that this opposition may have also come from the fact that O'Daniel's message and cultural appeal was less alluring to Mexican Americans—a distaste that would magnify as O'Daniel the governor became more conservative and more openly allied himself with segregationist voices and politics.[115]

Although Jimmie Davis tried in many ways to run a positive campaign in 1943, the fiercest attacks he weathered came from Longites and Maestri's Old Regulars, who had joined forces in opposition against reformers such as Davis and former governor Jones. Huey's brother, Earl Long, who was running for governor, was particularly livid. He argued that Davis was "bought out" by outgoing governor Sam Jones. "Six henchmen of Sam Jones are on the Jimmie Davis ticket," Long claimed.[116] Davis's campaign parried back with ads connecting Davis's reform message with the fight against fascism in Europe: "We, the people of Louisiana, have sent our sons to foreign lands to fight the dictators who would like to make us slaves. But here at home we face the threat of dictatorship coming from the city hall in New Orleans where Mayor Robert S. Maestri rules supreme."[117]

The whole of idea of Acuff running for office was first floated after Governor Prentice Cooper, associated with the Memphis-based Ed Crump machine, insulted the Grand Ole Opry in 1943. Cooper, according to the *Saturday Evening Post*, had been scheduled to appear on a special broadcast of the Opry that inaugurated its move to a total of 129 stations on the NBC Red Network. Cooper declined to make an appearance, however, saying that he would not be part of such a "circus" and that Acuff had brought disgrace to Tennessee by turning Nashville into what the *Post* paraphrased as "the hillbilly capital of the United States."[118] Reporters at the Nashville *Tennessean* got to joking that Acuff, as a representative of the Opry, would actually make

a great candidate and filed paperwork for him to run.[119] Although he did not end up running that year, Acuff bragged that he had played for seventy-five thousand potential voters in Crump's hometown of Memphis and, if elected, he would not be beholden to any machine. "There's this about it, if I was Governor there wouldn't be any graft," he told a reporter. "I'd insist on everything being on the up and up. The poor man would have just as good a chance as the fat politician."[120] *Time* magazine helped further Acuff's image as an anti-Crump politician by opining that Acuff was a "smart Hillbilly" while the sitting governor — "dull, nervous little Prentice Cooper" — was nothing more than Crump's "present stooge in the Governorship." Acuff, *Time* argued, might "yet give Crump the Memphis Blues," referring to the political boss' history of using blues musicians such as W. C. Handy to provide entertainment at his own campaigns.[121]

There was an element, too, of anti–machine politics that connected with country music lyrical tradition. Davis and Acuff, as candidates from rural regions challenging the urban Maestri-Long machine in New Orleans and the Crump machine in Memphis, proclaimed political messages that dovetailed nicely with the antiurban bent of much of the country repertoire. The Carter Family's "Behind Those Stone Walls," which depicts rural people being corrupted by the city and eventually imprisoned, was perhaps the most devastating of these, but there were dozens of others with similar themes.[122]

Though posturing as people's candidates who would take on invested interests in their inaugural campaigns, Davis and O'Daniel, the two successful candidates considered here, ended up embracing their own conservative brands of politics that included fiercely defending the South's segregationist traditions. The irony here is that over time they became almost as entrenched (for Davis) or more entrenched (as with O'Daniel) in elements of their state's political establishments than the establishment machines they had first sought to disrupt.

Although O'Daniel had run originally on a platform combining liberal positions such as old-age pensions and opposition to the death penalty with a pledge to uphold Christian virtues in public office, once in office he attacked labor unions, stoked fears of fifth columnists and

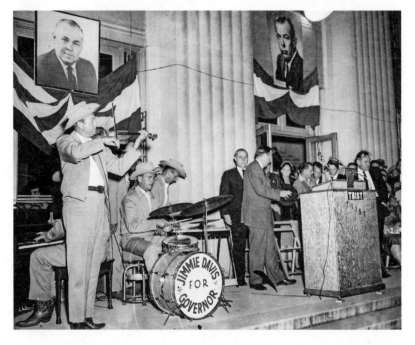

4.2 A campaign band warms up the crowd for Jimmie Davis at an appearance in the 1960s. Louisiana Collection, State Library of Louisiana.

a communist conspiracy, embraced appointees that were members of right-wing extremist organizations, led a "Texas Regular" movement that urged conservative Democrats to break with FDR in the 1944 election, and championed segregation and white supremacy.[123] Noting the irony here, one editorial writer even went so far as to argue that elderly Texans would make a deal with Hitler "if Lee O'Daniel dressed it up nice in Bible talk, just so that the Axis didn't interfere with old-age pensions or start radical talk about letting Negroes vote or paying labor more than ten cents an hour."[124]

Davis, on the other hand, is remembered for a more mixed bag during his noncontiguous two terms, the second of which extended into the 1960s (fig. 4.2). During his inaugural term, he took positions to reform the state worker pension plan and to veto a "right to work" bill that would have eliminated union shops.[125] Though Davis had worked closely with black musicians and promoted their careers in the studio,

his political career was largely focused on upholding the segregationist establishment.[126] When Davis was elected governor again in 1960, he fought vigorously against federally mandated school desegregation, even going so far as to order state administrators to drop 2,300 black children from the federal Aid to Dependent Children program in an effort to force their parents to move elsewhere.[127] It is possible, too, that he had completely compartmentalized his liberalism on workplace issues and his brutal intransigence on race and that he never entirely changed his views all along. His master thesis from Louisiana State way back in 1927, for instance, was an "intelligence study" of seven hundred nine- and ten-year-old Baton Rouge schoolchildren that argued that white and "mulatto" children scored higher on the National Intelligence Test than black children. Davis gave no weight to the fact that segregation had perhaps created uneven learning environments or to his role as outsider in administering the tests. In fact, he even commented in one section about how surprised he was that to "find the negro children falling readily into line" to take the tests.[128]

Acuff also became more conservative as time went on, although his work was largely relegated to playing a role as campaign performer and supporter from the sidelines. In 1959, Acuff performed in Athens, Alabama, in support of Jack Owen, a Democratic gubernatorial candidate who centered his campaign on the pledge that "segregation shall be maintained in Alabama."[129] Acuff was even more supportive of fellow Republican Richard Nixon. In 1968, he recorded a radio ad—aired in Tennessee and in other areas with a strong country music market—that had the fiddler promising how a Nixon presidency would bring "change" and "new leadership."[130] He told his biographer in the 1970s that, in terms of politics, he had been most involved as a musician and supporter working to elect national Republican figures as Dwight Eisenhower, Barry Goldwater, and Richard Nixon.[131]

That Acuff, Davis, and O'Daniel were successful in using their reach and their images as hillbilly stars suggests that hillbilly radio, jukebox, and record sales provided a platform that allowed less politically connected candidates to grab voter attention. All three of these figures also claimed time in the national political spotlight much earlier than

prominent Hollywood figures did. O'Daniel, for instance, won na-tional attention and a governor's chair well before Hollywood actress and Broadway star Helen Gahagan Douglas, who entered Congress in the mid-1940s. Acuff and Davis, likewise, beat out George Murphy and Ronald Reagan, who launched successful Senate and gubernato-rial races, respectively, in the 1960s (although, of course, Acuff did not win his bid). Their stories indicate that country music is not merely an apolitical, or an unbending parochial or conservative, genre. Rather, it is a contested landscape upon which some of the earliest and most suc-cessful performers turned politicians of mass media first tested how celebrity might be turned into political clout. As a side product, it also turned out to be fertile ground for candidates pushing segregationist politics.

★ 5 ★

Utopian Buckaroo

Senator Glen Taylor and Country Music's Left Tradition

The one surviving newsreel clip of Glen Taylor's first day in the
US Senate suggested his national political career would be any-
thing but stodgy. The newsreel, which is only partially augmented
with sound, opens to darkness and then a caption: "Universal News-
reel: Congress Convenes." The year is 1945, and the viewer is bom-
barded with a succession of silent flickering images: an establishing
shot of the Capitol building, a succession of shots of Harry Truman
and legislators and their wives hobnobbing and talking to the press.
The camera then cuts to dark interior shots of new legislators being
sworn in. All seems fixed in tradition and according to plan.

The mood then changes as the newsreel, still lacking narration,
cuts to a bright outdoor scene. Four figures — a well-attired Taylor, his
wife, and their two young sons — cross the Capitol steps. They sit on
the steps above a group of reporters, and Glen Taylor pulls out his
banjo. The Taylors are dressed up: Glen in a tie, black fedora, and gray
overcoat, Dora in feathered black hat and dress coat, and the boys in
black hooded coats. They seem well groomed and earnest, not wanting
to put on airs as they huddle together in the brisk January breeze — an
ideal young family unit (fig. 5.1). Suddenly, *actual sound*, singing and

5.1 Senator Glen Taylor (D–Idaho) plays banjo and sings with his family on the Capitol steps, January 3, 1945. Pictured with Glen from left to right are son Arod, nine, wife Dora, and son Paul Taylor (P. J.), two. Image © 2018 The Associated Press.

banjo plucking, fills the air as the Taylors and their older son, Arod, break into their own version of "Home on the Range":

> Oh give us a home
> Near the Capitol dome
> With a yard for little children to play . . .

The parody continues with pleas for a humble abode with a couple of rooms for a family. Glen then leans into the mic and says with an ever-so-slight western drawl, "We realize these are serious times. However, I brought the banjo along for my own amusement." Then he adds, "I do think it would be a good idea to put up a barracks here in Washington so new senators would have some place to live."[1]

Taylor's singing stunt on the day he was sworn in to the Senate might seem tame today in a world dominated by the norms of reality television, when a president tweets venom at pop stars and nary a brow is raised when two senators have themselves filmed for a survival TV series on a deserted island.[2] But in 1945—when it was a controversial for a Hollywood actress such as Helen Gahagan Douglas to even run for the House—Taylor's stunt was downright earthshaking. Here was an actor, a western camp-tent vaudevillian, and radio singing cowboy, baring it all on his first day on the job by singing—yes, singing—about his family's inability to find a place to stay amid the housing shortages that dogged many cities in the waning months of World War II. Senators were not supposed to act in this fashion.

As might be expected, the press had a field day with Taylor's theatrics, describing him as a "colorful" singing cowboy who was determined to fight any urge to yodel in the Senate chambers. Perhaps most brutal was the *New York Times*: "A singing cowboy sang his swan song on the Capitol steps today and then (almost reluctantly, it seemed) went inside and took his oath as Senator Glen H. Taylor of Idaho." By describing the stunt as a final performance, the *Times* suggested in one fell swoop that he had doomed his political career.[3]

Such assertions were of course premature. Taylor proved an important figure on the left flank of the postwar New Deal congressional coalition. As a senator, he pushed for civil rights in the South long before most of his cohort and ended up running unsuccessfully in 1948 for the vice presidency as Henry Wallace's running mate on a third-party ticket. Taylor not only achieved higher office than any other professional country music personality except possibly Pappy O'Daniel, but attained a temporary level of visibility on a par with such well-known liberal or populist amateur country musician-politicians as fid-

dlers Al Gore Sr. and Robert C. Byrd as well as Alabama governor "Big Jim" Folsom, a Congress of Industrial Organizations–backed candidate and nonmusician who nevertheless seldom ventured out without his Strawberry Pickers String Band.[4] The liberal Taylor—known foremost in his home state as a radio cowboy and hillbilly singer, blazed a trail by balancing celebrity and political candidacy decades before conservative politicians George Murphy, Ronald Reagan, Sonny Bono, and Arnold Schwarzenegger made careers out of a start in the entertainment business.

Taylor's political ascent suggests that country music's appeal as a political tool went beyond the usual pack of established performers and conservative Southerners such as Pappy O'Daniel, Jimmie Davis, and George C. Wallace who often dominate accounts. It also suggested that there were important regional variations of the country music politics far outside of South. As a performer, Taylor, of course, did not rise to level of stardom achieved by O'Daniel, Acuff, and Davis, but he nevertheless skillfully used his more regionally focused cowboy and country music image to carve out a relatively successful political life.

Taylor's political and music career closely parallels the way another poor young idealistic radical, Tom Watson, had used fiddling to drum up a crowd in his 1882 race for Georgia's House. Both used their musical performances in part to signal they were political outsiders who shared concerns with average people. Taylor used his radio and live stage performances, like Watson's fiddling stunts, to first get noticed and elected. Once in office, Taylor used his growing national reputation, like Watson, to run as a vice presidential candidate connected with racially liberal, economically radical third-party ticket, in his case the Progressive Party's ticket of 1948. Watson and Taylor differ, however, in that Watson made a marked and decidedly nasty turn away from such liberalism when he embraced white supremacy and antisemitism at the beginning of the twentieth century—a course that Taylor would never take.[5] Taylor's experiences suggest that the connections between economic populism, liberal social and racial attitudes, and country music could be maintained in the twentieth century. His example also foreshadowed such successful left-of-center

country music races as Jim Folsom's 1947 anti–poll tax and prolabor gubernatorial run and Southern moderate Estes Kefauver's less successful but noteworthy 1952 and 1956 presidential primary campaigns.

Taylor's repertoire demonstrates that there was no single path for success as a performer-politician. His music was not the tradition-bound public-domain material that appealed to Watson, Heflin, Gore, and Byrd voters, but was composed largely of covers of well-established numbers from hillbilly child-singing acts and adult singing-cowboy performers, along with western-themed songs from the radio-crooner tradition mixed with some additional influences from pop, jazz, Tin Pan Alley, and polka. His music was what sociologist Richard A. Peterson has deemed "soft-shell," a pop-oriented crossover variety distinguished from the grittier "hard-core" music of his more traditionalist-minded contemporaries—a lighter, more eclectic, pop-oriented music that might have appealed to the isolated farmers and miners of the Far West who relied on popular radio fare perhaps more than did Southerners for entertainment and a sense of community.[6]

Taylor got involved in politics because he wanted to eradicate the kind of poverty he grew up with. Taylor was born in Portland, Oregon, in 1904, the twelfth of thirteen children. His father was a left-leaning itinerant Disciples of Christ minister who had tried his hand at acting, law enforcement, and farming. The family was descended on one side from a group of Texans who had served in the Texas Rangers and from which the family asserts they received an inheritance of Southern folk music culture. Taylor biographer F. Ross Peterson notes that the father's politics "stressed the Golden Rule, brotherly love, and a modified Christian socialism." By the time Glen Taylor was born, his father had already planted the family on a 160-acre farm near Kooskia, Idaho. Glen, however, was born on the road during one of his father's ministry trips to Oregon. With so many mouths to feed and because only ten acres of the farm was fit for crops, the Taylors often lived in poverty, requiring young Glen to help out by collecting firewood and herding sheep for neighbors. His family's finances forced him to end

his schooling after the equivalent of a sixth-grade education. As the years progressed, the Taylors brought their children on the road, often assigning them roles as performers in the musicals and melodramas the family performed to help finance the father's ministry.[7]

As a young man in the early 1920s, Taylor hit the road, performing in his brother Ferris's Taylor Players traveling vaudeville act. Taylor eventually joined another itinerant group where he met his longtime wife, Dora, in 1928; and together they eventually formed their own traveling theater group. Much in love, the couple combined their first names and called the company the Glendora Players.[8] The troupe generally remained on the road for the next ten years, giving performances in the Northwest and central Mountain West, and often living on the verge of poverty. Competition with "talkie" motion pictures dampened profits, as did the Depression itself. "[We] ate jack rabbits more than once and sometimes we didn't eat at all," Taylor recalled in the 1960s.[9] In 1935, they had their first of three sons, Arod (the name an anagram of his mother's name), who eventually became the featured vocalist of the Taylor's family band.[10]

By then the Depression had made it difficult for the young actors to make ends meet. Glen noticed that a rival theater troupe was raking in cash by offering a free "hillbilly music" dance after their plays and by performing hillbilly music for free on the local radio station to advertise their shows. Taylor hired his own band of well-rehearsed swing musicians, but when that didn't work out, he chatted with his rival about why they were more successful. The rival conceded that rural audiences craved more heartfelt, folksy old-time and hillbilly offerings by less-polished musicians and with "corn enough to spare." Taylor then fired the swing musicians; Glen took to learning banjo, Dora worked on piano, Glen's brother Paul (who performed in Glen's troupe) learned the slide trombone, and Paul's wife, Gladys, took saxophone lessons.[11]

Paul Taylor purposefully wielded the trombone up front and in an ostentatious manner to emphasize his dramatic slides and with a wider array of instruments, they could easily handle the era's pop songs.[12] Eventually, the troupe took up the name of the Glendora

Ranch Gang, playing radio stations for free by day to drum up publicity while performing as a theater troupe and dance band combo at nightly paid performances.[13] In his autobiography, Glen recalled the audiences' desire for rural music in the mountain Northwest:

> Out in the beat-up halls in those little farming communities and cowtowns, they loved us. . . . Nobody ever missed the seven swing musicians and Paul never missed a chance to get in an arm's-length slide on that shiny brass trombone. As they say in show biz, "We killed them dead."[14]

Although Glen later joked about the band's inexperience and the naiveté of his audiences, the only known recordings of the band suggest that over time the Glendora Ranch Gang became better musicians and that they spent considerable time crafting their musical choices for an audience who demanded a sophisticated mix of pop, hillbilly, and jazz tunes suited for the dance floor. Realizing their limits, though, they hired a professional guitarist and accordionist to round out their ensemble. Dora and Glen appear to have served as vocalists during the early days, especially when addressing audiences on the radio, but their first son, Arod, would eventually come to serve as the band's lead vocalist when he reached the age of three.[15]

Even before this turn toward music, Taylor had begun to contemplate a political career. His autobiography retells how witnessing a campaign talk by the much ballyhooed Idaho governor C. Ben Ross led him to believe that he, as a practiced stage performer and presumably more polished speaker, had what it took to make it in politics. Taylor, like Woody Guthrie and other Agrarian radicals of the time, was particularly sickened by reports that growers and grain elevator operators were allowing produce and crops to rot in an effort to drive up prices while American citizens were starving.[16] But what seems to have motivated him the most was his chance encounter in the late 1920s with razor magnate King Camp Gillette's utopian writings.

Taylor described his introduction to Gillette's politics via the razor tycoon's *People's Corporation* as something of a conversion experience,

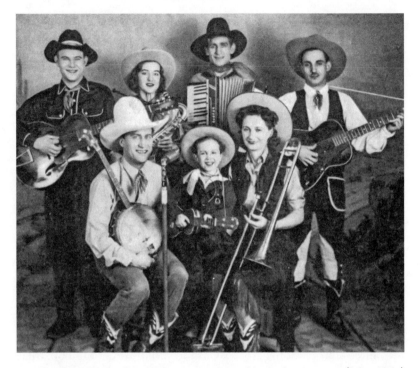

5.2 The Glendora Ranch Gang, late 1930s. Pictured in the front row are (left to right) Glen, Arod, and Dora. Taylor used his appearances on the band's radio program to get the word out about his campaign. Used by permission of Arod Taylor. Image courtesy of *Mother Jones* magazine.

a moment of epiphany that took place when he was visiting a wealthier relative with a sizeable book collection:

> I reached over and picked a book at random. That was the most fateful action of my life. The rest of my life and the lives of untold numbers of other people would be affected, altered, and made to flow in different channels because of that seemingly simple act. . . . No scholar receiving a rare and priceless volume had ever been more appreciative than I.[17]

Gillette, the inventor and original promoter of the famous Gillette razor, was a bit of a contradiction: a wildly successful capitalist who

enthusiastically prophesized the coming of a new socialist-like economic order. But his vision was not exactly conventional socialism. Instead, he imagined a highly technological world where all members of society would be stockholders in a "World Corporation" that would assure more efficiency and fairness in production, less workplace drudgery, and the elimination of poverty.[18] Influenced by the fever of scientific discovery generated by the inventions of Nikola Tesla and Thomas Edison and the utopias imagined by Henry George and Edward Bellamy, Gillette's planned-economy corporatism had a definite futuristic edge.

Gillette's primary goal was to restructure society toward a model of "production for use," where products would be efficiently created as they were needed by workers motivated by advancement in the corporation and a sense of prestige and personal achievement rather than a wasteful focus on personal acquisition and profit, which, he argued, dictated demand, supply, and prices in chaotic ways. The details of how such drastic changes in society would voluntarily come into being were hazy at best and never entirely spelled out in three separate volumes Gillette wrote or cowrote to explain his vision. Generally speaking, Gillette proposed that, if enough believers bought stock, the World Corporation would be powerful enough to buy out competing firms and eventually structure the entire international economy around a single corporate entity. Gradually, this World Corporation would replace national governments, whose artifices would fall away like a husk, allowing a new peaceful, productive economic order to sprout forth.[19]

Utopian it was, but Gillette's ideal society also had a technological component. Gillette imagined thousands of giant, circular, glass-domed skyscrapers that housed 2,500 people each, all centered in a single megacity named Metropolis into which all the North America population would be transplanted. For its location Gillette selected Niagara Falls, New York, the site at which Tesla helped develop a commercially viable hydroelectric facility, because it promised tremendous amounts of energy production. These skyscraper apartments and other buildings—which resembled cogs, from an aerial standpoint—

were to be laid out in an intricate hexagonal pattern that appeared more like a complicated blueprint for Kabbalah study than a traditional urban planning design. These structures would be supplied by a central kitchen structure and electric line that would transport food "in a few minutes in sealed containers."[20]

One can easily imagine how eliminating hunger and building science fiction metropolises might appeal to a poor young farm boy such as Taylor. Inspired by this vision, he committed to run for office and sought a place to settle his family and better his electoral chances. In 1938, soon after forming the Glendora Ranch Gang band, the Taylors choose Pocatello, in southern Idaho. The Taylors were somewhat familiar with the area because they had stayed there with their theater troupe for short period in the late 1920s. However, Taylor also realized that it would serve as a strategically savvy political base. Situated some seventy miles north of the Utah border, Pocatello had strong railroad unions that could translate into liberal votes. Biographer Peterson argues that the town also made sense in terms of statewide electoral prospects: as a northern Idahoan situated in the southern part of the state, Taylor figured he could carry the liberal mining and lumber-oriented northern half of the state, while also picking up farming votes by using his folksy radio and musical endeavors to appeal to the more conservative, Mormon-dominated south.[21]

Meanwhile, Taylor was busy establishing himself as a public persona in the area through his music. Accustomed to using stops at radio stations to advertise their shows, the Glendora Ranch Gang convinced Henry Fletcher, owner of Pocatello's KSEI radio station, to let them try out a daily half-hour musical program for two weeks. After a positive response from listeners, Fletcher made their program a permanent part of the lineup. The *Glendora Ranch Gang* program remained on the air for four years, with time off for campaigning and excursions with their theater and dance band troupe. Arod Taylor does not recall his mother and father being remunerated for their half-hour program, but the family did use the program to advertise paid-admission dances and theatrical productions that were usually held in the evenings.[22]

Like many hillbilly bands, the Glendora Ranch Gang invited their

audiences into the small KSEI studio to watch the performers broad-cast. Onlookers would file into the station—a small house on the north edge of town—and find a place to sit or stand in the gallery. Directly ahead was a window that opened into the studio. "We would always fill up the gallery," Arod remembered. "People would come with their kids to watch us play." The band also opened their show with a theme song that appealed to the rustic good life: "We like mountain music, ooh, we like mountain music, played by Glendora Ranch Gang band." The Glendora theme song was based on a rustic-themed 1933 Tin Pan Alley number by Frank Weldon and James Cavanaugh that also served as basis of the "Pass the Biscuits, Pappy" theme song of O'Daniel's *Light Crust Doughboys* program.[23]

The *Glendora Ranch Gang* show featured a mix of music genres, con-necting traditional and commercial country songs with other popu-lar genres—in effect, carving out a niche for the band as a cross-genre "soft-shell" western and hillbilly ensemble. It does not appear that any live KSEI broadcasts were recorded, but the family and their band made a set of home recordings on at least two separate occasions (the first most likely in 1939 and the second in 1941) that give some indi-cation of the kinds of music the group regularly played. Though old cowboy ballads like "Streets of Laredo," "authentic" Carter Family ballads, and Acuff-type instrumentals are absent, Taylor's recordings on these Sears & Roebuck "Silvertone" brand home recording discs connect with prominent traditions within the hillbilly genre during the 1930s and early 1940s: the child radio star phenomenon and the singing-cowboy and crooner traditions. They also hint at the group's dalliances in jazz, ragtime, and lyrical neominstrelsy.[24] Beyond the in-fluences that these recordings bare, they paint a portrait of the types of musical fare that Taylor, his family, and his band would later em-ploy in regional and national campaigns.

Arod—who was three years old in the earliest set of recordings and five in the later ones—lives up to his father's autobiographical admis-sion that the young boy was really the star of the band. He appears on every single one of the band's vocal recordings and is a soloist or dominant vocal presence on seven of the twelve other numbers.[25]

The Glendora Ranch Gang was in good company in placing a cute kid at the center of their act. Hillbilly music's leading family, the adult-dominated Carter Family, by this point had also taken to putting the daughters, Anita, Helen, Janette, and June, on the air.[26] Acts entirely dominated by children, such as father-son duo Asher and Little Jimmy Sizemore, as well as western child singer George Gobel, were also finding success on top national radio programs such as WSM's *The Grand Ole Opry* and WLS's *National Barn Dance*. Little Jimmy Sizemore was perhaps the more famous of the two. He came to fame in the early 1930s when he and his father, Asher Sizemore, became cast members of the Opry. Asher had already broken ground performing singing-cowboy and old familiar songs on West Virginia radio, but his popularity skyrocketed when he brought his five-year-old son into the act. The Singing Sizemores, as they were called, plastered songbooks with images of well-groomed dad and plump happy son and regaled listeners with father-son harmonizing on numbers such as "That Silver-Haired Mother of Mine," "The Booger Bear" and "Old Paint." In between the duo's sentimental and novelty songs, Jimmy would tug at the heartstrings of listeners by answering his father's questions with imperfect but peppy answers in little-kid diction.[27]

Arod's act with the Glendora Ranch Gang had much in common with the Sizemores. At the beginning of many of Silvertone tracks and in between numbers, Arod plays emcee, much like Little Jimmy, by introducing songs and vocalists, verifying the date and place of the recordings, and discussing his qualifications for stage or studio. Because he was three years old in some of the recordings and five in others, his speech is quickly paced and his voice is that of a child—bouncing around in pitch and volume, repeating words, and mispronouncing some speech sounds and letter blends. There is an element of humor in his speech because he puts on an air of confidence, or even bluster, that seems uncharacteristic of a child this age:

> This is Arod Taylor talking to you. I am three [mispronounced *thwee*] years old. My daddy and momma say I am still coming to you and the reason I can is because of the radio. I made my first appearance

on the stage when I was five [repeated] weeks old, so, you see, I am
not an amateur [pronounced with a *t* sound, with something of a
mock Shakespearean accent].

Combining confidence with childlike charm, Arod's act was akin to
Little Jimmy's radio exchanges with his father, which often featured
the smaller Sizemore serving as an expert or authority on some aspect
of the duo's music.[28]

Arod's performances appealed musically to campaign audiences in
ways similar to the national hillbilly child stars as well. In the Silver-
tone recordings, Arod actually performs "I Only Want a Buddy, Not a
Sweetheart," an Eddie Jones number that Little Jimmy Sizemore had
already performed and which may have been at least partially writ-
ten by the duo's father, Asher Sizemore.[29] Furthermore, the first vocal
recording in the Silvertone set features Arod as soloist singing and
yodeling to "My Dear Old Southern Home," a version of the Jimmie
Rodgers song "Dear Old Sunny South by the Sea," in much the same
fashion that the Sizemores opened their radio program with another
sentimental Southern nature ballad, "Memories of Old Kentucky."[30]

The Taylors, however, served up their own spin on the hillbilly
child act, privileging the mother-son relationship in way that rivaled
the Sizemore's sentimental father-son fodder. The Glendora Ranch
Gang's version of "My Little Buckaroo," for instance, is in many ways
more compelling listening than the typical Sizemore broadcast, which
tended to feature big Asher leading and Little Jimmie harmonizing
along on the choruses.[31] The Taylor version made use of Dora's voice,
in many ways stronger than her son's or husband's, while also incor-
porating Arod's bravado and cuteness. The song first appeared in the
1937 singing-cowboy film *The Cherokee Strip* when Dick Foran, an early
rival to Gene Autry, sang it to a child actor Tommy Bupp to quiet him
down for some rest by the campfire.[32] The *Cherokee Strip* song—which
would eventually serve as a lullaby for a generation of wee wannabe
cowboys—coaxed kids to sleep with metaphors involving the cattle
ranching and western landscapes, all in time with that same steady
"trail-ready" andante rhythm one finds scattered through the scores

of many western films of the era.[33] Written by Hollywood songwriting team of Jack Scholl and M. K. Jerome, "My Little Buckaroo" eventually became a hit on *Billboard*'s charts and spawned popular covers by Roy Rogers, Hank Snow, Eddy Arnold, and others.[34]

In both of the Glendora Dance Gang's recordings of "My Little Buckaroo," little Arod interjects with affirmations, questions, or demands between his mother's verses, making the song more of a dialogue and, in the exchange, seeking to appeal more directly to audience members as parents and grandparents. Although Dora has perhaps the clearest and the most pitch-perfect voice of three on the recordings, it is Arod's interjections that give the song its character. In the more complete of the two recordings, Dora starts out the song—true to the original sheet music—by imploring him to go to sleep to which Arod, three in this recording, answers with "All right, mommy dear." They continue with this same pattern of Dora singing a verse and Arod responding for much of the rest of the song. At the end of the song, Dora's voice trails off while Arod begins to recite the "Now I lay me down to sleep" prayer. The Sizemores similarly ended each program with Little Jimmie singing a version of that prayer. As a whole, the Glendora Ranch Gang song effectively reproduced the nighttime ritual of getting the kids to bed and would have undoubtedly tugged at the heartstrings of a radio audience of parents and grandparents. There is a closeness, a vulnerability that is revealed in this short performance, with Mother picking up on a theme her boy was obsessed with (cowboys, in this case; perhaps dinosaurs for more recent generations) and seemingly transforming it into the raw material for a lullaby.[35]

The Silvertone recordings also reveal heavy influences from the singing-cowboy subgenre and its connections with the movies, jazz and pop orchestration, and western swing. We can especially see the latter influence in the song "When It's Springtime in the Rockies," a 1929 Tin Pan Alley piece that became the springboard for a Gene Autry film, and in the 1923 waltz "The West, a Nest and You," composed by jazz bandleader and songwriter Billy Hill.[36] By recording and promoting such songs, the Taylors were tapping into national obsessions

with singing cowboys such Autry, Roy Rogers, and Tex Ritter, who in the 1930s had become a force on radio, in Saturday matinee films aimed at children, and in the recording industry.[37]

The biggest single influence on the Taylor family, however, was radio and film star Bing Crosby. Five songs recorded or made famous by the crooner appear in the recordings. The Glendora Ranch Gang recordings include an instrumental version of "An Apple for the Teacher," a pop love song that Crosby recorded with Connie Boswell, as well as Arod singing "Let Me Call You Sweetheart," Bing's 1934 hit. Another Crosby standard, "Little Sir Echo," based on a 1917 Tin Pan Alley number aimed at children, appeared in the Taylor's Silvertone recordings with Arod singing lead vocals and his father Glen responding with "Hello" in the song's call-and-response.[38] Although in hindsight it seems odd that the pop-oriented Crosby would influence a western band such as the Glendora Dance Gang, Crosby's popular and respectful covers of several cowboy songs in the 1930s gave credence to the claims of western and hillbilly performers that their music formed a legitimate music genre.[39]

Drawing on the band's cowboy songs and image, Glen Taylor made a concentrated effort to dress in western wear to appeal to live audiences and voters, joking that he "was togged out" like silent western star Tom Mix.[40] At various times, he wore a bulky white Boss of the Plains–style Stetson or, later, a trimmer Cattleman. Photographs from the era show him also wearing western-style "smile pocket" shirts and suits, as well as jeans-style dungarees.[41] The band wore similar apparel in publicity photos from the time.[42]

Jazz and associated musical styles made appearances in the Silvertone recordings too. Outwardly, Glen Taylor told family and others that he had absolutely "no interest in jazz," but Taylor's denial did not necessarily translate into fact.[43] If anything, there were strong jazz undertones to many of the recordings. For instance, there are two versions of Arod singing a very jazzy "Three Little Fishies," the swinging children's novelty tune that Kay Kyser made famous in 1939, as well as an instrumental version of the Shelton Brooks jazz standard "Darktown Strutters' Ball." The Taylors even had a tangential connection to

the professional jazz world in that Glen had an older sister, Lee Morse, who became a major jazz vocalist. Arod also remembers that the ensemble regularly performed the jazz standard "Margie," made famous by Eddie Cantor, while his uncle Paul would occasionally give in to the family's pleas and sing the Al Jolson hit "Sonny Boy" on the air. Jolson sang the song in blackface, but Paul apparently used it to tug on the emotions of listeners.[44]

Earlier styles connected with jazz were also apparent as well, including at least one variant of the what has come to be known as the "coon song" for its use of racist of imagery and ragtime rhythms. This lyrical style dates back to black ragtime pioneer Ernest Hogan's 1896 composition "All Coons Look Alike to Me," a song Hogan claimed was about a black woman's courting foibles, but which seemed to take on a life of its own, spawning a series of increasingly stereotypical knockoffs by Tin Pan Alley composers seeking to cash in on Hogan's success.[45] The Taylors incorporated at least one of these successors in their Silvertone recordings: the final chorus of the 1912 Joe Young song "Down in Dear Old New Orleans" appears as one of the set's last couple of recordings as part of a "partner song" in which two songs are sung simultaneously to the same tempo and rhythm. In this case, little Arod sang the partnering song, the lilting World War I–era British music hall song "It's a Long Way to Tipperary," while Glen sang the chorus of "Down in Dear Old New Orleans." Arod's vocal arrangement of the British song dominates, making it difficult to hear Glen's part, but the lyrics of "Down in Dear Old New Orleans" are nevertheless audible. The elder Taylor appears to have stayed pretty true to the final chorus of the original, which notes that "darkies all are hummin' and strummin' banjos to a Dixie tune" in the moonlight of "dear Old New Orleans."[46] "Down in Dear Old New Orleans" was certainly not the most racist Tin Pan Alley fare, but the song was nevertheless part of a slew of insulting songs depicting happy black people dancing for joy down at the old cotton plantation.[47] The elder Taylor's reasons for pairing this song with "It's a Long Way to Tipperary" remain a mystery. It is striking that Glen Taylor would include such a number in his repertoire some eight or ten years before choosing to get arrested in

protest of segregation in the South. Whatever the reasons, the existence of the "Down in Dear Old New Orleans" partner song recording suggests that nineteenth-century minstrelsy and twentieth-century neominstrelsy remained such strong influences in the American song bag that they could emerge within the repertoire of someone like Taylor, who would later make his mark as a committed race liberal.

On the campaign trail, the Taylors' musical radio broadcasts and live appearances proved an indispensable tool in launching a career for a national legislative seat. Like many candidates without family connections or political pedigree, Taylor ran and lost many times. He ran for US Congress in 1938 and for Senate in 1940 and 1942, losing all three times but increasing the percentage of the vote he obtained each time in part because of his popularity as a cowboy and hillbilly performer. His missteps in these early campaigns allowed him to slowly refine his public appeal, resulting finally in his election to Senate in 1944. Music and his broadcasting day job was an important launching pad for all these campaigns.

Although he made inroads with the public through his efforts, Taylor could not count on the support of the political establishment and the news media. As a political outsider lacking deep ties to the traditional parties and local political machines, he had a prickly relationship at best with the press, which was often politically enmeshed with community elites. The fact that he also represented a left-wing faction of the Democrats in a state dominated by conservative Republican-leaning newspaper editors and publishers did not improve the situation. "There are eleven daily papers" in Idaho, Taylor recalled in his autobiography, "and they were all against me but one and it was neutral."[48] His hillbilly music pursuits, however, allowed him to overcome the natural advantages other elite-supported candidates might have had because it gave him an alternative way of reaching voters. Taylor's strategy of speaking out to fans on the radio and actually meeting them at performances in Mormon recreation centers and Grange Halls played the same role in many ways that direct-mail campaigns, YouTube appeals, and Twitter feeds have in allowing more recent candidates to reach voters without relying on the support of the main-

stream media. Music became a means of shortcutting the traditional alliances that a politician would have to secure with local editors and reporters and their sponsors—which often included wealthy merchants and the statewide power company—in order to get elected.

During his first run for office, a congressional seat in 1938, Taylor regularly announced his political rallies on his program on KSEI. He also briefly used the Ranch Gang's radio broadcasts to push his own political agenda by making short political sermons during his broadcasts.[49] When KSEI station owner Henry Fletcher warned Glen that Federal Communications Commission rules prevented him from directly inserting politics into his radio program, Taylor suggested that the band instead broadcast supposedly neutral reminders about voting dates and educational statements about how to vote. Understanding Taylor's drift, Fletcher had no objection, and Arod proved instrumental in these so-called educational efforts, capitalizing on his child-star appeal. "From then on, at end of each day's broadcast, while all the gang were playing and singing our theme song," Glen Taylor wrote in his autobiography, "Cal the announcer would lower the volume on the music and Arod, who was not yet three, would chime in with a public service exhortation, 'Be sure to vote right.'"[50] The implication of these statements was that voting right meant not just submitting your ballot properly, but voting the cute little singing cowboy's father into office.

Taylor also brought his Glendora Ranch Gang on the road in an effort to capitalize on the band's growing radio audience. "There had never been a campaign like this before, noisy street rallies with a cowboy band entertaining from atop an old Ford car," Taylor recalled in his autobiography. "Heretofore, campaigns had been a terrific bore, dull uninteresting and stereotyped. For the first time a lot of people were *enjoying* a political campaign."[51] Despite the cartop performances, Taylor lost in a crowded primary, finishing fourth in a field of eight.

Taylor threw his hat in again in 1940 after the death of longtime Idaho politician William E. Borah created an opening in the US Senate. Because it was a statewide race and Taylor could not afford lodging for his band, he left the additional musicians in Pocatello and traveled

instead with Arod and Dora, forming a hillbilly trio. In a typical appearance, Arod would sing several songs on top of their car through the PA system, and then Glen and Dora would join in. Finally, Glen would take the mic and talk about what he would do as a senator.[52] At the Idaho Democratic Convention that year, he also played up his cowboy image, wearing "a small red silk handkerchief around his neck," a blue suit "with red thread woven in," and high-heeled Spanish-style boots "that tapered down to a spiked point no bigger than a silver dollar."[53] Although trio appearances were the norm during the final months of the campaign, evidence suggests that Taylor was actually campaigning earlier with his full entourage and even greater fanfare. An ad about an April performance of the Glendora Ranch Gang in Soda Springs, Idaho, is instructive: "Free Entertainment by the Glendora Ranch Gang . . . featuring AROD, Age 4, America's Youngest Cowboy Singer and Yodeler." The ad also included mention of how "Glen H. Taylor . . . Candidate for U.S. Senate will speak briefly on the subject of 'Plenty for Everybody,'" promised a performance of a play titled *Castaways of Plenty*, and invited readers to a dance featuring "Modern and Old Time Music by a Real Cowboy Band."[54] Although Taylor's bid was a long shot, he did sneak past two strong competitors in the primary election. But he was soundly defeated—by some fourteen thousand votes—in the general election that year.[55]

In 1942, Taylor threw his hat in again for Idaho's second US Senate seat. By then, the Taylors had another son and Glen had left KSEI to work at a war plant in San Francisco, believing it was his patriotic duty to support the war effort. He ended up campaigning alone because Dora was busy with the new baby. With no band or family members to back him musically, Taylor relied instead on the western image he had cultivated as part of his musical pursuits. That June, he bought a saddle and a "blue rinse dapple gray Arabian" horse in Coeur d'Alene and took part in a marathon two-hundred-mile equestrian ride to Grangeville, stopping along the way at voters' homes and outdoor rallies. (He had originally intended to traverse the whole state on a five-hundred-mile ride.) Taylor added an element of patriotism to this publicity stunt by starting out his ride in the Coeur d' Alene Fourth of

July parade and pledging that the marathon trek was part of his effort to save gasoline for the war effort. "As you may imagine, the tongue-in-cheek story of a cowboy candidate so patriotic as to undertake a grueling five-hundred-mile ride to save gasoline was printed even to the far corners of the land," he wrote in his autobiography. He also made use of his western garb as an advertisement in itself: "Across the front back of my maroon shirt, Dora had sewn white letters, three inches high, which spelled TAYLOR, and under that, in two inch letters, SENATE."[56]

Along the way, Taylor mailed reports of his progress to the press and wire services. He ended up getting just enough regional and national press to bolster him in the primary.[57] In these updates, Taylor stressed his image as a man of the people by relaying stories about how, during the campaign ride, his hand was gruesomely lacerated while opening a barbwire gate, or how he had spent a day baling hay. Taylor also handed out "Saddle Bag Campaign Cards" on the 1942 trail that capitalized on his singing-cowboy image by featuring pictures of him with Stetson and banjo.[58]

Although his adventures were successful enough, media-wise, to see him narrowly succeed in the Democratic primary, Taylor had come under attack for his associations with Gillette's utopianism. Taylor's own political statements focused on more practical and mundane articulations of Gillette's vision—namely, finding a way to reopen factories closed by the Depression, coordinating the war effort, reducing unemployment, and better distributing the fruits of labor.[59] There was no talk of futuristic skyscrapers delivering automatic meals. Instead, he fretted that not enough crops and war materials were being produced to meet demand. In an interview with the *Pocatello Tribune*, he also argued it was a patriotic duty to centralize some aspects of industry along Gillette's lines in order to win the war: "Many of our production experts are saying our war effort will not reach maximum efficiency unless it is coordinated into one production effort," adding, "I agree with them but the people, not Wall street, must own it."[60]

Even watered down, Taylor's enthusiasm for Gillette did not go unpunished. In the 1940 campaign, he was redbaited by the press and

opponents, who generally made little distinction between Taylor's call for gradual changes and the authoritarian command economies of Stalin and Hitler.[61] Worse, in the final weeks of his 1942 campaign for Senate, a group of southwestern Idaho merchants began circulating a letter, widely reprinted in the press, arguing that Taylor

> had a scheme to wipe out all private business. He does not believe in the profit system. His philosophy of government is based on a book written by King C. Gillette's entitled 'The People's Corporation.'"[62]

Such assertions put Taylor on the defensive—he had to argue that his promises were not "communistic" but simply sought to make Allied war production more efficient.[63]

Attacks on his ideological influences also became an occasion for critics to dredge up criticism that a cowboy singer and a comedic stage performer could not be serious about or fit for office. Perhaps most devastating, his own local newspaper, the *Pocatello Tribune*, lobbied against him, arguing it was "not fitting that the senator from Idaho should pick a banjo and sing cowboy songs as an argument for his fitness as a national legislator."[64]

Faced with attacks on his vocation and accusations that he was a closet totalitarian, Taylor lost his 1942 Senate bid, but he significantly improved on his 1940 run by losing by less than five thousand votes. It wasn't until 1944 that he finally succeeded in obtaining a Senate seat, after teaming up with a new campaign manager and retooling his look. This time he toned down his campaign style, eliminating the music stops and putting away his western wear. Instead, he donned a conservative business suit and made an effort to reach out to both employees and employers. He also tempered the Gillette rhetoric and talked instead about creating an economy that mimicked the farm union and Grange "cooperatives" already familiar to many Idaho farmers.[65] Although it represented his arrival as a new and improved campaigner, Taylor's win in 1944 cannot be completely divorced from his growing national reputation as a hillbilly performer and marathon equestrian. Success that year would not have been possible if he had

not already established an image based on music, horse riding, and populist-utopian volleys at the rich and powerful. Once established in the public eye as a cowboy performer-politician, he was a known quantity who could them demonstrate his better graces with a new outfit and speaking style.

In the 1944 race, Taylor narrowly beat out his primary opponent, a conservative Democratic who was critical of Franklin Delano Roosevelt's New Deal reforms; but Taylor continued to face accusations that he was a "pink" or a "commie." Perhaps just as damaging were the continued accusations that his performing career marked him as lacking the seriousness, qualifications, and temperament to serve in such an important position. The Idaho Falls *Post-Register*'s endorsement of Taylor's Republican opponent in the general election was particularly brutal: "Glen Taylor comes before the people with a background principally of stage and radio entertaining, an honorable and essential business but hardly the type of experience and training that qualifies a man to represent the great state of Idaho in the United States senate."[66]

Despite such attacks, Taylor narrowly won the election, buoyed in part by late-breaking and perhaps opportunistic endorsements from Democratic politicians who had come to admire Taylor's style. His win made headlines in newspapers around the nation with a wire story in which he claimed to have beat out more conservative Southern Democrats such as W. Lee "Pappy" O'Daniel and Governor Jimmie Davis as "the first of the cowboy singers" to go into politics. "I was the first to start, and the last to get elected," he said.[67]

Once in office, Taylor reverted somewhat to form, occasionally dragging out the western wear, his banjo, and his horse. However, those occasions were rarer and usually connected with a specific political project. The 1945 "Home on the Range" stunt on the Capitol steps was certainly one piece of evidence that he might bring hillbilly music back more fully into his political pursuits. So, too, was his 1946 "Paul Revere Ride for Peace," which combined a cross-country equestrian marathon with stops that included solo performances of

country songs on banjo and guitar. Beginning his horse ride in Seal Beach, California, Taylor hoped to travel all the way to the East Coast to protest Truman's foreign policy efforts, which he argued were dividing the world into an American orbit and a Soviet orbit and were foolishly pitting the two superpowers against each other.[68] Claiming to have been influenced by Gandhi's fasts and marches, Taylor was particularly angered by the proposed Marshall Plan—he contended that it rebuilt Western Europe in a one-sided, American-dominated way. Taylor said that the Truman administration's hostile approach to the Soviet Union was also pushing potentially independent Eastern European nations further into Soviet orbit. Taylor sang covers of country songs and traditional favorites at his stops, including the self-penned "Cowboy Joe from Idaho." His ride ended in Texas when Truman called a special session of Congress to consider several foreign policy issues.[69]

For the most part, Taylor now made headlines by taking political stances: his support of civil rights for African Americans and of Jewish aspirations for a state in the British Mandate of Palestine; his belief that the FCC should increase the availability of licenses to small radio stations; and his hope to establish a TVA–style "Columbia Valley Authority" for operating dams and managing the Northwest's watershed system.[70] Perhaps most dramatically, he outflanked the new Republican leadership by being the first senator to call for the Senate not to seat arch-segregationist Theodore Gilmore Bilbo, Democrat of Mississippi, in protest of Bilbo's repeated calls during the 1944 campaign to disregard the civil and constitutional rights of African Americans. Taylor then joined with eleven Democrats and the new Republican majority to try deny Bilbo that seat. That measure was ultimately tabled by the full Senate. Bilbo, who had been suffering from oral cancer, died before the issue was raised again.[71] Perhaps most admirably, Taylor was arrested in 1948 in Alabama for refusing to use a separate whites-only entrance to a black church in Birmingham. Facing off against Birmingham's notorious segregationist police commissioner Eugene "Bull" Connor in the press, Taylor was given a reprieve when

Alabama governor Big Jim Folsom—a nonperformer who used country music consistently in his own campaigns—refused to seek extradition.[72]

Despite the leading role Taylor played in several of these initiatives, critics continued to combine attacks on his loyalty with depictions of him as flighty, rootless, and temperamental. Noting Taylor's difficulty in getting Truman or the Democratic Party's support for leadership positions in the Senate despite the fact that he generally towed the party line, national columnist Holmes Alexander diagnosed him as a "hammy humorist" and "lightweight thinker" who was "strangely shy" for an actor and "sensitive about his lack of education and previous unsuccess in the world."[73] A Texas paper suggested that Taylor, with his "cowboy pants, boots and sombrero," presented himself as "non-senatorial" on the peace ride. Furthermore, since Taylor seemed to be repeating on the ride what warmongering "Russian diplomats" had said, he was either a witting dupe of the Soviets or a maladjusted, hysterical individual who needed "some device to attract attention and make headlines."[74]

Such criticisms followed Taylor and became even more biting once he switched parties and ran as Henry Wallace's vice presidential running mate on the Progressive Party ticket in 1948. Already dissatisfied with Truman's foreign policy, Taylor viewed the campaign as a way of highlighting issues neglected by the Democratic Party and to push for what he viewed as the more liberal or utopian legacy of Roosevelt's New Deal. Democrats worried the move would split the liberal vote and allow Republican Thomas E. Dewey an opportunity to thwart the reelection of Truman.

Accusations that Taylor was emotionally unstable and a Red continued from both sides of the aisle, but with renewed ferocity from liberals and Democrats. Marquis Childs—the same columnist who once praised Taylor—focused on Taylor's western roots, painting him as a paranoid, Agrarian populist "actor with a large streak of ham" who advocated a version of Gillette-inspired economic system that loosely resembled the "corporative state of Italian Fascism." The national columnist went on to argue that the anticapitalist streak of

this "frustrated, intensely ambitious, headline-seeking individual" was grounded in the western American tradition of harboring anger at railroads and making angry denunciations of "soulless corporations."[75]

The Wallace-Taylor campaign itself was a return to form for Taylor in many ways. Music played a large, unprecedented role for a presidential campaign, for one. Although presidential campaign songs extend as far back as "Adams and Liberty," the Wallace-Taylor ticket ensured its rallies would be accompanied by music in a particularly enthusiastic and modern way: the campaign hired People's Songs, a group of left-wing folk singers that included Pete Seeger, Woody Guthrie, Alan Lomax, Agnes "Sis" Cunningham, and Josh White. As a sort of outside vendor composed of singers and musicians who had a particular passion for the Progressive Party message, People's Songs proved an enthusiastic ally, sending individual musicians out with Wallace, Taylor, and their representatives at speaking events on the trail and helping organize a folk, blues, and pop extravaganza of sorts at the national convention in July 1948. Its weakness perhaps lay in the fact that many in the People's Songs lineup had associated with civil rights and labor organizations that critics claimed were front organizations for the American Communist Party.

Despite the fact that the press generally attacked Progressives as being quixotic idealists or dupes misled by Communist interlopers, reporters did praise the way organizers had brought music into the fold. "The opening session gave promise that this would be the most musical of all national conventions," wrote a *New York Times* political reporter. "The singing was led by an inter-racial volunteer chorus with the delegates joining in on many of the folk songs."[76] National columnist Thomas L. Stokes similarly argued that, despite the party's dim electoral hopes, the Philadelphia convention "was the most spirited and spontaneous of the three national political conventions in this city" that year.[77] Indeed, there was something profoundly revivalistic about the fervor with which music was used on the campaign. Sure, previous presidential contenders had had strong campaign songs and had convinced significant figures in the music world to write and per-

form for them, but recordings and news coverage of the 1948 convention suggest that this was the first campaign—perhaps since the height of the Populists' popularity—to weave musical performances and even sing-alongs into very fabric of the event rather than just using a brass band to highlight the appearance of dignitaries or an occasional vocal performance to provide a sort of break for reflection between impassioned speeches.[78] The Progressives' staging of the event set the scene for the way the mainstream parties were able to use television and its combination of word, image, and music in campaign jingles and songs in 1952 and beyond.[79]

Historical accounts of the collaboration between the Progressives and People's Songs generally argue that Wallace's inner circle hired People's Songs and dealt directly with only two People's Songs individuals: famed folklorist Alan Lomax, who handled musical arrangements for the campaign, and Mario "Boots" Casetta, a People's Songs staffer who maintained an office at Progressive Party headquarters.[80] People's Songs cofounder Pete Seeger recalled that there was little interaction between performers and the candidates because the Progressive Party handlers were afraid that the People's Songs musicians were potentially too close to Communist Party members and that close connections with the songsters might besmirch the campaign.[81] Taylor's autobiography and biographies of Wallace are silent about the music issue; Taylor's son Arod remembers meeting Seeger and Paul Robeson, but not spending an especially large amount of time with the performers.[82]

Nevertheless, there seems to be some evidence that Taylor may have played a bigger role in working with music on the campaign, or may have been instrumental in the decision to hire People's Songs in the first place. Taylor seemed to have at least some prior connection with the People's Songs well before he had even considered such a run. Photographs of Taylor singing with People Songs' cofounder Pete Seeger, for instance, appear among a collection of images shot by a *Life* magazine photojournalist who covered the Congress of Industrial Organization's political action committee school in July 1946.[83] Arod Taylor said he has always suspected that his father may have played a

central role in the decision to hire People's Songs.[84] Furthermore, it would seem odd that Taylor—who had a significant stage and musical background and who had worked carefully with Idaho Democrats to put more life into their conventions—would have been completely removed from decisions the hiring process of music along the trail.[85]

At individual campaign stops, Taylor regularly sang and appears to have worked very closely with the People's Songs musicians that the campaign assigned him. He took the stage with folk singer Michael Loring at stops in Idaho and with Pete Seeger at rallies in Kansas and Iowa. At a stop in Iowa, he not only appeared with Seeger, but was photographed taking the stage himself to sing a few songs with his wife Dora and sons.[86] The *Modesto Bee* even noted that Taylor, Dora, and Arod "demonstrated their idea of the bipartisan foreign policy" by singing "different popular songs all at the same time" as part of the trio's occasional penchant to use partner songs as a means of entertaining crowds.[87]

At the convention itself, the Taylors played a substantial role by performing a song after Glen's acceptance speech before thirty thousand at Shibe Park.[88] The four sang "When You Were Sweet Sixteen," a Tin Pan Alley composition published in 1898 by Irish American songwriter James Thornton.[89] A lighthearted love song, the number had been given new life the year before when Perry Como turned it into a hit.[90] Glen Taylor sang lead vocal, with Arod, Dora, and second son P. J. harmonizing on the chorus.[91] Although some commentators applauded the effort, the performance also elicited heckling from the press who viewed it as amateurish and portrayed it as a yet another example of Taylor's egotism and lack of decorum. Despite having earlier applauded the People's Songs performances in his newspaper column, Norman Thomas—a longtime Socialist presidential candidate and anticommunist critic of the Progressives—argued Taylor had enlisted his kin in an "excruciating barber-shop family quartet which he inflicted upon millions of Americans listening in on the radio."[92] Thomas connected the attempt at drumming up emotion before such a large outdoor crowd with the rehearsed mass psychology of a Nazi or Soviet rally.

The Progressive Party, however, did not go far, finishing fourth in a crowded field of mainstream parties and plausible new contenders. Truman won the race, beating Republican Thomas E. Dewey despite challenges from the Progressives on the left and the Dixiecrats on the right. The Wallace-Taylor ticket took only 1.1 million votes—mostly from the coasts and industrial centers, and less than 3 percent of the vote nationwide. The Wallace vote was about twenty-thousand votes less than that garnered by Strom Thurmond, the prosegregation Dixiecrat candidate who managed to earn thirty-nine electoral votes because his support was concentrated in less-populated Southern states. Nevertheless, the Progressives could have tipped the election to Dewey had they scored slightly better in Ohio, California, and Illinois.[93]

After the election, Taylor finished his term as senator and even achieved some level of reconciliation with Truman. Nevertheless, his decision to run on the third-party ticket and the accusations that he was an unserious politician and a pink continued to dog him. He caucused with the Democrats but was still treated as a traitor by many. Facing hostility from the leaders of the Idaho Democratic Party, he ran for reelection in 1950. This time Taylor hired a "western country music" band, the Idaho Ramblers, to do the performances. The Ramblers featured a steel guitar player who seemed to inaugurate a full turn toward the national western swing craze among hillbilly performers.[94] Taylor lost in the primary, a bitter and close election in which he asserted, with some evidence, that votes had been tampered with.[95] After two additional unsuccessful attempts to crack the Democratic primary for the Senate, Taylor finally retired from politics and moved to northern California, where he opened a successful business that sold Taylor Toppers, a special toupee that he had designed in part to hide his own baldness on the campaign trail.[96]

Ultimately, Taylor's topsy-turvy political-musical career has some lessons to teach about the history of country music and of liberal and left-wing American politics. Perhaps too much emphasis has been placed on country music as a Southern phenomenon, if a band as far west as Idaho could develop the listenership needed to help catapult a

musician to a senatorial seat. Although there were certainly elements of Southern culture that emerged within the Taylors' music—echoes of Jimmie Rodgers in particular—it is clear that mountain westerners were already developing a taste for a mix of music, a soft-shell amalgam that blended the sound and images of westernness promoted by radio, Hollywood, and Tin Pan Alley with local manifestations of music and culture. Additionally, as with O'Daniel and Davis, rural radio proved an effective alternative means by which candidates outside the local establishment might reach voters—at least, before the monopolization of the spectrum by conglomerates. Finally, country music could prove an excellent medium for a liberal or left-wing candidate to stress a connectedness with voters, but it could also be a double-edged sword: having a performing or broadcasting or cowboy background might extend one's appeal while building a political career, but it also could prove a liability. All performer-politicians face accusations of fickleness and artistic temperament to some degree. But it may just be that candidates with optimistic liberal or utopian political platforms are more susceptible to such attacks than conservatives and others.

Dixie-Bent and White House–Bound

Regional Culture, National Aspirations

I'd probably run for President of the Southern States.

HANK WILLIAMS JR., LYRICS, "IF THE SOUTH
WOULDA WON," 1988

★ 6 ★

A Fiery but Fickle Faith

The Vanderbilt Agrarians, Southern Politics, and the Country Music Memoir

N ew York intellectual Irving Howe once observed that the Southern writers known as the Vanderbilt Agrarians started from "a difficult intellectual position": "They were contemptuous of magnolia romanticism, but shared the hostility of their people toward Northern urbanism."[1] Such a pronouncement might just as easily be applied to the songwriters who have peddled their wares for decades on Nashville's Music Row, not far from Vanderbilt University. In country song, stark minimalist descriptions of disillusionment, hurt, and brokenness often reign, laying bare the hollowness of modern industrialism and urban life. Workers in gleaming factories are reduced to petty thieves eking out a living one piece at a time, while the coal miners fueling the infernal engine of modernity only grow older and deeper in debt. The vapor-lit streets of cities from Baltimore to Bakersfield shine brightly at first, but soon devolve into low places, full of whiskey lullabies and heartaches by the number—impoverished, overly industrialized sin cities where even your cheating heart will tell on you. In such places, one might sing Dixie, as Dwight Yoakam reminds us, but only as an elegy for a dying alcoholic deprived of his "rebel pride."

That the lyrics of country music and the poems and novels of the Agrarian writers share some common ground is not a novel obser-

vation. H. R. Stoneback—a poet, literary scholar, and country song-writer who bridged the two worlds in a way that few others could—even envisioned writing a book about how the Vanderbilt Agrarians, one of the most well-recognized literary movements to come out of the South, ended up being "exactly coincident and contiguous, geographically and historically, with the Grand Ole Opry and the evolution of hillbilly and country music."[2] Stoneback, who was immortalized in Austin country performer Jerry Jeff Walker's 1970 bromance song "Stoney," certainly has a point.

The Vanderbilt Agrarians were a group of Nashville-based writers that included most famously Robert Penn Warren of *All the King's Men*. They began their ascent with their *Fugitive* literary journal just a few years before the local WSM radio station began broadcasting *The Grand Ole Opry* in 1925. WSM at that time was located just two and half miles away Vanderbilt University, where many of the "Southern Renascence" writers studied or taught. The Agrarians reached out to a national audience in 1930 with the publication of their more political manifesto, *I'll Take My Stand: The South and Agrarian Tradition*, around the time that WSM began broadcasting at 50,000 watts, hitting a large swath of North America with its increasingly popular Opry program. Into the 1940s, individual Agrarians, many spanning out to other cities and the North, achieved national literary attention at the same time that Opry performers broadcast over NBC Red were becoming household names. Ernest Tubb's "Rainbow at Midnight," for instance, was released the same year that Warren published *All the King's Men*, his Pulitzer Prize–winning novel about Huey Long.

Despite toying with putting together a book about the Agrarians, Stoneback stated that he preferred penning and singing songs, not writing about them. Nevertheless, he remained fascinated by what he saw as the shared values of Music Row and literature's Southern Renaissance:

> The images and themes of the Vanderbilt Agrarians—evoking love
> of the land, sense of place, sense of the past, sense of family, sense

of community, and a fundamentally religious sensibility rooted in an inburnt knowledge of good and evil, love and betrayal—were shared by the other Nashville Agrarians: the singers, writers, producers, and fans of Country Music.[3]

While Stoneback may be correct in noticing connections between country lyrics and Agrarian writing, in reality the political projects of country music's star performers and singer-songwriters have often had little in common with the political goals expressed in *I'll Take My Stand*.[4]

Perhaps this should come as no surprise. Agrarian writers had a love-hate relationship with the music genre they shared a city with from the very beginning, developing a critique of popular music more generally and country music in particular that foreshadowed the more strident attacks on popular music culture unleashed by later thinkers such as the members of Frankfurt School. In their original 1930 manifesto, the Agrarians assailed the commercialization of music, and they continued to criticize country music into the 1940s. Although the group—especially poet and professor Donald Davidson—was enamored with elements of the burgeoning country music industry, they continued to rebuke country music performers who used Southern folk culture to promote themselves economically and politically, and only in the 1950s began to fully admit that the genre might provide a means for maintaining traditional music culture.

Songwriters, performers, and producers of country music also have regularly shunned central tenets of Agrarian political thought. Although country music performers may have shared some values with this more elite literary school, when our focus moves from a vague sense of values to the more concrete set of political goals the Agrarians proposed (especially in their 1930 manifesto), we see the musicians doing some rebuking of their own. Indeed, despite the presumption that the two groups organically and independently came to parrot each other in their views on regionalism and traditionalism, when we analyze the closest thing to *I'll Take My Stand* in coun-

try music—that is, country music autobiographies and more recently political polemics ostensibly penned by country music mainstays and chart toppers—we find a wide gap. More often than not, when country music performers sit down, often with ghostwriters, to write their own stories or articulate their own views in book form, they find themselves at loggerheads with central facets of the Agrarian project—regularly heaping praise, for instance, on specific elements of growth in government and big business that the original Agrarian manifesto excoriated.

This does not mean that there is no contiguity between Agrarian thought and the sentiments expressed in the autobiographies and political polemics of country musicians, which reach hundreds of thousands of fans and which no doubt influence or subtly shape voter perspectives. Indeed, at times it is surprising how closely stars who, to outward appearances, have little to no awareness of the Agrarian literary school seem to parrot certain aspects of their argument, but such instances are often wrought with caveats and other examples that bolster the counterarguments.

To a large extent, this divergence appears to be a product of the different economic and social worlds that country music personalities and the literati operate in. When country music performers write less critically about—or, in many instances, praise—big government and big business, they do so because of the immediate benefits that such enterprises seem to hold for their financially strapped families while they were growing up or when they started out as performers. This is not to say that the Agrarians lived lives free from economic or social adversity. Indeed, many suffered the plight of the poor artist even if they enjoyed familial connections and access to economic resources that went far beyond what poorer country performers could claim in early life. Rather, they took issue with such developments of modern life because they had time to contemplate larger social structures and time to read enough to develop more romantic notions about the connections between past and present. In doing so, they came to see the large, impersonal nature of business and government as a threat to

everyday social life. For many performers, these sectors offered the very means of navigating out of a dreary, hardscrabble life.

The Agrarian literary school emerged for the most part as an outgrowth of a group of writers and poets at Vanderbilt University who were involved in publishing the *Fugitive*, a journal of the early 1920s that featured literary criticism and poetry. The Fugitive Poets—so called because they styled themselves as enlightened renegades who sought nothing more than to flee from the "high-caste Brahmins of the Old South"—began meeting informally as a group of professors, teachers, students, and local businesspeople in 1915. Playwright Sidney Hirsch, a figure who helped establish the image of Nashville as a cultured "Athens of the South," was instrumental in arranging these meetings, which took place at the homes of relatives with which he was residing. In 1922, the group began publishing their work in a journal that took up the Fugitive name, with the stated goals of eschewing sentimentalism and extolling regionalism as a subject and style of literary practice.[5] Central to the new journal were up-and-coming journalist and poet Allen Tate, Vanderbilt literature professor Donald Davidson, and established poet John Crowe Ransom. During the three years it was published, the *Fugitive* developed a national reputation for poetry. Ransom contributed significant poems such as "Bells for John Whiteside's Daughter" and "Necrological," while new contributors such as Robert Penn Warren, a student at Vanderbilt, and Laura Riding, the wife of a history professor at a nearby college, submitted important poems such as Warren's "A Face in the Crowd" and Riding's "Dimensions."[6]

Several Fugitives—including Ransom, Tate, Warren, and Davidson—continued meeting in the late 1920s and began putting together a symposium on Southern literature (fig. 6.1). By 1929, that original symposium turned into a full-fledged book project: a collected set of essays that would address not just literature but the entire social condition of the modern South.[7] Joining the four Fugitives, who specialized mostly in writing novels and poetry and teaching literature, were

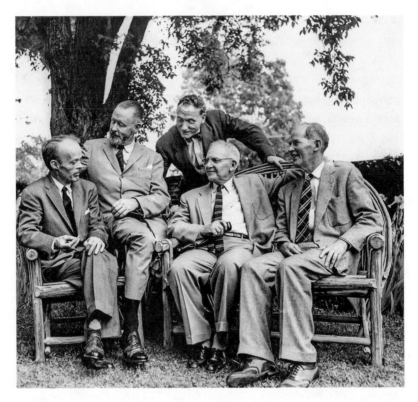

6.1 The Vanderbilt reunion of the Fugitives in May 1956. Pictured are (left to right) Allen Tate, Merrill Moore, Robert Penn Warren, John Crowe Ransom, and Donald Davidson. Fugitive and Agrarian Collection, Vanderbilt University Special Collections and University Archives.

scholars located more in the social sciences, such as psychologist Lyle Lanier and historians Frank Lawrence Owsley and Herman Clarence Nixon, as well as non-Fugitive poets and novelists such as Andrew Nelson Lytle and John Gould Fletcher.[8]

When the fruit of this work, *I'll Take My Stand*, was published by Harper and Brothers in 1930, it was preceded by a "Statement of Principles" to which the twelve contributing writers all nominally agreed. The South, these "Twelve Southerners" argued, had been maligned and misunderstood. An agrarian society at heart, the region faced an onslaught of industrialization from the Yankee North that exacer-

bated economic inequality, reduced work to an unfulfilling drudgery, and promoted meaningless consumerism. Traditional political divisions were powerless against this tide, they argued. Capitalists and socialists offered no more than a Band-Aid by relying on "the benevolence of capital, or the militancy of labor, to bring about a fairer division of the spoils." Industrialists, they said, were the "true Sovietists" because they sought to establish a larger social and economic structure that would replace traditional government with an "economic super-organization, which in turn would become the government." The only way to offset the creeping totalitarianism of the factory and mill was to reshape society along an agrarian model, with agriculture as the primary occupation.[9]

The rest of the book was composed of individual essays examining Southern identity and the impact of industrialization on art, schooling, religion, economy, race relations, and culture. Big business and big government were frequent targets. Davidson, for instance, argued that, under the industrial regime, art had been turned into a mere commodity and the museum into a feeble program for uplifting the working masses; Fletcher insisted that state-controlled education had reduced Southern schools from places devoted to humanistic inquiry and character-building to diploma mills that stressed testing and passage rates over actual achievement. Other essays took up the banner of the "lost cause" of the Old Confederacy by repeating historical inaccuracies about the white South's record on slavery or whitewashing elements of its racist past. Owsley, for instance, argued that slavery had been forced upon the South and that southern slave owners abided by the institution only to keep order, while Warren argued inaccurately that black state legislators in the Reconstruction era were mired in corruption (a stance at odds with his later advocacy of the civil rights movement).

I'll Take My Stand turned out to be something of a blessing and a curse to those involved. It helped catapult several of these writers to the national literary stage, served as a launchpad for the important New Criticism literary approach, and helped usher in an age when Southern writers finally could be taken seriously by the critical estab-

lishment, thus sharing or setting the stage in some ways for riptides created by the likes of William Faulkner, Flannery O'Connor, James Agee, and Eudora Welty. On the other hand, the volume's apparent apologia for slavery and segregation came to haunt many of the writers, some who later disclaimed their earlier views and a few who continued to cling to these positions in later years in relative isolation.

Two essays in *I'll Take My Stand* addressed the issue of music directly: one by writer Andrew Nelson Lytle, which supported the revival of traditional Southern and agrarian ways in farm life, and one by Davidson, which focused on criticizing the ways in which commodification and industrialization had affected art. Both essays praised traditional, organic musical folkways and heaped significant scorn on commercial music industry, although the burgeoning country music industry in Nashville was not singled out for criticism. Lytle wove his exploration of traditional music and dance into a lengthy passage that depicted and celebrated the average day on a farm that employed only traditional methods of agriculture. After a hard day of work, Lytle contended, rural people would let off steam with a variety of musical pastimes: the singing of religious "shape note" songs, interactive play-party songs, couple's square dances, and traditional fiddle tunes. Although each of these had a strict purpose (shape note singing competitions required a kind of federalism where regional leaders led a song, square dances allowed each couple a time in the spotlight, etc.), they all lent themselves in one way or another toward creating strong ties between the individual and the community without emphasizing commercialism. Lytle juxtaposed this cohesive entertainment with an unnamed urban form of entertainment that he argued "prostitute[d] society" by making monetary exchange a part of the interaction.

Lytle's conclusion, which promoted regionalism as a cure for the soulless homogeneity of modern life, touted resisting "industrial imperialism" by returning to traditional crafts and farming and spurning technological entertainments. "Throw out the radio and take down the fiddle from the wall," he advised in an oft-quoted section of the essay. "Forsake the movies for the play-parties and the square dances." Only a return to traditional musical and agricultural ways

would allow rural people to break free from industrial misery, he argued, presaging in some ways such antitechnological calls to arms of the 1970s as John Prine's "Blow Up Your TV" track and the "Kill Your TV" bumper stickers popular in that decade. Although Lytle railed against the kind of social engineering involved in modern farming, the essay strangely took on an almost sociological tone by making a case for traditional music, emphasizing how it led to various complex and beneficial forms of social intercourse.[10]

Davidson's essay was the only contribution to consider commercial music at some length, although his focus was relegated almost entirely to the way popular songs and popular jazz had become artless and mass-produced:

> Henry Ford's hired hands do not hum themes from Beethoven as they work. Instead, the shop-girl reads the comic strip with her bowl of patent cereal and puts on a jazz record as she rouges her lips. . . . The industrialists in art—that is, the Hollywood producers, the McFadden publications, the Tin Pan Alley crowd, the Haldeman-Julius Blue Books—will naturally make their appeal to the lower common denominator. They know the technique of mass-production, which, if applied to the arts, must invariably sacrifice quality to quantity.[11]

No mention was made of hillbilly music, folk songs, the blues, or other more regionally specific Southern music genres; and, although Davidson would later tout some aspects of the hillbilly performance tradition as being important manifestations of regionalism, he never entirely left behind the argument that mass-produced music was necessarily inferior.

Davidson's mention of Henry Ford's workers and their leisure time pursuits deserves some attention here. In many ways, the Detroit carmaker, Lytle, and Davidson drank from the same well of antimodernism that viewed mass-produced culture as a cheap and inferior imposter compared with the fine or folk arts. But the ends that Ford and two writers proposed were drastically opposed. Davidson and Lytle

viewed the mass-produced culture and the musical ditties they de-spised as the logical byproduct of the entire corrupt and degrading system of automation and mass industrialization that they reviled—and which Ford inevitably represented. Getting rid of mass industri-alization would lead to a return to purer, more authentic forms of culture, Davidson in particular seemed to argue. Ford, on the other hand, attacked Tin Pan Alley and Hollywood because they fostered new and "foreign" cultural influences that he felt were incompatible with the industrial work routine by which he reaped his enormous profits. These forms of popular culture were symptoms of a chang-ing and modernizing culture that needed to be excised in order for workers and the broader society to reap the full benefits of unbridled industrialization.

Davidson's distaste for the carmaker was palpable. He savaged Ford, for instance, in a review of Ford and collaborator Samuel Crowther's *Moving Forward* in a weekly literary column in the Nashville *Tennes-sean* the same month that *I'll Take My Stand* was released. "Ford doc-trine"—or "Ford-ideas," as Davidson called them—were rooted in "a very pinched and narrow view of life," where the world was no more than a "gigantic Ford factory" in which people manufacture Ford auto-mobiles for the "sole reason of getting money" to buy more cars and more consumer goods. Fordism, he argued, led to uncertainty and chaotic competition between manufacturers, prompted consumers to "spend and spend unceasingly, in order to consume the never-ending stream of new products that industry hurls upon them," and eventually left workers idle, poor, and unemployed "milling painfully around our industrial centers." Despite his opposition to statist solu-tions, Davidson even cited left-wing poet, journalist, and labor advo-cate Marion Clinch Calkins to make his point, contending that the Calkins' *Some Folks Won't Work* was "a sharp and distressing study of unemployment" that provided strong counterarguments to Ford's "glib assurance."[12]

Davidson argued that even Ford's conservatism was unhinged. To him, Ford's traditionalism and antiquarianism was merely window

dressing for business, possessing no connection to the human realm of relationships and aspirations beyond the fiduciary:

> Of professional life, of politics and government, of housekeeping, lovemaking, motherhood, fatherhood, literature (to say nothing of philosophy and religions and such pleasant trivialities as conversation and good digestion), Henry Ford takes no account. And we may presume, from his childish comments on Prohibition and his naïve views of leisure, that he has no thoughts on these various subjects and no valid information about them. His theories of manufacture are all tied up with his views of life, which have the simplicity of fanaticism.

To top it all off, Davidson compared Ford, in the essay's concluding paragraphs, to the boogeyman of all boogeymen to white Southern patriarchs: abolitionist and insurrectionist John Brown. He stated that Ford, like Brown, sought "to disrupt a whole nation by offering its citizens" a quick fix to a thorny problem. Ford, he argued, was offering "precisely the same temptation that Satan offered Christ."[13]

Despite Lytle and Davidson's rather dim view of popular and commercial music, the very name of *I'll Take My Stand* stems from "Dixie's Land," a song so ubiquitous and commercialized that its chorus now invokes an almost cartoon-like depiction of the South in the minds of many listeners. That song is usually attributed to northerner Daniel Emmett, the nineteenth century's most famous white performer of blackface minstrelsy, the custom of white performers blacking their faces with burnt cork and performing insulting comedic skits that questioned blacks' intellect or made degrading implications about black sexuality. Seemingly narrated by a former slave, the song seems in part to poke fun at the relationship between a master and his missus, but also waxes nostalgic about how life on a presumably Southern plantation provided better amenities than what the freedman is experiencing at his current abode: richer food ("buckwheat cakes" and "Injun batter"), stronger relationships, and beautiful surroundings.

Den I wish I was in Dixie, Hooray! Hooray!

In Dixie's Land I'll took my stand [later changed to "I'll take my stand"],

To lib and die in Dixie.[14]

Several theories abound about how Emmett (if he in fact authored the song) came up with the term *Dixie,* including the possibility that it was simply a reference to the Mason-Dixon line or that it might relate to the issuance of "Dix" script by a New Orleans bank. At least one source suggests that the name came from "a negro's paradise on earth," a plot of land on Manhattan Island owned by a Dutch farmer named Dixie who was renowned for treating slaves particularly well.[15] The song nevertheless ended up being adopted by Confederate troops during the war, becoming something of an unofficial Confederate anthem.[16]

Even with the song's possible alternative understandings, the decision by the Agrarians to draw their title from a song that was usually interpreted as a celebration of the Southern plantation system marked the Twelve Southerners as staking out a defiant and backward-looking position. This was not just "taking a stand"; it was also pledging one's commitment to the kind of nostalgic, agrarian, and arguably racist vision suggested by the song ("I'll take my stand / to live or die in Dixie"). Taking a stand, too, seemed to connect with the prickly independence the Agrarians seemed to promote, the unwillingness to take a back seat to Northern critics such as H. L. Mencken, who famously depicted the South as a cultureless "Sahara of the Bozart" in his famous 1917 essay. The rosy picture of slavery painted by the song also seemed to connect with what essays such as Owsley's and Warren's maintained.

The contributors themselves were divided about the title. Tate, Warren, and Lytle worried that it would turn off readers and prompt critics to dismiss its politics as fiery and retrograde. They argued for a vote among the twelve contributors on whether to jettison the title. Tate was perhaps the most forceful: "It makes my ears burn. It is a breach of decorum in my mind beyond any rationalization."[17] The

title was defended by Ransom and Davidson, who contended it was too late for the publisher to change the name and that borrowing the title from "Dixie's Land" was not cause to be "startled" but rather a bold move that took nothing away from the book's worth or presumed complexity:

> We hold that we are not quoting the whole of the song Dixie; that the song Dixie is not so disreputable as you hold; and that even the full total of the associations of the song Dixie, both private and general, which an enemy might seek to fasten upon us, will not do any particular damage.

Ultimately, Ransom and Davidson worked to calm the fears of their compatriots and ended up retaining the title.[18]

Interestingly enough, the thing not debated was the song's actual connection with the sale of broadsides and use in thousands of commercialized endeavors. Indeed, it reeked of the kind of commercialism that the Agrarians themselves despised. Within country music tradition and even the wider expanse of American musical culture, "Dixie's Land" never seemed to lose its general appeal. It remained a relatively popular tune at the time of *I'll Take My Stand*'s release, appearing on recordings by such popular bands as Gid Tanner and His Skillet Lickers in the late 1920s and the Yellow Jackets in the 1930s.[19] Throughout the nineteenth century and far into the twentieth, it remained a highly bowdlerized, easily parodied and re-adapted, and even overexposed song, the kind of hypercommercialized ditty that Lytle and Davidson seemed to excoriate in *I'll Take My Stand*.[20]

As time went on, the Twelve Southerners went their separate ways and for the most part tabled their respective interests in traditional music culture or country music. When they did incorporate themes about traditional song into their writing—Warren's 1959 novel *The Cave* comes to mind—they generally tried to rehabilitate Southern music as something akin to literature, not emphasizing its sociological or salvific functions in creating an agrarian utopia. Loosely based on a real spelunker who got lost and died in a cave in Tennessee in

1925, that novel, H. R. Stoneback argues, used the double entendre common in old Southern religious hymns to explore subjects such as teenage sexual experimentation, while later the book alludes repeatedly to the melancholy honkytonk of Hank Williams Sr. to examine the loneliness of the cave and solitary life struggles each human being must face.[21] Warren's novel seems to echo Lytle's view in *I'll Take My Stand*: that old music and worthwhile new contributions should be learned and preserved, though not for their socially cohesive properties, as Lytle had contended, but for the way they poetically illuminate the perilous and the mundane for the individual in daily life. Warren by then had become much less enamored with the Agrarian project, particularly its racial politics, setting himself up as more of a quieter regionalist who saw some worth in preserving Southernisms without continuing the Agrarian project of a major socio-agricultural makeover.[22]

Of all the Agrarians, Davidson was the one to maintain, well beyond the 1930s, a robust and committed interest in Southern musical traditions and their connections to commercialization and the Agrarian project. However, he also perhaps was the most stubborn in adhering to the types of defenses of Southern race relations outlined in *I'll Take My Stand*. Davidson's interest in country music culture was expressed most clearly in the 1940 essay "Current Attitudes toward Folklore" in the *Tennessee Folklore Society Bulletin*, which was later revised and reprinted in his important 1957 collection of essays, *Still Rebels, Still Yankees and Other Essays*. His earlier, more skeletal 1940 version of the essay comes off as relatively dismissive of commercially produced country music, but by the time he amended the essay for the 1957 volume, he apparently had made his peace with local music industry, acknowledging its role as a better conduit for preserving folk tradition than academic studies or urban folk recordings.[23]

The 1940 version of the essay—like his treatise and Lytle's in *I'll Take My Stand*—casts aspersion on commercialized culture and expressed a general appreciation for authentic folk tradition, but went a step further by identifying four possible ways of reclaiming it. Davidson outlined what were becoming common criticisms of efforts to pre-

serve folk culture in an age of mass media. "Historical-Scholarly" collectors such as Francis James Child and Cecil Sharp preserved, but also entombed ballads away from actual life in the halls of academia, while "Enthusiastic-Promotional" promoters such as Alan Lomax bastardized the music by adapting and curtailing it to fit the needs of a fickle urban audience. A third category of full-fledged "Commercial-Exploitive" promoters and musicians at least invited us "to witness folksong impinging fruitfully upon art-song" by means of new artistic material created from old folk themes; but this category also engaged in a "vulgarizing process" by constantly demanding new and often inferior material.[24] Here the anti-Marxist and staunchly regionalist Davidson anticipates the arguments made by the Marxist, internationalist Frankfurt School of the 1940s, especially Theodor Adorno and Max Horkheimer's contention that the culture industry "infantilized" audiences by getting them to clamor for constant novelty and repetitive, inferior "pseudoindividualized" creations.[25]

Davidson concluded his 1940 essay by arguing that the ideal type of preservation effort, a fourth and yet-to-be-named category, would involve actually singing, learning, and performing old ballads. Adherents to this fourth category could even create new folk songs as part of this process as long as they could forswear any authorship or monetary compensation—an idea in keeping with the larger Agrarian dream of protecting culture from industrial and market forces: "We must be nameless, we must let the song go, we must set up no copyright claim."[26] Although on the surface, the professorial and sometimes dour segregationist Davidson had little in common with bohemian, left-wing folk singer Woody Guthrie (himself recorded and promoted by Alan Lomax), Davidson's prescription neatly dovetails with the folksy anticapitalist arguments made by Guthrie, who encouraged workers and common people to sing and wrote disparagingly of copyright claims. Guthrie, for instance, wrote on one of his songbooks in 1937 that a specific song was "copyrighted by us. And if we ketch you a-singin' it, we'll shake yore hand like it was never shook before, 'cause anybody we ketch a-stealin' our material, we figger they must like it. . . . We don't care who sings it, swings it, yodels it,

prints, or uses it to start a fire with."[27] Despite the ideological gulf that separated them, one wonders whether Davidson might have also begrudgingly agreed with Guthrie that "little pockets" of hillbilly music "guerilly fighters" would have been a better musical choice for the 1948 Progressive Party convention than the pop and folk-pop performances that were actually booked.[28]

In the seventeen years between initial publication of the essay in the bulletin and its later publication in book-chapter form, Davidson had even begun to develop something of an appreciation for Nashville's burgeoning music industry. The early version of the essay heaped considerable scorn on commercial hillbilly music, stating that it was often guilty of the most significant excesses of the "Commercial-Exploitive" mode:

> At its worst, it gives us the hill-billy singer and the hill-billy band, from whom we generally only get the lower levels of folk performance, and very rarely any performance that reflects the genuine worth and dignity of folksong. Radio performances by hill-billy singers notoriously run to sentimental ditties and hardly ever to the true ballad, the real convincing folksong.[29]

By the release of the much more widely read 1957 edition of the essay, though, Davidson recognized that WSM's *The Grand Ole Opry* radio program—the "great originator and popularizer of hillbilly music"— had begun at a "genuine folk level" with groups performing genuine folk songs and fiddle tunes. The problem, as he saw it, was that commerce had interfered by constantly demanding that musicians come up with new material, "quasi-folk songs and frankly popular ditties" that "run to sentimental numbers, and hardly ever to the true ballad, the real convincing folksong."[30] This edit in particular signaled a dramatic transformation in the depth of his knowledge of and sympathy toward country music. By noting that the country music institutions had helped spread folk tradition, caveats and all, Davidson signaled an important attempt to make peace with the industry two and half miles down the road. He did remain skeptical, but was willing to admit that

country music could very well be a leader in his fourth category, the yet-to-be-named group who could transmit old folk songs as well as create new ballads of worth.

Davidson did not stop here. His one attempt at a novel—the post-humously published *Big Ballad Jamboree*—actually featured a hillbilly singer as its hero. Written in the 1950s, the novel was in many ways an effort to dramatize and expound upon the general principles outlined in the "Current Attitudes toward Folklore" essay, but it also provides ample evidence of the extent to which Davidson had warmed to his music-industry neighbors. Davidson juxtaposes his hero Danny MacGregor, a budding young hillbilly singer who grew up listening to his kin sing the old songs, with the attractive, ambitious, but like-able Cissie Timberlake, a graduate student in folklore studies. Timber-lake convinces MacGregor to lug her heavy recording equipment out to the boondocks so she can record elderly people singing traditional songs. Though the two go through their travails and at times Danny wonders whether Cissie is really capable of returning his affections, Danny learns the value of recording the old tunes from Cissie and Cissie learns the value of being flexible and true to one's roots from Danny. The two of course find love at the end, bringing together academic preservation, commercial performance experience, real, living vibrant folk culture, and ultimately the creation of valid new expressions of folk tradition.

Davidson contrasts these two lovebirds with a cast of miscreants. For the academic, we have Cissie's mentor, the absentee professor Dr. Hoodenpyl, who once studied the old ballads but now is engaged in academic fraud and meaningless pseudoscientific studies of radio listeners' tastes. Folk music purists are parodied in the character of the bossy bespectacled upper-middle-class clubwoman and local concert promoter, Mrs. Jethro Z. Eccles, who waves her knowledge of the Mixolydian scale and tone quality over actual folk musicians like a cudgel. In Eccles's hands, it would seem any bit of life in the folk tradition would be squeezed to death over concerns about authenticity and whether the tunes aligned with the most ancient of collected versions.[31] Popularizers are excoriated, too, in the character of Buck Ken-

nedy, a lecherous and marginally criminal, poor white hill dweller with a box of his grandma's old ballads who somehow manages to impress Eccles and Hoodenpyl. The Buck character's subplot seems in many ways to represent the way the real African American folk and blues singer Lead Belly—a former prison inmate whom the novel at one point calls out as "a criminal and a jailbird"—achieved fame through his association with popularizers John and Alan Lomax.[32]

Perhaps most entertaining of them all is the big-talking, ballad-singing lothario Carlos B. Reddy, an "always ready" senator modeled after moderate Tennessee politician Estes Kefauver. Kefauver—who served in Congress in the 1940s and in the US Senate from 1949 until his death in 1963—was known nationally for his opposition to organized crime, and among Tennesseans for his opposition to Memphis's corrupt Crump machine. He also made a name for himself for supporting consumer protections and big New Deal programs such as the TVA, and for taking a firm, almost Victorian, stand on media-related morality issues, which involved a concentrated attack on horror and crime comic books in the Senate in 1954.[33] In 1948, the East Tennessean emerged as something of a national political icon, with a frontier-style coonskin hat that he took to wearing in response to a political ad that Boss Crump had taken out ridiculing him as a sneaky, raccoon-like pretender with a "pro-Communist" voting record.[34]

Though the real Kefauver claimed that comic books led to juvenile delinquency, he apparently had no qualms about employing other kinds of popular culture—especially country music, with its increasing emphasis in the 1950s on nightlife and drinking—for his own uses. In fact, Kefauver seems to have set a precedent for using country performers on the campaign, which later candidates such as George C. Wallace would follow in the 1960s and '70s. Kefauver's connections with country music seem to have first been cemented in the late 1940s, when he appeared on the "In Your Senator's Office" segment of *Farm and Fun Time*, a Bristol, Tennessee–based musical radio program that served as a launching pad for several bluegrass acts, including the Stanley Brothers.[35] Kefauver seems to have moved in this direction after witnessing the relative success with which Opry star Roy Acuff

had used music in 1948 to drum up support for Acuff's gubernatorial campaign.[36] That year, Kefauver hired Curly Seckler's band, the Country Boys, to perform for him at rally in Selmer, Tennessee.[37]

In the 1950s and '60s, Kefauver's use of performers expanded even further. Perhaps the biggest affair was his kickoff campaign for the Democratic primary in December 1951, an event held in the Grand Ole Opry's Ryman Auditorium that included political ally Senator Al Gore Sr. praising Kefauver's ethics and other speakers comparing Kefauver to Andrew Jackson, as well as Karl Garvin's jazz orchestra regaling the crowd with "Dixie" and Opry performer George Morgan and his Candy Kisses Kids entertaining the crowd with his signature tunes. Kefauver even seemed to borrow from Alabama politician Big Jim Folsom's country music campaign routine (see chapter 7) when a Cumberland University representative presented Kefauver with a giant mop with which he hoped Kefauver would "sweep the government clean." Also appearing that night were Opry comedian Minnie Pearl, as well as a quartet, the Dinning Brothers, who performed a "new novelty in Kefauver's favor—'The Senator from Tennessee.'"[38] Although it is unclear if it was indeed the same song, pop icon Dinah Shore and country vocalist and western swing bandleader Tex Williams released a jazzy, similarly titled "Senator from Tennessee" duet on RCA Victor that spring which joked about Dinah turning Tex over to Kefauver's committee for his gambling. Though it failed to chart, that song received some critical acclaim from *Billboard* pop critics.[39]

In 1952, as the Democratic presidential primary campaign heated up, Larry Dean and his Virginia Play Boys, a band from Kefauver's hometown area, recorded a slogan-themed number, "Estes Is Bestes," on Rich-R-Tone Records for the Kefauver campaign.[40] Kefauver continued such antics throughout the 1952 race as well as his 1956 presidential primary run, hiring Minnie Pearl, George Morgan, and Nashville-based songwriter Hank Fort to perform at rallies in Tennessee in these bids, as well as a new duo of Opry performers, Hank Snow and Billy Grammer, to support him during his 1960 Senate reelection campaign.[41] Though Kefauver appears not to have hired the Opry stars to follow him on the road outside of his home state, evidence

6.2 Nancy Kefauver (center), Estes's wife, pictured with members of an unidentified country or western swing band in front of a campaign bus during California's 1952 presidential primary. An oversize photograph of Sen. Estes Kefauver (D–Tennessee) is posted behind at center. One member of the band (second from left) wears the coonskin cap that had become a signature part of Kefauver's political image. At home in Tennessee, Kefauver employed Grand Ole Opry stars to perform for him, but on the road outside of his home state, he appears to have relied on area bands. "Band Plays in Front of Kefauver Campaign Bus," Estes Kefauver Image Collection, Estes Kefauver Papers, 1925–1967, MPA.144, University of Tennessee, Knoxville, Libraries.

suggests he may have strategically used lesser-known country music bands in races such as the California presidential primary of 1952 (fig. 6.2). When he made a campaign speech to the Oklahoma State Picnic in northeast Los Angeles (one of several "state picnics" that emerged in California among transplants from other states), Kefauver's campaign made sure that the event included "western stars of stage and television," a group that likely drew singers and musicians from such local western-themed country music programs and television barn

dances as the *Spade Cooley Show, Hometown Jamboree,* and *Town Hall Party.*[42]

Whether or not his country music campaigning made a difference, Kefauver largely dominated the Democratic primaries of 1952 by capturing twelve of the fifteen races, but, in probably one of the most antidemocratic examples of intraparty deal-making in American history, was routed by party leaders at the convention in favor of Truman favorite Adlai Stevenson, who had not won a single primary. By 1956, when Kefauver ran unsuccessfully again for the Democratic nod, his campaign had apparently hired or somehow acquired a performer named Cowboy Brown in Florida, who according to the *New York Times* had a hillbilly band and "an old sedan equipped with a loudspeaker" that would lead Kefauver's caravan "with his horns blaring the Kefauver hill-billy song ('Kefauver! Kefauver! Kefauver is the name')."[43] Brown apparently wasn't a very loyal campaign worker — he repeated the stunt for opponent Adlai Stevenson a few weeks later and then reappeared with Kefauver in a widely published wire photo a week after that.[44] By convention time, Kefauver had used country music and the popular Pee Wee King hit "Tennessee Waltz" so much on the campaign trail that party organizers played the song for him at the Democratic National Convention when he was instead nominated as Adlai Stevenson's vice presidential running mate.[45] Eisenhower, of course, bested Stevenson in both those elections.

Davidson's Carlos B. Reddy character, like Kefauver, wears a Davy Crockett–style coonskin hat and supports agricultural programs that Davidson suggests allow farmers to "sleep late ever' mornin'."[46] Reddy is even more of an ace at finding pork barrel funds for colleges so they can correct the "speaking defects" of poor mountain boys and teach the psychology of sex so "the coeds" would not all "be repressed and inhibited."[47] "He can feel the pulse of the NEA and PTA and all the other A's," argues one character:

When the pulse throbs a little faster, he telephones another half-million dollar prescription, and all we have to do is pick the medi-

cine off the counter and take the dose. It's easy. Just listen to it fizz and swallow it right down.[48]

Here the real Kefauver's solutions to social problems are lampooned as facile at best—quick, feel-good remedies that have no more depth than an Alka-Seltzer commercial.

The satire runs even deeper, though, in the ways Reddy tries to link himself with the country music and balladry tradition while campaigning over a live radio feed at a Future Farmers of America conference—a nod, perhaps, to the Ryman rally or to the way in which the real-life *Farm and Fun Time* combined farming news, bluegrass music, and the occasional senatorial public relations message. In the novel, Reddy had brought the much younger Cissie up on stage to make a public service announcement about her ballad-collecting project, but tricks her into singing with him so he can put his arm around her, angering MacGregor but apparently pleasing the crowd.[49] Here Davidson may be referring to the fact that the real Kefauver was known, among Washington insiders and others, to be a bit of a philanderer.[50] Considering the level of detail that Davidson put into the Reddy character, it would almost seem that he took more pleasure in parodying politicians who use traditional music for political purposes—especially those favoring growth in big government, such as Kefauver—than he did in satirizing other targets such as jailbird popularizers, academic frauds, and fanatical folklore purists.

Despite these portrayals, the novel marked a significant transformation in the way Davidson viewed county music compared to his essay in *I'll Take My Stand*. Davidson went from agreeing with Lytle that we should throw out our radios in the 1930s to situating a commercial-trained country radio performer with folk roots as his only novel's main protagonist in the 1950s. Furthermore, throughout *The Big Ballad Jamboree*, his hero seems to be building a bridge between folk tradition and modern implements such as broadcasting. In one scene, MacGregor becomes consumed by the thrill of performing a traditional song live with fiddle, vocals, guitar, and bass on his radio program. He seems transported almost to another mental plane:

"It goes right to the marrow of the bone, it just gathers you up, and I don't see how any man or woman can stand out against it."[51] In another scene, MacGregor finds his bliss by creating his own traditional arrangement:

> It was late one night, like that, when I first floated up against the idea that maybe Danny MacGregor by a turn of luck, might hit of on some ballad of his own. I was picking away at some chords for a tune in the back of the Virginia ballad book, and wandered off into a piece of another tune that wasn't the same at all, nor like anything I had been playing or knew about. It was just a piece of a tune at first. I played it over and over, and it seemed to be telling me something.[52]

This feeling of serendipity and this gnawing to finish an original folk ballad indicate that, yes, broadcasting and live amplified performance could be combined successfully and completely with authentic folk performance, if only one had become as immersed in the real meaning of balladry as Danny had. That the novel was not published in Davidson's lifetime does not detract from the fact that his viewpoint had shifted so much that by the 1950s he acknowledged that country music might just play a role in preserving and passing on the old ballads that he so revered.

Although Davidson's literary career testifies to the notion that the Agrarian project could embrace the commercial country music industry, country music performers, on the other hand, have stood somewhat distant from discussions of the Agrarian political project. Nevertheless, there are fragments within country music tradition that assume the mantle of the Vanderbilt Agrarians' call.

It has become almost cliché among country music writers and historians to assert that country music deals with, or was once largely concerned with, "agrarian" themes. Sometimes this "agrarianism" is of the Jeffersonian variety focusing on the virtues of small landholders holding forth in a virtuous agricultural society; and sometimes it is of the vaguer utopian variety, where the old ways of the

country are extolled in songs by performers as varied as Montgomery Gentry, Charley Pride, Tom T. Hall, and Dolly Parton.[53] Although extremely helpful in thinking through individual performers and songwriters' worldviews, such studies often focus on a single song or set of songs and try to make judgments about the entire genre, leaving naysayers to point out those songs that offer contradictory messages or seem to take outright anti-Agrarian, proindustrialization, or modernist stances.[54] Although there is no direct evidence that *I'll Take My Stand* tops some sort of preferred reading list for country performers and songwriters, we can surmise that country music shares considerable space in specific ways with the political project of the Vanderbilt Agrarians. But we can also see how country music also easily dismisses Agrarian sentiments and has become a monolithic, modernizing force in itself, relocating its primary concerns from the fields of yore to the landscapes of modern women's working lives or bro-country beer parties in the parking lots of suburban shopping malls. Such songs that do cling to the past can be passed off as fleeting instances of a generalized nostalgia that aren't meant to be taken too seriously.

Published writing by country music performers in the form of autobiographies and political-themed books, on the other hand, has the advantage of offering a more stable message—one rooted in the performer's own experiences and one that, by the nature of such writings, tends to teach a deeper message, beyond a mere moment of fancy expressed perhaps by another songwriter in a single hit song. Country music autobiography in particular has been around since Tennessee Ernie Ford's *This Is My Story—This Is My Song* in 1963, but certainly became nationally prominent with Loretta Lynn's bestselling 1977 *Coal Miner's Daughter*. Such books, first analyzed extensively by feminist lit scholar Pamela Fox, generally feature the recollections of a star performer or songwriter, often retold with the help of a collaborator or ghostwriter.[55] Proving popular with the public, such autobiographies have focused mostly on the performer's formative experiences and career evolution, often spinning compelling tales about the climb from rags to riches. They also tend to serve as instructional manuals for fans and aspiring artists, explaining how hard work, strategic plan-

ning, and a bit of luck have brought them into the limelight, while also expounding on how rural and Southern upbringings often led them to take seriously such issues as professional ethics. Several, such as Ford's *This Is My Story*, Johnny Cash's 1975 *Man in Black*, and Alabama front man Randy Owen's 2008 *Born Country: How Faith, Family, and Music Brought Me Home*, even serve as religious instructional manuals, which outline how one might follow their path in finding salvation from alcoholism, drugs, and other dangers by adhering to Christian practice and teaching. Lee Greenwood's semiautobiographical book *Does God Still Bless the USA?* even goes so far to include a thirty-day prayer devotional as an appendix. Although the primary goal of such books has been to establish the author-performer's authenticity as an artist and how they prevailed over poverty and other obstacles, they have also allowed artists to include brief political or social commentary about how their experiences have shaped their views of how they would approach a particular policy.

This teaching function is even more apparent in the political polemics that have more recently become popular among fans, following mostly in the wake of the 9/11 attacks. Most of these books— starting with Charlie Daniels's *Ain't No Rag: Freedom, Family and the Flag* in 2003—have taken stridently hawkish, jingoistic positions, although the genre can include softer, more philosophical, and ostensibly more liberal works such as Willie Nelson's 2006 *Tao of Willie*. These books aim to make sense of the political landscape or social issues by using the performer's own experiences, either from their hardscrabble upbringings or from their encounters in the studio and on the road. Like *I'll Take My Stand*, they often serve as personal but proscriptive manifestos about how to achieve the good life and make America great again.

Analyzing the extent to which a 1930 political and cultural manifesto resonates with a post-1963 genre of popular writing might seem strange on the surface, but it is important to keep in mind that Southern Agrarian writing and thought has remained relevant during the postwar era and continued to win adherents in the late twentieth and early twenty-first centuries, especially as debates about antimodern-

ism, the historical memory of the "lost cause" (e.g., debates about Confederate statues), and Southern-style populisms continue to take center stage in American culture. Although there are plenty of high-profile non-Agrarian individuals who have made waves in Southern literary circles, it is difficult to argue that there is any one other unitary school of writers, even now, who has risen to the level of visibility the Vanderbilt Agrarians have enjoyed.[56] Beyond that, leading Agrarian novelist Robert Penn Warren continued to be prolific until his death in 1989, with anthologies, collected poems, a reissue of his nonfiction interview work *Who Speaks for the Negro?*, and a restored version of *All the King's Men* published posthumously over the last three decades. Warren's fiction in particular has inspired numerous adaptations—theatrical (even one operatic) and film, including a 2006 film adaptation.[57] Davidson published poetry and nonfiction, including his important history of the Tennessee River valley, until his death in 1968 and saw *The Big Ballad Jamboree* finally published posthumously in 1996.[58] Beyond that, Agrarian ideas have certainly remained prolific in late twentieth- and twenty-first-century America. Warren's textbook, *Understanding Poetry*, cowritten with Cleanth Brooks, influenced the important New Criticism movement of critiquing poetry and continued to be published in separate new editions until 1976.[59] One would be hard pressed to find a college campus today where the New Critics have not had some impact in how poetry, and even blues and country music lyrics, are taught.

Perhaps more important, the thinking of the "Twelve Southerners" has paved the way for a new generation of Agrarian political ideals that have been especially influential among traditionalists on the right. Poet and writer Wendell Berry has certainly demonstrated how the radical anti-industrialism of the Vanderbilt Agrarians could be forged into a cogent argument for an environmentalist left concerned with the rise of corporate-dominated agriculture. Berry even laid out this position in an essay on responsible eating in a book published by Farm Aid, the charity started in 2005 by country star Willie Nelson and others to publicize the farmer's plight. In that essay, Berry almost seems to be drawing a line straight out of Lytle in *I'll Take My Stand* by

arguing that concerned urbanites should revive in their own "mind and life the arts of the kitchen and household" and "learn the origins of the foods" they buy.[60] On the right, however, the Agrarian presence is even more commanding. Historian Paul V. Murphy has argued that Agrarian thinking found its way into the writings of University of Chicago intellectual Richard M. Weaver, who articulated "a politics of order" based on social custom, small-scale capitalism, individual restraint, and hesitancy toward civil rights. Weaver's neo-Agrarian ideas and their connection to figures such as Davidson were then absorbed by rising leaders of the conservative movement, including William F. Buckley Jr., who helped popularize them by rooting out certain elements (e.g., wariness about laissez-faire) and "fusing" them with other forms of conservative thought to articulate central tenets of modern mainstream conservatism.[61] Others, such as University of Dallas literary scholar M. E. Bradford—who had looked to Davidson as a mentor while a student at Vanderbilt—idealized the community and political order of the Old South to the point of demonizing Abraham Lincoln and arguing that an "organic" patriarchy like that purportedly represented by the Confederate army was best suited to preserve liberty. Bradford's views became fodder for an angry public debate in 1981 when Ronald Reagan (a politician he had supported as a campaign organizer) nominated him to head the National Endowment for the Humanities. Bradford had opposed the Civil Rights Acts of the 1960s and regularly wrote for the neo-Confederate *Southern Partisan Quarterly Review* and thus proved unpalatable. Ultimately, William J. Bennett was selected.[62] Such debates about the role of traditional hierarchies and the place of Confederate memory have continued on as important facets of the culture wars between the political left and right ever since.

Taken as a whole, country music performers' autobiographical and polemical works suggest that the original political project of the Vanderbilt Agrarians, and Davidson's and Weaver's later articulations of it, resonates to some degree with the country music field; in general, though, any alignment with the views of the Agrarians are fragmentary or fleeting at best. When first laying out their arguments,

the original Southern Agrarians (especially Davidson) were not just skeptical of the massive governmental projects of the 1930s such as the Federal Emergency Relief Administration (FERA) and the Tennessee Valley Authority (TVA), they were often downright hostile. These entities were not mentioned specifically by name, but the original Agrarian statement of principles claimed such governmental and private-public "remedial programs" had little measurable impact and, even worse, created more opportunities to inundate the culture and society with cold, destructive industrialization.[63] In their individual essays, Fletcher and Lytle railed against government involvement in, and the bureaucratization of, the fields of education and farming.[64]

Although many of the Agrarians later began to express some appreciation for the TVA as a means of supporting small farms with cheap electricity, Davidson in particular remained suspicious of these schemes well into the 1950s. Davidson was originally open to the idea of the TVA project as a private-public means of preventing flooding, but soon derided it as a power grab in favor of "King Kilowatt" and denounced the power its board members retained. Even more damning, he said, was that it created a damaging "permanent flood in the valley itself" in the name of flood control:

> Because of its encroachments, there would be removals of many a family from homes where, in symbol or in fact, the Revolutionary sword or the pioneer rifle still hung above the mantel. . . . Old landmarks would vanish; old graveyards would be obliterated; the ancient mounds of the Indian, which resisted both the plow of the farmer and the pick of the curiosity seeker, would go under water. There would be tears, and gnashing of teeth, and lawsuits. There might even be feud and bloodshed.[65]

For Davidson, the TVA necessitated the displacement of farms and substituted a Southern mono-economy based on "King Cotton" for an even more destructive one focused on "King Kilowatt." To him, the TVA and similar large government projects served as little more

than a launching pad for the totalitarian tides of industrial development.

There were, of course, those Agrarians who defended segments of the New Deal that they thought might protect individual autonomy and ownership for small farmers or might, like the TVA, make the South more economically autonomous; but for the most part they spent the decade abhorring the way it was implemented.[66] As Emily S. Bingham and Thomas A. Underwood, editors of a collection of Agrarian New Deal–era essays, put it:

> They vowed to fight Northeastern historians over any narrative of American history that cast the industrial North as a moral exemplar, to denounce social scientists who claimed to understand Southern social relations, and to battle liberal policy makers who wanted to collectivize—or to corporatize—agriculture in the South.[67]

Agrarians largely remained steadfast in their skepticism.

In their biographies and polemics, country music writers share little of the skepticism toward government uplift efforts, finding in them not an ineffective "homeopathic" remedy but a welcome and necessary means of making ends meet during hard times. In fact, country music writers display a general warmness and even a degree of reverence toward New Deal–era government programs such as the TVA, the Works Progress Administration (WPA), and federal farming programs, and to some degree even later social safety-net programs such as welfare. Eddy Arnold, who published one of the earliest autobiographies in 1969, talked about the TVA with almost unreserved awe in the introductory pages of his book, noting the way it allowed his family to maintain their livelihood. The TVA, he pointed out, gave his family electricity, allowing his family some basic comforts and to install an electric pump, thereby making farming much easier. "The TVA brought that," he gushed.[68] Minnie Pearl's autobiography similarly speaks with great respect for Kentucky senator and US vice president Alben Barkley, who helped secure passage of both the TVA and FERA

in Congress. "He was a down-to-earth grass-roots politician-turned-statesman who really loved people and knew how to mix with them. . . . I grieved when he died. America lost a great champion."[69] Pearl's mention of just Barkley in her autobiography nevertheless seems strictly a strategic ploy for protecting her own legacy, because she was most connected politically with Alabama's segregationist governor George C. Wallace (as we see in the next chapter).

Johnny Cash and Loretta Lynn similarly hailed the role of Depression-era government agencies in assisting their families during desperate times. Cash explained in both of his separate 1975 and 1997 autobiographies how the FERA basically saved his family from starvation by providing them with a homestead on an inexpensive loan in an agricultural "colony" in eastern Arkansas in 1934:

> In the settlement toward which we were headed, we and all the other families would have a stake in the general store, the cannery, the cotton gin, and other facilities; we were all responsible for them and we all shared in their profits, if any. . . . So as I've said in the past, I grew up under socialism—kind of. Maybe a better word would be communalism.[70]

Cash went on to talk about how hard his father worked to clear the less desirable delta bottomland in Mississippi County, and that, in any case, the homestead was "a Promised Land," because it included

> a brand new house with two big bedrooms, a living room, a dining room, a kitchen, a front porch and a back porch, an outside toilet, a barn, a chicken house, *and* a smokehouse. To me, luxuries untold. There was no running water, of course, and no electricity; none of us ever dreamed of miracles like that.[71]

As Cash continued his narrative, there was no overt endorsement of poverty programs or agri-assistance; yet, in many ways, his nonpartisan retelling of his family's experience with big government comes

off as a more powerful commendation than an outright endorsement would. Loretta Lynn similarly told in her autobiography how the 1930s-era Works Progress Administration provided her father with a paycheck for mending roads when he couldn't find jobs in the lumber mills. The WPA agent even bought Lynn her first "store-boughten" dress. "This is why you go into homes back in Kentucky today and you'll see pictures of FDR on the wall," she recalled.[72] Charley Pride echoed such sentiments, but with a more of world-weary tone in his autobiography when he described how recently arrived Latvian immigrants to his hometown of Sledge, Mississippi, in the late 1940s suddenly were provided with new housing when townsfolk realized these new immigrants were living among, and possibly dating, African Americans. "I watched that happen with no small measure of resentment. Black Americans had been here for generations, living in shacks and attending inferior schools. Now a group of white foreigners who barely spoke our language was getting new houses and attending the schools I should have been attending."[73]

On the other hand, Naomi Judd's autobiography treated the later Aid to Families with Dependent Children (AFDC) welfare program as a necessary but also a potentially degrading means for survival for a struggling single parent. Her complaint, though, focused largely on the kinds of sexism she had to endure to get the assistance. After describing how she was forced to leave an unscrupulous employer and was left unsupported by the fathers of her daughters, she retold the story of how she had to rely for a period on AFDC to feed her family after moving to Los Angeles. Judd's anger, though, was not with the program itself, but with the way predators used welfare lines to prey on women desperate for money:

Introducing himself as a talent agent, he complimented my figure. Then he segued into offering me $5,000 to do a centerfold spread. I felt naked just standing there! "No thanks!" I answered tersely. "It is humiliating enough having be on welfare, stripped of my pride. I'm not stripping off my clothes, too."

Judd said she later realized such men probably purposefully hang around in such lines to target women who had few defenses.[74]

Experiences such as those of Arnold, Pearl, Cash, Lynn, Pride, and Judd, of course, do not exist without counterexamples from the genre, especially among the spate of more recently writings by outwardly conservative performers. Trace Adkins, for instance, briefly attacked welfare in his list of reasons he thinks evangelicals don't vote Democratic, while ardent conservative Charlie Daniels noted in his political polemic, *Ain't No Rag*, that he supported welfare but "only for those who truly need it."[75] Such viewpoints, however, are rarer and, like the Daniels example, often softer in their rebuke of such programs than the Agrarians had been in their assessment that such government-run "remedial programs" would be ineffective (again, "homeopathic") in curbing the excesses of urbanization and industrialization.

This doesn't mean governmental authority is given a free pass. One theme that runs through many earlier autobiographies is anger at the overreach of governmental authorities, especially those in law enforcement and corrections fields. Indeed, this mistrust parallels rather precisely the kind of misgivings the Agrarians of the 1930s expressed about higher rungs of the federalist system. Merle Haggard, for instance, devoted several passages of his autobiography to the violence among young detainees and the abuse of young people by sadistic prison guards in California's youth correctional system. "Most of them were out-of-shape men who could have been criminals themselves if they had any intelligence," he wrote. "They hated society and took pleasure in persecuting its outcasts—the inmates."[76] Alabama lead singer Randy Owen recalled in his autobiography how a federal inspector came close to arresting his father for cattle rustling until a local sheriff discovered that an unscrupulous out-of-state seller was selling his own cattle but reporting them stolen so he could collect insurance money.

> This kind of screwup happened more than once. Federal officials and other experts with badges would show up at our farm on occasion and ask a lot of insinuating questions about our livestock. . . .

I have a real tough spot in my heart for officials like that. They invariably treated my dad like a criminal, a really good man who was as honest as they come. To this day I still resent that feeling I got then of being pushed around and looked down on.[77]

Waylon Jennings probably summed up this idea best in his autobiography when he noted approvingly that "there were two kinds of people Grandpa didn't trust, a preacher and cop."[78]

Although elements of the Agrarians' distaste for modern merchandising and consumption patterns appear in country music autobiographies and polemical writings, country music authors again tend to diverge from *I'll Take My Stand*'s passionate volleys against the "brutal and hurried" "aimlessness" of consumerism and marketing. Most performers, in fact, write fairly enthusiastically about how the radio and recording industries introduced them to new styles of music or gave them opportunities early in their careers, even if they take issue with the actions of particular promoters and agents.[79] Charlie Daniels went so far as to explain, somewhat jokingly, how the singing-cowboy movies of the late 1930s and '40s helped him develop a flair for the dramatic; he also devoted several pages to explaining how radio fare of the early 1950s and Elvis's early television appearances prompted him to first pick up the guitar, mandolin, and fiddle.[80] Predictably, there is no country music memoir equivalent of Lytle's Agrarian dictum to "throw out the radio."

Loretta Lynn's famous *Coal Miner's Daughter* is probably the most critical of modern implements of consumerism and merchandising. Her autobiography, more than most country music memoirs, retells the larger history of American retailing in the twentieth century, recalling an early phase dominated by rural, localized general stores and predatory company stores and a later phase dominated by chain stores and supermarkets. Lynn focused several passages on how Kentucky mining families like hers became indebted to company-run stores and how the use of company-store scrip and store debt created friction in families. "If you went into debt," she wrote, parroting Merle Travis's famous country composition "Sixteen Tons," "you owed your

soul to the company store."[81] As her narrative moves forward, however, noncompany stores become central to her enjoyment, allowing her necessary temporary release from the perils of stressful life as an entertainer and some anonymity once she becomes star. For instance, she retold how, once she was established as something of a national household name, she liked to sneak out and go shopping at "the five-and-ten cent and the dollar stores" with her twin daughters because it allowed her a means to enjoy buying items without necessarily being recognized.[82]

Lynn, however, is not alone. Many of the autobiographies of women performers in particular tout the allure of "store-boughten" goods, focusing on how commercially sold items signified a small but meaningful respite from an often impoverished upbringing. In her discussion of her family's meager but joy-filled Christmases, Dolly Parton told how her parents always managed to buy each one of her siblings at least one "store-bought gift":

> We girls usually got a little pink plastic doll with its own white cloth diaper held in place by a tiny gold safety pin. That may sound really cheap, and I'm sure it was. But for us, just the fact that it was plastic made it different from the ordinary things we saw in the holler. There was no way this could be homemade.[83]

In her autobiography, Shania Twain recalled the same joy decades after Parton when she and her mother, a victim of domestic violence, were living a rather dreary existence in a shelter in Toronto. One bright spot, she recalled, was visiting a discount department store called Honest Ed's: "Everything was so cheap! Now and then, I'd 'splurge' on something for fifty cents or a dollar."[84]

Interestingly, chains and big-box stores such as Wal-Mart—which in many ways has produced one of the biggest threats to the community-focused localized life envisioned in *I'll Take My Stand*—are largely ignored or written off in the autobiographies and polemics.[85] Trace Adkins, one of the few to mention the retailer by name in his polemic, noted that the company is "grotesquely big and powerful"

but wouldn't initially commit to a position, saying, "I don't know how I really feel about that." As he elaborated, however, he seemed to shift gears, poking fun in a somewhat condescending way at the way Wal-Mart stores are staffed, but also celebrating the convenience and immediate consumer gratification available:

> Sure I feel bad for mom and pop businesses when Wal-Mart comes in and shuts them down, but God, don't you just love going to Wal-Mart? Everything you need is in one big place! You don't have to go anywhere else. There's a nice rickety old man who smiles through yellow dentures, says hello when you walk in the door, and shoves a basket at you. I mean, you can have your tires rotated, buy some groceries, get some hemorrhoid cream, pick up some golf balls, and fill a prescription all under one roof.

Adkins continued the half-jesting endorsement by noting that Wal-Mart had sold more of his CDs than anyone else and explaining how he, personally, has never felt pressured to clean up his bawdier songs in order to get shelf position at the retailer. He also noted that Wal-Mart provided employment opportunities and cheaper retail opportunities for the poor "while the rich folks look[ed] down their noses." He concluded by stating that, if smaller communities felt the influence was all bad, they had the opportunity to protest and "let their voices be heard."[86] Even Willie Nelson, with his critiques of the environmental excesses and other foibles of big business in *Tao of Willie*, ended up touting commercial alternatives such as his BioWillie biodiesel fuel sold at his Carl's Corner truck stop.[87]

One area where many of the country music writers do connect with an agrarian agenda is in their reverence for the ties that bind people, local cultures, and the land. Randy Owen, who moved back to and continues to reside his hometown in Alabama, noted in his autobiography that, while other country stars purchased homes in Jamaica (Johnny Cash?) and Hawaii (Willie Nelson, Kris Kristofferson?), and though he loved to visit such locales, he "never had a desire to live in any of those places":

It's pretty simple, really. If I relocated to any other spot on earth, it might be heavenly, but it wouldn't be comfortable. It wouldn't be where my heart is and near the hearts of my mother, my two sisters, all my other blood relations, and now my children. This mountain is our heart. This mountain is our home.[88]

Nelson, of course, has promoted something of his own agrarian vision by organizing three decades' worth of Farm Aid concerts to raise money to help struggling smaller farmers avoid losing their land. In his first autobiography in 1998, he noted how large financial institutions and large farming corporations were coming to own a larger and larger share of American farmland and how he was motivated to stem at least some of this tide.[89] By the time of his 2015 autobiographical follow-up, Nelson's prose reads even more like a Southern Agrarian essay on the moral efficacy of traditional farming, or perhaps like one of Agrarian Wendell Berry's compositions on ecology and mental health—at least, in the way he focused in on the spiritual significance of agricultural life:

"If we abandon the farmer," I testified [before a Senate committee], "we're abandoning the essential values that made America great. It's all about our relationship to the land—how we cultivate it, how it yields goodness and provides us with sustenance. And it's not just economic sustenance. It's spiritual sustenance. It's our heart. We need make sure that our heart stays strong."[90]

Nevertheless, Nelson noted in both autobiographies that Farm Aid does not serve as a cure-all nor as the kind of widescale restructuring of the agricultural economy envisioned by the original Agrarians. In fact, by Nelson's own admission, it is more like the Band-Aid, the ameliorative offered by labor or capital, that the Agrarians dismissed. "I'm not saying that my friends and I single-handedly saved the farmer or stopped the suffering of those looking to make a living off the land," he wrote in 2015. "We did not. In this postmodern world of corpo-

rate greed and government indifference, the family farm continues to struggle."[91]

Southernness—or, at least, the sometimes resentful or benighted version of Southern history and identity promoted in *I'll Take My Stand*—is not an idea or an identity that is routinely embraced in autobiography or political polemic. Charlie Daniels, perhaps one of the most outwardly right-wing among the autobiographers, even went so far as to devote a whole chapter of his recent autobiography to detailing the cruelties of segregation and publicly expressing his regret that he did not take more of a stand against the system while growing up in the 1940s and '50s.[92]

One exception, however, is Trace Adkins, who devoted a whole chapter, "American Stars and Bars," of his 2007 political memoir to discussing his Southernness and the role one should play in preserving Southern history and identity. Whether intended or not, the name of his autobiographical polemic, *A Personal Stand: Observation and Opinions from a Freethinking Roughneck*, certainly invoked the manifesto of the Vanderbilt Agrarians, and the "Stars and Bars" chapter contained more than passing similarities. Like Owsley, Adkins—who identified himself as a proud member of the Sons of Confederate Veterans—maintained that the Civil War was not fought over slavery but over economic issues, especially the North's tendency to focus on policies that promoted industrialization.[93] Also like Owsley, Adkins argued that slavery had already been eroding as an economic institution at the time of the conflict and that "it didn't require a war to bring about what was already inevitable."[94] Owsley perhaps went a step further by saying slavery was forced on the South by the British Crown and the industrial policies of North.[95] Nevertheless, Adkins, in his rendition of the history of what he calls the "War of Northern Aggression," also seemed to parrot the sensibilities of Agrarians such as Lytle by arguing (as Lytle did in a 404-page biography) that Confederate general and Ku Klux Klan founder Nathan Bedford Forrest was a laudable figure. Adkins, much like Lytle, contended that Bedford was unfairly blamed for the brutal massacre of surrendered black Union troops at Fort Pil-

low and that he was only involved in the Ku Klux Klan when it was "a good ol' boy fraternity formed to protect white Southerners' rights" and not when it had evolved into an "ugly night rider organization."[96]

Adkins—who invited controversy in 2013 by wearing an earpiece emblazoned with the Confederate battle flag during a performance on a televised Christmas special—devoted much of the "Stars and Bars" chapter to defending white Southerners' actions before and during the war and defending symbols such as Confederate flag, including both the widely used but unofficial battle emblem and the official three-stripe Stars and Bars flag. Adkins, however, diverged from *I'll Take My Stand* by making the case that such emblems have nothing to do with racism:

> While the Civil War was brutal on both sides, the South has always gotten an unfair shake and a bad rep because of the way revisionists have tried to make isolated incidences of barbarism the rule rather than the exception. . . . I'm deeply proud to be a descendant of the Confederacy, which is not always a cool thing to say. Everybody's always stirred up by the Confederate flag, mainly because supremacist groups, like the Ku Klux Klan, took it and soiled it and transformed it into something dirty. There were so many gallant, courageous men who fought under that banner and it's sad that people now equate it with racism, because that's not what it stood for.[97]

Unlike the Agrarians, who focused much more of their efforts on excoriating the power grabs of a "tyrannical" North, Adkin's goal is to cleanse figures such as Forrest and symbols such as the Stars and Bars of the taint of racism, while exonerating the Old South by making a somewhat lopsided, zero-sum argument that both sides committed atrocities and so were equally to blame. One might note in particular how Lytle's biography outright omits Forrest's late-life change of heart about race relations, signified by a conciliatory speech the former general gave to an African American group, while Adkins highlights this small act as being as significant as Forrest's Fort Pillow or Klan activities.[98]

Adkins aside, what stands out about country music autobiographies and polemics is just how much they seem to part ways with the goals of the Agrarians—a situation perhaps parallel to the way the Agrarians, for much of their literary lives, held country music at arm's length. Sure, country music writers used their memoirs and political books to venerate the soil and to vent their resentment toward authority to some degree; but they certainly did not advocate that readers throw out their radios, or even avoid shopping. Government assistance programs are not viewed as poor substitutes for real reform, but rather as lifesaving temporary solutions one might resort to when faced with limited choices and dire poverty.

The central factor dictating this difference of approach seems to be class stratification and economic mobility. While Agrarians themselves struggled with poverty from time to time, they also had, for the most part, family and friends and resources that gave them time to think deeply about notions of the good life and what an ideal society might look like. Country musicians, on the other hand, were often concerned with much more mundane issues, such as basic survival during their upbringings and finding psychological release from daily problems. While elements of an agrarian vision or a backward-looking nostalgia are often present within the memoirs, such thoughts are scuttled in the more polemical works in favor of solving more pressing, survival-oriented issues, even if they involve that dreaded industrial technology or intervention by big government or big business. One might best sum up this attitude by borrowing from Irving Kristol's famous remark about neoconservatives and liberals: country music memoirists are Agrarians mugged by a hard case of reality.

Although most of the Vanderbilt Agrarians moved on to other places and other political persuasions, it is worth noting that Davidson remained in Nashville and stayed committed to the original reactionary racial vision of *I'll Take My Stand*—most noticeably in 1955, when he chaired the prosegregation Tennessee Federation for Constitutional Government, a dressed-up version of the White Citizens' Councils that were emerging in other states to do battle with integrationists.[99] Such ugliness was perhaps a logical extension of the origi-

nal Agrarian manifesto, a gaping stain on his personal character that seems hard to reconcile with his more nuanced thought on other subjects. It also should not come as any surprise that the Agrarians would produce acolytes such as M. E. Bradford, the former student of Davidson who would not only uphold a neo-Confederate interpretation of American history but become a major backer in Texas of segregationist third-party presidential candidate George C. Wallace.[100] In the next chapter, we will analyze how Wallace used country music to transform his own image and the nation's relationship with the genre.

The Nonperformers Take Over

Big Jim, the Little Judge, and the Nationalization of Country Music Politics

I t was February 1958, and a sudden, cold wind snapped violently at the white "Wallace for Governor" banner that hung above the flatbed truck serving as a stage. Despite temperatures in the forties, some three thousand people had gathered in front of Kirkland's Pharmacy in the southeastern Alabama town of Ozark to hear local judge George C. Wallace launch his race for governor. Wallace—known in these parts as an ambitious young state legislator and as an Army Air Force veteran who had flown dangerous missions as a flight engineer during World War II—didn't take the stage first. Instead, the rally opened with what can only be described as a little outpost of radio's *Grand Ole Opry*.[1]

Webb Pierce, a honkytonk star from the Opry cast, sang for the crowd, backed by a local band from Montgomery, while Minnie Pearl, country music and the Opry's leading comedienne, regaled the audience with jokes that, if they were anything like her later monologues on the campaign trail that year, focused on her flirtations with good-looking men and her Uncle Nabob's quixotic campaigns for office and his run-ins with the law. It was so cold that Pearl, with her signature price-tag hat, wore long underwear under her ruffled dress.

The audience applauded politely fourteen times during Wallace's

7.1 A crowd of about three thousand gathers to hear Opry stars Webb Pierce and Minnie Pearl perform at a 1958 campaign rally for George C. Wallace in Ozark, Alabama. Although Wallace did not invent the idea of hiring Opry performers for political campaigns, he eventually used Opry stars so frequently and in locations so far outside the South that he popularized the notion that top country stars were an important asset to a national political campaign. "Well-Wrapped Crowd Braves Chilly Ozark Winds to Hear Wallace," newspaper photo and caption, *Montgomery Advertiser*, February 16, 1958, 1. Photo by George Prentice. Image used by permission of the *Advertiser*.

short address, in which he pledged to uphold, with "fairness and dignity," the state's eighty-year history of preventing most of its black citizens from voting and segregating black children into impoverished schools; it seemed, though, that it was really the country music entertainers the audience came out for, if the coverage in the *Montgomery Advertiser* was to be believed (fig. 7.1). "Entertainers Warm Things Up before Wallace Takes Over," read a subheading accompanying the *Advertiser*'s front-page photo of the crowd, while the story inside asserted that they "won a rousing reception."[2] From this first appearance, Wallace would go on to popularize the use of country music campaigning on a national level, employing Opry cast members in numerous campaigns and eventually persuading even Richard Nixon to open the doors of the White House to the genre.

Twelve years earlier, the scene had been much the same—only in

front of the courthouse in the northern Alabama town of Oneonta. There, tall gubernatorial candidate "Big Jim" Folsom was scheduled to speak. But first out came a five-member string band of local performers, the newly christened Strawberry Pickers, who wowed the crowd with their own string version of the jazzy western swing number "Silver Dew on the Blue Grass Tonight."[3]

After a quick musical introduction by his new campaign band, Folsom took to the platform. But unlike Wallace, Folsom made no mention of segregation, focusing instead on old-age pensions, better pay for teachers, and a reapportionment and anti–poll tax plan that would potentially give more power to black voters and poor whites. Folsom would later make Alabama's planter and business class stop in their tracks by adding a mop and bucket to his act and using the homey props to argue he was going clean out corruption in the state capitol.[4] Indeed, once elected governor, Folsom would surprise everyone with a Christmas 1949 radio address in which he echoed the idealistic young Tom Watson's pronouncements about how restrictions on blacks held down the white working class: "As long as Negroes are held down by deprivation and lack of opportunity, the other poor people will be held down alongside them," he said. "Let's start talking fellowship and brotherly love and doing-unto others and let's do more than talk about it—let's start living it."[5]

Despite the seeming gulf that separated these two country music–loving Alabama governors, Folsom and Wallace were on-again, off-again allies for nearly ten years, often working together on such projects as old-age pensions, school construction, and better roads. Once a racial moderate, Wallace in fact patterned not just his early wintertime campaign starts after Folsom's, but drew on Folsom in countless ways in terms of campaign showmanship and, most important, the use of hired or assembled local country music bands. Indeed, Folsom dramatically transformed politicking so much in Alabama in his two terms as governor that, by the early 1960s, having a country band was almost a requirement when running for statewide office. Furthermore, Folsom wove country music into the very fiber of his campaign, selecting in 1954 a charting country music song as his central cam-

paign slogan and message, joining perhaps only Louisiana performer-politician Jimmie Davis and his "Sunshine" references in making the music such a major focus of a campaign.

Wallace—known as the "Little Judge" for his vocation and his slim five-foot-seven frame—was not the first candidate to hire top-notch Opry cast members for the campaign trail, but his consistent decades-long use of Nashville-based performers popularized the practice not just among Alabama voters but among politicians and audiences nationwide. Wallace is typically treated as an innovator in bringing country music campaigning to the national political stage, and his reputation as a race baiter and unreconstructed segregationist is often tied to this; Folsom's role as a moderately liberal Southern Democrat who at least initially supported a gradual goal of integration is important in that it demonstrates how the modern country music campaign did not have to dovetail with racial destructiveness. Indeed, the notion that country music politicking would be bound to the kind of backward-looking politics that Wallace espoused in his famous 1968 campaign for the presidency was anything but inevitable.

Though Big Jim and the Little Judge might have shared some characteristics with the amateur performer-professional politicians best known to contemporary voters such as West Virginia's Senator Robert C. Byrd and vice presidential father Senator Al Gore Sr., Folsom and Wallace fit more concisely into a longer history of nonperforming politicians who hired hillbilly performers for the campaign trail or associated themselves with country music that included figures such as Kansas goat gland doctor and gubernatorial candidate John R. Brinkley; Oklahoma, Georgia, and Illinois governors Jack Walton, Eugene Talmadge, and Dwight H. Green; and senators Hattie Caraway, Huey Long, and Joseph T. Robinson.

Despite these early instances of politicians using hillbilly bands, the figure who most influenced Wallace was his political mentor, Jim Folsom, the liberal two-term Democratic governor of Alabama, a figure whom Wallace would later turn on and defeat. Folsom—nicknamed "Big Jim" for his height, or "Kissin' Jim" for his penchant for kissing

young women on the campaign trail—was a racial liberal and eco-
nomic populist from Southeast Alabama's historically Populist "Wire-
grass" region who took on the state's ruling "Big Mule" coalition of
wealthy industrialists from Birmingham and planters from the highly
segregated middle stratum of "black-belt" counties of the state. An
insurance man whose father had served as a county commissioner,
Folsom appears to have first experimented with hiring string bands
during his unsuccessful 1942 run for the Democratic nomination for
governor. Biographers Carl Grafton and Anne Permaloff suggest that
Folsom was influenced by socialist-leaning Oklahoma governor Jack
Walton's use of music or by Pappy O'Daniel's broadcasts and flour bar-
rel routine, but papers of the time often suggested he was borrow-
ing more from Huey Long's playbook especially in regards to Long's
use of sound trucks and hillbilly music during the 1932 campaign for
Caraway.[6]

At six-foot-eight, Folsom was a towering oak of a man who tem-
porarily challenged the state's economically conservative and pro-
segregation elite by running colorful campaigns that were inundated
with humor and country music. During his 1946 run for governor,
Folsom, who was endorsed by the more liberal Congress of Indus-
trial Organizations union confederation, would pass out a wood-and-
galvanized-steel "Suds for Scrubbin'" bucket for collections from his
supporters while wielding a corn-shuck mop, arguing that contribu-
tions—"suds"—would help him "scrub" the state capitol free of elit-
ists (fig. 7.2).[7] Folsom may have picked up this bit of theatrics from
Pappy O'Daniel, who had used a flour barrel, or from Huey Long, who
reportedly passed around contribution baskets. Whatever the case,
George C. Wallace would later adopt the bucket collection technique
by having his "Wallace girls" gather up a similar collection in yellow
baskets.[8]

Folsom pledged to uphold a fiery brand of economic populism that
challenged the Big Mules by attempting to bring about an ambitious
"People's Program" that included a $50-a-month old-age pension,
free textbooks to schoolchildren, rights to organize, veterans' bene-
fits, workman's compensation, paved roads, and an end to the poll

7.2 Big Jim Folsom's "Suds for Scrubbin'" campaign contribution bucket, circa 1946. Folsom may have gotten the idea of a campaign contribution bucket from Huey Long or from Pappy O'Daniel's use of a flour barrel as a contribution receptacle. Folsom's suds bucket was later emulated by George C. Wallace. Alabama Department of Archives and History.

tax, which hamstrung both poor whites and African Americans. "It is my ambition to better the lot of every man, woman, and child in the state," he told the paper in his adopted hometown of Cullman.[9] Given the long history of domination by the Big Mules, poor and working Alabamians were ready for Folsom's message, giving him what the *Economist* magazine called "the greatest majority in the history of the state in state history" based on "the most liberal platform ever offered in Alabama."[10] His 1946 general election win by an 88 percent super-majority "made him the first non-Bourbon Democrat to be elected governor since the enactment of the 1901 Constitution that disfran-

chised almost all African American and many poor white voters."[11] In national politics, Folsom represented the liberal Henry A. Wallace wing of the Democratic Party and, as delegate to the national convention in 1944, even voted to keep Henry Wallace as FDR's running mate, despite moderate and conservative delegates' successful attempt to replace Wallace with the more moderate Truman.[12] Liberal national columnist Stetson Kennedy later noted that Folsom's popularity amounted to a "second southern revolt . . . not against civil rights" but against federal inaction and "monopolists, brass hats, Wall Street Lawyers and tea sippers."[13]

Although Tom Watson and Jack Walton, and to some degree Talmadge, O'Daniel, and Long, had played on these economic populist themes, Folsom was unique in being a fairly consistent advocate for advancing the rights of African Americans and women, although his approach to civil rights was that of a moderately liberal Southern gradualist, one whom left-wing critics accused of moving too slowly. His press secretary would later recall that Folsom had claimed he made up his mind about race after a stint in the Merchant Marine as a young man where he "slept and ate with men of different colors" and realized that there "are a lot more important things about a man than the color of his skin."[14] Although black voters were already largely locked out of voting in the white-controlled though largely African American "black-belt" counties of Central Alabama, Folsom campaigned against the so-called Boswell Amendment, which aimed to further restrict black electoral rights during the 1946 gubernatorial campaign by establishing a "white primary" within the all-powerful Democratic Party; he called the measure "undemocratic."[15] Folsom also pledged to appoint five returning Women's Air Corp officers as leaders in his administration.[16] He would later push even further in a Christmas 1949 radio address, echoing the young Tom Watson's pronouncements about how restrictions on blacks held down the white working class: "As long as Negroes are held down by deprivation and lack of opportunity," he said, as mentioned earlier, "the other poor people will be held down alongside them."[17]

Country music was key to Folsom's success in the 1946 election

7.3 Members of the Strawberry Pickers on stage with Big Jim Folsom (second from left, behind the podium in coat and tie). James Elisha Folsom Papers, Alabama Department of Archives and History.

and actually was the spark that led to his trademark mop-and-bucket bit. Building on his smaller earlier successes with hiring bands, Folsom and his supporters decided in February to put together their own official campaign band. They put out word of their search and advertised for those in northern Alabama who could play fiddle, banjo, accordion, and guitar.[18] Folsom and his supporters settled on the name Strawberry Pickers (fig. 7.3), which was both a play on words and alluded to the local festival in Cullman, the northern Alabama city he had settled in four years earlier in an effort to widen his appeal outside the Wiregrass. Active in local affairs, Folsom had been voted king of Cullman's Strawberry Festival in 1941.[19] Although there was some rotation in the Strawberry Pickers' rolls, key members included vocalist Roland "Racehorse" Johnson, a minor league baseball player who ended up going into politics himself, and the three Key brothers: fiddler, mandolin player, and vocalist Hobart, a returning veteran;

James, an iron worker and guitarist; and younger brother E. Jimmy, also a fiddler and vocalist. At various times during the first campaign, the band featured multiple fiddlers and guitarists as well as a mandolin, a bull fiddle (bass), and an electric steel guitar.[20]

At rallies, the Pickers played a mix of contemporary hits and traditional songs and seemed to make something of a cross-generational appeal to voters that dovetailed nicely with how the People's Program combined focus on veteran's benefits for the young with pension promises for the elderly. Jimmy Key, the youngest of the three brothers in the band, provides a glimpse of what the first rally with the Strawberry Pickers in Oneonta in March 1946 looked like in a book of reminiscences he wrote with Folsom's widow. The Pickers arrived in town with the band car and an "advance car," a four-door 1940 Chevy with a platform and three speakers mounted to its roof. "Come one, come all, see and hear Big Jim Folsom at 2:00 PM, at the Blount County Courthouse," one band member would announce from the advance car as part of a process band members called "ballyhooing." Once a crowd gathered and the band was set and assembled at the square, the Pickers launched into the Bob Wills jazzy western swing number "Silver Dew on the Bluegrass Tonight." Roland Johnson sang lead vocals on the song. Written by New York songwriter Edith Berbert, the song hit subtle patriotic notes, telling the story of a lonely Kentucky girl who misses her soldier sweetheart and worries about whether he will return. After that, Folsom made his way up the courthouse step to the tune of the lively old fiddle tune "Fire on the Mountain." Once there, Folsom gave a speech about his opposition to the Big Mules and his support for higher teacher pay, better roads, and old-age pensions. The rally would wrap up with Hobart Key playing "Are You for Folsom, I Say for Folsom," a song written for the candidate by campaign volunteer Newt Raines. Folsom would later add on the mop-and-bucket routine complete with having the band play Stephen Foster's "Oh, Susanna" (with emphasis on the "I come from Alabama" line), Roy Acuff's "Down in Union County," the Appalachian folk song "Old Mountain Dew," and other numbers while his volunteers circulated the bucket for money. The passing of the bucket was originally

instituted to gather the funds necessary to support the band, but as larger contributors got involved, the bucket routine evolved into a way of building an emotional connection between the candidate and his audience.[21]

Playing at campaign stops in the state's urban areas and rural "bush arbors and branchheads," the Pickers proved popular with audiences — sometimes more so than Folsom. When Folsom appeared at a rally in eastern Alabama with the Strawberry Pickers, an estimated five thousand people turned out. "The crowds overflowed from the space at the side of the Court House, where Folsom was speaking, and stretched up and down 11th Street and up the alley toward 12th Street," noted the *Anniston Star*.[22] A similar scene took place when Folsom spoke at a campaign stop in Tuscaloosa at the University of Alabama. Students filed into Graves Hall after hearing the music outside, one student remembered. Still waiting for their monthly GI Bill payments, many students who were returning veterans figured the Strawberry Pickers at least offered entertainment. They were surprised, however, when Folsom wowed them with a rousing a speech, and many students ended up trying to round up change when Folsom's crew brought out the suds bucket and mop.[23] The *Tuscaloosa News* crowed about the Pickers' "snappy fiddle tunes that would make grandma take on hepcat ways."[24]

Folsom had some successes during his first term, such as increases in teacher pay and progress in maintaining control of the highways department, making good on his promise to pave the "farm-to-market" roads so coveted by poor farmers.[25] But he also ran into significant opposition from the legislature and the press. Lawmakers tried unsuccessfully to undermine his authority by pushing a "self-starter" amendment that gave them permission to start their own special session and set its agenda. On the surface, the move seems a basic change in parliamentary procedure; but in reality, in Alabama's system it dramatically shortcut the governor's powers.[26] Nearly all the fifty-six bills introduced by Folsom supporters in the legislature in 1949 went down to defeat; but Folsom forces were successful in passing an anti-KKK law that criminalized wearing a mask, and in defeating an attempt to

revive the Boswell Amendment, which had been approved by refer-
endum but now faced court challenges.[27] Folsom also faced strident
criticism from the state's largely conservative press, including an em-
barrassing story in *Life* magazine that painted him as a hard-drinking,
crass philanderer, relaying how he ate dinner with his male staff in
his underwear and how he purportedly flirted incessantly with young
women.[28] Worse, in 1948, his hopes to enter the Democratic presiden-
tial race as a challenger to Truman were dashed when news spread
that he had fathered a son out of wedlock with a former girlfriend,
although public uproar partially abated later that year when he mar-
ried another woman, Jamelle Moore, a secretary in the state highway
division.[29]

Folsom found that his association with the Strawberry Pickers
could be both a bonus and burden as he navigated his first term. In
November and December 1947, Folsom took to the road with his band
to drum up support for his roads program and his old-age pension
plan and to build opposition to lawmakers' attempts to undermine his
authority. "For seven weeks, Folsom, accompanied by the Strawberry
Pickers String Band, has been spending each Wednesday through
Saturday talking to the home folks," reported the *Cumberland Evening
Times*. "He attends to state affairs in Montgomery on Monday and
Tuesday."[30] Like O'Daniel, Folsom also occasionally used the Pickers
on his radio addresses to draw listeners and increase support for his
causes.[31] On the other hand, Folsom's decision to appoint members of
the band to important state positions brought volleys from the press.
Although it was common practice for politicians to reward volunteers
and campaign supporters with state jobs, critics were particularly in-
censed that band members seemed to be nothing more than musi-
cians who lacked qualifications and who had not taken the state quali-
fying exam that other job seekers had to pass.[32]

Folsom did not run in 1950 because of a state law preventing two
consecutive gubernatorial terms; but in 1954 he ran a second success-
ful campaign for governor. By then, a standard Folsom campaign did
not go forward without a thematic rebranding of the Strawberry Pick-
ers and a new kind of collection receptacle of some kind. In this re-

election race, the Strawberry Pickers became the Corn Grinders and took to passing around a toll bucket instead of a suds bucket. "Now somebody has got to pay the toll in this campaign if I'm gonna grind out the pensions, the (reapportionment-oriented) Fair Vote Convention, and the mail box roads," Folsom told voters at a stump speech in Holtville, Alabama.[33] In his unsuccessful 1962 gubernatorial race, Folsom would travel with his Meat Grinders and collect funds in a ham sack, telling constituents that leaders in Montgomery were "taking too much gravy out of the ham." By then, he and Jamelle would join the Meat Grinders in song at rallies; Jim would croon "Little Redwing" and "On Top of Old Smokey," and his wife would regal audiences with Jimmie Davis's "You Are My Sunshine."[34]

Folsom even went so far as to weave sentiments from popular country hits into the dominant themes and sloganeering of his campaign. In his 1954 campaign, Folsom adopted the slogan "Y'all come," a regional folkism that signaled Southern hospitality but also hinted at Folsom being the most accepting candidate in terms of working with and seeking votes from blacks. Although the phrase itself likely extends into the back reaches of Southern etymology, Folsom latched onto it after Texas schoolteacher and country performer Arlie Duff had a hit with a song that has become a standard part of the country and bluegrass canon: 1953's "Y'All Come."[35] Originally titled "You All Come," the song was one of the first singles to be released by up-and-coming label Starday, and helped the neophyte label gain important early traction in the recording market. Duff, a newcomer to the recording industry, wrote the song after hearing his grandmother repeat the neighborly phrase seventeen times on a walk to school. He reportedly wrote the song in less than half an hour.[36] The song first charted locally in Dallas and Houston and soon became popular in cities such as Chicago, St. Louis, Durham, and Los Angeles.[37] By the end of January 1954, when Folsom was launching his "getting reacquainted" reelection tour, the song had climbed to its peak position at no. 7 on *Billboard's* national "Top C&W Records" charts, just below Hank Thompson's and Eddy Arnold's hits that winter.[38]

The song's lyrics pulled on voters' heartstrings with tales of South-ern neighborliness, boisterous relatives, and home. Somewhat re-petitive with its signature line "Y'all come," the peppy song never-theless smartly capitalized on a phrase a large section of the nation already viewed warmly, combining that appeal with comic choruses about endless numbers of neighbors and kinfolk lining up for food and Grandma wishing that someone would help her clean the dishes. It was comedic enough for Lucille Ball to perform a silly jug band ver-sion with guest performer Tennessee Ernie Ford on *I Love Lucy* in 1954, but had enough genuine sentiment that country music's master vocal-ist, George Jones, could turn it into a more earnest number in 1965 in a duet with pop singer-songwriter Gene Pitney. Duff's original ver-sion walked a fine line between corn and sincerity. Duff's somewhat nasally vocals and the band's shouted call-and-response "Y'all come" emphasized the comedic elements of the song, while Bobby Black's steel guitar riffs between verses connected the song with modernizing developments in the country music industry. Duff—who by late 1954 was on the road promoting the song in the Southwest—had deliber-ately ordered his band members to play corny during the recording session.[39]

Newspaper accounts suggest that Folsom's Strawberry Pickers–cum–Corn Grinders began performing an adapted version, "Y'All Come, Up Yonder in the Governor's Chair," at a political rally just two weeks after Duff's version of the song peaked on the charts. After spelling out his political program to an audience in Ramer, Alabama, Folsom opened the floor to the Grinders' version of "Y'All Come" and three other "significant tunes": "Seven Long Years," "You, You and You," and Gene Autry's "Back in the Saddle Again."[40]

Whatever the case, the "Y'all come" slogan and performance of Duff's song became a central component of Folsom rallies that year, signaling Folsom's folksy charm but also hinting that his neighbor-liness extended to everyone (*y'all*, "you all"—the Southern second-person plural), including African Americans.[41] Folsom's own account of the phrase in his stump speeches almost parroted Duff's anecdote

about chatting with the neighbors with his grandmother; Folsom took the phrase a step further by suggesting it was a call to reach across lines of race and nation:

> When I was a boy in knee breeches, my mama and papa used to take me visiting to neighbors. . . . When it was time to go home, Mama would call me, and I'd stand by her side all tired out and ready to go while she said, "Y'all come," and the neighbors would say, "We will, and y'all come," and they would go on like that for thirty minutes. But, you know, there's something friendly, and warm, and sincere about that farewell; there's something about it that is deeper and bigger than even fear. And, you know, nations ought to be friendly and warm toward each other, and the peoples of different nations should part with a "Y'all come."[42]

Folsom's "Fair Vote Convention" platform plank that year could, in some ways, be read as an extension of the "Y'all come" philosophy because it called for a major reapportionment in the state legislature that would have empowered certain groups of voters, including the small numbers of black voters in the North and in the Wiregrass, who had not been completely locked out of balloting. For decades, the political aspirations of the urban, Northern, and Wiregrass counties had been stifled by a system of representation produced in the state's 1901 constitution convention—in part by fiddle convention speaker and white supremacist politician "Cotton Tom" Heflin, as means of maintaining Jim Crow–style segregation and planter and business control. Voters in staunchly segregationist central and rural counties enjoyed sometimes as much as twenty times more influence in the state Senate. The constitution technically called for reapportionment every ten years, but none had taken place for fifty-three.[43]

Folsom pledged that once convened, his "Fair Vote Convention" would make representation more equitable by empowering these neglected regions. He noted at one press conference that he expected racial segregation to be "brought up, of course," but that the effort would be made to "work something out."[44] Logically extended, his

plan would have resulted in a power shake-up that would have eventually, if slowly, led to a policy of desegregation, but his plans were derailed after the US Supreme Court issued its groundbreaking *Brown v. Board of Education* decision, which created such tensions among legislators that it was impossible to get agreement on anything related to reapportionment.[45] In this way, Folsom's 1950s political career perhaps mirrors that of early-1940s Mississippi governor Paul B. Johnson. Both wrapped themselves in the banner of improving the lot of poor whites, as champions of the "runt pig people" (Johnson's phrase) and the "branchheads" (Folsom's).[46] And both proved frustrated by local forces and therefore more reticent when their liberal policies came up against issues of race.

Folsom's choice of "Y'All Come" proved auspicious in the 1954 campaign because the song continued to percolate in popular culture until the all-important May Democratic primary with appearances such as the aforementioned *I Love Lucy* episode and covers on mainstream radio. Bing Crosby perhaps did the most to keep "Y'All Come" in front of national pop audiences by performing it on his new *Bing Crosby Show* television program and recording his own version with famous steel guitarist Speedy West shortly after Duff's initial release.[47] Crosby's version climbed to no. 20 on the pop charts, helping Duff earn a BMI songwriter award. Other major-league country performers, including Grandpa Jones and Little Jimmy Dickens, also covered it that year. The song—perhaps aided to some degree by the limelight Folsom brought to it during his campaigns—went on to become a major country and bluegrass classic, recorded by dozens of artists over the years.[48]

Once selected during the all-important Democratic primary, Folsom kept up his connections with the country world by officiating as governor-nominate at Montgomery's first ever Hank Williams Memorial Day commemoration that fall, an event that celebrated the life and music of the hit maker before his legacy and ensuing legend had been more firmly established by Nashville institutions. That event, which took place a year after Williams Sr. had died, was a star-studded affair, with a parade that drew sixty thousand observers and a tribute con-

cert that attracted ten thousand. Not only did former Louisiana governor Jimmie Davis, former gubernatorial candidate Roy Acuff, Senator Lister Hill of Tennessee, and current Tennessee governor Frank Clement make official visits, but top country stars such as Ernest Tubb, Jim Reeves, Hank Snow, Pee Wee King, Ferlin Husky, Minnie Pearl, and local favorite Jack Cardwell performed or made appearances.[49] Folsom in particular made a splash at the parade. "Folsom was shouting 'Ya'll Come [sic]' and he was pointing occasionally to his pretty wife who was riding in the automobile with him," reported the *Montgomery Advertiser*.[50] Not to be outdone, Jimmie Davis later sang Williams's "Mansion on a Hill" at the concert before launching into his own hits "Suppertime" and, after a particularly dramatic and loud call for an encore, "You Are My Sunshine."[51]

Folsom couldn't run in 1958 (again, because Alabama governors could not by law succeed themselves), but by then the country band formula proved so successful that nearly every candidate in the Georgia gubernatorial race fielded their own bands. "This can be directly related to Folsom's stunning win in '46," explained an editor for the *Montgomery Advertiser*.[52] Besides Folsom's musical efforts with his own campaigns, Folsom had contributed to this mania by enlisting his childhood best friend Philip Hamm to run for governor in 1950 during one of Folsom's off-terms. Accompanying Hamm were the Strawberry Pickers, thinly disguised with a new name, the Hog Scrapers.[53] When Folsom won his second term in 1954, one of his competitors, Gadsden politician and future US senator Jim Allen, had "substituted an organ player for a string band."[54]

By 1958, however, country music dominated the field and gubernatorial candidates seemed to be jockeying to outdo one another in terms of attracting star power: publisher Jimmy Faulkner had his string band playing gospel; George Wallace, the circuit judge and former Folsom supporter, enlisted Grand Ole Opry stars Minnie Pearl and Webb Pierce to perform for his campaign; John Patterson, the son of a slain candidate for state attorney general who ended up winning the race after being backed by the Ku Klux Klan, had opened his campaign with performances from Rebe Gosdin and the Sunny Valley Boys.[55]

Jack Owen, a state public service commissioner who ran on a platform of maintaining segregation, probably created the biggest splash by enlisting the talents of Roy Acuff and his Smoky Mountain Boys. Acuff had by then apparently reneged on his promise to Arkansas political candidate T. H. Barton not to campaign outside his own state. "Three times during his address Owen sat down to allow Acuff and his band to return for more entertaining," noted one flabbergasted reporter.[56] In the aftermath, one powerful lobbyist complained that gimmickry— not just musical interludes, but politicians riding helicopters to rallies, holding "talkathons," and driving around with replicas of the Alabama state capitol—had become so prevalent in the state that it seemed to replace a traditional emphasis on issues and policy.[57]

By 1962, one of those candidates, George C. Wallace, a former Folsomite, would come forward and not only defeat Folsom but break free from the moderately liberal racial politics that a Folsom campaign had come to espouse. Wallace would borrow much of the Folsom campaign routine in his race that year, and went on to popularize consistent use of country music performers and bands on a national level with his 1968, 1972, and 1976 bids for the presidency.

Wallace was born in Alabama's Barbour County, not far from Folsom's place of birth in Coffee County. Barbour has elected more governors than any other Alabama county, and falls within the more conservative black-belt region of the state, though it technically sits on the border with the more populist and egalitarian-oriented Wiregrass region that Folsom came from. Perhaps not coincidentally, Wallace's political career would reflect a sometimes perplexing mix of black-belt racial conservatism and antiradicalism and insurgent Wiregrass populism and egalitarianism.

Wallace's grandfather was a well-respected local doctor; his father struggled as a farmer, and his family's fortunes declined precipitously after his father died in 1937. Wallace nevertheless attended law school and, like Folsom, served in uniform during World War II. After the war, he served a short stint as a state assistant attorney general before seeking and winning election to the Alabama House in 1946, a race in which he appears not have used country music at all.[58] On the guber-

natorial level, Wallace may have been a Folsom supporter as early as the 1946 campaign, although some accounts suggest he had withheld his endorsement to placate supporters of both Folsom and his conservative opponent, Leven Handy Ellis.[59]

Once Folsom rode to victory, Wallace, who seemed to be entertaining liberal inclinations, became more public in his support of Big Jim. Wallace introduced fifty bills during his first session in the state House, worrying conservatives that he was going to be liberal firebrand; but his politics reflected a pragmatism that included a warmness toward big out-of-state industrial interests seeking sweetheart deals to move to Alabama. Wallace also fought for and received appointments from Folsom to the board of trustees of the prominent black Tuskegee Institute, where, by all accounts, Wallace served students and faculty conscientiously.[60] Folsom balked at Wallace's premature effort to gain the govenor's endorsement for speaker before even finishing his first year in the state House. But they appeared to have mended whatever differences they had by the end of the decade as the energetic Wallace—by then an elected circuit court judge—was recruited by Folsom to head the southern Alabama wing of Folsom's successful 1954 "Y'All Come" reelection campaign.[61] "Everything that boy [Wallace] learned," claimed one Folsom aide, "he learned at the feet of Folsom. He even got to where he would mispronounce things like Folsom, like saying I-dee-ho and things like that."[62] Beyond that, Folsom taught Wallace to pay attention to working-class voters as well as to pageantry, like that offered by the Strawberry Pickers and his mop-and-bucket routine, as means of representing oneself as an outsider who challenges the political elite. Wallace, too, gained important broadcasting experience when he wrote scripts for television commercials for Folsom.[63] Folsom's bandleader, Roland Johnson, was in fact one of the first friends to tell Wallace in the early 1950s that he thought Wallace might be headed for a gubernatorial career.[64]

Realizing that political winds were shifting as court rulings and federal actions forced white Southerners to confront unfair practices, Wallace threw in his lot with the newly organized White Citizens' Councils in 1956, publicly breaking with Folsom over Folsom's

inaction regarding federal attempts to integrate the University of Alabama and outrage about an invitation Folsom extended to black New York congressman Adam Clayton Powell to sip scotch at the governor's mansion. Folsom would receive death threats over the Powell invitation. Wallace gained national attention for his claims that he, as a judge, had refused an FBI request to gather information regarding the racial composition of juries.[65]

By the time Wallace ran for governor in 1958, he sought to distance himself from Folsom, even if he relied on several former Folsom staff members as campaigners. It was also apparent that Wallace may have taken a note or two from Arkansas oilman and politician Thomas H. Barton and Tennessee senator and perennial presidential primary candidate Estes Kefauver by employing entertainers from the Grand Ole Opry. At the opening of his campaign, Wallace spoke from that truck on the courthouse square in Ozark, Alabama, promising that a dignified segregation would be maintained "without violence or ill will" and throwing a bone to liberals by pledging to reexamine the state's reapportionment issue. Several Folsom supporters were in the audience, including Folsom's longtime friend and chosen (but unsuccessful) successor Philip Hamm. The biggest hit of that day, of course, was the entertainment by the Opry members described in this chapter's introduction: honkytonk singer Webb Pierce and comedienne Minnie Pearl, who "won a rousing reception from the crowd" of three thousand.[66] Wallace himself admitted in his autobiography that Folsom was the one who whet his appetite for music on the trail, recalling a time when Folsom defended the practice from critics:

> They are making fun of me for using good old hillbilly music in my campaign. You see that Confederate statue over there? Well, men marched off to war to the tune of country music. If country music was good enough for them, it's good enough for Big Jim.[67]

Pearl and her opening act—a local band named Curly Brooks and His Western Rockers that featured three guitarists and a bull fiddle—continued to perform on and off for Wallace, as the campaign could

afford. Once Wallace advanced to a runoff with Patterson, Pearl and the band made a comeback on the campaign trail with another Opry performer, Little Jimmy Dickens.[68] Pearl even went so far as to give a stump speech for Wallace when he came down with laryngitis a month before the primary runoff: "I don't intend this to be one of those un-solicited testimonials that I've heard about, but I do want to tell you that Judge Wallace is certainly sincere in the things he's been telling people all over Alabama."[69] A month later, Pearl told a crowd gathered in Childersburg, Alabama, that she was "as happy as a dead pig in the sunshine to introduce your next governor, George Wallace."[70]

Pearl was by then a fairly seasoned campaigner, having performed on behalf of Arkansas's unsuccessful Senate candidate Thomas Barton in the 1940s and Tennessee senator Estes Kefauver in the 1950s and early 1960s.[71] In fact, throughout his career, Wallace seems to have walked fairly closely Kefauver's shadow, employing the very same Opry cast members for his national campaigns that Kefauver did for stops in Tennessee. Wallace would later enlist Opry members George Morgan, Billy Grammer, and Hank Snow as central figures, all three of whom had previously campaigned for Kefauver.[72] Though perhaps no white knight for integration, Kefauver, who died in 1963, differed from Wallace in that he publicly took a stand against segrega-tion by keeping his signature off the prosegregation Southern Mani-festo that was put forward by Southern congressmen and senators in 1956.[73] Wallace, for his part, went beyond Barton and Kefauver with the Opry strategy in his later presidential bids in the 1960s by hiring Opry stars to accompany him not just in his home state, but in strate-gic primaries such as California and Wisconsin. In doing so, he helped nationalize the idea that campaigning with top stars and Opry cast members could be employed as an effective vote-getting strategy.[74]

Hiring Pearl was a tremendous expense for Wallace's 1958 guberna-torial campaign, and the press was quick to criticize the strategy after Patterson—who ran to the right of the already conservative Wallace on an ardently prosegregation and anticrime platform—bested him in the all-important Democratic primary. The *Anniston Star*, for instance, noted in its reporting on official campaign expense statements that

Wallace spent $12,000 on Pearl, more than any other single expense in his campaign; Wallace's own campaign managers estimated Wallace spent $3000 for each Pearl appearance which would have brought the actual total to well over $20,000.[75] Although Patterson had some success with the Gosdin band (which, according to one report, cost him as much as $6,000 a stop), his ardent opposition to integration, not his musical talent, ultimately won him the election. It was after this loss that Wallace reportedly vowed to devote himself fully to segregationist rhetoric so that he would never be "out-niggered" by a more sectarian candidate again.[76]

Country bands were out in full force again in Alabama's 1962 gubernatorial election when Wallace would launch an important showdown against Folsom. Folsom, of course, campaigned with his Meat Grinders and collected money in his ham sack, but this time he also made sure his supporting performers booked time in the recording studio. The small Alabama-based Cinema label issued a campaign-year record that paired Mobile-based King artist, disc jockey, and television host Jack Cardwell performing "The Ballad of Big Jim Folsom," with a B side of Strawberry Picker–Meat Grinder Roland Johnson performing "Y'All Come" with Duff's original lyrics, apparently with the help of the rest of the Pickers. The Cardwell offering, set to the tune of country performer Jimmy Dean's novelty 1961 hit "Big Bad John," touted the country roots of "Big, Big Jim," along with his hard work as a public servant (but with more of a Johnny Horton-style lead vocal and a doo-wop-style backing than Dean's starker original).[77] Cardwell, who had national country hits in the 1950s with the "Death of Hank Williams" and "Dear Joan," would also record a second track, "Big Jim Folsom," a more dance-focused, steel guitar–driven, rockabilly-influenced number, on King's Le Noir Records side label.[78] Folsom continued to maintain the most moderate position on civil rights of all the candidates; but, feeling pressure from white voters who resented *Brown v. Board* and other court decisions, he had begun claiming that hardliners like Patterson and Wallace were only bringing about court decisions that would hasten the institution's end.[79]

For his part, Wallace brought back Minnie Pearl, George Morgan,

a local disc jockey to spin country discs in between acts, and what the *Anniston Star* deemed "a good hillbilly band."[80] Even Bull Connor—the Birmingham police commissioner who would later rise to infamy by ordering dogs and fire hoses be directed at civil rights protesters—joined in the fuss, campaigning against Folsom and Wallace with three groups: local TV celebrity and fiddler Country Boy Eddie, String Bean's Hillbilly Band, and the gospel-oriented Rhythm Masters Quartette.[81]

Beleaguered by past associations with racial liberalism and a poor and perhaps drunken or deliberately drugged appearance on television, Big Jim made little headway against the Little Judge and didn't make it to the runoff. In some ways, Wallace had beaten Folsom at his own game by making appearances in rural areas—Folsom's coveted "bush arbors and branchheads"—and providing entertainment, thus defeating him in much of the state.[82] Wallace then handily defeated his only remaining competition, Republican Tuscaloosa attorney Ryan deGraffenried, to take the governorship. At his inauguration, Wallace—who frequently displayed Confederate flags at rallies and pledged during the campaign to "stand in the school house door" to prevent integration—issued a defiant and accusatory speech that applauded the "Great Anglo-Saxon Southland." Wallace's speech went on to target civil rights leaders, liberals, intellectuals, and "communist front organizations" as it tossed down "the gauntlet" of "segregation today, segregation tomorrow, segregation forever."[83] The next four years would prove turbulent for the state as Wallace more or less declared war on the civil rights movement, standing in the doorway to block three black students from registering at the university in 1963, igniting tensions that possibly led to the 16th Street Baptist Church bombing, which killed four young black girls, and exacerbating the violence that occurred when state police confronted marchers on their way to Selma in 1965.[84]

Alabama was not the only southern state in the mid-1960s where country music played a dominant role in an all-important Democratic gubernatorial primary; nor did country music have to come down on the side of segregation. In North Carolina, for instance, George

Gobel, a former child country music star who had realized a career as a television comic, and Lulu Belle Wiseman, part of the *National Barn Dance*'s popular comic-musical duo Lulu Belle and Scotty, performed at campaign stops for L. Richardson Preyer. Preyer, a local judge and scion of the Vicks VapoRub family, hoped to carry on Governor Terry Stanford's efforts to use a private-public fund to fight racial discrimination and poverty.[85] Preyer was soundly defeated in the 1964 primary by conservative Democrat Dan K. Moore, who rode into office on a wave of white outrage.[86] Wiseman's frustration with the Preyer loss would later prompt her to run for office herself in a rural largely Republican district where she would end up serving as a North Carolina state legislator in the 1970s.[87]

Wallace, of course, was ineligible to run for governor in 1966 but convinced his wife, Lurleen, to run and hold the seat until he could run again for governor in 1970. Perhaps as a way to distract from escalating violence, the Wallaces' self-described "ma and pa" campaign seemed to have Grand Ole Opry acts coming out of the woodwork (fig. 7.4.).[88] Though opponent and racial moderate Carl Elliot scored a coup by recruiting Hank Williams Jr. and his Cheatin' Hearts, the Wallaces brought back George Morgan and his Candy Kids, but also western swing–influenced honkytonker Hank Thompson ("Wild Side of Life"), the Wilburn Brothers (known for "I'm So in Love with You" and "Trouble's Back in Town"), Billy Walker ("Charlie's Shoes"), and banjo- and steel guitar–playing comedian and session musician Harold Morrison. A sunglasses-wearing Thompson even appeared at a Wallace rally in a photograph reproduced in the Nashville *Tennessean*, complete with his shiny rhinestone Nudie suit.[89] A *Wallace Record* campaign insert explained that, though the busy schedules of Opry performers precluded figures like Morgan and Pearl from being at all the rallies, audiences were being given a "break" by "getting to see a host of stars," which included the Wallaces' house band Sam Smith and the Alabamians (fig. 7.5); George Wallace Jr. and his Governor's Five, a country band made up of the Wallace's singing son and several off-duty Air Force musicians; and even a British Invasion–style boy rock 'n' roll band, the mop-topped preteens of the Wallace Workers band.[90]

7.4 George and Lurleen Wallace join Roy Acuff next to mics at the Grand Ole Opry, June 1966. Acuff, a Republican, did not campaign for the Wallaces, but the Wallaces hired many Opry stars to perform for their campaigns. Image courtesy of the Grand Ole Opry LLC archives. For image licensing requests, please contact opryphotos@opry.com.

As a campaigner, Lurleen appeared stiff to some observers, but as the election progressed she seemed to others to exude an effective brand of sincerity because she, as a novice politician, came across as genuine and unrehearsed—for instance, she won Tuscaloosa County, an area that had voted against her husband.[91] As governor she fought for more state parks and for improving services for the state's mentally ill, persuading the legislature to levy a cigarette tax and float a $15 million bond that would be used to build mental health facilities and modernize existing ones. She also launched a blistering rebuke to a panel of federal judges who had ordered a desegregation order regarding Alabama schools, claiming untruthfully that it meant transferring students back and forth as well as the end of all black schools. This stance earned her the disapproval of critics such as singer and

7.5 Sam Smith and the Alabamians, George Wallace's house/campaign band, pictured in dinner jackets in 1966. Although *Time* portrayed the Alabamians as representing true Southern culture, critics claimed the band played inauthentic pop renderings of real country music. *Wallace Record*, campaign insert, *Montgomery Advertiser*, April 17, 1966, 65. Image used by permission of the *Advertiser*.

activist Nina Simone, who called her out in a live recording of her famous protest song "Mississippi Goddam."[92] Lurleen had been treated for cancer before the election but was convinced by George to run anyway. She died in office in spring 1968, her husband lying to the press about her condition as he campaigned for president from afar and her condition worsened.[93]

Wallace had set his sights on higher office as early as his first gubernatorial term and prioritized country music as his efforts matured and expanded. He did not emphasize country bands when he tested the presidential waters in the West and Midwest in 1964, but they

were a central component of his rallies in 1968 when he ran a full-fledged third-party American Independent campaign for the presidency, and in 1972 and 1976 when he returned to the Democratic fold as a more traditional primary candidate.[94] His house band, Sam Smith and the Alabamians, were important in these earlier races, as were other, lesser-known home-state outfits such as Curly Brooks's country band and Johnny Long's pop combo. By the 1970s Wallace recruited another Opry cast member, Billy Grammer ("Gotta Travel On"), who toured with his Travel On Boys band, and often booked key performances at certain primary stops around the nation by top Opry and Nashville stars such as Hank Snow, Marty Robbins, Ferlin Husky, Hank Locklin, and Grandpa Jones. Grammer had some experience with politics having backed Tennessee's Estes Kefauver in his 1960 Senate election.[95]

The 1968 presidential campaign in particular seemed a return to the Folsom style, but with a focus on Wallace's increasingly reactionary politics. Like Folsom, Wallace renamed his Alabamians to emphasize his political theme of the moment: an effort to build his fledgling American Independent Party into a credible anticommunist, pro–small government, and prosegregation party. And, like Folsom, he passed around a bucket for collections to energize attendees and raise precious funds. *Time* magazine described it this way:

> To open a rally, there is "Sam Smith and His American Independent Party Band," a small combo with electrified instruments that churns out Nashville-style country music and leads the audience in a slow rendition of God Bless America. Then on come the Taylor Sisters, Mona and Lisa, two seasoned blondes who harmonize a couple of toe-tapping standards and belt out an anthem entitled Are You for Wallace? (to the tune of Are You from Dixie?)

After the Taylors (one of whom Wallace would later briefly marry), the Smith band played the "George Wallace Waltz," a song that cajoles its listeners to stand up for Wallace and the flag and against pseudointellectual politicians and social engineers:

He will scatter the Commies and
pseudos like sheep;
So dance to the George Wallace Waltz, my sweet . . .

When the band wound down, an aide briefly introduced Wallace, while the "Wallace girls, dressed in dark skirts and white blouses, pass[ed] up the aisles with yellow contribution buckets." Wallace then appeared, delivering a speech that tore into big government, civil rights legislation, the "Eastern money-interest crowd," Nixon, Herbert Humphrey, war protesters, social engineering, and "pointy-headed professors." Band members, too, seemed to get into the action. "It's going to be mighty funny next January 20," Smith somewhat prophetically told an audience in Charleston, West Virginia, "when we have a *country music band* a-pickin' in the East Room of the White House!"[96]

While *Time* depicted the event as drawing on authentic Southern culture, critics argued that Smith and the Alabamians were anything but. Kentucky-born novelist Gurney Norman, an opponent of Wallace's politics, took issue with the fact that the band included a trumpet player and played a version of the Broadway number "Hello, Dolly!," but with the lyrics adapted to "Hello, Georgie!," when Wallace spoke at the Cow Palace in the San Francisco Bay area. "For here I have come all the way to the Cow Palace in the expectation of seeing a charismatic Politician from My Native South touch the spleen of ten thousand earthy commoners," he wrote. "Visions of Huey Long and the young Happy Chandler fill my mind, and my ears are made to positively itch by the promise of some true string music from the hill country. And what do I find at the Cow Palace but Sam Smith and his boys twanging 'Hello, GEORGIE!'" Norman postulated that Wallace audiences—made up of blue-collar workers from places like Kentucky, Alabama, and Oklahoma who now lived in "foreign places" like Ohio, Michigan, and California—only put up with Smith's performances of "fake country songs like Bobby Gentry's 'Ode to Billy Joe' and Eddy Arnold's 'Anytime'" because they hungered to see something they recognized *and* somebody who recognized them.[97]

Wallace used country music in other ways, too. During efforts

to drum up support in faraway California, Wallace campaigners directed much of their advertising to KFOX, Long Beach's popular country music AM and FM radio station, in an effort to entice working-class voters in surrounding blue-collar areas such as Downey, South Gate, and Bell Gardens, many of them "Okies" and "Arkies" who had resettled in California as a result of the Dust Bowl migration.[98] Wallace campaign workers also used the band to keep would-be supporters around long enough that his team of registrars could process their voter registration cards. "Out here," noted one of the registrars busy at a Wallace event in Vista, California, "we use the band to hold, not to draw."[99]

Wallace, by then, villainized liberals and antiwar radicals, running on a platform that would limit government, confront Communism, prohibit busing, and roll back federal civil rights law. Publicly Wallace eschewed aspects of the old far right such as antisemitism, but critics claimed he and his American Independent Party organization—as a kind of symbolic head of the emerging "New Right"—too easily accepted money, support, or manpower from groups with outright fascist inclinations. Though Wallace managers had given Klan organizers latitude at gubernatorial races in the past, Wallace staffers went a step further in 1968, actually setting up a meeting to coordinate efforts with outwardly antisemitic Dixiecrat Leander Perez, representatives of the White Citizens' Councils, and Willis Carto, founder of the Liberty Lobby and publisher of the antisemitic magazine *American Mercury*.[100] Wallace also made special appeal to "forgotten" middle- and working-class white voters and reached out effectively to "white ethnics"—second- and third-generation Polish, Serbian, and Italian immigrants in places such as Michigan, Illinois, Wisconsin, and Ohio.[101] Assessing his legacy years later, congressman and civil rights leader John Lewis noted that, though Wallace "never pulled the trigger or threw a bomb," he created situations where others could commit acts of violence: "I think he in a sense provided cover for a lot of people."[102]

Wallace, of course, lost the election to Nixon, but he would carry five Deep South states in 1968, winning the most electoral votes of any third-party candidate since Theodore Roosevelt ran on the Bull

Moose/Progressive Party ticket in 1912. An attempted assassination on Wallace in May 1972 when he ran again as a Democrat in the presidential primary brought Wallace and his country music connections into the national limelight once again. Grammer and his Travel On Boys had just finished playing "Under the Double Eagle," and Wallace had made a speech when he was struck down by several bullets.[103]

Wallace, who had spent much of the campaign assailing busing and making coded references to race, would recover but lost control of his legs, beginning a personal transformation that eventually led him to ask forgiveness for his earlier stances on race. Long before that transformation was complete, however, country music's top royalty came to Wallace's aid. Less than a month after shooting, superstars Tammy Wynette and George Jones organized a "Wallace Woodstock" in Lakeland, Florida, that brought Ferlin Husky, Del Reeves, and ten thousand fans out to raise funds for the wounded candidate's campaign (fig. 7.6).[104] Though Wallace's more contentious stances were not mentioned at the event, the Associated Press reported that one ticket taker paired a Wallace T-shirt with a "United Klans of America" belt buckle.[105] Wallace, who featured prominently on Nixon's enemy list that year, would go on to speak from his wheelchair at the 1972 Democratic National Convention, arguing unsuccessfully for a more conservative anti-busing and pro–school prayer platform; Jesse Jackson and other activists supporting nominee George McGovern shouted down his anti-busing proposal.[106] Wallace would again rely on Grammer and his Travel On Boys in the 1976 presidential election, maintaining conservative positions on big government for his platform. By then, though, his appeal to voters had waned, and he ended up playing the role of a regional power broker, helping swing votes to fellow southerner Jimmy Carter over more liberal competitors. It was only in 1978 that he began to reflect on his life and reached out to African American leaders to ask forgiveness.[107]

We might note, too, that during the years Wallace maintained his support for segregation, the country music industry itself was slowly—perhaps begrudgingly—embracing black and Latino artists. Charley Pride, a black singer from Mississippi who called Montana

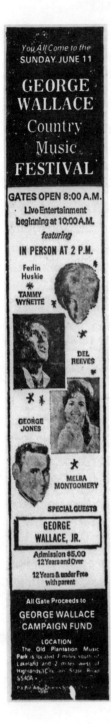

7.6 Top country stars George Jones, Tammy Wynette, Ferlin Husky, and Del Reeves came to George C. Wallace's rescue after an attempted assassination in 1972 by playing at a campaign fundraiser in Florida that was deemed the "Wallace Woodstock." This was before Wallace had formally renounced his race-baiting and prosegregation campaign tactics. About ten thousand people attended. Political ad, *Orlando Evening Star*, June 8, 1972.

home, landed a hit with a Jack Clement song, "Just between You and Me," in the country top 10 in 1967, right before Wallace launched his third-party presidential campaign. Pride continued to climb and top the charts with other songs in the 1970s, and ended up with a Grammy nomination.[108] Born in South Texas, Mexican American singer Johnny Rodriguez had two hits in 1972, with songs "You Always Come Back to Hurting Me" and "Ridin' My Thumb to Mexico."[109] Freddy Fender, born Baldemar Garza Huerta, also had a minor country hit ("Holy One," in 1959) and was beginning to see some traction with another song, "Wasted Days and Wasted Nights," before he ended up being sentenced to five years in Louisiana's Angola penitentiary on a marijuana conviction. Jimmie Davis paroled the Texas-born Fender in 1963 during his second term. Fender later recorded "Before the Next Teardrop Falls," which would go on to become a number-one pop and country hit in 1975, just as Wallace was gearing up for a final presidential run.[110]

George Wallace was not, as is often suggested, the first serious aspirant to the presidency to seek an association with country music. In fact, at least one major-party nominee and several sitting presidents had deliberately associated themselves with performers by the time Wallace ran for president the first time. One might argue that Theodore Roosevelt was the first US president to endorse something approximating what became recorded country music—cowboy songs—but he did so as an ex-president, when he wrote a glowing preface for John Lomax's *Cowboy Songs and Frontier Ballads* in 1909.[111] Earlier as president, Roosevelt and First Lady Edith Kermit Carow Roosevelt had seen to it that American folk songs were sung on occasion in the White House, although these tended to be performed by classically trained singers and musicians.[112] Folklorist Archie Green has argued that seminal hillbilly band Al Hopkins and the Hillbillies performed for a White House Press Correspondents event that included Calvin Coolidge as early as 1926.[113]

Teddy's distant cousin, Franklin Delano Roosevelt, invited folk performers such as Joe Glazer to perform in the White House and seems to have been the first president to invite a bona fide country music star to

the White House for an official publicized gathering: in 1940, singing-cowboy actor and recording luminary Gene Autry attended a combination birthday party and ball for FDR that was organized as part of a fundraising effort for the March of Dimes campaign against polio.[114] Roosevelt had been stricken by the disease for which they raised funds; he gave a short speech before retiring to his room, and Autry spent the rest of the evening with Eleanor Roosevelt, other movie actors on hand to support the cause, and administration officials.[115] Autry, in fact, described his early screen persona in his 1978 autobiography as "a New Deal cowboy who never hesitated to tackle . . . the dust bowl, unemployment, or the harnessing of power," a self-identification that would clash with his later politics in the 1990s, when George H. W. Bush tagged him as being "one of the stars of the GOP galaxy."[116] An equal-opportunity presidential visitor, Autry returned to the White House for a press op in 1953, where he reportedly talked about his golf game with Eisenhower and a CBS television executive.[117]

In 1954, as Wallace was campaigning for Folsom, Adlai Stevenson, the two-time Democratic nominee for president, tried to use country music in something approximating a campaign rally, although this dalliance with country music took place during a non–election year in between his runs for president. Perhaps to get a head start on Eisenhower in shoring up Southern electoral votes and on intraparty rival Estes Kefauver, Stevenson spoke at the end of a combined National Hillbilly Music Day and Jimmie Rodgers Day festival in Meridian, Mississippi. The three-day event—which featured appearances by Ernest Tubb, Hank Snow, and Minnie Pearl, and performances by Hank Thompson and his band—had opened with a fiery political speech in which the international president of the Locomotive Firemen and Enginemen union excoriated the Eisenhower administration for kowtowing to big business and overlooking working people.[118]

Although some observers hinted that Stevenson's speech would be largely apolitical, Stevenson briefly acknowledged his love of hillbilly music and his respect for Jimmie Rodgers, but spent most of the 45 minute speech lambasting Eisenhower for not standing up to congressional Republicans, especially Joseph P. McCarthy, who had used

his power to accuse high-level military officials of Communist influence.[119] The press, which seemed to expect a speech about "hoedowns, ballads, the late Confederacy, and beaten biscuits," was largely critical of Stevenson's supposed hijacking of the nonpartisan event. The influential Nashville-based Country Music Disc Jockey Association issued a statement critical of the festival.[120] At a press conference on the day of the speech, a reporter had asked whether Stevenson had "ever considered campaigning with a hillbilly band in the manner of Jim Folsom or Pappy O'Daniel." Stevenson replied with a joke that also seemed to relay his discomfort with the genre: "No, I'm not equipped for it. . . . I'm tone deaf."[121] In 1956 in the primary race in Florida, Stevenson, of course, would go on to acquire the services of Cowboy Brown, the hillbilly performer who was also apparently representing or working for his primary opponent and eventual running mate, Estes Kefauver.[122]

Harry Truman and Lyndon Johnson, too, booked country and country-folk performers at dinners for visiting heads of state. In 1959, while Eisenhower was president, Eddy Arnold performed for former president Truman and then-senator Johnson at Johnson's Texas ranch during a state visit by Mexican president Adolfo Lopez Mateos. The *Los Angeles Times* account of the event featured a photo of a seemingly perplexed Lopez Mateos strumming Arnold's guitar while Arnold assists and Johnson looks on, smiling in the background.[123] Four years later, then-president Johnson had the folk-country band the Wanderers Three perform at a December 1963 affair welcoming the West German chancellor, Ludwig Erhard, that was held near Johnson's ranch in Stonewall, Texas. The Wanderers Three were known for "Turn Around," a song adopted for a popular Kodak commercial and a sound that seemed to bridge the three-part harmonies of singing-cowboy tradition with the mellow folk-pop of the early 1960s folk revival. Chancellor Erhard was even outfitted improbably in a western hat for press photos.[124]

Though he never entirely crossed over from serious aspirant to likely White House candidate, Wallace played a significant but nevertheless indirect role in convincing the White House to open its doors to country performers beyond the occasional appearance at the White

House or adding a little local color to state dinners. Nixon, it seems, inaugurated these moves largely as a way of fending off the threat to the political right that Wallace posed in 1968, 1972, and other future elections. Well aware of Wallace's shtick, Nixon campaigners had already begun to co-opt country music in 1968 as a means of undercutting Wallace's potential threat in the South. Nixon strategist Fred LaRue, a southerner who helped direct Nixon's "Southern Strategy," identified a country ballad, "Bring Our Country Back," which promised that Nixon could return "a good and decent life" to worried voters in a strife-torn nation. LaRue asserted that the song could be sung by both national country music stars and local talent on television and radio, and that stanzas could be added or omitted to fit the situation in different locales. "The problem was in finding country and western singers," argued journalist Joe McGinnis in his 1969 account of lives of Nixon's PR men. "Most were backing Wallace." LaRue then went back to an older generation of performers and identified Roy Acuff, a strong Republican who already had a political pedigree; Tex Ritter, a longtime Hollywood singing cowboy who had his eye on one of Tennessee's US Senate seats, up for grabs in 1970; and Stuart Hamblen, a Los Angeles–based singing cowboy and gospel singer, who had run unsuccessfully for Congress in California in the 1930s as a pro-pension Democrat and for president in the 1950s as a Prohibition Party candidate.[125]

Acuff, for one, recorded "Bring Our Country Back" in the last few months of the campaign with backing by Bashful Brother Oswald and Acuff's Smoky Mountain Gang. According to the *Tallahassee Democrat*, Acuff noted (somewhat disingenuously, given the song's origins at the top levels of the campaign) that the lyrics came "straight from his heart." The paper also asserted that the song—which had more than a passing resemblance to Wallace's "Stand up for America" slogan and the pro-Wallace Lamar Morris song of the same name—was being delivered to "country music fans in Tennessee and across the country."[126] Hamblen would also be recruited to perform on an anti-Wallace spot that warned conservative Southerners to avoid chasing a rabbit with Wallace while allowing Herbert Humphrey to take charge

of 1600 Pennsylvania Avenue.[127] In the final days of the campaign, Acuff appeared on the trail in Tennessee, performing with his "Nixon Cannonball Express" while Nixon's daughters, Julie and Tricia, and Tennessee's Republican senator Howard Baker spoke to voters at five cities throughout the state.[128] Whether Acuff made a difference or not that fall, Tennessee's electoral votes went to Nixon. The most perplexing aspect of the Nixon run was that the candidate himself seemed to get caught up in the fury. In Austin, Texas, in the final days of the campaign, Nixon himself sat down before a rally of seven thousand people and played "The Eyes of Texas Are Upon You" on the piano.[129]

Once Nixon defeated Wallace and Humphrey, he and his advisers seemed to keep country music at beck and call, just as Folsom had with the "self-starter" amendment issue and Wallace had with a seemingly never-ending progression of gubernatorial and presidential campaigns for himself and his wife. For Nixon, however, mass media had become a central component of the proposal. In January 1970, for instance, administration officials enlisted the help of Sacramento's powerful country radio station KRAK and the West Coast's Academy of Country and Western Music to drum up support for the administration's "National Week of Unity," an effort to drum up support for Nixon's strategies in the Vietnam War. Roy Rogers, the former New Deal liberal who had grown to embrace conservative politics, spoke on the announcements that publicized an effort to distribute some ten thousand American flag–bearing bumper stickers in California, Washington, and Oregon while Merle Haggard's "Okie from Muskogee" played softly in the background.[130] This did not mean that Nixon or his staff had suddenly developed an intimate understanding of country music. In April 1970, Johnny Cash was invited to White House but was asked to perform other people's songs: Merle Haggard's "Okie from Muskogee" and Guy Drake's "Welfare Cadillac." Cash refused and performed his own songs.[131]

Nevertheless, the threat that Wallace might pose in the next presidential election seemed to keep Nixon on his toes. Indeed, there seemed to be some parallel between the way Nixon reacted to country music's embrace of Wallace and the way, during the campaign, that

Nixon seemed to belatedly and reactively parrot Wallace's criticism of school busing as a means of achieving integrated schools. President Nixon had, for instance, intervened in legal proceedings regarding a busing plan in Charlotte, North Carolina, by issuing a legal statement in favor of keeping the status quo, in part to fend off future attacks from Wallace that he was soft on shuttling pupils to and fro.[132] Likewise, Nixon used the pageantry of office to purport that he was just as "country" as Wallace, as evidenced in his official designation of October as National Country Music Month in fall 1970. The language is clumsy, trying to balance folksy sentiment with a kind of detached social scientific analysis of country music's cultural importance:

> Its simplicity expresses the candor, the humor, the love and the pain of country people. Its unique and varied melodies are vivid portrayals of men and women whose experiences have taught them that life brings blessings and hardships, joys and sorrows, satisfactions and anxieties.[133]

However, the timing of the proclamation was anything but. Whether intentional or not, issuing the statement so that the honorary month fell right before important elections in November would serve as a reminder to country fans and allow Nixon to draw positive press coverage when he issued annual updated proclamations, which he did in 1971, 1972, and 1973, and which his predecessors would issue thereafter.[134]

Nixon's outreach to the country music community was not a one-way street. The Nashville-based Country Music Association (CMA), in fact, had been lobbying Lyndon Johnson's administration to establish a country music month for some time as means of bringing a patina of prestige to the genre and of cementing connections with politicians who could further the interests of the corporations involved in the genre. Diane Pecknold notes that the CMA leadership, somewhat dumbfounded by their luck, asked few questions and demonstrated "an ideological bent no deeper than that a businesslike investment in cultivating power."[135]

Not yet hampered by the assassination attempt, George Wallace, rejoined the Democratic Party to run in primaries in early 1972, fired back at Nixon and his newly acquired country music bona fides by lining up top Nashville performers such as Grandpa Jones and Hank Locklin to perform rallies as far as way as La Crosse, Wisconsin.[136] Wallace also seemed, by that point, to have attracted country music challengers from the left. Liberal Maine politician Edmund Muskie hired African American country western singer O. B. McClinton to campaign for him that year in the Florida Democratic primary. Historian Charles L. Hughes notes that Muskie purposefully mapped his Florida "Sunshine Express" tour with McClinton to adhere to "Wallace's strongest sources of support in his 1968 campaign" in an effort to pick up black voters and at least some of the disaffected whites Wallace attracted.[137] McClinton, a singer-songwriter from Mississippi known for mainstream country chart climbers such as "Don't Let the Green Grass Fool You," performed Merle Haggard and Charley Pride numbers for the Muskie rallies alongside fellow performers such as Rosey Grier, a black former NFL player who by then sidelined as a movie actor and singer. By enlisting McClinton, Muskie—an early frontrunner who eventually conceded the Democratic nomination to fellow antiwar candidate George McGovern—certainly signaled a different and more liberal approach to country music politicking than what a typical Wallace campaign had come to represent.[138]

Undaunted, Nixon continued to "go country" in 1972, switching out his pop-oriented "Nixon's the One" theme song and television commercial for "Nixon Now" (or what is technically titled the "Nixon Now Rally Song") just months after the attempt on Wallace's life. California record company executive Mike Curb and his Mike Curb Congregation appeared on the MGM recording of "Nixon Now," spicing up the song with a twangy Byrds-like steel guitar accompaniment and peppy, if a bit cultish sounding, Up with People–style backing vocals.[139] Curb, a Republican Ronald Reagan supporter and president of MGM records, would go on to serve as lieutenant governor of California during the late 1970s, often speaking out in favor of controversial issues such as the state's conservative tax revenue-limiting Proposition 13.

He would later found his own country-oriented Curb Records label and move that label to Nashville.[140]

The Nixon campaign's choice of MGM and Curb is fascinating, considering that label had already started to assemble a puzzling amalgamation of Wallace and Nixon supporters who by all accounts seemed to work with each other both inside and outside of campaigns. From the start, the MGM lineup included Nixon supporters and campaigners such as Curb himself as well as Sammy Davis Jr., who had used the Mike Curb Congregation for backing vocals on his famous "Candy Man."[141] In March 1972, MGM opened the doors for political activity in its country wing when it signed Hank Williams Jr., who campaigned for Carl Elliott, Lurleen Wallace's 1966 primary opponent. Elliot had preached "racial peace and harmony" but also segregation—just a more moderate variety than the Wallaces'.[142] Another MGM recruit was Lamar Morris, a singer-songwriter who had cut and released his own pro-Wallace tracks such as "Stand Up for America" in the 1968 campaign.[143] Morris and Williams Jr. were already close; not only was Morris married to Williams's stepsister, but he helped Williams organize, and served as leader of, Williams's Cheatin' Hearts band, and wrote 1972's "Eleven Roses," which became Williams's first number-one hit single.[144] By July 1973, Curb and MGM had reached even further into the Wallace camp, signing Wallace's long-haired mustachioed son, George Wallace Jr., to a one-year contract. The label even hosted a signing party that brought Wallace Sr. and Curb together for a photo op.[145] George Jr. and Hank Jr. were already friends who had worked together briefly in late 1972 on an unsuccessful campaign in Alabama for Republican senatorial candidate Winton "Red" Blount, a candidate whom George Sr. had publicly opposed.[146]

Whatever the case, the mellow positive vibes of the Mike Curb Congregation's "Nixon Now Rally Song" were a little foreshadowing of what was to come as Watergate slowly unraveled Nixon's presidency. Something might have been in the air in 1973 when topflight country singer and songwriter Merle Haggard was invited to play at the White House. Though staff clapped for "Okie from Muskogee," Haggard was less than happy about the dearth of reception during the rest of his set

and wondered if the affection for country music was little more than a ruse to win votes. "I felt like I was coming for hand-to-hand combat with the enemy," he wrote in his autobiography. "The least he could do, on behalf of simple politeness, was lead his flock of sheep in some hint of appreciation."[147]

On March 16, 1974, a perfect storm of politics, country music history, public emotion, and presidential angst converged upon Nashville's newly opened Opryland theme park. On that date, Nixon was on hand to help inaugurate the Grand Ole Opry's move from its traditional "Mother Church," the Ryman Auditorium in downtown Nashville, to a new abode in a suburban amusement park. Minnie Pearl had wept the week before as the cast said a final farewell to the Ryman, an imposing stained-glass-and-red-brick structure that was once something of a low-church Protestant cathedral, the Union Gospel Tabernacle. With his appearance at Opryland, Nixon became the first sitting president to attend a performance of the Opry.[148] This does not mean his appearance was without contention, even among the members of the Opry: Ernest Tubb, a longtime Democrat who had supported Lyndon Johnson but developed a taste for the Wilburn Brothers' antiwar songs once Nixon came to office, told fellow performer Bill Anderson that he was impressed to have a president in the house, but that he wished "it had been another president."[149]

Nixon, who was deeply enmeshed in Watergate at that point and would serve only another four and half months in office before resigning, surprised audiences by taking the stage (fig. 7.7). Nixon not only played "Wild Irish Rose" and "God Bless America" (to the vocal accompaniment of the entire Opry cast) on the piano, but gave a short speech about country music that invoked themes such as the music's religiosity and its connection with national renewal. "It talks about family, it talks about religion, the faith in God that is so important to our country and particularly to our family life," Nixon said, appearing remarkably relaxed and candid, especially considering the extent of the Watergate crisis. "As we all know, country music radiates a love of this nation, patriotism." Overcome, Roy Acuff exclaimed while onstage with Nixon, "We'll never see nothing like this in our state again."

7.7 President Richard Nixon plays piano at a special performance inaugurating the new Opry House auditorium in Opryland, March 1974. Image courtesy of the Grand Ole Opry LLC archives. For image licensing requests, please contact opryphotos@opry.com.

(Remarkably, George C. Wallace, who perhaps had as much to do with this official presidential anointment of country music as any of the performers, sat in the audience that night, though he did not speak or appear on stage.)[150]

Country music would go on to be used by other successful presidential candidates: Jimmy Carter, whom Wallace tacitly supported after losing the primary in 1976, and Ronald Reagan, who would rely on the support of Roy Rogers, Gene Autry, and others for his campaigns. Though the genre would continue to retain a high profile in presidential races, its acceptance has not been simply related to the tastes and predilections of presidents and their advisers. Rather, it was an outgrowth of the Nixon's campaign to canonize country music in the 1970s, which was a product in many ways of Nixon's attempt to "out-country" George Wallace. And Wallace's prolific use of the genre was

an outgrowth itself of a larger story that includes Kefauver's previous use of Opry stars and Big Jim Folsom mentoring Wallace in the ways of buckets and Strawberry Pickers, as well as the experiments carried out by the host of performers in the 1930s who influenced Kefauver and Folsom with their sound truck campaigns.

Though their use of the genre was clearly rooted in history, Folsom, Wallace, and Nixon each brought their own innovations. Folsom found ways to intricately link themes and songs related to country music to the politics his campaign espoused rather than simply using the music to attract and entertain crowds. Though Wallace wasn't the first to do so, he popularized a new strategy: using the nationally renowned members of radio's *The Grand Ole Opry* to promote his message. Nixon then used television commercials and the official power and pageantry of the presidency to establish country music as a genre worthy of presidents.

The lingering question, though, is: At what cost? Further, what are the larger social and political consequences of institutions like the Opry and top Nashville country performers such as Wynette and Jones (and their labels) linking themselves so publicly with the national candidate who most clearly represents the legacies of Jim Crow and segregation? To what extent is country music culpable for some of the violence of the 1960s and '70s? Do institutions like the Opry and Music Row, more broadly, owe African Americans, victims of the violence, and the American public an official apology? Surely the Opry and associated labels cannot be held responsible for the political positions taken by all their performers; but, given that so many stars for so many decades supported Wallace in the most public way possible, perhaps they should.

★8★

Still Not Ready
to Make Nice

The Legacies of the
Country Music Campaign

I t was the kind of rally that might have delighted a politician in the
mold of a Big Jim Folsom or a Pappy O'Daniel. A crowd of five thou-
sand jumped to its feet and roared with approval when a five-member
band with country roots made a much-anticipated appearance on the
stage. The lead singer, dressed in a black Stetson, boots, and a spar-
kling purple jacket, sang a song defending his connection to the earth,
his desire for a fair pension, and his connections to America. Above
them a giant banner reading "Stronger Together" slowly furled in the
cool evening breeze. Afterward, the candidate made an appearance on
stage and promised to fight for the average person.

This campaign stop did not take place in Fort Worth or Birming-
ham in the 1950s or 1960s, but in largely Mexican American suburb of
North Las Vegas in October 2016. The band, norteño's Los Tigres del
Norte, performed something of a politically charged tearjerker, "Mis
dos patrias," translated as "My Two Countries," a song which argues
that one can be both Mexican and American in one's heart. It tells
the story of an old man who decides to take the naturalization oath as
means of protecting his old-age pension. Afterward, lead singer Jorge
Hernandez urged those there to vote for a woman, Senator Hillary
Clinton, for president, because, he argued, she could be trusted to de-

8.1 Hillary Clinton and Los Tigres Del Norte appear together on stage, October 2016, North Las Vegas, Nevada. Image © 2016, Erik Verduzco, Las Vegas Review-Journal Inc.

fend the working man (fig. 8.1).[1] Los Tigres, a Mexican supergroup known for combining lyrics about the grittier aspects of life and the northern Mexico music style with rock, cumbia, and other influences, would appear quite a bit in the heavily Latino north and east sides of greater Las Vegas that fall. Two and half weeks after the North Las Vegas rally, the same band played at the Cardenas Market, a Mexican supermarket, in east Las Vegas. The next day, on election day, hundreds waited in a long line at an election site at the same store.[2]

While national Democrats were assessing their setbacks in the aftermath of the 2016 election, Nevada was one of the few bright spots for the party. All seven of Nevada's electoral votes went to Clinton; the state also simultaneously elected another Democrat, Catherine Cortez Masto, the nation's first Latina US senator. Though it was a close election, commentators and pundits argued that the once purple state's solid-blue election results were largely a result of an energetic campaign by local activists who skillfully energized the Latino vote by a variety of means, foremost among them musical performances and endorsements by entertainers. For Democrats, the question perhaps

was not why Hillary did not do better elsewhere, but why a similar strategy was not adopted in other southwestern swing states, such as Arizona, or why other types of music and other means weren't used more affectively to appeal to voters in places such as Michigan, Ohio, and Wisconsin.

On the other hand, Donald Trump's victory itself seems to have connections to country music campaigning as well, less in its actual application of music and more in its effective outreach to the frustrated and neglected, its articulation of resentment toward threats and outsiders, and its ability to use a new medium—Twitter—to generate cycles of media outrage and increased publicity that mimicked, in many ways, how country music politicians since Tom Watson have used country music performances, radio, and other forms of publicity to capture headlines and energize voters.

This final chapter seeks to provide a brief outline charting the legacy of the country music campaigning tradition between the post–World War II era and the election of Trump, while also providing an assessment of the extent to which major themes identified in this book—populism, concern for the elderly, connections with Southern identity—remain prominent in country music culture. The goal here is to provide a skeletal sketch of the use of the genre in campaigns that future research might illuminate further. The first section of this chapter analyzes how nonperformers and performer-politicians have used the genre as a means of getting elected to state-level or congressional office. It is perhaps not surprising that the longest-serving US senator in American history, Robert C. Byrd, as well as another long-serving senator who gave his name to important current political dynasty, Al Gore Sr., were amateur fiddlers who used their musicianship to get noticed by voters. Since the 1950s, nonperformer politicians from Southern states in particular have employed country musicians; however, a small but significant coterie of performer-politicians has remained a constant presence in a variety of races as well. Conservative candidates were perhaps better represented among these two groups than liberals were, but there is nevertheless significant ideological diversity. Much as they have in the past, contemporary candidates and

performer-politicians often use connections with the genre to signal to voters that they are outsiders of one stripe or another running against purportedly more well-heeled or well-connected opponents.

The second section of this chapter analyzes the ways in which country music has been incorporated into the national presidential campaigns of major-party nominees. In the years after George Wallace, liberal nominees have used the genre effectively in key components of their races. As time has passed, though, it has been conservative presidential nominees who appear most successful in attracting A-list country music celebrities to their campaigns. For presidential-level politicians, using country music is less about branding themselves as outsiders, and more about signaling their affinity with important rural, regional, and ideological constituencies.

The final section is less chronological in focus, taking up the issue of the degree to which themes arising from the earlier chapters of this book remain thriving within country music culture at large. Though many elements of the political project that was connected with country music campaigning during the genre's old-time, hillbilly, and "classic" country incarnations remain present in the contemporary form, others have withered away, leaving new areas and new concerns to come to the fore.

Congressional, Gubernatorial, and Legislative Candidates

Country music has remained an important part of campaigns for US Congress and Senate as well as a variety of state offices in the latter half of the twentieth century. Although nonperforming politicians increasingly wooed country performers for endorsements, the second half of the twentieth century was not without its prominent performer-politicians. It is perhaps no accident that two of the most prominent senators to come out of the South in the second half of the twentieth century—Robert C. Byrd and Al Gore Sr.—used their back-

ground as amateur fiddlers to help generate attention for their earliest political races.

Though neither Byrd nor Gore had ever really made a living with music as Davis, Glen Taylor, and O'Daniel had, they both used music to create interest in their campaigns early in their careers in ways similar to how early amateur fiddlers Tom Watson and Tennessee's Taylor brothers had used music to attract crowds. And like these earlier figures, both Byrd and Gore put aside their fiddles once they had gotten to a certain political level. Byrd, the adopted son of a poor coal miner, learned to play fiddle at the two-room elementary school he attended in the late 1920s in Spanishburg, West Virginia. In his teens, Byrd formed a band and competed in contests before finding work as a butcher at a local grocery store. In 1946, however, he decided to run for the West Virginia House of Delegates, during which time a lawyer friend suggested he take up fiddling on the trail to distinguish himself in a field of twelve other candidates. At first Byrd played informally for constituents, but eventually he began advertising that he would play music at his rallies. He won that election and went on to use his fiddle in a variety of his own races. At times, he took to the road with his instrument to support fellow Democrats in national elections or in key races for the party.[3]

In 1978, then-senator Byrd cut his own record of fourteen tunes on the County Records label. The album, *Mountain Fiddler*, earned Byrd criticism about his playing ability but sold briskly in his home state.[4] As time went on, the fiddle became less important in his campaigns until finally he put the instrument away during his 1982 Senate race (although he wasn't adverse to borrowing one or pulling his own out if an audience was unenthused).[5] As a politician, Byrd was the longest-serving senator in US history, known for his initial reluctance regarding civil rights and his later opposition to gay marriage, but also for working with eleven different presidents, for steering many Democratic bills to passage, and for quite vocally opposing the 2003 invasion of Iraq.

Al Gore Sr., like Byrd, used the fiddle in some of his earliest races,

but set it aside much earlier than Byrd as his reputation as an office-holder grew. The son of a Middle Tennessee farmer, Gore learned to play after his mother saved for a pawnshop fiddle and his father sent him to learn from a local fiddler. According to his 1970 book about his upbringing and political style, Gore had such passion for the fiddle that it took encountering a poor disheveled local musician named "Old Peg," wobbling along on his broken-down wagon, to make him decide that politics might be a better route. Gore attended college and spent some time as a schoolteacher and superintendent before being selected by a political friend to serve as state commissioner of labor. In 1938, he ran for a congressional seat.[6] He was advised to not play the fiddle on the trail, but when a group of musician friends confronted him with a fiddle during a rather dry rally where he was explaining reciprocal trade statistics, he started using his fiddling to earn votes. Gore recalled:

> Thereafter, wherever Gore went he fiddled! Eventually I took with me some of my musician neighbors, and, interspersed with "Casey Jones" and "Arkansas Traveller," I tried to discuss the problems of the people as I saw them.[7]

The stunt helped him stand out from and ultimately defeat five opponents in a difficult race that covered eighteen counties.[8] Gore, however, appears to have put away his fiddle when he successfully campaigned for a Senate seat in 1952.[9] Like Byrd, Gore, who served in the Senate from 1953 to 1971, was initially reluctant about civil rights, but notably refused to sign the prosegregation Southern Manifesto and supported the Civil Rights Act of 1965. He ended up fighting to establish today's interstate highway system, voted in favor of much of Lyndon Johnson's Great Society legislation, and took a stand against the Vietnam War just before leaving office.[10] Gore of course lent his name and legacy to one of the most important politicians of the late twentieth century, his son Vice President Al Gore Jr. Although the younger Gore has written and spoken fondly of his father's fiddling, he appears to only dabble in harmonica privately and certainly did not

follow in his father's footsteps by performing his own music on the campaign trail.[11]

In terms of state-level political campaigns using country music, there have been spates of activity in states outside of Alabama. Postwar Florida was one of those places. In 1949, attorney Fuller Warren successfully campaigned for governor of Florida with TV and radio hillbilly bandleader Toby Dowdy. At the end of his term, Warren convinced Dowdy to perform for his chosen successor, state representative Dan McCarty, while McCarty's opponent, Alto Adams, traveled with his own band.[12] The enthusiasm even prompted Florida's attorney general, Richard Ervin, to issue a ruling in early 1952 that hiring a hillbilly band was indeed a legitimate campaign expense.[13] Ervin's opinion, however, did not prevent sitting governor Warren, like Alabama's Big Jim Folsom, from coming under fire when it was discovered that he had hired Dowdy—by all accounts a great entertainer—to serve as a state roads inspector, a position for which he had no training.[14] Hiring musicians for state offices proved to be an issue of controversy in Louisiana as well. In 1961, singing governor Jimmie Davis would follow in Folsom and Warren's footsteps during a second nonconsecutive term in Louisiana when Davis was accused of hiring members of his Plainsmen Quartet campaign band as agricultural marketers and license inspectors.[15]

As the national center of the country music industry, Tennessee also remained an important spot for conventional politicians to rely on appearances and endorsements from country performers. Politicians from Governor Frank Clement in the 1950s to Governor Winfield Dunn in the 1970s used country-style jingles or sought to tether their campaigns to performers such as Hank Williams Jr. and Tammy Wynette.[16] Johnny Cash has been perhaps the most prolific among the performers who supported candidates—notably, in offstage roles. In 1976, Cash served as campaign chairman for T. Tommy Cutrer, a disc jockey and former Opry announcer who was among the first to play Cash on the air, when Cutrer campaigned for a congressional seat.[17] Cutrer, who was defeated in the Democratic primary by a young Al Gore Jr., ran a campaign promoting fiscal conservatism and was en-

dorsed by the ultraconservative Young Americans for Freedom. Cash told the press that he admired Cutrer's Christian values and that Cutrer was "my kind of man."[18] In 1988, Cash appeared to do something of a complete turnabout by very publicly endorsing Senator Al Gore Jr.'s bid for the Democratic presidential primary.[19]

In the latter third of the twentieth century, actual country performer-politicians have been in shorter supply, but have bridged the political spectrum in colorful ways. Tex Ritter—a 1930s-era singing-cowboy matinee hero who once competed for the box office with Gene Autry—ran unsuccessfully as a Republican for a Tennessee US Senate seat in 1970 soon after relocating there from Hollywood for a radio job. Had he won the primary, he would have faced off against Al Gore Sr. Although Ritter proclaimed himself a moderate on Social Security and the environment and attacked his primary opponent for ties to the John Birch Society, much of his platform was in line with a suburban New Right: backing of school prayer, promises to appoint strict constructionist judges, and unabashed support of Nixon's policies in Cambodia and Vietnam.[20] Like Cutrer, Ritter enlisted chart topper Johnny Cash to his campaign staff, this time as Ritter's campaign finance chairman.[21] Tennessee continued to be a hotbed of musical and political crossroads into the late 1970s when conservative Republican Lamar Alexander used his Alexander's Washboard Band—complete with jug-band-style washboard instrumentation—to campaign for governor, although Alexander's outfit tended to play Dixieland over country.[22] Grand Ole Opry performer Charlie Walker also made an unsuccessful bid for the Tennessee state Senate in 1992.[23]

Mississippi and North Carolina elected fairly high-profile country musicians to their state legislature in the 1970s. Cecil McLeod, a dairy farmer and old-time fiddler from Leakesville, Mississippi, first ran unsuccessfully for the Mississippi state Senate in 1967, but lost that election before winning the same seat in 1970 when the original winner bowed out to run for a judge position.[24] During his time in the state Senate, McLeod—whose folk musical background has been documented by musicologist Chris Goertzen—advocated for dairy farming issues and chaired the state water resources committee.[25] McLeod

also used his visibility to speak about the need to preserve old-time fiddling traditions and was invited by bluegrass legend Bill Monroe to perform at the Grand Ole Opry in 1979.[26]

Lulu Belle Wiseman, part of the husband-wife *National Barn Dance* comedy-singing act Lulu Belle and Scotty (see chap. 7), ran for and won a seat in the North Carolina state House in 1974, becoming the first Democrat since the 1920s and the first woman ever to represent her district.[27] Wiseman had built a reputation locally for her years of work with the Red Cross and ran a campaign that emphasized her nonpartisan approach to politics. Republican Roy Acuff, a longtime friend of the Wisemans, had organized and performed at a music-filled rally for Lulu Belle that also featured country performers Arthur Smith and George Hamilton IV.[28] Wiseman made national news in 1975 when, pressured by her rural constituents, she cast one of the deciding votes against North Carolina joining the other states adopting the Equal Rights Amendment, even though she had previously voted in favor of the measure. Thirty-five of the required thirty-eight states had ratified the proposed amendment to the US Constitution at that point, making North Carolina's vote a significant one.[29]

More recently, Kinky Friedman—a fiction writer and performer from the outlaw country days of Austin and central Texas whose song choices often stretch into the realm of comedy and satire—ran unsuccessfully for governor of Texas as an independent in 2006, on an eco-friendly, libertarian-inspired platform that included support for both school prayer and gay marriage. The Stetson-hatted cigar-chomping Friedman used music on the campaign trail, and delighted in entertaining his audience with zingers about himself and his opponents.[30] Friedman hoped to ride on the antiestablishment coattails of Minnesota's successful celebrity wrestler–governor Jesse Ventura, and for a while riled his opponents, including Republican incumbent Rick Perry, who ultimately won the race.[31] Friedman next entered the Democratic primary for state agriculture commissioner in 2014, but lost. Afterward, he told reporters he was done with politics.[32]

Another more mainstream performer, Republican Sammy Kershaw, best known for his 1993 number-one hit "She Don't Know She's

Beautiful," ran unsuccessfully in primaries for lieutenant governor of Louisiana in 2007 and 2010 with a "pro-life, pro-marriage, pro-gun" campaign that promised, improbably, to establish the state as the entertainment capital of the nation and, more probably, to attract new businesses.[33]

On the left end of the political spectrum, Montana's Rob Quist invoked in some ways the image of fellow mountain westerner Senator Glen Taylor when he ran for Congress in 2017 in a special election. Quist used his public stature—as a singing cowboy, state arts and culture promoter, and veteran of such 1970s-era bands as the bluegrass-oriented Mission Mountain Wood Band—to put forward a Bernie Sanders–inspired platform that embraced gay rights, the continuation of the Affordable Care Act, and protections for federal lands.[34] Quist did not win the congressional seat he sought in the heavily Republican state, but came within a respectable six points of Republican candidate Greg Gianforte after the latter was charged with assaulting a reporter.[35]

Country Music and Major-Party Presidential Nominees

Although performer-politicians such as Ritter, Friedman, and Quist remain something of an anomaly on the American political scene, nonperforming politicians—especially at the level of major-party presidential nominees—have taken to using country music with gusto. In the years after Nixon, presidential political campaigns, with a few notable exceptions, have used country music or reached out to country musicians for support on the trail. In general, most of this has involved the use of prerecorded or canned country music as filler at routine campaign stops or to highlight certain ideas at candidate introductions or party conventions. Benjamin Schoening and Eric Kasper, a musicologist–political scientist team who has studied campaign music in great detail, argue that the use of preexisting hits by country performers to create a certain feel or relay a certain message is

8.2 Country performer Charlie Daniels (center), presidential candidate Jimmy Carter (right, wearing Daniels's trademark black hat), and Capricorn Records executive Phil Walden. Daniels, who later become known as one of country music's most vocal conservatives, performed at several fundraisers for Carter in 1976 as a result of Carter's relationship with Walden. Ken Hawkins/KenHawkinsPictures.com.

part of larger cross-genre trend in which campaigns have moved away from professionally written "slogan songs" such as "Nixon Now" and "I Like Ike" and toward playing prerecorded, market-tested pop hits from a variety of genres as filler or theme songs in recent decades.[36]

That said, presidential campaigns from Carter to Trump have continued to use live performances by country chart toppers at key moments or with key constituencies. Georgia governor Jimmy Carter was among the most notable in making country performers a part of his public image. During the 1976 presidential campaign, Carter forged a relationship with Georgia-based promoter and record label exec Phil Walden that allowed him to schedule campaign fundraisers with leading Southern and country rock acts such as the Marshall Tucker Band and the Allman Brothers.[37] However, an even closer relationship emerged with the more straightforward country artist Charlie Daniels (fig. 8.2), a touring partner of Marshall Tucker and best known

at the time for "The South's Gonna Do It Again," a rockabilly-style hit off his AOR-oriented album *Fire on the Mountain*. Daniels had already taken something of stand by performing as member of the Earl Scruggs Revue in support of the Moratorium to End the War in Vietnam rally in Washington, DC, in 1969 after Scruggs began vocalizing misgivings about the war.[38] In 1976, Daniels eschewed talking about political issues but told the press that he decided to perform at three fundraisers for Carter as a kind of "campaign contribution" after sitting down with him and coming to the conclusion that Carter "was an honest man." "I probably won't see the man again if he's elected and that's the way it should be. Presidents shouldn't owe anybody anything. I can say that, but General Motors and Standard Oil can't say that," Daniels told the Associated Press.[39] Ironically, Daniels—whose 1979 hit "The Devil Went Down to Georgia" went platinum and made the Charlie Daniels Band a household name—would in the twentieth-first century become known as one of the most outspoken conservative figures in Nashville. Carter was seen in his day as something of a social conservative among economically liberal Democrats and had garnered the last-minute support of George C. Wallace; he came to be regarded, on the other hand, as a figure of increasingly liberal reputation because of his postpresidential activism and controversial views on the Arab-Israeli conflict.

Opry star Hank Snow and Tom T. Hall, the latter known for hits such as "Old Dogs, Children, and Watermelon Wine," campaigned for Carter in his unsuccessful 1980 reelection bid, holding a barbecue with some seventy-five country music stars and their spouses to discuss how to advance his campaign. Snow, who had performed in the past to support Estes Kefauver and George Wallace, told the Associated Press that he was prepared to do "just about anything" the Carter campaign requested.[40] Right before his defeat, Carter had even participated in something akin to a swan song by joining Willie Nelson on stage before five thousand people at a final campaign rally in Columbia, Maryland, where the two sang "Amazing Grace" as a duet.[41]

In the 1980s, Ronald Reagan reached out for connections with country music during his campaigns, but his supporters tended to come

from the older generation of singing cowboys that Nixon had called upon. Roy Rogers and Dale Evans, for instance, appeared at a rally for Reagan in Dallas during the 1980 campaign, while Gene Autry spoke in support of him at his 1984 reelection campaign opener in Orange County, California.[42] As a state-level political aspirant, Reagan had established connections with singing cowboys as early as 1966, when he recruited Rogers's comedic film sidekick Andy Devine to perform at his gubernatorial rallies in Southern California and kept the momentum going as governor of the state by proclaiming a state country music week and officially pardoning country superstar Merle Haggard for a robbery committed in his youth.[43]

Reagan's vice president, George H. W. Bush, enlisted the talents of country artists such as Larry Gatlin, Naomi Judd, and Crystal Gayle at stops during his 1988 presidential campaign. Critics suggested the New England–born candidate's professed love of country music, like his purported love of pork rinds, was a disingenuous attempt to appeal to voters by suggesting he was a regular guy.[44] But Gatlin, who campaigned for the elder Bush in both 1988 and 1992, told the press he considered the politician a personal friend. Gatlin and his band, the Gatlin Brothers, even toured with Bush to promote Republican candidates during the nonpresidential years.[45]

During his unsuccessful reelection bid in 1992, the elder Bush appeared with the Gatlins and Judd at several rallies as he crossed Tennessee, hoping to steal home-state electoral votes from Al Gore Jr., who ran as the Democratic vice presidential candidate.[46] In what might be seen as an attempt to retrace Nixon's efforts to woo the Opry, the elder Bush even made an appearance at the Country Music Association (CMA) Awards a year before he ran for reelection, becoming the first and only US president to do so.[47] Though his use of the genre did not secure George Sr. a victory in any way, the affiliations that the elder Bush's campaign established with Judd and the Gatlins marked the beginnings of a lopsided tradition where top-notch mainstream country artists supported mostly conservatives and Republicans— a trend that seems to have continued well into the twenty-first century. Democrats and liberals, on the other hand, tended to rely on per-

formers on the rootsy outskirts of mainstream country (e.g., Rodney Crowell, Allison Moorer) or artists from other genres who might confess to country influences (Fleetwood Mac, John Cougar Mellencamp, Sheryl Crow) but whose music and performance style signaled a more pop-and-rock-focused orientation.

Bill Clinton did not make country music a central fixture of his 1992 and 1996 campaigns; but, as a young unsuccessful congressional candidate in Arkansas's third congressional district, Clinton dabbled in its use in 1974, inviting Senator Robert C. Byrd, for instance, to perform his fiddle at a campaign stop.[48] Clinton's focus on the presidential trail was more centered on rock acts, most notably his use of Fleetwood Mac's 1977 recording "Don't Stop (Thinking about Tomorrow)" at the 1992 convention. In the weeks that followed, such a connection was solidified between Clinton-Gore and "Don't Stop" that the classic rock hit began functioning as campaign song in the way earlier commercial hits turned campaign songs had, such as FDR's "Happy Day Are Here Again." Realizing the song's continued appeal to baby boomers, the members of Fleetwood Mac returned the favor by reforming the band to perform the song at the Clinton inaugural ball.[49] Nevertheless, with his pronounced Arkansas accent and undeniably Southern roots, it was clear to many voters that Clinton was a son of the country. This was understood even among those unfamiliar with stunts such as Byrd's guest appearances and even when opponents attempted to use associations with country music to "out-country" Clinton, as Republican nominee Bob Dole tried to do with appearances in Branson, Missouri, with Glen Campbell and Mel Tillis in 1996.[50]

Although in his earlier bids for the Democratic presidential primary Al Gore Jr. received the public endorsements of top country figures such as Johnny Cash and Tom T. Hall, his 2000 campaign as the official nominee followed Bill Clinton's lead by lining up significant Hollywood and rock-star power, so much that the media began crowing about how much he had outgunned opponent and political progeny George W. Bush with celebrity endorsers.[51] Though crossover country performer Mary Chapin Carpenter performed for Gore

at the convention, the younger Bush, for his part, largely eclipsed Gore within the world of country music. Ricky Skaggs, who in past years had pulled for conservative candidates such as Pat Robertson, performed for Bush on the trail in Kentucky, while Loretta Lynn appeared with Bush in Little Rock; Travis Tritt, Hank Williams Jr., and Brooks & Dunn performed for the campaign at various times in Tennessee.[52] The 2000 Bush campaign also selected as its theme song "We the People," a largely apolitical song saluting working Americans, recorded by a slew of country performers including Waylon Jennings, John Anderson, and Troy Gentry on a Billy Ray Cyrus album, none of whom appeared to officially endorse the candidate. Cyrus, in fact, was the son of a longtime Democratic Kentucky legislator, had performed for Clinton in 1992, and was known around Nashville as a supporter of Gore.[53]

George W. Bush, of course, emerged as the winner of that race in one of the most hotly contested presidential elections of the modern era, but his interaction with country music would not end there. In fact, contestation of the genre would only escalate in spring 2003 after an appearance by the Dixie Chicks at Shepherd's Bush, a hundred-year-old theater in West London, more known for its long history of vaudeville-style "music hall" productions than the pop- and bluegrass-flavored country music played that night. Natalie Maines, lead singer of the Dixie Chicks, took the stage and made an offhanded comment about the Iraq War and the president at the time, George W. Bush. "Just so you know, we're on the good side with y'all. We do not want this war, this violence, and we're ashamed that the president of the United States is from Texas." Almost immediately, the American press picked up the story and it spread like wildfire. Media commentators pitched the incident as the latest melee in the culture wars, one where either three courageous women upstarts confronted an entrenched conservative political culture or one where three rising stars, blinded by their celebrity, insulted a sitting president and betrayed their country during time of war. Betty Clarke, the journalist from the *Guardian* who first reported the comment, noted that the statement got ap-

plause from the audience and that it proved "practically punk rock" at a time when other American country stars were releasing pro-war anthems.[54]

As a result of political pressure and fan backlash, the Chicks would end up becoming personae non gratae in the country music field, banned by the powerful radio conglomerate Cumulus Media and subject to protests—even death threats, and the smashing of their CDs in one Louisiana town.[55] The flare-up also set the stage for the younger President Bush to present himself as even more aligned with mainstream fans and performers than previous Republican nominees in his successful 2004 reelection campaign. Darryl Worley—whose 2003 hit "Have You Forgotten" suggested that questioning Bush on the rush to war was unpatriotic—ended up campaigning for the former Texas governor alongside earlier Bush stalwarts such as Skaggs, who performed at two Bush events, and Brooks & Dunn, Lee Ann Womack, and Sara Evans, who all performed at the convention.[56] John Kerry had the backing of a group of more liberal Nashville performers and promoters calling themselves the Music Row Democrats and received financial support from two "Kerry-Oke" nights featuring country or "Americana"-aligned performers such as Rodney Crowell, Emmylou Harris, Raul Malo, and Allison Moorer. Although the Democratic convention that year included a performance by Willie Nelson, its lineup almost entirely favored pop and rock stars such as Carole King, the Black Eyed Peas, Patti LaBelle, and John Cougar Mellencamp.[57] By that point Nelson, like Johnny Cash, had become something of a serial endorser; but Nelson's picks were mostly Democrats, such as Walter Mondale, Michael Dukakis, and Bill Clinton, or third-party candidates such as Ross Perot and the Green Party's Ralph Nader. Nelson would go on to endorse Dennis Kucinich in the Democratic primaries of 2004 and 2008, Barack Obama in 2012, Hillary Clinton in 2016, and Democrat Beto O'Rourke over Ted Cruz in the heated Texas Senate race of 2018.[58] Many credited Nelson, who toured with and performed for O'Rourke, with helping the young El Paso politician and former punk musician nearly unseat Cruz in the traditionally Republican state. At one rally in Austin, the pair attracted a crowd of fifty thousand people,

attesting to the power that country music campaigning still holds in the twenty-first century.[59]

In 2008, both Barack Obama and Republican contender John McCain received high-level country endorsements in a series of events that would recall, in some ways, the fervor surrounding the Taylor brothers' 1886 gubernatorial "War of the Roses." McCain's candidacy was promoted by two songs from country chart toppers: John Rich's (of Big & Rich) "Raising McCain" in August, and, in October, Hank Williams Jr.'s "McCain-Palin Tradition," the latter involving the re-wording of "Family Tradition," Williams's classic 1979 hit about growing up in his famous father's shadow. The Williams song in particular took jabs at what Williams dubbed an untrustworthy "left wing liberal media," which, the lyrics argued, could be countered by steadfast figures such as McCain and running mate Sarah Palin.[60] Just days before Hank Williams Jr. unveiled his campaign version of the song at a Palin rally in Virginia, bluegrass legend Ralph Stanley announced that he was endorsing Obama and was releasing a series of radio ads promoting the candidate. The ads, in which Stanley cajoled fellow Virginians to support Obama as means of making college more affordable to their children and grandchildren, were run in the coal-producing area of Southwest Virginia but got national exposure through media and the internet.[61] Stanley's outreach for Obama in many ways followed the lead of colorful Democratic organizer David "Mudcat" Saunders, who had used bluegrass events in rural Virginia to drum up votes for Governor Mark Warner in 2001.[62]

Though country performers had been endorsing presidents for decades, the Williams and Stanley endorsements raised the bar because the two performers were not just contemporary A-list country celebrities, but something akin to royalty among audiences—Ralph Stanley and his brother Carter being among the progenitors of the bluegrass genre and Hank Jr. being connected with the advent of 1970s "outlaw country" and his father, Hank Williams Sr., holding a legendary status within the field. Although it is difficult to tell how much the Stanley endorsement helped Obama, the thirteen electoral votes from Stanley's home state of Virginia went to the Illinois senator—a con-

siderable improvement on Democrat John Kerry's loss of eight percentage points there in 2004.[63]

In Obama's successful 2012 reelection campaign, country music played a much more sedated role. Pop and rock acts such as Paul Simon, will.i.am, Demi Lovato, James Taylor, Mary J. Blige, Foo Fighters, and Boyz II Men dominated the campaign and Democratic National Convention stage, although Hollywood actor and part-time country singer Jeff Bridges did entertain crowds before the event.[64] Republican contender Mitt Romney received support from country endorsers such as Lee Greenwood, Ricky Skaggs, Randy Owen, and Trace Adkins, the latter introducing a new song dedicated to Romney at a fundraiser connected with the Republican National Convention. Generally speaking, though, the Romney-Ryan campaign placed attention on acts in noncountry genres such as Kid Rock, Taylor Hicks, and 3 Doors Down.[65]

On the surface, country played an even more diminished role in the 2016 race. Republican primary candidate Ted Cruz seemed to breathe new life into connections between the genre and conservative politics early in the election cycle by asserting on a morning talk show that the 9/11 attacks on the US had subconsciously made him switch from listening to rock to listening to country.[66] But, following in the footsteps of recent Democratic nominees, Hillary Clinton relied heavily on pop, rock, R&B, and Latino music acts such as Alicia Keys, Katy Perry, Lady Gaga, Lenny Kravitz, Vicente Fernández, and of course, Los Tigres del Norte, as mentioned at the start of this chapter. Willie Nelson and the Dixie Chicks predictably made statements supporting Clinton and Merle Haggard surprised some by performing a pro-Hillary composition at a few gigs, but none of these figures played dominant roles in the campaign. Perhaps more remarkable, Republican nominee Donald Trump's support among country performers was weaker than even Romney's. The New York real estate mogul did get official campaign support from country performers Lee Brice and Chris Janson at the Republican convention and lined up some endorsements from stalwart endorsers such as Ronnie Dunn of Brooks & Dunn and Joe Bonsall of the Oak Ridge Boys; but there

were no blockbuster endorsements from current superstars or living legends. Even Hank Williams Jr., who had lost his longtime gig as the theme song performer for *Monday Night Football* in 2011 after comparing Obama to Hitler, and Charlie Daniels, who secured his position as country's foremost right-wing political pundit with his fiery opinions on the Soap Box section of his own website and CNSNews.com, both declined to endorse Trump.[67] "I don't give a shit about the election," Williams famously told *Rolling Stone Country*, "I've got a smash CD coming out!"[68] Toby Keith, who did end up playing for Trump's inauguration, nevertheless berated both candidates during the campaign and called the election a "dumpster fire."[69]

Noticing the lackluster response—especially for a Republican hopeful—commentators pontificated about country taking an apolitical turn. Most notable was a lengthy article in the Britain's *Guardian* newspaper which held that many country performers were afraid to touch the election for fear it might be toxic to their careers. The piece quoted country performer and independent label executive Dave Moody to affirm that the risks in 2016 kept many from publicly taking sides: "Twelve or 16 years ago, artists would say, 'I'm for Bush. I'll get on a stage with him and I'll do everything I can to support him.'" Moody's point, of course, was that few artists felt compelled to do the same for Trump. The article nevertheless noted a *Country Aircheck* poll which revealed that Trump led Clinton by a five-point margin (46 percent to 41 percent) among Nashville industry insiders. It also quoted astute country music historian Don Cusic about how, even with reservations, male country insiders privately indicated that they felt Trump was "one of us." And the piece noted the paradox of writers, creative people, and performers of a variety of political inclinations eking out a living together in the liberal urban oasis of Nashville within one of the redder of the red states, Tennessee.[70]

If country music's support was more conflicted or at least quieter than in previous elections, there nevertheless were striking similarities between the country music politicians analyzed in this book and the way in which Trump emerged as a serious presidential candidate and officeholder. Though Trump never experienced the kind of

poverty that figures such as Folsom and Davis did, his transition from real estate heir and businessman to reality television host and finally to politician mirrors the self-transformation from performer to politician undergone by many of the politicians covered in this book.

Beyond that, Trump's message is eerily close to that of the country music politicians. Folsom's mop-and-scrub-bucket for cleaning out the capital is a near-perfect analog to Trump's promise to drain the swamp in Washington. Trump's argument that a giant wall would be necessary to keep illegal immigrants from bringing crime into the nation was perhaps less forceful than Wallace's threat to send three thousand troops to Washington, DC, "five feet apart with three-foot bayonets" to quell "criminals" in the largely African American city, but some critics argued it drew from a similar fount of political hyperbole.[71] Trump's campaign promise to improve American infrastructure compares quite easily with Jimmie Davis's and Huey Long's gubernatorial promises to pave farm-to-market country roads. His downplaying of his campaign's connections with the Russian inner state and his naysaying about Vladimir Putin's intentions toward the West echo Glen Taylor's assertions that Stalin would be a great negotiating partner, a leading world citizen, and a diplomatic friend if only given the chance. Even Trump's pledge to unravel the North American Free Trade Agreement seems in some ways a revival of Tom Watson's charge that monopolists and federal monetary standards were keeping the common man down. Trump may be the Republican president least connected to country music in recent times, but this may be in fact because he has arguably best internalized the language of populist frustration that country performer-politicians have been speaking to for nearly a century. In this, he may be the most "country music" of all recent politicians.

Trump's path to the candidacy, too, retread many of the paths first taken by country music performer-politicians and in some ways retraced by television and movie actor Ronald Reagan. One can certainly argue that his years of reality television functioned as a means to bypass the usual political stepping stones that typically confront presidential hopefuls. Trump's visibility on television meant he did

not need to serve as governor or vice president or hold a Senate seat to develop the credibility and rapport he needed to win over voters, in much the same way that performer-politicians used radio airtime, open-air rallies, recordings, and the resulting publicity to surmount such obstacles as party establishments, hostile newspaper editors, and courthouse rings. Although for the most part none of the country music politicians came into their races with the surplus of economic resources Trump did, they—like Trump in his *Apprentice* television role—used performances in these relatively new mediums to generate publicity, which in turn created the audience recognition necessary for even a political newcomer to mount a successful electoral run. And like Trump with his provocations in the press and on Twitter, they used radio and the resulting publicity to maintain a relationship with their audience and constituents, provoke controversy, stoke publicity, and influence legislation.[72]

Missing in analyses of Trump is the one country performer with whom Trump has been most connected: the tall, black-hatted country baritone Trace Adkins. The winner of the 2013 season of Trump's *Celebrity Apprentice*, Adkins had originally appeared on the program in 2008 to earn money for a charity benefiting children with severe allergies like his own daughter; he lost in the final championship round to newscaster Piers Morgan. Then, in 2013, he joined the cast of the Trump program a second time and ended up winning the season with his maple-macadamia-nut-flavored ice cream and triumphant fundraising efforts on behalf of the American Red Cross. Though Adkins, who identifies as a voter typically supporting Republicans, campaigned for Bush in 2008 and Romney in 2012, he stayed out of the 2016 election, telling one reporter—cryptically, and with something of a smirk on his face—"You have no idea how apathetic I am trying to be."[73]

Nevertheless, Adkins's *A Personal Stand*, the 2008 biographical political polemic discussed in chapter 6, lays out a populist political vision of anger toward undocumented immigrants and, in some parts, unbridled contempt for a generalized Islam that at times is breathtaking in the ways it anticipates central tenets of Trumpism. For in-

stance, the book spends considerable time discussing how traditional Democrats and Republicans were unwilling or unable to address illegal immigration, which Adkins argued only suppressed the wages of good working-class citizens:

> Illegal immigration was a big issue in the 2006 midterm election and will become an even bigger issue in the upcoming presidential election. The Republicans are going to learn the hard way how the American public (and legal immigrants) feel about this issue because there is a huge group of conservative voters out there like me who are incredibly frustrated.[74]

As a solution, Adkins recommended a concerted and dramatic effort to "seal the border," which certainly foreshadows Trump's pledge to build a wall between the United States and Mexico. "After years of neglect," Adkins wrote, "this isn't a problem that going to be easily rectified in a matter of a few years."

> Once you seal the border, the remedy of enforcement is going to take time. If the federal and state politicians won't do it, then local people are going to take justice in their own hands and deal with it. This whole fence idea is a good idea, but it's going to take forever to build.[75]

Some eight years before Trump asserted that he "thinks Islam hates us" during a campaign interview on CNN, Adkins dismissed George W. Bush's assertion that Islam was a religion of peace, arguing instead that it was often the unacknowledged "elephant standing in the living room" when one addresses the causes of international conflict.[76] Though some of these positions and rhetorical choices seem to be drawn from conservative talk radio, the language Adkins used in *A Personal Stand*—at one moment folksy and down-to-earth, and at other times cocksure, making a startling claim in one section and then dialing it back a bit later on—certainly shares some similarities with Trump's speaking style. At times, one wonders whether candidate

Trump at least consulted the mass-produced paperback, if he didn't crib certain sections outright.

Adkins's reasons for not taking a stand on Trump in 2016 remain unclear, clouded in part by the way Adkins has used humor to deflect questions about the real estate mogul. In the past, he had publicly joked about Trump's ego. When asked by CNN's Anderson Cooper in 2011 what he thought of Trump's plan to purchase land to prevent the building of a mosque on the 9/11 Ground Zero area, Adkins quipped, "Was Trump going to build something (there) where they would worship *him*?"[77] In 2016, Adkins told reporters that he did not have enough time to get to know Trump very well while filming the programs, and that Trump's presidential bid and primary wins caught him by surprise. On another appearance, Adkins interjected humor, saying that, if Trump was elected, Adkins expected a cushy job serving as ambassador to Australia.[78]

Adkins did appear to be invited to and attend the inaugural ball, suggesting that the two reality show actors were not nursing some sort of behind-the-scenes grudge.[79] One might speculate that perhaps Adkins distanced himself because of prior political dustups or because he genuinely did not trust Trump. On the other hand, the reticence might have extended the other way, given the series of scandals Adkins faced just prior to 2016 primaries (including a fight on a cruise ship with a performer who made his career impersonating Adkins, and a subsequent drunken performance in front of ticket-paying fans; despite this, a spring 2017 article in *Rolling Stone* asserted that Adkins was again recording and was sober[80]). Adkins did not respond to my inquiries, so assertions about whether Trump was influenced in any way by Adkins or about why Adkins did not perform for Trump remains speculation.

The Legacies of the Musical-Political Campaign in the Larger Country Music Culture

Outside of Trump's connections with the genre, many of the threads examined in this book persist to this day within country music culture outside of campaigns. Outright racism has played less of a role in recent years; elements still persist in some quarters, including some antisemitism. Similarly, country music has never entirely left behind its veneration of the elderly, even if it has developed closer ties to lobbies for other causes. Agrarian ideals are still debated in song, though there are ample examples of lyrics trumpeting consumerism and modernity.

Opry performers' flirtations with the segregationism of George Wallace continued to some degree after Wallace set his presidential ambitions aside. This was perhaps most clearly displayed in 1979, when several cast members complained to a Gannett wire reporter about funk and soul artist James Brown being invited to perform on the Grand Ole Opry. Porter Wagoner, a fan of Brown's music, helped arranged the guest performance, but the visit received sharp criticism from fellow cast members such as Jean Shepard, who claimed having Brown on the stage was a "slap in the face," even though white non-country artists such as Frank Sinatra had already performed there.[81]

Nevertheless, after decades of associations with the segregationist politics of the Solid South, several country music performers, from Merle Haggard in the 1970s ("Irma Jackson") to Brad Paisley in the early twenty-first century ("Welcome to the Future"), have moved to re-embrace the racial egalitarianism that Tom Watson espoused early in his career and that later figures such as Glen Taylor upheld. (Paisley perhaps has complicated his own legacy in this respect with the release of his controversial and, some would argue, subtly prejudiced "Accidental Racist" track in collaboration with LL Cool J in 2013.) Even more important, African American performers of country music have reclaimed the longtime, profound connections between the genre and

African American culture themselves. The paths first carved out by Charley Pride, O. B. McClinton, and Linda Martell in the 1960s and '70s have evolved today into highways traversed by the likes of Darius Rucker, Rhiannon Giddens, Jimmie Allen, and Kane Brown, while all along African American artists from outside and within the genre have been shaping and contributing.[82] In recent decades that move has also extended somewhat toward sexual orientation. Numerous performers over the years have touted racial equality or acceptance of lesbian and gay people in song, from Garth Brooks in 1993 ("We Shall Be Free") to Kacey Musgraves in 2013 ("Follow Your Arrow"). LGBTQ performers such as Chely Wright, Ty Herndon, and Billy Gilman have come out about their sexuality, even if there are still homophobic or racist tendencies among some performers and fans.[83]

The flip side of Tom Watson's legacy also remains alive both within country music and the larger political culture in terms of antisemitism and other forms of xenophobia. Stacy Harris has noted, for instance, that the New York–based American Guild of Authors and Composers (AGAC) tried to establish an outpost in Nashville in the 1960s to represent songwriters and advocate for better compensation, but was deterred because of distrust of the Jewish leaders of the guild. The AGAC (originally the Songwriters Protective Association) had been founded in New York in 1931 by Jewish songwriters such as Billy Rose, Irving Berlin, and Jerome Kern, but Nashville musicians, according to longtime singer-songwriter John D. Loudermilk, refused to work with organizers "because they were Jews." Country songwriters instead established their own looser trade organization, the Nashville Songwriters Association, in 1967. Loudermilk eventually helped overcome that resistance and brought the AGAC, by then called the Songwriters Guild of America, to Nashville officially in 1983.[84]

Though Harris has documented several incidents of individual prejudice into the 1980s and '90s, outwardly at least, modern mainstream country music has largely steered clear of antisemitism. Performers running the ideological gambit—for example, Johnny Cash, who endorsed the more liberal Al Gore Jr. for president, and Charlie Daniels, in his more strident recent years as a conservative pub-

lic figure—have publicly embraced Jews and Israel, often exhibiting a mild, tolerant form of Christian Zionism that reserves respect for Jewish culture and beliefs.[85] Many Jews defied the types of stereotypes Henry Ford tried to create by playing understated but important roles in the early days of the genre, including fiddler Maurice Blumen, who appeared on the Opry, and brothers Joachim Jean and Julian Aberbach, who operated the important Hill & Range publishing house in the 1940s; producer Paul Cohen, who promoted rising stars such as Patsy Cline and Kitty Wells in the 1950s; manager Saul Holiff, who helped Johnny Cash rise to legendary status, and fiddler Gene Lowinger, who played with bluegrass pioneer Bill Monroe's Blue Grass Boys in the 1960s.[86] More recent figures include songwriters such as Michael Kosser, Victoria Shaw, and Pam Belford, record producer Richard Landis, and Ray Benson, lead singer of the popular western swing revival band Asleep at the Wheel.[87] One could easily argue that modern country music wouldn't be modern country music if it weren't for the numerous hit songs of Jewish songwriter and children's book author Shel Silverstein, probably best known for his writing credits on "A Boy Named Sue," "Tequila Sheila," and "Marie Laveau."[88] Although Kinky Friedman certainly tops the list for those attempting to account for Jewish country music stars, several performers outside the Nashville mainstream have dabbled in or made substantial contributions to country music, including Mare Winningham, the 1980s "Brat Pack" star and convert to Judaism who cut an entire album of bluegrass-tinged Jewish religious-themed country songs, and Texas-based Joe Buchanan, another singer-songwriter convert who has left behind an Americana sound to combine Jewish religious expression and Hebrew prayers with classic Southern- and Bakersfield-style country.[89] Indeed, an entire "Jewgrass" subgenre, perhaps represented most prominently by the husband-wife duo Nefesh Mountain, has arisen out of the blending of performers' religious and cultural values with the traditionally Appalachian music.[90]

This is not to say that country music is free of the kind of conspiratorial scapegoating that marked the diatribes of Ford and the aging Watson in the 1920s. In 2004, Jewish British comedian Sacha Baron

Cohen shone a light on latent antisemitism in a controversial and contested incident during which he tricked patrons of a country bar in Tucson, Arizona, into singing along with antisemitic verses composed by his famous Borat character.[91] Elements of this occasionally appear in country song as well—as in the rapacious "little man whose name is Saul" and "has a lot of money to loan" that prefaces Dwight Yoakam's 1989 hit "I Got You."

Although the nomenclature has changed from pensions to retirement plans, one might argue that, despite criticisms of modern country neglecting its own history, there is no shortage of songs that continue in the tradition of "That Silver-Haired Daddy of Mine." Indeed, one finds sensitivity and concern for the elderly in several songs: for example, Randy Travis's 1987 "Forever and Ever, Amen," Kenny Chesney's 1995 "Grandpa Told Me So," Justin Moore's 2009 "Grandpa," and Carrie Underwood's 2012 "Forever Changed." Many songs use story form to tell of everlasting love, or to bemoan the loneliness and other issues (e.g., poverty, Alzheimer's) that the elderly face. In 1992, George Jones sang in first person about his own efforts to stall retirement and the trappings of old age in "I Don't Need Your Rocking Chair," a song that ended with a "billion dollar" backup chorus featuring Garth Brooks, Mark Chesnutt, Travis Tritt, and several other top names in the business. That song peaked at no. 34 on the Hot Country Charts.[92]

Six years later, the Old Dogs—a short-lived country music supergroup featuring Waylon Jennings, Mel Tillis, Bobby Bare, and Jerry Reed—put out an album of songs about aging penned by Shel Silverstein. Silverstein and Bare had been joking about how the genre was dominated by skinny, good-looking young men and realized there was a lack of self-referential songs about aging. Tracks on the album took on such topics as aging in the workplace and the still-vital sex lives of older people, often with a self-deprecating, devilish, or humorous twist. Although the album received little mainstream radio play, it did earn a CMA award nomination.[93] More recently, country songwriters have followed the George Jones route by singing about aging in the first person, as in Trace Adkin's "Watered Down," which insists that there is still much to look forward to later in life, even if you have to

slow down a little. Surveys of country music listeners similarly indicate that the genre, though gaining ground with younger listeners, remains popular with consumers in the 55-to-64 and 65-plus age groups.[94] Should politicians unravel Social Security or other elements of retirement income at some point, one can imagine a return to the connections that candidates and performers have made in the past. During the period of job loss and mortgage foreclosures of the 2008 recession, one might note that country music, with its characteristic expressions of loss and hurt, actually grew in popularity, especially among ethnic and racial minorities.[95]

Despite this history, there does not appear to be a concerted attempt by players such as the AARP (formerly the American Association of Retired Persons) or the National Committee to Preserve Social Security and Medicare to link themselves with country music in any way. In fact, the kind of alliances one might imagine connecting country music and retirement politics focused instead on the issue of gun ownership, or at least until October 2017 mass shooting at the Route 91 Harvest country music festival in Las Vegas. Before the shooting, the National Rifle Association included on its website a list of more than thirty country music partners involved in its "featured artist campaign."[96] In the aftermath, however, the NRA has appeared to have taken down the featured artist page, and influential performer Eric Church publicly called out the NRA for its involvement in creating loopholes in the law for purchases at gun shows and the kinds of bump stocks that were used in the killing. "I don't understand why we have to fear a group [like the NRA]," Church told *Rolling Stone*. "It's asinine. Why can't we come together and solve one part of this? Start with the bump stocks and the gun shows. Shut a couple of these down."[97] By late 2018, the shooting and its connections to country music had implications in the electoral realm. Nevada assemblywoman Sandra Jauregui, who was at Route 91 and survived the shooting, talked about her Latina roots, her love for country music, and her support for stronger laws around gun safety during her successful reelection campaign that fall. "You shouldn't have to die to matter,

but the fact that people died SHOULD matter," she wrote in one social media post to voters.[98]

Finally, country music remains an important examination table on which the ways of modern life are dissected and compared with traditions from the past. In this regard, modern mainstream country performers are perhaps moving a step further away from being the "Agrarians mugged by reality" that I mention at the end of chapter 6. Toby Keith's celebration of the "Red Solo Cup" and Lee Brice's "Parking Lot Party" celebrate consumerism combined with hedonism in a way that country music autobiographies never did—not as a welcome temporary escape from a hard life or even the pangs of stardom, but as a way of life involving fancy pickup trucks and off-road toys, rendezvous in shopping mall lots, excessive drinking, and chasing after young women. Writer Nick Murray goes so far as to argue that modern country music has associated itself with the very forces that the historical Vanderbilt Agrarians seem most poised against. According to Murray, a series of outdoor Farm Tour concerts featuring contemporary country star Luke Bryan has been used by sponsor Bayer AG and its sometimes vilified Monsanto subsidiary to whitewash the ways in which Bayer-Monsanto and other corporations have used proprietary seed technologies, sales of agrichemicals, and even electronic surveillance techniques to "roll back the limited autonomy" that family farmers still have. Though popular with many rural people, the concerts, which are held on specially selected family farms, act as the antithesis of Willie Nelson's more anticorporate Farm Aid concerts by making large agri-companies seem benign, he contends.[99]

Murray's criticisms aside, agrarian themes have not disappeared, nor have they been completely co-opted, in country music. Rather they have reemerged in exaggerated and dystopian ways, especially on the rootsy edges of the genre. Hank Williams Jr.'s hard-nosed, crafty outdoorsman in "A Country Boy Can Survive," for instance, has given way to Canadian Corb Lund's paranoid doomsday survivalist in "Gettin' Down on the Mountain," which leaves the listener unsure whether Lund is lampooning the prepper he portrays or whether

industrial life has become so tainted, so unlivable, we all ought to go join him.

Ultimately, country music and its political legacy are haunted by many ghosts: Tom Watson and George Wallace's bigotry, but also Glen Taylor and Big Jim Folsom's inclusivity; Jimmie Davis's concern about the elderly, but also Tom Heflin's mendacity toward African Americans and the poor; the Southern Agrarians' critique of wasteful consumerism, but also Loretta Lynn's appreciation of the simple pleasure of a "store-boughten" dress. Country music not only pioneered much of the current conflagration of politics and celebrity that dominates our national scene, but its history reminds us about the promises and perils of mixing policy with listening pleasure. Let us hope that, if our music and our politics continue to converge, they enable the better angels of our nature.

ACKNOWLEDGMENTS

I have been lucky to have had the assistance of supportive family, friends, and colleagues while writing this book. Any errors or omissions are solely mine. Two fellow music researchers in particular deserve considerable thanks. Richard Blaustein at Eastern Tennessee State University graciously offered suggestions during the early stages about how one might even begin tackle this topic. His experience and insight were invaluable. During the final stages of this project, Pete Gough at Sacramento State University helped me immensely by carefully reading my chapters and offering perceptive comments and suggestions about how to move the manuscript forward. I am honored to call him a friend. In a strange way, the late labor and gay rights activist Harry Hay deserves some credit, too, having told me in a moment of prescience nearly two decades ago that I would be spending much of my life examining the connections between country music and politics. (Little did I know.) Mark Allan Jackson, Nancy Raynor, Josh Kun, Lisa Ansell, and Bruce Zuckerman were also extremely helpful in providing feedback to various iterations of this project.

Several people at Nevada State College were also particularly supportive by assisting me with faculty travel and research funds over the years and with a sabbatical that was necessary for this work to

move into its final stages. Among the administrators, faculty, and staff who have been particularly helpful are Jo Meuris, Andy Kuniyuki, Elizabeth De LaTorre, Vickie Shields, Erika Beck, Adam Davis, Daniel Grassian, Gwen Sharp, and Gregory Robinson. Provost Shields, Caitlin Hipper, Penny Morris, and Sita Salas in particular provided an enormous amount of assistance when I undertook the task of acquiring photographs for the book and deserve much thanks for their hard work, persistence, and patience. In a time of heightened antisemitism, I am also particularly grateful to the Vidal Sassoon International Center for the Study of Antisemitism at Hebrew University in Jerusalem, Israel, which provided me with important assistance needed for my travels to Dearborn and my research on Henry Ford. I also want to make a special acknowledgment of Arod Taylor and the Taylor family for sharing their time, resources, and memories of Glen with me.

I also owe an enormous debt to many librarians and archivists who assisted me and went above the call of duty. Kate Hahn, Tiffany LeMaistre, Nathaniel King, Kelly Lutz, Maya Hobscheid, Francesca Marineo, Janette Reynaga, and Mina Eissa at my campus library were always there to assist. I am grateful to Stephanie Lucas at the Benson Ford Research Center; Sara Keckeisen and Jessica Heck at the Kansas State Historical Society; Stephen C. Sturgeon at the Utah State University special collections and archives; Kris Bronstad at the libraries of the University of Tennessee, Knoxville; Germain Bienvenu at the Louisiana State University special collections; Meredith McDonough at the Alabama Department of Archives and History; Charlene Bonette at the State Library of Louisiana; Tad Brown of the Watson-Brown Foundation; Matthew Turi and Jessica Kincaid at the University of North Carolina special collections; Jen Larson at the Opry; and Molly Dohrmann at Vanderbilt University Library special collections. For photos, Mark Murrmann at *Mother Jones* and Glenn Cook (go Wildcats!) and Erik Verduzco at the *Las Vegas Review-Journal* all really went out of their way to help me as well.

I started this project at the University of Chicago Press with Robert Devens, whom I thank for putting his initial trust in me, and finished it with Timothy Mennel, who continued to believe in this project

and who has shown real professionalism and Gandhi-like patience as an editor. Rachel Kelly Unger and Johanna Rosenbohm also deserve many thanks.

I am also thankful for the help of a number of scholars, experts, and enthusiasts along the way whom I consulted or who offered assistance or advice on this project in myriad ways. Among these are F. Ross Peterson, Allison Robbins, Kevin Fontenot, Chris Goertzen, Simon J. Bonner, Keith R. Perry, Greg Reish, Michael Green, Doug Datwyler, Jonny Whiteside, Steven Green, Ed Cray, Karl Koenig, Julian Kilker, Yvonne Houy, Helen Zakina-Montgomery, Michael Montgomery, Charlie McGovern, Jeff Place, Ted Olsen, and Richard D. White. Steven J. Ross deserves credit, too, for helping me strategize about finding a press for this manuscript in the first place. I also want to send a special thank-you to the students who participated in my *O Brother, Where Art Thou?*–themed history topics course at Nevada State for listening to me float many of the ideas in this book and offering helpful suggestions along the way: Babatunde Adesanwo, Zoe Berry, Suzanne Capps, Antonio Delgado, Amalia Kelso, Alec Maxwell, Loree Parker, Tiara Parkinson, Katherine Ruvalcaba, Tucker St. John, John Walls, and Brenton Wilde.

My parents, Gary and Elinor, and mother- and father-in-law, Nachman and Ronit, have been wonderfully supportive in a variety of ways and deserve my unending gratitude. Asher and Samuel have also patiently put up with their father's pursuits and given me inspiration to move forward; I am truly blessed to have such great sons. And last but certainly not least, I want to confess that I would have never finished this book without my wonderful wife, Shirli Brautbar. Shirli has always been my first reader and editor, as well as my day-to-day research and writing consultant. Her insights and judgment are impeccable, and I am very lucky to have her as an academic and life partner.

NOTES

Introduction

1. "Tom Watson's Fiddle," *Kansas City Journal*, October 4, 1896, 19.

2. "Curbstone Echoes Caught on the Wing," *Atlanta Constitution*, November 19, 1882, 1.

3. The young Watson did not, however, support complete social equality, preferring that blacks sit in back or apart from whites at political meetings that he organized. Omar H. Ali, *In the Lion's Mouth: Black Populism in the New South, 1896–1900* (Jackson: University Press of Mississippi, 2010), 79–80.

4. Not to be confused with Otis "Doc" Bowen, a doctor who served as governor of Indiana and Secretary of Health and Human Services in the Reagan administration.

5. Some important expressions of this viewpoint—which also sort of bookend a lot of literature arguing for reactionism or the apolitical—are Paul DiMaggio, Richard A. Peterson, and Jack Esco Jr., "Country Music: Ballad of the Silent Majority," *The Sounds of Social Change: Studies in Popular Culture* (Chicago: Rand McNally, 1972), 38–55; and Robert W. Van Sickel, "A World without Citizenship: On (the Absence) of Politics and Ideology in Country Music Lyrics, 1960–2000," *Popular Music and Society* 28, no. 3 (July 2005): 313–31.

6. This does not mean that other genres have not produced politicians. Among the list of professional noncountry performers who have successfully transitioned to politics are such names as US representative Sonny Bono, the pop singer and partner of Cher; guitarist and Spanish-language performer

and New Mexico lieutenant governor Roberto Mondragón; soul singer and Detroit city council member Martha Reeves; progressive-rock keyboardist and Utah governor John Huntsman; blues guitarist and national GOP chairman Lee Atwater; and Hollywood musical performer and California senator George Murphy. Compared to country, there does not seem to be a concentration of politicians in any one genre, nor enough of a track record to identify a particular style of electoral politics associated with these figures. For a general overview of these performer-politicians, see, for instance, Steve Terrell, "Blues for Mr. President," *Pasatiempo*, arts and culture insert, *Santa Fe New Mexican*, March 2, 2012, 18; and "Musicians Turned Politicians," *Telegraph* (London), accessed June 1, 2017, http://www.telegraph.co.uk/culture/culture picturegalleries/8992353/Picture-gallery-Musicians-turned-politicians .html.

7. Issues of authenticity have become sort of a standard lens for country music scholarship ever since Richard A. Peterson's important 1995 article that pointed out that the music and performers' public images could be divided into traditionalist, rebellious "hard core" and pop and cross-over "soft-shell" varieties. Rather than finding neat through lines where liberals sorted themselves into one group and conservatives into another, I instead discovered that politicians and performer-politicians often scuttle any neat binary. See Richard A. Peterson, "The Dialectic of Hard-Core and Soft-Shell Country Music, *South Atlantic Quarterly* 94, no. 1 (1995): 273–300. See also Richard A. Peterson, *Creating Country Music, Fabricating Authenticity* (Chicago: University of Chicago Press, 1997), especially chapter 9.

Chapter 1

1. *New Orleans Daily Democrat*, editorial, November 23, 1878, 4.

2. "Curbstone Echoes Caught on the Wing," *Atlanta Constitution*, November 19, 1882, 1.

3. Robert L. Taylor Jr., "Demagoguery, Personality, and the Gospel of Democracy: Family Influence on Centennial Governor Taylor," *Tennessee Historical Quarterly* 55, no. 2 (Summer 1996): 163–65.

4. James P. Taylor, Alf A. Taylor, and Hugh L. Taylor, *Life and Career of Senator Robert Love Taylor (Our Bob)* (Nashville: Bob Taylor, 1913), 81–86.

5. Taylor, Taylor, and Taylor, *Life and Career*, 95.

6. Taylor, Taylor, and Taylor, *Life and Career*, 99, 102, 117–18.

7. C. Van Woodward, *Tom Watson: Agrarian Radical* (Oxford: Oxford University Press, 1963), 1–51.

8. Woodward, *Tom Watson*, 9, 18.

9. "Tom Watson's Fiddle," *Kansas City Journal*, October 4, 1896, 19.

10. Woodward, *Tom Watson*, 32–34, 37, 42.

11. See, for instance, Howard W. Marshall, *Play Me Something Quick and Devilish: Old-Time Fiddlers in Missouri* (Columbia: University of Missouri Press, 2013), 107–34; and J. Justin Castro, "Music Heard Deeply: Song and Ethnic Interaction in the Cherokee Ozarks" (master's thesis, University of Central Oklahoma, 2008).

12. Noel C. Fisher, *War at Every Door: Partisan Politics and Guerilla Violence in East Tennessee, 1860–1869* (Chapel Hill: University of North Carolina Press, 1997), 10–11, 16, 29, 38–41.

13. "Waynesboro," *Daily American (Nashville)*, September 29, 1886, 1.

14. Taylor, Taylor, and Taylor, *Life and Career*, 125.

15. L. L. Poats, "Hawkins Country Department," *Morristown (TN) Gazette* October 2, 1878, 3.

16. *New Orleans Daily Democrat*, editorial, November 23, 1878, 4.

17. Robert L. Taylor Jr., "Tennessee's War of the Roses as Myth and Symbol," *Tennessee Historical Quarterly* 41, no. 4 (Winter 1982): 337–40.

18. See, for instance, "Fiddles Brought In," *Ashville (NC) Citizen-Times*, September 17, 1886, 4.

19. Taylor, "Tennessee's War of the Roses," 337–40.

20. Woodward, *Tom Watson*, 99–102.

21. Thomas E. Watson, diary, items 264–65, Thomas E. Watson Papers, collection 755, scrapbook 4, Southern Historical Collection, Wilson Library, University of North Carolina at Chapel Hill.

22. "Curbstone Echoes Caught on the Wing," *Atlanta Constitution*, November 19, 1882, 1.

23. Chris Goertzen, *Southern Fiddlers and Fiddle Contests* (Jackson: University Press of Mississippi: 2008), 97–101; Wayne Erbsen, *Southern Mountain Mandolin* (Pacific, MO: Mel Bay Publications, 1995), 52–52.

24. William J. Mahar, *Behind the Burnt Cork Mask: Early Blackface Minstrelsy and Antebellum American Popular Culture* (Urbana: University of Illinois Press, 1999), 272–79; Chris Goertzen, "George Cecil McLeod, Mississippi's Fiddling Senator, and the Modern History of American Fiddling," *American Music* 22, no. 3 (Autumn 2004): 355–62.

25. Woodward, *Tom Watson*, 100, 107–11.

26. Woodward, 220.

27. Omar H. Ali, *In the Lion's Mouth: Black Populism in the New South, 1886–1900* (Jackson: University Press of Mississippi, 2010), 64, 78–81.

28. Goertzen, *Southern Fiddlers*, 97–101; Erbsen, *Southern Mountain Man-*

dolin, 52–52; Mahar, *Behind the Burnt Cork Mask*, 272–79. One might read between the lines and connect the song with the long history of white masters or white men raping or taking advantage of black women and enslaved people as well, although completely understanding the performer's intent and the audience's reception of the song is near impossible, especially as the song became so popular and bowdlerized over time.

29. Robert L. Taylor Jr., "Apprenticeship in the First District: Bob and Alf Taylor's Early Congressional Races," *Tennessee Historical Quarterly* 20, no. 1 (Spring 1969): 31.

30. "It Must Not Be Forgotten," *New York Sun*, July 28, 1896, 6.

31. "New Faces in the Senate," *Baltimore Sun*, March 18, 1907, 2.

32. See "The Fiddle and the Bow," in Robert L. Taylor, *Gov. Bob Taylor's Tales* (Nashville: DeLong Rice, 1896), 9–18.

33. 'When Fiddlin' John Met Fiddlin' Bob," *Middlesboro (KY) Daily News*, June 12, 1924, 3.

34. "Tom Watson's Violin," *Atlanta Constitution*, August 30, 1896, 2. This piece was reprinted in magazine form in Boston's *Opera Glass* 3, no. 10 (October 1896): 171.

35. Watson quoted in "Tom Watson's Fiddle," *Kansas City Journal*, October 4, 1896, 19; Woodward, *Tom Watson*, 298; Wayne W. Daniel, "Tom Watson of Georgia: Politician and Fiddler," *Devil's Box* 24, no. 2 (1990): 16.

36. Peter Argersinger, *The Limits of Agrarian Radicalism: Western Populism and American Politics* (Lawrence: University Press of Kansas, 1995), 64–79; William Kock, "Campaign and Protest Singing during the Populist Era," *Journal of the West*, 47–57.

37. Gene Wiggins, *Fiddlin' Georgia Crazy: Fiddlin' John Carson, His Real World, and the World of His Songs* (Urbana: University of Illinois Press, 1987), 112–13.

38. "The Issue Analyzed," editorial, *Atlanta Constitution*, August 30, 1920, 4; "Plan Revolt in the South," *Washington Post*, March 1, 1920, 1. For detail on Watson's later political evolution, see Woodward, *Tom Watson*, 370–450.

39. Wiggins, *Fiddlin' Georgia Crazy*, 112–14; Daniel, "Tom Watson," 13–14.

40. Woodward, *Tom Watson*, 370–450.

41. Ali, *In the Lion's Mouth*, 80; Thomas E. Watson, "What Goes On in the Nunneries?," *Watson's Magazine* 21, no. 2 (June 1915): 69–73; Thomas E. Watson, "The Official Record in the Case of Leo Frank, a Jew Pervert," *Watson's Magazine* 21, no. 4 (September 1915): 292–94.

42. Gavin James Campbell, *Music and the Making of the New South* (Chapel Hill: University of North Carolina Press, 2004), 134–35; Patrick Huber, *Lint-*

head Stomp: The Creation of Country Music in the Piedmont South (Chapel Hill: University of North Carolina Press, 2008), 58–62, 91–94.

43. "Mob's Own Story Told in Detail," *Atlanta Constitution*, August 18, 1915, 7.

Chapter 2

1. See, for instance, William Adam Simonds, *Henry Ford and Greenfield Village* (New York: Frederick A. Stokes, 1938), 153–214; and William C. Richards, *The Last Billionaire: Henry Ford* (New York: Scribner, 1950), 161–95.

2. Details about old-time dance and music expenses gleaned mostly from materials in the Benson Ford Research Center, the Henry Ford, Dearborn, Michigan, especially the reminiscences of Ernest G. Liebold and Benjamin B. Lovett. Important secondary sources here are Eva O'Neal Twork, *Henry Ford and Benjamin B. Lovett: The Dancing Billionaire and the Dancing Master* (Detroit: Harlo Press, 1982); and James C. Foust, "Mass-Produced Reform: Henry Ford's *Dearborn Independent*," *American Journalism* 14, no. 3–4 (summer/fall 1997): 421.

3. Spencer Ervin, *Henry Ford vs. Truman H. Newberry: The Famous Senate Election Contest* (New York: R. R. Smith, 1935), 3–39.

4. See, for instance, Neil Baldwin, *Henry Ford and the Jews: The Mass Production of Hate* (New York: Public Affairs, 2001), 97–107. On speculation about a Ford presidential run, see "Neighbors Enter Ford in 1924 Race to White House," *Chicago Tribune*, June 8, 1922, 17.

5. "Henry Ford's Mania," *Akron (OH) Evening Times*, December 6, 1920, 6. Descriptions of Ford's penchant for old-time music and dance stem from "Henry Ford Shakes a Wicked Hoof," *Literary Digest* 86, no. 7 (August 15, 1925): 38; and Virginia Pope, "Maine's Champion Fiddler Finds Fame at His Door," *New York Times*, November 13, 1925, SM4; "Ford and His Fiddler Move on Detroit: Will Seek to Covert Local Devotees of Terpischore with Old-Fashioned Dances," *New York Times*, December 13, 1925, 6.

6. "Ford Hires Big Hall for Old-Time Dance," *New York Times*, December 14, 1925, 2; "Fiddling to Henry Ford," *Literary Digest* 88, no. 1 (January 2, 1926): 356.

7. "Ford Wars on Jazz," *Los Angeles Times*, July 12, 1925, E2.

8. "Take Down the Fiddle and the Bow," *Youth's Companion* 100, no. 1 (January 7, 1926): 10.

9. Robert Lacey, *Ford: The Men and the Machine* (Boston: Little, Brown, 1986), 137–46, 154–58; Douglas Brinkley, *Wheels for the World: Henry Ford, His Company, and a Century of Progress* (New York: Penguin 2003), 194–200.

10. Leo Ribuffo, "Henry Ford and *The International Jew*," *American Jewish*

History 69 (June 1980): 448; 452–53, 457; Josh Kun, "The Yiddish Are Coming: Mickey Katz, Antic-Semitism, and the Sound of Jewish Difference," *American Jewish History* 87, no. 4 (December 1999): 356; Steve Allen Carr, *Hollywood and Anti-Semitism: A Cultural History Up to World War II* (Cambridge: Cambridge University Press, 2001), 87–90.

11. Ford's distaste for dance halls, jazz, and Tin Pan Alley is especially evident in the anonymously penned articles in his newspaper "Jewish Jazz Becomes Our National Music," *Dearborn Independent*, August 6, 1921, 8–9, and "How the Jewish Song Trust Makes You Sing," *Dearborn Independent*, August 13, 1921, 8–9. Ford mentions old-time music and dancing as an alternative to these forms in the aforementioned "Ford Wars on Jazz," E2; and Rose C. Feld, "Ford Revives the Old Dances" *New York Times*, August 16, 1924, SM2.

12. Text portions of the manuscript of *"Good Morning"*, including the introductory chapter, "The Return of the Dance," ca. 1925, are found in folders 1, 3–5; box 1, acc. 356, "Ford, Henry—Miscellaneous Papers," Benson Ford Research Center, the Henry Ford, Dearborn, Michigan.

13. On Ford's impact on the emergence of these musical genres, see Richard A. Peterson, *Creating Country Music: Fabricating Authenticity* (Chicago: University of Chicago Press, 1997), 59–62; Charles K. Wolfe's *A Good-Natured Riot: The Birth of the Grand Ole Opry* (Nashville: Country Music Foundation Press/Vanderbilt University Press, 1999), 77–70.

14. Karl Hagstrom Miller, *Segregating Sound: Inventing Folk and Pop Music in the Age of Jim Crow* (Durham, NC: Duke University Press, 2008), 198, 217–23; John S. Otto and Augustus M. Burns, "Black and White Cultural Interaction in the Early Twentieth Century South: Race and Hillbilly Music," *Phylon* 35, no. 4 (December 1974): 407–17; "a creolized synthesis": William G. Roy, "Aesthetic Identity, Race, and American Folk Music,' *Qualitative Sociology* 25, no. 3 (Fall 2002): 462.

15. See Richard Nevell, *A Time to Dance*, 63–65. Perhaps the best analyses of these dances to date is Allison Robbins, "Henry Ford's Old Time Dance Revival" (paper, Society for American Music's 32nd Annual Conference, Chicago, March 16, 2006).

16. Ernest G. Liebold, reminiscences, acc. 65, p. 1367, Benson Ford Research Center, the Henry Ford, Dearborn, Michigan.

17. Perhaps the best secondary source on the effect of Ford's promotion on the old-time, or hillbilly, music audience is Wolfe's *A Good-Natured Riot*, 77–79. See also Peterson, *Creating Country Music*, 60–62.

18. Invitation and club member listing, January 27, 1910, in "Ford, Henry—

Dancing" folder, vertical file, Benson Ford Archive. Ford R. Bryan reproduces the invitation and mentions the 1910 dance, which attracted forty people, in *Friends, Families, and Forays: Scenes from the Life and Times of Henry Ford* (Detroit: Wayne State University Press, 2002), 13–15; but the dance is generally left out of most attempts to mine Ford dance history.

19. Roger Butterfield, "Henry Ford, the Wayside Inn, and the Problem of 'History is Bunk,'" *Proceedings of the Massachusetts Historical Society* 77 (1965): 53–66. See also discussion in Brinkley, *Wheels for the World*, 225–26, 244–48.

20. "Henry Ford Still Thinks Soldiers Are Murderers," *New York Times*, July 16, 1919, 1; "Odd Definitions Given by Ford in Libel Suit," *New York Times*, July 17, 1919, 1.

21. Associated Press, "History and Art Bunk, Says Ford," *Los Angeles Times*, July 16, 1919, I8.

22. See, for instance, the 1890s-era S. S. Stewart banjo noted in the Henry Ford's Music and Sound online exhibit: https://www.thehenryford.org/collec tions-and-research/digital-collections/artifact/154465.

23. "Ford Keeps a Promise," *New York Times*, October 13, 1923, 2. Relying on recollections by the farmer Stewart Carmichael of Evart, Michigan, Paul Gifford has argued that Ford, Edison, and Firestone had come across Bisbee on an annual camping trip in the area after Ford's brother-in-law, Milton D. Bryant—a Ford dealer in Traverse City, north of Paris—had recommended Bisbee as a skilled fiddler. Paul Gifford, "Jasper E. 'Jep' Bisbee: Old-Time Michigan Dance Fiddler," *Old-Time Herald* 9, no. 6, accessed December 15, 2009, http:// www.oldtimeherald.org/archive/back_issues/volume-9/9–6/jasper-bisbee .html.

24. "Ford Brings Old Fiddler," *New York Times*, November 22, 1923, 11; "Edison 'Cans' Music of Old Time Dance Fiddler," *New York Times*, November 22, 1923, 2; "'Jep' Fiddles for Edison," *New York Times*, November 24, 1923, 3; "Ford at Oldtime Dance," *New York Times*, January 5, 1924, 3.

25. Associated Press, "Ford Indorsed in Call Issued for Convention," *Tennessean* (Nashville), November 22, 1923, 1.

26. "Ford's Indorsement of Coolidge," *Minneapolis Morning Tribune*, December 20, 1923, 20.

27. "Mine Host Ford Fiddles for Dance," *New York Times*, February 10, 1924, E1; "Ford Debt to Longfellow," *New York Times*, February 17, 1924, S6. For details about Ford's patronage of traditional musicians during this time period, see Paul Gifford, *The Hammered Dulcimer: A History* (Lanham, MD: Scarecrow Press, 2001), 352–58.

28. Benjamin B. Lovett, reminiscences, acc. 1, box 134, Benson Ford Research Center, the Henry Ford, Dearborn, Michigan. See also Twork, *Henry Ford and Benjamin B. Lovett*, 54.

29. "Ford to Learn Oldtime Dances," *New York Times*, August 29, 1924, 1; Richards, *The Last Billionaire*, 104–5.

30. William C. Richards, "Ford Trips Ripple as Lizzies Look On," *World* (New York), August 2, 1925, S7; "Henry Ford Shakes a Wicked Hoof," *Literary Digest* 86, no. 7 (August 15, 1925): 38, 40; Rose C. Feld, "Ford Revives the Old Dances," *New York Times*, August 16, 1924, SM1–2, SM23.

31. "Henry Ford Shakes a Wicked Hoof," 40.

32. Robbins, "Ford's Old Time Dance Revival," 4.

33. Liebold, reminiscences, 1367.

34. Quoted in script for the Blue Network's *Early American Dance* program, March 11, 1944, 2, in "Radio—Early American Dance Music—1944" folder, acc. 1, box 135, Benson Ford Research Center, the Henry Ford, Dearborn, Michigan.

35. "Ford Greets Dunham at Dearborn Home," *New York Times*, December 9, 1925, 14. A helpful secondary source on the Dunham fanfare is Paul F. Wells, "Mellie Dunham: Maine's Champion Fiddler," *John Edwards Memorial Foundation Quarterly* 12, no. 43 (Autumn 1976): 112–18. On Martin, see "Ford to Hear Dulcimer," *Los Angeles Times*, December 13, 1925, 21.

36. "Fiddling to Henry Ford," *Literary Digest* 88, no. 1 (January 2, 1926): 36.

37. "Henry Ford Greets New Dance Tune Fiddler," *New York Times*, December 10, 1925, 16.

38. Quoted in Associated Press, "Fiddles as Ford Dances," *Los Angeles Times*, December 12, 1925, 1. On sparking ire, see, for instance, coverage of challenges to Dunham raised by championship winners in Rhode Island, New England, and California: "71-Year-Old Fiddler Wins," *New York Times*, January 6, 1926, 8; "Old-Timer Wins Fiddle Title Glory," *Los Angeles Times*, January 8, 1926, 7; and "Fiddling Title at Stake," *Los Angeles Times*, January 25, 1926, A1.

39. Wolfe, *Good-Natured Riot*, 75–77.

40. Associated Press, "Fiddler Champ Challenged," *Los Angeles Times*, January 4, 1926, 8.

41. Wolfe, *Good-Natured Riot*, 77–79.

42. Edmund Morgan, *Virginians at Home: Family Life in the Eighteenth Century* (Charlottesville: University of Virginia Press, 1952), 87–88; Richard Jason Blaustein, "Traditional Music and Social Change: Old Time Fiddlers Association Movement in the United States" (PhD diss., Indiana University, 1975), 53–55.

43. Kevin S. Fontenot, "Country Music's Confederate Grandfather: Henry C. Gilliland," in *Country Music Annual 2001*, ed. Charles K. Wolfe and James Akenson (Lexington: University Press of Kentucky, 2001), 200.

44. Henry Sapoznik, *Klezmer! Jewish Music from Old World to Our World* (London: Schirmer Trade Books, 2006), 7–8, 13–14, 43.

45. Stacy Harris, "Kosher Country: Success and Survival on Nashville's Music Row," *Southern Jewish History* 2 (1998): 112–16. Lowinger speaks of his Jewish New Jersey upbringing in his memoir, mentioning the influence of his father, who was a bandleader in the 1920s, although it is unclear if his father's band played klezmer or another type of music. See Gene Lowinger, *I Hear a Voice Calling: A Bluegrass Memoir* (Urbana: University of Illinois Press, 2009), 8, 31. Monroe told Lowinger that he was fond of his playing partly because Lowinger knew Jewish music and Monroe revered what he called its "ancient tones."

46. Wayne W. Daniel, *Pickin' on Peachtree: A History of Country Music in Atlanta, Georgia* (Urbana: University of Illinois Press, 2001), 17–18; Fontenot, "Confederate Grandfather," 195.

47. Fontenot, "Confederate Grandfather," 196–97.

48. Chris Goertzen, *Southern Fiddlers and Fiddle Contests* (Jackson: University Press of Mississippi, 2008), 9. On the Atlanta competition, see Steve Goodson, *Highbrows, Hillbillies, & Hellfire: Public Entertainment in Atlanta, 1880–1930* (Athens: University of Georgia Press, 2002), 163–66; Gavin James Campbell, *Music and the Making of a New South* (Chapel Hill: University of North Carolina Press, 2004), 100–142; and Daniel, *Pickin' on Peachtree*, 18–23.

49. Fontenot, "Confederate Grandfather," 196–98.

50. "Stanley's Big Day," *Lincoln County (NC) News*, July 19, 1912, 3. On Heflin's background, see Ralph Melvis Tanner, "The Wonderful World of Tom Heflin," *Alabama Review* 36 (July 1983), 83–112; Elbert L. Watson, "J. Thomas Heflin," in Watson, *Alabama United States Senators* (Huntsville, AL: Strode, 1982), 116–18; and "Congressman Shot Negro in Street Car," *New York Times*, March 28, 1909.

51. "Fiddlers' Convention," *Blocton (AL) Enterprise*, March 22, 1917, 2.

52. Ralph M. Tanner, "Senator Tom Heflin as Storyteller," *Alabama Review* 15 (January 1962): 54–60; Watson, "J. Thomas Heflin," 116–18.

53. Glenn T. Harper, "'Cotton Tom' Heflin and the Election of 1930: The Pride of Party Disloyalty," *Historian* 30, no. 3 (May 1968), 389–411; J. Mills Thornton III, "Alabama Politics, J. Thomas Heflin, and the Expulsion Movement of 1929," *Alabama Review* 67, no. 1 (January 2014): 10–29; Watson, "J. Thomas Heflin," 117.

54. Russell Kent, "'Nero' Heflin to Engage Chemist to Examine Fiddle; 'Thing Is Poisoned,'" *Montgomery Advertiser*, March 2, 1928, 1; "Fiddlin' Tom May Give Concert on Monument Top; Would Outnero Nero," *Montgomery Advertiser*, March 1, 1928, 1; "Tom and the Fiddle," editorial, *Montgomery Advertiser*, March 6, 1928, 4.

55. This seems confirmed by an informal search for fiddlers conventions between 1880 and 1908 that I conducted of newspapers in New York, Massachusetts, and Maine, which yielded mostly coverage of Southern fiddling contests. Simon J. Bronner, an expert on northern fiddling traditions, noted in a personal conversation (August 16, 2018) that New Englanders generally embraced contests of farming and shooting skills, but they seemed to place music in a social category.

56. Gifford, *Hammered Dulcimer*, 354.

57. Paul Sheedy, "Los Angeles in Fiddle Contest," *Los Angeles Times*, January 23, 1926, A5; "Fiddling Title at Stake," *Los Angeles Times*, January 25, 1926, A1.

58. "World News," photo editorial, *Los Angeles Times*, February 7, 1926, H2.

59. "West Dances to Ford Orchestra," *Ford News*, March 1926, 4.

60. "You Are Invited to Hear Henry Ford's Old Fashioned Dance Orchestra," 1927, radio program, concerts, no. 92.150, 9453, program collections, "Behind the Barriers" program, Benson Ford Research Center, the Henry Ford.

61. "Jewish Jazz Becomes Our National Music," *Dearborn Independent*, August 6, 1921, 8–9; Rexford Harvey, "Perpetuating Ideals of Idiocy and Depravity," *Dearborn Independent*, January 14, 1922, 10–11; "A Dance a Week," *Dearborn Independent*, February 20, 1926. 29.

62. "Ford Wars on Jazz," E2.

63. "Ford Strong for Coolidge," *Los Angeles Times*, February 11, 1927, 1.

64. Norman Hapgood, "The Inside Story of Henry Ford's Jew-Mania," *Hearst's International* 42 (July 1922): 14.

65. Liebold, reminiscences, 409.

66. Neil Baldwin, *Henry Ford and the Jews: The Mass Production of Hate* (New York: Public Affairs, 2001), 1–7; Richard Hofstadter, *Age of Reform: From Bryan to FDR* (New York: Vintage, 1960), 80; David A. Gerber, "Anti-Semitism and Jewish-Gentile Relations in American Historiography and the American Past," in *Anti-Semitism in American History*, ed. Gerber (Urbana: University of Illinois Press, 1986), 30.

67. "Mr. Ford's Page," July 5, 1924, 7.

68. James Hurtgen, *The Divided Mind of American Liberalism* (Lanham, MD: Lexington Books, 2002), 30–31; Ronald A. Mulder, "Reluctant New Dealers:

The Progressive Insurgents in the United States Senate, 1933–1934," *Capitol Studies* 2, no. 2 (1974): 5–22; Otis Graham Jr., *An Encore for Reform: The Old Progressives and the New Deal* (New York: Oxford University Press, 1967), 24–100; Fred Greenbaum, *Men against Myths: The Progressive Response* (Westport, CT: Praeger, 2000).

69. Ribuffo, "Henry Ford and *The International Jew*," 446–53.

70. This is based on my examination of a run of the *Dearborn Independent* from May 20, 1920, to January 14, 1922. The article on Christmas cards appears after the series, though during a period of ongoing but less frequent antisemitic material: "How Christmas Cards Have Been Degraded," *Dearborn Independent*, December 17, 1923, 3.

71. "Jewish Jazz Becomes Our National Music," *Dearborn Independent*, August 6, 1921, 8.

72. "Jewish Jazz," 9.

73. "How the Jewish Song Trust Makes You Sing," *Dearborn Independent*, August 13, 1921, 8–9.

74. Sander Gilman, *Freud, Race, and Gender* (Princeton, NJ: Princeton University Press, 1993), 19–33.

75. "Turkey in the Straw" was frequently requested and played by old-time fiddlers Ford entertained in the mid-1920s; see, for instance, "Old-Time Fiddlers at Wayside Inn," *New York Times*, January 10, 1926, 10. This version of the lyrics is drawn from Karal Ann Marling, *Designs on the Heart: The Homemade Art of Grandma Moses* (Cambridge, MA: Harvard University Press, 2006), 145. For discussion of "Turkey in the Straw" and other bawdy versions, see Ed Cray, *The Erotic Muse: American Bawdy Songs*, 2nd ed. (Urbana: University of Illinois Press), 253–56, 238.

76. "After the Ball" is mentioned favorably in "How the Jewish Song Trust Makes You Sing," 8. For lyrics and analysis, see Jon W. Finson, *The Voices That Are Gone: Themes in Nineteenth-Century Popular Song* (Oxford: Oxford University Press, 1994), 67–72.

77. The four volumes are *The International Jew, Jewish Activities in the United States, Jewish Influences in American Life,* and *Aspects of Jewish Power in the United States,* all published by the Dearborn Publishing Company in 1920 and 1921.

78. "Berlin Hears Ford Is Backing Hitler," *New York Times*, December 20, 1922, 2; A. R. Pincini, "Fascism as New Cure for Demagogy," *Dearborn Independent*, February 17, 1923, 2; "Bark versus Bite," editorial, *Dearborn Independent*, January 9, 1926, 11; James Wilbur, "Mussolini as Arbiter of Fate in Italy,"

Dearborn Independent, January 8, 1927, 1–2; Walter M. Moff, "Germany, Prey of Alien, Faces Complete Ruin," *Dearborn Independent*, September 9, 1922, 9, 11; Wolff, "Anti-Semitism in Germany," 2.

79. Victoria Saker Woeste, "Insecure Equality: Louis Marshall, Henry Ford, and the Problem of Defamatory Antisemitism, 1920–1929," *Journal of American History*, December 2004, 877–905.

80. John P. Jackson Jr. and Nadine W. Weidman, *Race, Racism, and Science: Social Impact and Interaction* (Santa Barbara, CA: ABC-CLIO, 2004), 105–7.

81. Madison Grant, *The Passing of the Great Race: or, The Racial Basis of European History*, 4th rev. ed. (1916; New York: Scribner Press, 1922), 15–18, 88–91, 167–78. I opted for the fourth revised edition of *Passing* for these passages because it was most current edition available during Ford's music and dance promotion.

82. Lothrop Stoddard, *The Rising Tide of Color: The Threat against White World-Supremacy* (New York: Charles Scribner's Sons, 1921), 164–65.

83. "Jewish Jazz Becomes Our National Music," 8.

84. "When the Ku Klux Klan First Flourished," *Dearborn Independent*, December 1, 1923, 4, 13; "Are the Jews 'God's Chosen People'?," *Dearborn Independent*, September 22, 1923, 12; "Producing Jewish 'Martyrs' by Propaganda," *Dearborn Independent*, February 3, 1923, 12; Walter M. Wolff, "Anti-Semitism in Germany: Where and Why?," *Dearborn Independent*, January 17, 1925, 2.

85. "The Jewish Attempt to Bolshevize the Negro," *Dearborn Independent*, December 22, 1923, 12.

86. "Mr. Ford's Page," *Dearborn Independent*, August 16, 1924, 7.

87. See "Are We a Shylock Nation?," *Dearborn Independent*, January 9, 1926, 3.

88. "Old-Time Fiddlers at Wayside Inn," *New York Times*, January 10, 1926, 10.

89. "Ford Kindlier toward Jews," *Los Angeles Times*, January 25, 1926, 2.

90. Sources connecting Ford's antisemitism and his distaste for jazz include Robbins, "Ford's Old Time Dance Revival"; Richard A. Peterson, *Creating Country Music: Fabricating Authenticity* (Chicago: University of Chicago Press, 1997), 59–62; Roderick Nash, *The Nervous Generation: American Thought, 1917–1930* (1970; Chicago: Elephant Paperback, 1990), 161–63; and Richard Jason Blaustein, "Traditional Music and Social Change: The Old Time Fiddlers Association Movement in the United States" (PhD diss., Indiana University, 1975), 40.

91. This language is used in both the 1925 and 1926 editions of the book: [Mr. and Mrs. Henry Ford], *"Good Morning": Being a Book on the Revival of the Dance* (Dearborn, MI: Dearborn Publishing, 1925), Fairlane Papers, acc. 1, box 134,

folder 17, Benson Ford Research Center, the Henry Ford, Dearborn, Michigan; and Mr. and Mrs. Henry Ford, *"Good Morning": After a Sleep of Twenty-Five Years, Old-Fashioned Dancing Is Being Revived by Mr. and Mrs. Henry Ford*, 2nd rev. ed. (Dearborn, MI: Dearborn Publishing, 1926).

92. Text portions of the manuscript of *"Good Morning"*.

93. Richards, "Ford Trips Ripple," S7; and "Ford Shakes a Wicked Hoof," 3, 40. The latter piece drew extensively from a copyrighted article by Richards in the *World*. The *Digest* quote differed only slightly from the original manuscript with variations in spelling: "African Kongo" with a *k*, "gipsies" with an *i*, "southern" in "southern Europe" uppercased.

94. Richards, "Ford Trips Ripple," S7.

95. See [Mr. and Mrs. Henry Ford], *"Good Morning"*. Compare with the more widely available *"Good Morning": After a Sleep of Twenty-Five Years, Old-Fashioned Dancing Is Being Revived by Mr. and Mrs. Henry Ford*, 2nd rev. ed. (Dearborn, MI: Dearborn Publishing, 1926), which carries the inscription "Mr. and Mrs. Benjamin B. Lovett, masters of dancing, assisted in arranging the dance descriptions herein given." The 1941 and 1943 editions of the book are both titled *"Good Morning": Music, Calls, and Directions for Old-Time Dancing as Revived by Mr. and Mrs. Henry Ford*. These editions bear the Dearborn Publishing name but were produced by Cincinnati music publisher Otto Zimmerman & Sons.

96. The dances I list were South American– and southern European–origin dances popular during the 1910s and '20s. Arthur Elson, *The Book of Musical Knowledge* (Boston: Houghton Mifflin, 1925), 355.

97. Grant, *Passing of the Great Race*, 33, 76–78, 111, 148–66. Although later Nordicists would deem "gypsies" undesirable, Grant makes no mention of them.

98. "How the Jewish Song Trust Makes You Sing," 8.

99. Grant, *Passing of the Great Race*, 58–59.

100. Doris Eaton Travis with Joseph Eaton, Charles Eaton, and J. R. Morris, *The Days We Danced: The Story of My Theatrical Family from Florenz Ziegfeld to Arthur Murray and Beyond* (Seattle: Marquand Books, 2003), 191.

101. *Good Morning*, 1926 ed., 109; "A Dance a Week: Sicilian Circle," *Dearborn Independent*, March 27, 1926, 28–29. On the Sicilian circle's historical origins, see Lloyd Shaw, *The Round Dance Book: A Century of Waltzing* (Caldwell, ID: Caxton, 1950), 378.

102. *Good Morning*, 1926 ed., 7, 141; "A Dance a Week: Polka," *Dearborn Independent*, May 1, 1926, 28–29. See the general anti-Slavic arguments of Grant in *Passing of the Great Race*, 64–65. Grant did not consider Slavs a distinct race,

but rather feared they were slightly Nordicized Alpines whose mixing with Mongolian conquerors had left them "checked in development and warped in culture."

103. *Good Morning*, 1926 ed., 7.

104. Otto Zimmerman materials, Henry Ford Office Files, acc. 285, box 1405, folder 1291A, Benson Ford Research Center, the Henry Ford, Dearborn, Michigan.

105. Twork, *Henry Ford and Benjamin Lovett*, 122–26.

106. "The Return of the Dance," *Dearborn Independent*, editorial, June 6, 1925, 10.

107. Cameron's authorship of the editorials and "Mr. Ford's Page" is mentioned in his own Ford Motor Company reminiscences, acc. 65, box 11, folder 1, p. 35; and in Fred L. Black, reminiscences, final draft, acc. 65, box 6, folder 7, p. 21. Nearly all the other major sources concur, including Lacey, *Ford: The Men and the Machine*, 196; Brinkley, *Wheels for the World*, 258; and David L. Lewis, *The Public Image of Henry Ford: An American Folk Hero and His Company* (Detroit: Wayne State University Press, 1976), 135.

108. Quoted sections are from Sorenson, *My Forty Years*, 3, 176, referring to both Cameron and Crowther's duties of interpreting Ford to the public. The specific process is outlined in Black, reminiscences, Oral History Reminiscences, final draft, acc. 65. box 6, folder 7, p. 15; Lewis, *Public Image of Ford*, 135; and Brinkley, *Wheels for the World*, 258.

109. Lewis, *Public Image of Ford*, 215–16.

110. Longtime production and development chief Charles E. Sorenson describes how writers such as Cameron and Crowther served as Ford's public mouthpieces in *My Forty Years with Ford* (New York: W. W. Norton, 1956), 3, 142–43. Most of if not all secondary sources credit Cameron with writing "Mr. Ford's Page." Cameron admitted his authorship of the column during the Sapiro trial and mentions it in his own Ford Motor Company reminiscences, acc. 65, box 11, folder 1, p. 35. Cameron's authorship is corroborated by Fred L. Black, reminiscences, final draft, acc. 65, box 6, folder 7, p. 21. Cameron states that he wrote the original content of *Ford Ideals: Being a Selection from Mr. Ford's Page in the* Dearborn Independent (Dearborn, MI: Dearborn Publishing, 1926) in the form of "Mr. Ford's Page," but was not involved with the selection or editing of the pieces; Cameron, reminiscences, 35.

On Crowther, see Henry Ford, in collaboration with Samuel Crowther, *My Life and Work* (Garden City, NY: Doubleday, Page, 1922); Henry Ford, in collaboration with Samuel Crowther, *Today and Tomorrow* (Garden City,

NY: Doubleday, Page, 1926); and Henry Ford, in collaboration with Samuel Crowther, *Moving Forward* (Garden City, NY: Doubleday, Page, 1930).

111. Ford R. Bryan, *Henry's Lieutenants* (Detroit: Wayne State University Press, 1993), 53–54.

112. E. G. Pipp, speech transcript, 8–16, in "Special File and Reports—Address by E. G. Pipp on Henry Ford," Edsel Ford Papers, acc. 6, box 1, Benson Ford Research Center, the Henry Ford, Dearborn, Michigan; Lewis, *Public Image of Ford*, 139; Liebold, reminiscences, 479; Fred L. Black, reminiscences, draft version, acc. 65, box 6, folder 7, p. 144, Benson Ford Research Center, the Henry Ford, Dearborn, Michigan. Liebold's antisemitism is documented by many sources, but perhaps the most revealing is his own reminiscences. See, for instance, his comments on pages 447, 458, and 518.

113. Ribuffo, "Henry Ford and the *International Jew*," 455; Michael Barkan, *Religion and the Racist Right: The Origins of the Christian Identity Movement* (Chapel Hill: University of North Carolina Press, 1994), 37–39.

114. "Mr. Ford's Page," *Dearborn Independent*, July 24, 1926, 9.

115. Sorenson, *My Forty Years with Ford*, 176.

116. Cameron, reminiscences, 207.

117. Cameron, reminiscences, 34.

118. Cameron, reminiscences, 38; radio scripts, folders 6 and 8, acc. 1, box 165, Fairlane Papers, Benson Ford Research Center, the Henry Ford, Dearborn, Michigan.

119. Richards, "Ford Trips Ripple," S7. It should be noted, however, that some of the Dearborn Publishing Company's printing did take place with contractors off the Ford property.

120. Cover illustration and "A Dance a Week for Beginners," *Dearborn Independent*, January 16, 1926, 32–33.

121. Grant, *Passing of the Great Race*, 31, 167.

122. "A Dance a Week," 32.

123. Liebold, reminiscences, 1367–1369.

124. See correspondence between Liebold and Otto Zimmerman and Son representatives, 1942–1943, in "The Otto Zimmerman and Son Co. LTD. Inc. 1942–1943" folder, acc. 285, box 2786, Benson Ford Research Center, the Henry Ford, Dearborn, Michigan.

125. One exception is an old-time ball he was involved with in Rutland, Vermont, in 1928: Henry E. Lhjehlolm, "Henry Ford Forgets Motors for Stately Rhythms," *Albany (NY) Evening News*, August 14, 1928, 1–2.

126. On the CBS radio program, see Fair Lane Papers, acc. 1, box 165, fold-

ers 1–8, Benson Ford Research Center, the Henry Ford, Dearborn, Michigan. On later editions of *Good Morning*, see Benjamin Lovett and Otto Zimmerman and Son Company representatives, correspondence, 1931, Henry Ford Office, acc. 285, folder 1291a, box 1405; and Ernest G. Liebold and Otto Zimmerman and Son representatives, correspondence, 1942–1943, "The Otto Zimmerman and Son Co. LTD. Inc. 1942–1943" folder, acc. 285, box 2786, Benson Ford Research Center, the Henry Ford, Dearborn, Michigan.

127. See "Radio—Early American Music-1944" folder, acc. 1, box 135, Benson Ford Research Center, the Henry Ford, Dearborn, Michigan.

128. On Ford's role in temporarily reviving and preserving what would become known as contra dance, see Richard Nevell, *A Time to Dance: American Country Dancing from Hornpipes to Hot Hash* (New York: St. Martin's Press, 1977), 63–65, 74; Kate O'Neill, "Henry Ford and the Revival of Country Dancing," *Dance Magazine* 71, no. 8 (August 1997): 50–53; Mark Matthews, "Promenading toward Democracy: The History of Squares, Contras, and Waltzes," unpublished book manuscript, 2009, 101–35.

On Ford's impact on the revival of the western square dance, see Everette S. Wolfe, letter to H. E. Edmunds, director, Ford Archives, July 14, 1969, Everette S. Wolfe Papers, small acc. 1040, Benson Ford Research Center, the Henry Ford, Dearborn, Michigan. Ford did not champion western-style squares that would go through a major revival in the 1950s but favored nineteenth-century ballroom forms—which included a variety of forms of both social and stylized folk dancing. Wolfe, however, claims that pivotal western square dance revivalist Lloyd Shaw was summoned to meet Ford and demonstrate some of his Colorado group's old-time dances at some point in the 1930s or '40s, and that Ford's campaign to collect and preserve these nineteenth-century forms of dance inspired Shaw to do the same with western square dance.

Shaw interestingly seemed to reject Ford's exclusiveness. He started teaching his students the dance because he believed football was too dangerous as PE exercise and discriminated against girls. Furthermore, he used the dance in inclusive ways by having students learn it alongside Mexican traditional dances. He also made an effort to bring Native American artists and teachers to campus to teach his students about Native American culture and religion. "Boys and Girls Who Love to Dance," *Albuquerque Journal*, October 31, 1948, 4; "Shaw Trippers Do Waltz, Polka, Squares, Folk Dances at State," *Lansing (MI) State Journal*, April 2, 1950, 36; Dorothy O. Moore, "High Priest of Square Dance Revival," *St. Louis Post-Dispatch*, April 25, 1952, 67.

129. Estelle Schneider and Bob Norman, "The Ford Dance Movement: Fid-

dling while the Crosses Burned," *Sing Out!* 25, no. 4 (November/December 1977): 27.

130. Grant, *Passing of the Great Race*, 51. On Ford's general lack of eliminationist rhetoric, see Baldwin, *Henry Ford and the Jews*, 174.

131. On connections between Ford, Nazism, and European fascism, both Max Wallace's *American Axis: Henry Ford, Charles Lindbergh, and the Rise of the Third Reich* (New York: St. Martin's Press, 2003) and Baldwin's *Henry Ford and the Jews* do not find a smoking gun but do uncover several potentially damning leads. On Ford's interest in the presidency, see Liebold, reminiscences, 520–25.

132. "Nazi Consuls Decorate Ford on Birthday," *Baltimore Sun*, July 31, 1938, 6.

133. Lilian Karina and Marion Kant, *Hitler's Dancers: German Modern Dance and Third Reich*, trans. Jonathan Steinberg (New York: Berghahn Books, 2003), 87, 209. See also "Does the Five O'Clock Tea Suit Our Time?," in *Nazi Culture: Intellectual, Cultural and Social Life in the Third Reich*, by George L. Mosse, trans. Salvator Attanasio and others (Madison: University of Wisconsin Press, 1966), 50. On Nazi support for the *Schäfertanz*, see Joshua Hagen, *Preservation, Tourism and Nationalism: The Jewel of the German Past* (Hampshire, UK: Ashgate, 2006), 209.

134. Karina and Kant, *Hitler's Dancers*, 34, 73–77, 167–68. Ford was indifferent to modern dance pioneer Isadora Duncan, ignoring her requests for support. Apparently the feeling became mutual, as she was ardently critical of what she saw as the overt sexuality that formed the basis of courtly dances Ford preferred. Richards, *The Last Billionaire*, 112; Isadora Duncan, *My Life* (New York: Horace Liveright, 1955), 342.

135. Bill C. Malone, *Country Music, U.S.A.*, 2nd ed. (Austin: University of Texas Press, 1985), 317; Beth A. Messner, Arthur J. Jipson, Paul J. Becker, and Bryan Byers, "The Hardest Hate: A Sociological Analysis of Country Hate Music," *Popular Music and Society* 30, no. 4 (October 2007): 516.

136. Fan letter to Henry Ford, November 11, 1925, Fair Lane Papers, acc. 1, box 134, folder 17, Benson Ford Research Center, the Henry Ford, Dearborn, Michigan.

137. Virginia Pope, "Maine's Champion Fiddler Finds Fame at His Door," *New York Times*, December 13, 1925, SM4; script for the Blue Network's *Early American Dance* program, March 11, 1944, 2, in "Radio—Early American Dance Music—1944" folder, acc. 1, box 135, Benson Ford Research Center, the Henry Ford, Dearborn, Michigan.

138. Sapoznik, *Klezmer*, 34.

139. David Whisnant, *All That Is Native and Fine: The Politics of Culture in an American Region* (Chapel Hill: University of North Carolina Press, 1983), 240–44.

Chapter 3

1. Sandor Salgor, *Thomas Jefferson: Musician & Violinist* (Charlottesville, VA: Thomas Jefferson Foundation, 2000), 29.

2. Benjamin S. Schoening and Eric T. Kasper, *Don't Stop Thinking about the Music: The Politics of Songs and Musicians in Presidential Campaigns* (Lanham, MD: Lexington Books, 2012), xvii–xviii, 29–41, 44–47, 99–110. On Jackson, see Robert V. Remini, *Andrew Jackson: The Course of American Freedom, 1822–1832* (New York: Harper & Row, 1981), 134–35. On the Lincoln and Davis quicksteps, see Danny O. Crew, *Presidential Sheet Music: An Illustrated Catalog* (Jefferson, NC: McFarland, 2001), 92, 354.

3. "Jazz Players Add Spice to Walton's Pep," *Muskogee (OK) Times-Democrat*, October 28, 1922, 16.

4. "Walton Inaugural to Be Rip-Snorter," *Kansas City Kansan*, November 14, 1922, 2; "2 'Walton Clubs' Prepare for War," *Morning Tulsa Daily World*, November 28, 1922, 1.

5. Gilbert C. Fite, "Oklahoma's Reconstruction League: An Experiment in Farmer-Labor Politics," *Journal of Southern History* 13, no. 4 (November 1947): 551–54.

6. Charles K. Wolfe and Ted Olsen, eds., *The Bristol Sessions: Writings about the Big Bang of Country Music* (Jefferson, NC: MacFarland, 2005); Jocelyn R. Neal, *Country Music: A Cultural and Stylistic History* (Oxford: Oxford University Press, 2013), 37–61; Don Cusic, *Discovering Country Music* (West Port, CT: Praeger, 2008), 16–23.

7. Douglas B. Green, *Singing in the Saddle: The History of the Singing Cowboy* (Nashville: Country Music Foundation and Vanderbilt University Press, 2002), 28–29, 32–34.

8. R. Alton Lee, *The Bizarre Careers of John R. Brinkley* (Lexington: University Press of Kentucky, 2002), 118–29; Pope Brock, *Charlatan: America's Most Danger Huckster, the Man Who Pursued Him, and the Age of Flimflam* (New York: Crown, 2008), 157, 177, 183–85.

9. Details gleaned largely from Zula Bennington Greene, "Peggy of the Flint Hills: Lonesome Cowboy," newspaper clipping, *Topeka Capital-Journal*, February 26, 1986; and Faulkner obituary, both found in the Roy Faulkner

scrapbook, part 2, p. 9, and part 3, p. 7, Roy Faulkner Collection, unit ID 218726, Kansas State Historical Society, Topeka, Kansas.

10. "Theme Song," Roy Faulkner scrapbook, part 2, p. 47.

11. H. D. Munal, program director of XER, letter of recommendation for Faulkner, October 7, 1933, in Roy Faulkner scrapbook, part 2, p. 47, Roy Faulkner Collection, unit ID 218726, Kansas State Historical Society, Topeka, Kansas.

12. Greene, "Peggy of the Flint Hills."

13. Details gleaned from various promotional materials and letters of recommendation in the Faulkner scrapbook as well as Mable Ross, "Life Can Be Interesting," *Horton Headlight*, February 13, 1986, newspaper clipping, Roy Faulkner scrapbook, part 2, p. 56, Roy Faulkner Collection, unit ID 218726, Kansas State Historical Society, Topeka, Kansas.

14. Brock, *Charlatan*, 177, 219–28.

15. "Brinkley Met by Huge Crowd on Visit Here," *Iola (KS) Register* October 27, 1930, 1; "Seeks Vindication; Causes Vote Upset," *Detroit Free Press*, November 7, 1930, 12.

16. Brinkley Enters Kansas Campaign," *Ashville (NC) Citizen-Times*, November 3, 1930, 1–2; Lee, *Bizarre Careers of Brinkley*, 122. Compare with Edwin Amenta, *When Movements Matter: The Townsend Plan and the Rise of Social Security* (Princeton, NJ: Princeton University Press, 2006), 35.

17. "Gov. Huey Long to Speak at City Hall 8 O'Clock Tonight," *Town Talk* (Alexandra, LA), August 23, 1930, 1; "Huey Long Was Speaker Here Last Night," *Ruston (LA) Leader*, August 27, 1930, 1; "Brinkley Seeks to Be Governor," *Des Moines (IA) Tribune*, September 23, 1930, 1; "Brinkley Met By Huge Crowd on Visit Here," *Iola (KS) Register*, October 27, 1930, 1.

18. "Long Stakes Future on Senate Campaign," *Evening Sun* (Baltimore), August 18, 1930, 15.

19. Huey Long, *Every Man a King: The Autobiography of Huey P. Long* (Cambridge, MA: DeCapo Press, reprint, 1996 [1933]), 220.

20. Rolla Clymer quoted in Lawrence P. Klintworth, *True Tales of Butler County* (El Dorado, KS: Butler County Historical Society, 1981), 149–50.

21. Lee, *Bizarre Careers of Brinkley*, 124.

22. "Dr. J. R. Brinkley Will Speak at Iola," advertisement, *Iola (KS) Register*, August 3, 1932, 2.

23. "Brinkley Speaks Here," *Belleville (KS) Telescope*, September 1, 1932, 1; W. G. Clugston, "Kansas and Doc Brinkley," *Daily Capital Journal* (Salem, OR), September 6, 1932, 4; Lee, *Bizarre Careers of Brinkley*, 133–50.

24. The original source for this oft-repeated assertion about a hillbilly warm-up band seems to be Frank Buckley Walker, interview by Mike Seeger, June 9, 1962, SFC Audio Open Reel FT-20009/5597, subseries 1.1, Open Reel Recordings, 1923–2000, Mike Seeger Collection no. 20009, Southern Folklife Collection, Louis Round Wilson Special Collections Library, University of North Carolina at Chapel Hill, https://dc.lib.unc.edu/cdm/singleitem/collection/20009/id/2720/rec/1. During the interview, Walker seems to accurately remember his interactions with the Leake County Revelers, but he incorrectly notes that, after the Revelers had achieved some success with their recording of the 1927 bestseller "Wednesday Night Waltz," he connected them with Huey Long, who he claims was running for lieutenant governor of Mississippi. Long, of course, was running for governor, not lieutenant governor, of Louisiana in 1927. Other elements of the story do not match up. Long started his campaign in August 1927 and won the all-important Democratic primary in January 2008, whereas Columbia was just beginning its advertising blitz for "Wednesday Night Waltz" in November and December 1927. It seems unlikely that the Revelers would have been pitched to Long before they achieved acclaim with the song, and it contradicts Walker's memory that the Revelers had already established their reputation with it before being hired by the politician. It seems likely that Walker had confused Huey Long with another Southern populist, Mississippi governor Paul B. Johnson, who we know for sure was using the Revelers at campaign stops as early as 1931.

The assertion that "country musicians" played at Long's 1928 inauguration was made in Forrest Davis, *Huey Long: A Candid Biography* (New York: Dodge, 1935), 96; but given the parlance of the time period and accounts and records of the inauguration, it seems very likely that Davis was referring to a nonhillbilly band of rural musicians, rather than a band that played hillbilly music. The nonhillbilly bands that Long did indeed highlight during the campaign and inauguration—Standard Oil Refinery Band, Sous DeGeneris, the Orpheum vaudeville theater's orchestra from New Orleans, Emile Tosso and the New Democratic Regular band—are noted in sources such as "Huey P. Long Opens Race for Governor at Big Meeting Here," *Weekly Town Talk* (Alexandria, LA), August 6, 1927, 1. Although it may be impossible to completely disprove assertions about this purported early hillbilly band, materials in the Louisiana State University's Huey P. Long Papers from the 1927 campaign reinforce the idea that Long was primarily dealing with groups such as his own New Democratic Regular band, which played patriotic numbers (e.g., "Star Spangled Banner," "Dixie") and Long-specific campaign adaptations of popular songs such as "Mary Lou" and "In a Little Spanish Town."

See, for instance, "Campaign Songs" pamphlet, box 4, folder 140; and various correspondence with music dealers, box 2, folder 47, Huey P. Long Papers, 1915–1936, Mss. 2005, Special Collections, LSU Libraries, Louisiana State University, Baton Rouge, Louisiana.

25. On the Serenaders, see, for instance, "Great Throng Will See Long Take Up Reins," *Shreveport Times*, May 20, 1928, 1; and Karl Koenig, *Music in the Parishes Surrounding New Orleans: Pontchartrain — The Mother of All Jazz Rivers/St. Tammany*, e-book, BasinStreet.com jazz website, http://basinstreet.com/wp -content/uploads/2016/09/pontjazz.pdfm, 323–49. Koenig includes an extensive oral history of Mattie Louise Gyden Robards, who organized the band covered in the e-book.

26. Stuart Towns, "A Louisiana Medicine Show: The Kingfish Elects an Arkansas Senator." *Arkansas Historical Quarterly* 25, no. 2 (1966): 117–27.

27. "Long Will Aid Mrs. Carraway," *Reno Gazette-Journal*, August 1, 1932, 1. H. L. Mitchell makes the assertion about the Ozark hillbilly band in *Mean Things Happening in This Land: The Life and Times of H. L. Mitchell, Co-founder of the Southern Tenant Farmers Union* (Norman: University of Oklahoma Press, 2008), 32–33. Mention of the band also appears in a widely reprinted 1938 Associated Press story: "Hillbilly Song Wins Place for Texas Governor," *Santa Cruz Sentinel*, July 27, 1938, 3.

28. David Malone, *Hattie and Huey: An Arkansas Tour* (Fayetteville: University of Arkansas Press, 1989), 63, 90.

29. Beth Campbell, "Mrs. Hattie Caraway Plans 'Own' Campaign Reelection along Very Simple Design," *Corsicana (TX) Daily Sun*, June 22, 1938, 1; Sigrid Arne, "So You Can't Do the Impossible?," *Salt Lake Tribune*, October 2, 1938, 19.

30. Nancy Hendricks, *Senator Hattie Caraway: An Arkansas Legacy* (Charleston, SC: History Press, 2013), 71–95; Molly Mayhead and Brenda Devore Marshall, *Women's Political Discourse: A 21st-Century Perspective* (Lanham, MD: Rowman and Littlefield, 2005), 45–50.

31. Tony Russell, *Country Music Originals: The Legends and the Lost* (Oxford: Oxford University Press, 2007), 204.

32. "Thousands Expected for Johnson Homecoming," *Daily Clarion-Ledger* (Jackson, MS), June 21, 1931, 1.

33. Chester Morgan, *Redneck Liberal: Theodore G. Bilbo and the New Deal* (Baton Rouge: Louisiana State Press, 1985), 20, 78–80, 152; "Death Ends Career of Gov. Paul Johnson," *Greenwood (MS) Commonwealth*, December 27, 1943, 1.

34. "Johnson's Complete Unofficial Lead Is 26,372," *Daily Clarion-Ledger* (Jackson, MS), September 1, 1939, 1. Johnson does not appear to have used

music as much in that latter campaign, but one opponent, a state senator, possibly took note of Johnson's earlier efforts and made all his appearances with his own hillbilly band, the similarly named Leake County Harmonizers. "Candidates Speak at Holiday Meetings," *Greenwood Commonwealth*, July 3, 1939, 2.

35. *Mississippi Encyclopedia* (Jackson: University Press of Mississippi, 2017), s.v. "Paul B. Johnson Sr.," by David G. Sansing, 659–60.

36. Jason Morgan Ward, *Hanging Bridge: Racial Violence and America's Civil Rights Century* (Oxford: Oxford University Press, 2017), 115–18, 138.

37. Kevin Fontenot, personal correspondence, September 6, 2018.

38. Long's use of pop, jazz, and marches—especially his "sponsorship" of the Louisiana State University band—are well documented. On Long's use of old-time fiddling, see Ron Yule, ed., *Louisiana Fiddlers* (Jackson: University Press of Mississippi, 2009), s.v. "Cecil Berge," 44.

39. Dick Lee, "Capital Stuff," *Daily News* (New York), March 4, 1933, 8.

40. Lee, "Capital Stuff," 8.

41. "Long Croons Vote Plea in New Orleans," *Chicago Tribune*, January 23, 1934, 1; "Crooner Senator Long Sings Classic Melody," *Pottstown (PA) Mercury*, January 23, 1934, 1; "Defeated Huey Charges Fraud," *Pittsburgh Press*, January 24, 1934, 1.

42. See, for instance, "Today's Camera: Hillbillies Serenade Huey Long," *St. Louis Star-Times*, November 30, 1934, 3.

43. "Hail the Conquering Crooner Comes!," *Daily Democrat* (Tallahassee, FL), February 7, 1935, 3.

44. "Long's Song Made Funeral Dirge," *Monroe (LA) News-Star*, September 11, 1935, 1.

45. See J. Michael Hogan and Glen Williams, "The Rusticity and Religiosity of Huey P. Long," *Rhetoric and Public Affairs* 7, no. 2 (Summer 2004): 149–71.

46. T. Harry Williams, *Huey Long* (New York: Alfred Knopf, 1969), 703–6.

47. William Anderson, *Wild Man from Sugar Creek: The Political Career of Eugene Talmadge* (Baton Rouge: Louisiana State Press, 1975), 62–97.

48. "Talmadge Puts on Good Show at His Meets," *Greenvile (SC) News*, August 19, 1934, 2.

49. Anderson, *Wild Man from Sugar Creek*, 76–78.

50. "Gene & Junior." *Time*, September 7, 1936, 12; Rufus Jarman, "Wool-Hat Dictator." *Saturday Evening Post*, June 27, 1942, 20; "Exit Gene Talmadge." *Time*, September 21, 1942 21.

51. "Death of the Wild Man." *Time*, December 30, 1946, 20.

52. John Minton, *78 Blues: Folksongs and Phonographs in the American South*

(Jackson: University Press of Mississippi, 2008), 197, 202–3; Gregory N. Reish, "The NRA Blues: Commercial Country Music and the New Deal," in *The Honky Tonk on the Left: Progressive Thought in Country Music*, ed. Mark Allan Jackson (Amherst: University of Massachusetts Press, 2018), 32–33.

53. "Joe T. to Speak Here This Week," *Blytheville (AR) Courier News*, September 20, 1932, 1; "Sen. Robinson to Stump Country for Roosevelt," *Ruston (LA) Daily Leader*, September 22, 1932, 1; "Senator Joe Goes Huey One Better," *Monroe (LA) News-Star*, September 20, 1932, 1.

54. Reish, "The NRA Blues," 30–36, 41.

55. "Primary Campaigns End in This District Tonight," *Poughkeepsie (NY) Eagle-News*, September 19, 1938, 1; "Taking a Tip from Texas Campaign," *Kingston (NY) Daily Freeman*, August 26, 1938, 5; "Another Hillbilly Campaign," *Marysville (OH) Tribune*, September 15, 1938.

56. "Bowen Takes Fight to Beacon and Falls," *Poughkeepsie (NY) Eagle-News*, August 27, 1938, 1, 11; "Bowen Issues Defi to Martin," *Poughkeepsie (NY) Eagle-News*, September 12, 1938, 12. On Martin, see Ben Martin, "I Run for Congress," *Atlantic Monthly*, December 1939, 759–67.

57. "Campaigns with Music," *Nebraska State Journal*, August 9, 1938, 1; "Dr. Wherry Defies Police Order to Quiet Sound Truck," *Ogden (UT) Standard Examiner*, August 18, 1938, 2.

58. Associated Press, "Utah Doctor Seeks to Charm Voters," *Albuquerque Journal*, August 9, 1938, 1.

59. William M. Pinkerton, "Can Hill-Billy Bands Swing Votes?," *Lubbock (TX) Avalanche-Journal*, September 11, 1938, 12; Arthur Sears Henning, "Conservatives, Radicals Fight in Washington," *Chicago Tribune*, September 22, 1938, 8.

60. Nat Green, "American Folk Tunes," *Billboard*, November 4, 1944, 66.

61. Joe Hatcher, "Politics," *Tennessean (Nashville)*, July 5, 1944, 1, 6; "Barton to Speak Here on July 4," *Courier* (Blytheville, AR) *News*, June 27, 1944, 1; "Colonel T. H. Barton," advertisement, *Courier News*, July 3, 1944, 2. J. William Fulbright ended up winning that election.

62. Green, "American Folk Tunes," 66.

Chapter 4

1. Paul Moore, "Biggest Crowd in Political History at O'Daniel Rally," *Corsicana (TX) Semi-Weekly Light*, June 28, 1938, 7.

2. Moore, "Biggest Crowd in Political History," 7.

3. Al Gore [Sr.], *The Eye of the Storm: A People's Politics for the Seventies*

(New York: Herder and Herder 1970, 202). Gore Sr. would eventually serve an eighteen-year career in the Senate.

4. Taylor's run is featured in chapter 5 of this book, while Hamblen's campaign is analyzed in Peter La Chapelle, *Proud to Be an Okie: Cultural Politics, Country Music, and Migration to Southern California* (Berkeley: University of California Press, 2007), 69.

5. See, for instance, discussion of the hillbilly image in Richard A. Peterson, *Creating Country Music: Fabricating Authenticity* (Chicago: University of Chicago Press, 1997), 6–8.

6. C. L. Douglas and Francis Miller, *The Life Story of W. Lee O'Daniel* (Dallas: Regional Press, 1938), 112.

7. Douglas B. Craig, *Fireside Politics: Radio and Political Culture in the United States, 1920–1940* (Baltimore: Johns Hopkins University Press, 2005), 280–82.

8. William M. Pinkerton, "Hillbilly Bands Swing Votes Now," *Indianapolis Star*, September 11, 1938, 17.

9. C. L. Douglas and Francis Miller, The Life Story of W. Lee O'Daniel: A Saga of American Success, series, 17 parts, Scripps-Howard Newspapers, appearing in *Pampa (TX) Daily News* and *Paris News*, August 10 to September 1, 1938; Seth Shepard McKay, *W. Lee O'Daniel and Texas Politics, 1938–1942* (Lubbock: Texas Tech Press, 1944), 17–21.

10. John Mark Dempsey, *The Light Crust Doughboys Are On the Air: Celebrating Seventy Years of Texas Music* (Denton: University of North Texas, 2002), 20–32.

11. Dempsey, *Light Crust Doughboys*, 33–34; McKay, *O'Daniel and Texas Politics*, 22.

12. McKay, *O'Daniel and Texas Politics*, 21–23; Robert A. Caro, *The Years of Lyndon Johnson, Vol. 1: The Path to Power*, (New York: Vintage Books, 1996), 696–98.

13. Douglas and Miller, "The Life Story of W. Lee O'Daniel," *Paris News*, August 26, 1938, 7.

14. Gary Ginell, liner notes, 10–13, in *W. Lee O'Daniel with the Hillbilly Boys & Lightcrust Doughboys, 1933–1938: Western Swing Chronicles*, vol. 4, Origin Jazz Library OL-1003, 2005, compact disc.

15. Caro, *Years of Lyndon Johnson*, 697.

16. James T. Yauger, "Persuasive Tactics of a Radio Politician: W. Lee O'Daniel," *Southern Speech Journal* 36, no. 4 (1971): 372fn34.

17. For more on these country music variety shows, see, for instance, Charles K. Wolfe, *A Good-Natured Riot: The Birth of the Grand Ole Opry* (Nashville: Country Music Foundation and Vanderbilt University Press, 1999) and

Chad Berry, ed., *The Hayloft Gang: The Story of the National Barn Dance* (Urbana: University of Illinois Press, 2008).

18. McKay, *O'Daniel and Texas Politics*, 22–32.

19. Ginell, liner notes, 11–15.

20. Gus Weill, *You Are My Sunshine: The Jimmie Davis Story* (Gretna, LA: Pelican, 1992), 1–2, 11–15.

21. Weill, *You Are My Sunshine*, 35–46.

22. Weill, 47–48.

23. Peter Mikelbank, "Places in the Sun: The Many Splendored Careers of Jimmie Davis," *Journal of Country Music* 10, no. 3 (1985): 30–31.

24. Stephen Deusner, "'You Are My Sunshine: How a Maudlin Song Became a Children's Classic," *Salon*, May 26, 2013, http://www.salon.com/2013/05/26 /you_are_my_sunshine_how_a_maudlin_song_became_a_childrens_classic/.

25. Bill C. Malone, *Country Music, U.S.A.*, 2nd ed. (Austin: University of Texas Press, 1985), 175.

26. Mikelbank, "Places in the Sun," 49.

27. Weill, *You Are My Sunshine*, 53–55; "Cowboy Band Will Appear at School," *Ruston Daily Leader*, April 1, 1937, 1; "Shreveport Police Probe Is Ordered," *Monroe (LA) Morning World*, March 19, 1939, 1.

28. Kevin S. Fontenot, "You Can't Fight a Song: Country Music in the Campaigns of Jimmie Davis," *Journal of Country Music* 25, no. 2: 53.

29. "Davis Announces for Commission," *Monroe (LA) Morning World*, July 19, 1942, 18; Weill, *You Are My Sunshine*, 59–60.

30. Mikelbank, "Places in the Sun," 29–32, 49–56; NEA Service, "Would-Be Governor Wins Ballots with Ballads in Louisiana Race," *Brownsville (TX) Herald*, February 10, 1944, 18.

31. Jerry Purvis Sanson, *Louisiana during World War II: Politics and Society, 1939–1945* (Baton Rouge: Louisiana State University Press, 1999), 115–135; Charles Pellegrin, "Administrative Reform in Louisiana and Progressive Influences, 1940–1948," (master's thesis, University of Southwestern Louisiana, 1990), 63–66; Mikelbank, "Places in the Sun," 52.

32. Michael L. Kurtz and Morgan D. Peoples, *Earl K. Long: The Saga of Uncle Earl and Louisiana Politics* (Baton Rouge: Louisiana State University Press, 1990), 105.

33. Elizabeth Schlappi, *Roy Acuff: The Smoky Mountain Boy* (Gretna, LA: Pelican, 1978), 3–7, 183.

34. Schlappi, *Roy Acuff*, 15–36.

35. *The Encyclopedia of Country Music: The Ultimate Guide to the Music* (New York: Oxford University Press, 1998), s.v. "Roy Acuff," by John Rumble, 4–5.

36. Noel C. Fisher, *War at Every Door: Partisan Politics and Guerilla Violence in East Tennessee, 1860–1869* (Chapel Hill: University of North Carolina Press, 1997), 10–11, 16, 29.

37. Fisher, *War at Every Door*, 22–62.

38. Gordon B. McKinney, "Southern Mountain Republicans and the Negro, 1865–1900," in *Appalachians and Race: The Mountain South from Slavery to Segregation*, ed. John C. Inscoe (Lexington: University Press of Kentucky, 2001), 203–5.

39. Sean J. Savage, *Truman and the Democratic Party* (Lexington: University Press of Kentucky, 1997), 36–40.

40. Schlappi, *Roy Acuff*, 195–98.

41. See, for instance, Jack Anderson and Fred Blumenthal, *The Kefauver Story* (New York: DialPress, 1956), 117–18; Charles L. Fontenay, *Estes Kefauver: A Biography* (Knoxville: University of Tennessee Press, 1980), 152, and Penny Parsons, *Foggy Mountain Troubadour: The Life and Music of Curly Seckler* (Urbana: University of Illinois Press, 2016), 57.

42. Clive S. Thomas, "Understanding Interest Group Activity in Southern State Politics," in *Interest Group Politics in the Southern States*, ed. Ronald J. Hrebenar and Clive Thomas (Tuscaloosa: University of Alabama Press, 1992), 18–19.

43. Richard Perloff, *Political Communication: Politics, Press, and Public in America* (Mahwah, NJ: Erlbaum, 1998), 166.

44. Si Sheppard, *The Partisan Press: A History of Media Bias in the United States* (Jefferson, NC: McFarland: 2008), 197–98; Carl R. Osthaus, *Partisans of the Southern Press: Editorial Spokesmen of the Nineteenth Century* (Lexington: University of Kentucky Press, 1994), 210–11.

45. Douglas and Miller, *Life Story of O'Daniel*, 97.

46. McKay, *O'Daniel and Texas Politics*, 32–33.

47. McKay, 36.

48. Sheilah Graham, "Bill Fields Writes a Play" and film roundup, *Indianapolis Star*, August 4, 1938, 10.

49. McKay, *O'Daniel and Texas Politics*, 45, 48–50, 49.

50. Data from "First Democratic Primary, 1938—County Table No. 1," *Texas Almanac, 1939–40* (Dallas: A. H. Belo, 1939), 359–62.

51. Raymond Brooks, "Radio Talks Are Factor in Campaign," *Valley Sunday Star-Monitor-Herald* (Harlingen, TX), June 12, 1938, 5.

52. Weill, *You Are My Sunshine*, 61–63.

53. "Runoff Planned by Old Regulars," *Monroe (LA) News-Star*, January 20, 1944, 4; Sanson, *Louisiana during World War II*, 1290.

54. All three endorsements were reprinted "All New Orleans Papers Endorse Davis," political ad, *Monroe (LA) Morning World*, January 16, 1944, 9.

55. "For Governor, J. H. 'Jimmie' Davis," *Times-Picayune*, December 5, 1943, 1; "People Are a Big Interest to Davis," *Times-Picayune*, December 19, 1943, 14.

56. Weill, *You Are My Sunshine*, 66–67.

57. Tennessee Secretary of State Office, *Tennessee Blue Book 2015–2016*, 583–89.

58. Deborah Kalb, ed., *Guide to US Elections* (Los Angeles: Sage Publications, 2016), 1713.

59. Schlappi, *Roy Acuff*, 188–89.

60. "O'Daniel Will Face Problem at Austin," *Pampa (TX) Daily News*, July 25, 1938, 1, 8.

61. Quoted in Moore, "Biggest Crowd in Political History," 7.

62. Edwin Amenta, *When Movements Matter: The Townsend Plan and the Rise of Social Security* (Princeton, NJ: Princeton University Press, 2006), 1–8, 35–38.

63. Carey McWilliams, *Southern California: An Island on the Land* (1946; Salt Lake City: Peregrine Smith, 1995), 299–303; Harry T. Williams, *Huey Long* (New York: Alfred A. Knopf, 1970), 693–96.

64. Yauger, "Persuasive Tactics of a Radio Politician," 373.

65. Kurtz and Peoples, *Earl K. Long*, 76.

66. Sanson, *Louisiana during World War II*, 130; Kurtz and Peoples, *Earl K. Long*, 111–12.

67. "Davis Advocates Improved Roads," *Times-Picayune*, November 7, 1943, 16 Davis made similar pledges throughout his campaign; see "Davis Speaks at Ruston," *Times-Picayune*, October 24, 1944, 14.

68. Floyd Martin Clay, *Coozan Dudley LeBlanc: From Huey Long to Hadacol* (Gretna, LA: Pelican, 1973), 161–63; Kurtz and Peoples, *Earl K. Long*, 53; T. Harry Williams, *Huey Long* (New York: Alfred A. Knopf, 1970), 693–96.

69. Clay, *Coozan Dudley LeBlanc*, 170, 172.

70. On Davis's anti-Longist rhetoric, see, for instance, "Let's Give Jimmie Davis and His Ticket a Great Victory," political ad, *Monroe (LA) Morning World*, February 27, 1944, 6. On Earl Long's pension promises, see Kurtz and Peoples, *Earl K. Long*, 102.

71. "Retirement System Plan Is Submitted," *Monroe (LA) News-Star*, May 2, 1946, 1.

72. B. L. Krebs, "Retirement System for State Employees Passed by House," *Times-Picayune*, June 26, 1946, 1, 3.

73. "Retirement Plan Group Appointed," *Times-Picayune*, December 31, 1946, 9.

74. H. B. Teeter, "Speaker Portrays Acuff as 'Bulwark' against Isms," *Tennessean* (Nashville), October 6, 1948, 18.

75. "Half a Million Voters Want Reece and Acuff," advertisement, *Tennessean* (Nashville), November 1, 1948, 4.

76. Schlappi, *Roy Acuff*, 197.

77. Quoted in "Acuff Seeks Labor Votes," *Kingsport (TN) Times*, September 7, 1948, 1.

78. Peterson, *Creating Country Music*, 56.

79. See, for instance, *The Encyclopedia of Country Music*, s.v. "Stephen Foster," by Norm Cohen, 178–79. Analysis of the song is mine.

80. James Crissman, "Death and Dying in Central Appalachian Music," chap. 9 of *Death and Dying in Central Appalachia: Changing Attitudes and Practices* (Urbana: University of Illinois Press, 1994), esp. 159–63; John Bush Jones, *Reinventing Dixie: Tin Pan Alley's Songs and the Creation of the Mythic South* (Baton Rouge: Louisiana State University Press, 2015), 59.

81. Patrick Huber, *Linthead Stomp: The Creation of Country Music in the Piedmont South* (Chapel Hill: University of North Carolina Press, 2008), 88–91.

82. Mark Zwonitzer and Charles Hirshberg, *Will You Miss Me When I'm Gone? The Carter Family and Their Legacy in American Music* (New York: Simon & Schuster, 2002), 33–34, 170.

83. Jimmie Rodgers, "Dear Old Sunny South by the Sea," Victor 21574-B, 1928, 78-rpm phonograph record.

84. Holly George-Warren, *Public Cowboy No. 1: The Life and Times of Gene Autry* (Oxford: Oxford University Press, 2009), 73–74; B. Malone, *Country Music, U.S.A*, 143.

85. Pamela Grundy, "'We Always Tried to Be Good People': Respectability, Crazy Water Crystals, and Hillbilly Music on the Air, 1933–1935," *Journal of American History* 81, no. 4 (March 1, 1995): 1595–1596, 1620.

86. *Colonel Jack and Shorty's Crazy Hillbillies*, radio program, ca. 1934, 15 min., ca.1934, as appears on *Pat O'Daniel Hillbilly Boys* compact disc, Onesmedia, n.d., compact disc.

87. Gene Fowler and Bill Crawford, *Border Radio: Quacks, Yodelers, Pitchmen, Psychics, and Other Amazing Broadcasters of the American Airwaves* (Austin: University of Texas Press, 2002), 234–35; La Chapelle, *Proud to Be an Okie*, 56.

88. Clay, *Coozan Dudley LeBlanc*, 164.

89. "Millions Are Getting Hadacol," advertisement, *Detroit Free Press*, December 4, 1950, 17.

90. Dick Vaughan, "Race Men Hope Next Governor Allows Bang Tails to Run," *El Paso Herald-Post*, August 20, 1938, 3; George Norris Green, *The Estab-*

lishment in Texas Politics: The Primitive Years, 1938–1957 (Norman: University of Oklahoma Press, 1984), 25; McKay, *O'Daniel and Texas Politics*, 82, 154.

On Acuff and patent medicine, see Clay, *Coozan Dudley LeBlanc*, 170; and "Millions Are Getting Hadacol," advertisement, *Detroit Free Press*, December 4, 1950, 17.

91. Paul F. Lazarsfeld and Patricia L. Kendall, *Radio Listening in America: The People Look at Radio—Again* (New York: Prentice-Hall, 1948), appendix C, 136, table 14.

92. Charles R. Townsend, *San Antonio Rose: The Life and Music of Bob Wills* (Urbana: University of Illinois Press, 1986), 71. On specific songs, see Bill Crawford, *Pass the Biscuits, Pappy: Pictures of Governor W. Lee "Pappy" O'Daniel* (Austin: University of Texas Press, 2004), 8; and W. Lee O'Daniel and His Hillbilly Boys, "Mother's Crazy Quilt," *W. Lee O'Daniel and His Hillbilly Boys: Recorded 1935–1938*, 2014, compact disc, British Archive of Country Music, BACM CD D 463.

93. Caro, *Years of Lyndon Johnson*, 696.

94. "O'Daniel Has Special Mother's Day Program in House Hall," *Valley Morning Star* (Harlingen, TX), May 15, 1939, 8.

95. Dempsey, *Light Crust Doughboys*, 40–41.

96. Walter Davenport, "Where's *Them* Biscuits, Pappy?," *Collier's Weekly*, January 6, 1940, 21.

97. Moore, "Biggest Crowd in Political History," 7.

98. Yauger, "Persuasive Tactics of a Radio Politician," 372–74.

99. Richard H. Tate, "Davis Open Tour with Talk, Songs" and "Davis Speaks at Ruston," *New Orleans Times-Picayune*, October 24, 1943, 14.

100. "Would-Be Governor Wins Ballots with Ballads in Louisiana Race," *Brownsville (TX) Herald*, February 10, 1944, 18; Sanson, *Louisiana during World War II*, 122. On the backfiring, see Weill, *You Are My Sunshine*, 68–69. On the paid dancers, see Fontenot, "You Can't Fight a Song," 54.

101. "People Are a Big Interest to Davis," *Times-Picayune*, December 19, 1943, 14.

102. "Davis 'Spreading Sunshine' on Way," *Times-Picayune*, November 20, 1943, 7.

103. Dorothy Horstman, *Sing Your Heart Out, Country Boy* (New York: Dutton, 1976), 241–42.

104. H. B. Teeter, "Acuff, Reese Speak at Rally," *Tennessean* (Nashville), October 12, 1948, 21.

105. McKay, *O'Daniel and Texas Politics*, 32; "O'Daniel Quotes Bible Opposing Death Penalty," *Corsicana (TX) Daily Sun*, October 28, 1938, 1.

106. See, for instance, "State Party Chiefs to Fix Ballot," *Abilene Reporter-News*, June 7, 1938, 3; "O'Daniel Tells Why He Had No Poll Tax," *Denton Record-Chronicle*, June 21, 1938, 1.

107. "Lee O'Daniel Flayed by Bill M'Craw," *Valley Evening Star* (Harlingen, TX), July 10, 1938, 3.

108. "Nothing Like It in Half a Century," *Waco (TX) News-Tribune*, June 14, 1938, 1–2. On the cheering, see "O'Daniel Appeals to Texans to Throw Out the Politicians," *Lubbock (TX) Morning Avalanche*, July 19, 1938, 6.

109. Herman Teeter, "Acuff, Reece, to Open Campaign" *Tennessean* (Nashville), August 31, 1948, 1, 11.

110. Schlappi, *Roy Acuff*, 196.

111. McKay, *O'Daniel and Texas Politics*, 103–4, 406–7; Robert Mann, *Legacy to Power: Senator Russell of Louisiana* (Lincoln, NE: iUniverse, 2003), 31; Alan Brinkley, *Voices of Dissent: Huey Long, Father Coughlin, and the Great Depression* (New York: Vintage, 1983), 33.

112. B. Malone, *Country Music, U.S.A.*, 130–35.

113. "O'Daniel Will Face Problem at Austin," *Pampa (TX) Daily News*, July 25, 1938, 1, 8.

114. Yauger, "Persuasive Tactics of a Radio Politician," 373.

115. "First Democratic Primary, 1938—County Table No. 1," *Texas Almanac, 1939–40* (Dallas: A. H. Belo, 1939), 359–62; Caro, *Years of Lyndon Johnson*, 732; J. Gilberto Quezada, *Border Boss: Manuel B. Bravo and Zapata County* (College Station: Texas A & M University Press, 1999), xv, 49–50.

116. "Morgan Backers Speak at Monroe," *Times-Picayune*, November 8, 1943, 6.

117. "Let's Give Jimmie Davis and His Ticket a Great Victory," *Monroe (LA) Morning World*, February 27, 1944, 6.

118. Maurice Zolotow, "Hillbilly Boom," *Saturday Evening Post*, February 12, 1944, 38. The Nashville *Tennessean* reported that Cooper was scheduled to perform, but it did not provide follow-up coverage of the event or mention the remark that was reported in the *Post*. See "Grand Ole Opry NBC Network Is Enlarged," *Tennessean* (Nashville), October 9, 1943, 5.

119. Schlappi, *Roy Acuff*, 182–86.

120. Marion Porter, "Fiddler Acuff Ponders: To Be Governor or Not," *Courier-Journal* (Louisville, KY), November 1, 1943, 9.

121. "A Challenge to Boss Crump," *Time*, November 2, 1943, 20.

122. Ivan Tribe, "The Hillbilly vs. the City: Urban Images in Country Music," *John Edward Memorial Foundation Quarterly* 10 (1974): 41–50.

123. Green, *Establishment in Texas*, 25–44.

124. Jay Franklin, "Texas as Political System Soft," *Valley Morning Star* (Harlingen, TX), August 16, 1942, 4.

125. Sanson, *Louisiana during World War II*, 135.

126. Patrick Huber, "Black Hillbillies: African American Musicians on Old-Time Records, 1934–1932," in *Hidden in the Mix: The African American Presence in Country Music*, ed. Diane Pecknold, (Durham, NC: Duke University Press, 2013), 36–37.

127. Frank Durham, "Inescapable Reality: Pragmatism and the Press in the New Orleans Desegregation Crisis of 1960–61," in *The* Times-Picayune *in a Changing Media World: The Transformation of an American Newspaper*, ed. S. L. Alexander, Frank D. Durham, Alfred Lawrence Lorenz, and Vicki Mayer (Lanham, MD: Lexington Books, 2014), 52–62; Laura Briggs, *Somebody's Children: The Politics of Transracial and Transnational Adoption* (Durham, NC: Duke University Press, 2012), 41.

128. James Houston Davis, "Comparative Intelligence of Whites, Blacks, and Mulattoes" (master's thesis, Louisiana State University, Baton Rouge, 1927).

129. Bob Ingram, "Owen Pledges He Will Save Segregation," *Montgomery (AL) Advertiser*, March 1, 1958, 1.

130. James K. Batten, "Nixon, Wallace Split Tennessee," *Tallahassee (FL) Democrat*, September 23, 1968, 2.

131. Schlappi, *Roy Acuff*, 208.

Chapter 5

1. "Congress Convenes," Universal International News newsreel, January 4, 1945, on Newsreels 1945, DVD37, a set of historic UIN newsreels compiled by Dr. Steven Schoenherr of the University of San Diego Department of History. It is not entirely clear why sound appears only on the Taylor segment of the newsreel, nor whether this newsreel was ever finalized and brought before a theater audience. It may in fact just be a bit of abandoned "orphan" film-making.

2. Jeff Flake and Martin Heinrich, "Two Opposing Senators, a Deserted Island and an Idea," *Washington Post*, October 21, 2014, http://www.washing tonpost.com/opinions/two-opposing-senators-a-deserted-island-and-an -idea/2014/10/21/127ef9e6-579c-11e4-bd61-346aee66ba29_story.html.

3. "Cowboy Sings Swan Song on Capitol Steps, Then (Reluctantly) Takes Oath of Office," *New York Times*, January 4, 1945, 36. See also "95 Newcomers in Congress Are Colorful Crew," *Chicago Tribune*, January 4, 1945, 7; "Singing

Solon Stands on Steps for Sympathy," *Pampa (TX) Daily News*, January 3, 1945, 1; and "Singing Cowboy Not to Yodel as He Works at Job of Senator," *Mason City (IA) Globe-Gazette*, January 3, 1945, 4.

4. Carl Grafton and Anne Permaloff. *Big Mules & Branchheads: James E. Folsom and Political Power in Alabama*. (Athens: University of Georgia Press, 1985), 31, 56–59.

5. "Curbstone Echoes Caught on the Wing," *Atlanta Constitution*, November 19, 1882, 1; C. Van Woodward, *Tom Watson: Agrarian Radical* (Oxford: Oxford University Press, 1963), 99–101, 107–11.

6. Richard A. Peterson, "The Dialectic of Hard-Core and Soft-Shell Country Music," *South Atlantic Quarterly* 94, no. 1 (1995): 273–300.

7. F. Ross Peterson, *Prophet without Honor: Glen H. Taylor & the Fight for American Liberalism* (Lexington: University Press of Kentucky, 1974), 3–5.

8. Glen Hearst Taylor, *The Way It Was with Me* (Secaucus, NJ: Lyle Stuart, 1979), 130.

9. Glen H. Taylor, letter to F. Ross Peterson, December 11, 1967, Glen Taylor Papers, MS 252, series 2, subseries B, box 16, folder 1.

10. G. Taylor, *The Way It Was with Me*, 130–42.

11. G. Taylor, 137–39.

12. G. Taylor, 129–37.

13. Arod Taylor, phone interview by the author, September 15, 2014, Millbrae, California. Arod is Glen H. Taylor's first son, and his full name is Glen Arod Taylor; the Taylors have always called him by his middle name.

14. G. Taylor, *The Way It Was with Me*, 138.

15. A. Taylor, interview.

16. G. Taylor, *The Way It Was with Me*, 151, 279; A. Taylor, interview.

17. G. Taylor, *The Way It Was with Me*, 119. For more on how Taylor processed Gillette's work, see ibid., 119–21.

18. Russell Adams, *King Gillette: The Man and His Wonderful Shaving Device* (Boston: Little, Brown: 1978), 134–37.

19. King Camp Gillette, *The People's Corporation* (New York: Boni and Liveright, 1924), 11–58.

20. King Camp Gillette, *The Human Drift* (Boston: New Era, 1894), 87–105; King Camp Gillette, *World Corporation* (Boston: New England News, 1910), 220–32; Gillette, *People's Corporation*, 167–68.

21. G. Taylor, *The Way It Was with Me*, 110; A. Taylor, interview; Peterson, *Prophet without Honor*, 9.

22. Peterson, *Prophet without Honor*, 9; A. Taylor, interview.

23. A. Taylor, interview. On the theme song, see Frank Weldon and James

Cavanaugh, *I Like Mountain Music*, sheet music (New York: M. Witmark & Sons, 1933).

24. Glendora Ranch Gang recordings, May 20, 1941, compact disc recorded from Silvertone disc. Twenty-six songs in all appear on the recordings, but several songs were recorded more than once in the set, sometimes in both instrumental and vocal form, giving us a total of twenty separate songs. Arod Taylor provided the author an audio CD copy of these discs.

25. G. Taylor, *The Way It Was with Me*, 141–42.

26. See, for instance, Carter Family, *On Border Radio 1939*, Arhoolie Records, 1995, compact disc.

27. On Gobel (also spelled Goebel) and the Sizemores, see Charles K. Wolfe, *Kentucky Country: Folk and Country Music of Kentucky* (Lexington: University of Kentucky Press, 1982), 60–61; and *The Encyclopedia of Country Music: The Ultimate Guide to the Music* (Oxford: Oxford University Press, 1998), s.v. "Asher & Little Jimmy Sizemore," by W. K. Neil, 486. Several recordings of the Sizemores' radio programs were at one time available at http://obscurecountry .com/sizemore.html (accessed June 2017). Two Sizemore programs were available at the time of this writing at Country Music Hall of Fame and Museum's Digital archive: http://digi.countrymusichalloffame.org/cdm/search/collec tion/musicaudio/searchterm/asher%20sizemore/order/title.

28. Glendora Ranch Gang recordings, especially track 15, "Little Buckaroo," May 20, 1941, compact disc recorded from Silvertone disc.

29. Glendora Ranch Gang Recordings, tracks 6 and 17, "I Only Want a Buddy;" "Sizemore: Nashville Sound is Upbeat," *Billboard*, July 15, 1967, 40, 51; "I Only Want a Buddy, Not a Sweetheart," words and music by Asher Sizemore and Eddie Jones, in *Asher Sizemore and Little Jimmie's Hearth & Home Songs* (Louisville, KY: Raynor, Dalheim, 1934), 9. The Sizemores list Asher as a cowriter in the aforementioned songbook, but the Library of Congress's *Catalog of Copyright Entries* for 1932 lists Jones as a sole writer of music and words in 1932. It may be that the elder Sizemore simply adapted the lyrics to fit his son in this case.

30. Glendora Ranch Gang Recordings, track 12, "My Dear Old Southern Home."

31. Glendora Ranch Gang Recordings, tracks 15 and 19, "Little Buckaroo."

32. Noel M. Smith, *The Cherokee Strip*, Warner Bros., (1937).

33. Jack Scholl and M. K. Jerome, "My Little Buckaroo" (M. Witmark & Sons, 1937).

34. Don Cusic, *The Cowboy in Country Music: An Historical Survey with Artist Profiles* (Jefferson, NC: McFarland, 2011), 236.

35. A. Taylor, interview.

36. Glendora Ranch Gang Recordings, track 20, "Springtime in the Rockies." On "Springtime," see Ardis E. Parshall, "Mary Hale Woolsey: Always Springtime," *Keepapitchinin, the Mormon History Blog*, August 7, 2009, http://www .keepapitchinin.org/2009/08/07/mary-hale-woolsey-always-springtime/. On Billy Hill, see Jack Burton, "The Honor Roll of Popular Songwriters: No. 64—Billy Hill," *Billboard*, June 10, 1950, 41. The lyricist Ted Lewis (née Larry Yoell) was jazz leader who specialized in performing ragtime and jazzed up Tin Pan Alley on vaudeville. Scott Yanow, *Classic Jazz: Third Ear—the Essential Listening Companion* (San Francisco: Hal Leonard Corporation, 2001), s.v. "Ted Lewis," 136.

37. Peter Stanfield, *Horse Opera: The Strange History of the 1930s Singing Cowboy* (Urbana: University of Illinois Press, 2002); Peter Stanfield, "Dixie Cowboys and Blue Yodels: The Strange History of the Singing Cowboy," in *Back in the Saddle Again: New Essays on the Western*, ed. Edward Buscombe and Roberta E. Pearson (London: British Film Institute, 1998), 96–118.

38. These songs appear on tracks 1, 13, and 20 of the Glendora Ranch Gang recordings.

39. Cusic, *The Cowboy in Country Music*, loc. 1923–49; Gary Giddins, *Bing Crosby: A Pocketful of Dreams—The Early Years, 1903–1940* (New York: Little, Brown, 2009), chap. 17.

40. G. Taylor, *The Way It Was with Me*, 159.

41. Numerous photos of Glen, Dora, and Arod in western wear appeared in the Idaho and national press during the era. Peter Collier, "Remembering Glen Taylor," *Mother Jones Magazine*, April 1977, 42–48, includes a fairly comprehensive chronological collection of the Taylors pictured in western wear at various time periods. Taylor's western wear seems to also have increased in quality as he rose in office, so that by his marathon equestrian "peace ride" in 1947 he was wearing a top-notch tailored western suit that looked like something famous country music tailors Nudie Cohn or Nathan Turk might have put together. "Eastbound," photograph in news collage, *Los Angeles Times*, October 27, 1947, 3.

42. "Farewell Appearance: The Glendora Ranch Gang," advertisement, *Caribou County (ID) Sun*, December 19, 1940, 6.

43. A. Taylor, interview.

44. A. Taylor, interview.

45. David Gilbert, *The Product of Our Souls: Ragtime, Race, and the Birth of the Manhattan Musical Marketplace* (Chapel Hill: University of North Caro-

lina Press, 2015), 27–33; James H. Dormon, "Shaping the Popular Image of Post-Reconstruction American Blacks: The 'Coon Song' Phenomenon of the Gilded Age," *American Quarterly* 40, no. 4 (December 1, 1988): 450–71; Philip Furia, *The Poets of Tin Pan Alley: A History of America's Great Lyricists: A History of America's Great Lyricists* (New York: Oxford University Press, 1990), 25–29.

46. I reproduce the Taylors' version of the lyrics here; they are only a slight variation on the original in that a few incidental words are changed and mention of a banjo is added to the line about strumming a Dixie tune. Con Conrad and Jay Whidden, music, Joe Young, words, "Down in Dear Old New Orleans," sheet music (New York: Jerome H. Remick, 1912), box 9, folder 34, William Ransom Hogan Jazz Archive, Howard-Tilton Memorial Library, Tulane University, https://digitallibrary.tulane.edu/islandora/object/tulane%3A19038/datastream/PDF/view.

47. Dormon, "Shaping the Popular Image of Post-Reconstruction American Blacks," 450–71. The lyricist of "Down in Dear Old New Orleans," Joe Young, spent most of his life contributing to the Alley as a singer, song plugger and lyricist and wasn't necessarily known for his coon songs. Young, in fact, was probably best known for the later Fats Waller–Billy Williams hit "I'm Gonna Sit Right Down and Write Myself a Letter." See "Joe Young," in *Tin Pan Alley: An Encyclopedia of the Golden Age of American Song*, ed. David A. Jasen (Routledge, 2003), 425.

48. G. Taylor, *The Way It Was with Me*, 187.

49. Peterson, *Prophet without Honor*, 11.

50. G. Taylor, *The Way It Was with Me*, 173.

51. G. Taylor, 171.

52. A. Taylor, interview; Peterson, *Prophet without Honor*, 14; "Pocatellan Leading U.S. Senate Race," *Pocatello Tribune*, August 14, 1940, 1.

53. G. Taylor, *The Way It Was with Me*, 203.

54. "Free Entertainment" advertisement, *Soda Springs (ID) Sun*, April 25 1940, 4.

55. "Glen Taylor, Cowboy Musician, Holds Slim Lead," *Post-Register* (Idaho Falls), August 14, 1940, 1.

56. Taylor, *The Way It Was with Me*, 229–33; Peterson, *Prophet without Honor*, 21–22.

57. Taylor, 228–29; Peterson, 19.

58. Taylor, 233.

59. "Singing Cowboy Out to Corral Nomination," *Soda Springs (ID) Sun*, May 28, 1942, 1.

60. "Taylor Jumps on Financiers," *Pocatello Tribune*, August 16, 1942, 1.

61. Peterson, *Prophet without Honor*, 17.

62. "Idaho Merchants Rap Candidacy of Glen Taylor," *Post-Register* (Idaho Falls), October 29, 1942, 10.

63. "Singing Cowboy Out to Corral Nomination," *Soda Springs (ID) Sun*, May 28, 1942, 1.

64. *Pocatello Tribune*, August 16, 1942, quoted in Peterson, *Prophet without Honor*, 20.

65. G. Taylor, *The Way It Was with Me*, 204.

66. "'Bott' for Senator," *Post-Register* (Idaho Falls), October 22, 1944, 4.

67. Associated Press, "Cowboy Crooner Wins Seat in Senate," *Fitchburg (MA) Sentinel*, November 9, 1944, 6.

68. "Idaho Senator Begins 'Paul Revere' Ride East," *Los Angeles Times*, October 27, 1947, 2.

69. United Press International, "Senator Glen Taylor of Idaho Is Trying to Let America See How Soviets Must Feel," *Lubbock (TX) Evening Journal*, November 13, 1947, 16; "Senator Plans to Ride Horse across Continent," *Los Angeles Times*, October 21, 1947, 2; United Press International, "Sen. Taylor Starts 'Paul Revere' Ride," *Daily Trojan* (University of Southern California), October 27, 1947, 1; "Horse Riding Senator Will Be Here Saturday," *El Paso Herald-Post*, October 30, 1947, 13.

70. On Taylor's pro–civil rights and Zionist record, see "Taylor Charged with Violating Segregation Law," *Albuquerque Journal*, May 3, 1948, 1; "Says Senators Ask Jews' Delegation," *New York Times*, May 23, 1945, 13; and W. H. Lawrence, "'Wallace or War' Keynotes Progressive Party Conclave," *New York Times*, July 24, 1948, 1. On radio, see "Puts FM in Field of Small Business," *New York Times*, December 14, 1945, 34. On the Columbia Valley Authority proposal, see "Cain Begins Slowdown Campaign against CVA," *Post-Register* (Idaho Falls), April 24, 1949, 6.

71. Harold B. Hinton, "Bilbo Is Held Off," *New York Times*, January 4, 1947, 1.

72. Peterson, *Prophet without Honor*, 112–15.

73. Holmes Alexander, "What Will the Democrats Do about Glen Taylor?," *Los Angeles Times*, September 17, 1949, A4.

74. "The Cowboy Crusader," editorial, *Odessa (TX) American*, November 26, 1947, 6.

75. Marquis Childs, "Taylor, Wallace's Running Mate Is Actor with Streak of Innate Ham," *Janesville (WI) Daily Gazette*, August 20, 1948, 6.

76. W. H. Lawrence, "'Wallace or War' Keynotes Progressive Party Conclave," *New York Times*, July 24, 1948.

77. Thomas L. Stokes, "Washington Column," *Daily Mail* (Hagerstown, MD), July 27, 1948, 8.

78. "Band Nine: Progressive Party Convention," *I Can Hear It Now—Vol. 2: Edward R. Murrow, Narrator*, Columbia Records, 1949, ML 4261, phonograph recording. I base my analysis in part on my reading of Robbie Lieberman, *My Song Is My Weapon: People's Songs, American Communism, and the Politics of Culture* (Urbana: University of Illinois Press, 1989), 126–39; Benjamin S. Schoening and Eric T. Kasper, *Don't Stop Thinking about the Music: The Politics of Songs and Musicians in Presidential Campaigns* (Lanham, MD: Lexington Books, 2012); Stuart Schindler, "Campaign Music," in *Music in American Life: An Encyclopedia of the Songs, Styles, Stars and Stories That Shaped Our Culture*, ed. Jacqueline Edmondson (Santa Barbara, CA: ABC-CLIO, 2013), 177–78; and Peter Argersinger, *The Limits of Agrarian Radicalism: Western Populism and American Politics* (Lawrence: University of Kansas Press, 1995), chap. 3.

79. Lieberman, *My Song Is My Weapon*, 132–33; and Schoening and Casper, *Don't Stop Thinking about the Music*, 122–23.

80. See Richard Reuss with Joanne C. Reuss, *American Folk Music and Left-Wing Politics, 1927–1957* (Lanham, MD: Scarecrow Press, 2000), 198–203; Lieberman, *My Song Is My Weapon*, 126–39; Ronald Cohen, *Rainbow Quest: The Folk Music Revival and American Society, 1940–1970* (Amherst: University of Massachusetts Press, 2002), 56–57.

81. Peter Seeger, phone interview, August 15, 2013, Beacon, New York.

82. A. Taylor, interview.

83. Cornell Capa, "Sen. Glen Taylor (L) and Pete Seeger Singing and Playing at PAC School," photograph, July 1946, Washington DC, *Life*, http://images.google.com/hosted/life/4c8bbd8a8d3ef5b4.html.

84. A. Taylor, interview.

85. See, for instance, G. Taylor, *The Way It Was with Me*, 203–5.

86. "Hear Senator Glen Taylor," advertisement, *Kansas City Star*, October 10, 1948, 56; "1,000 Hear Taylor Lash 'Dangerous Leaders,'" *Iowa City Press-Citizen*, October 14, 1948, 15.

87. "Taylor Will Speak Here Tomorrow at Luncheon," *Modesto (CA) Bee*, July 7, 1948, 8.

88. Curtis D. MacDougall, *Gideon's Army* (New York: Marzani and Munsell, 1965), 529–31.

89. "James and Bonnie Thornton," in Frank Cullen, *Vaudeville Old and New* (New York: Routledge, 1006), 1104.

90. See, for instance, "Retail Record Sales," *Billboard*, November 15, 1947, 27.

91. "Band Nine: Progressive Party Convention," *I Can Hear It Now*.

92. Norman Thomas, "Thomas Sees Third Party Platform as One of Trickery," *Oregonian* (Portland), July 26, 1948, 4.

93. Irwin Ross, *The Loneliest Campaign: The Truman Victory of 1948* (New York: New American Library, 1968), 246–47.

94. A. Taylor, interview.

95. Peterson, *Prophet without Honor*, 169–71. Taylor lost by less than a thousand votes in the first count and demanded a recount. Because Idaho required a court hearing to determine that a recount was necessary, Taylor had requested that the election subcommittee of the US Senate Rules Committee first conduct an investigation. Investigators were sent to Idaho and did find irregularities, but the subcommittee decided to drop the investigation. No recount was ever conducted.

96. G. Taylor, *The Way It Was with Me*, 407–9.

Chapter 6

1. Irving Howe, "They Took Their Stand," *New York Times Book Review*, August 8, 1965, 26.

2. H. R. Stoneback, "The Box, the Glittering Strings, and the Unbearable Hillbillyness of Being: Warren's The Cave, Country Music, and Vanderbilt Fugitive-Agrarianism," *RWP: An Annual of Robert Penn Warren Studies* 8 (2008): 12.

3. Stoneback, "The Box, the Glittering Strings," 13.

4. Although early students of the Vanderbilt Agrarians such as Richard Weaver argued that *I'll Take My Stand* should be viewed as a document of the literary movement and a philosophy, not a political program, much of the scholarship since then—whether negative or positive—has taken the political aspirations of the Agrarians as important aspect of their message and their history. See especially Paul V. Murphy's discussion in *The Rebuke of History: The Southern Agrarians and American Conservative Thought* (Chapel Hill: University of North Carolina Press, 2001), 5–7.

5. William Pratt, "In Pursuit of the Fugitives," in *The Fugitive Poets: Modern Southern Poetry*, ed. Pratt (Nashville: J. S. Sanders, 1991), xiii–xlviii.

6. Pratt, "In Pursuit of the Fugitives," xxv–xxvi

7. Murphy, *Rebuke of History*, 16–17.

8. Twelve Southerners, *I'll Take My Stand: The South and the Agrarian Tradition* (New York: Harper & Brothers, 1930), xvii.

9. Twelve Southerners, *I'll Take My Stand*, xxvi–xlvii.

Woody Guthrie and Maxine Crissman, *Woody and Lefty Lou's Favorite* ~ion *of Old Time Hill Country Songs: Being Sung for Ages, Still Going Strong* ~na, CA: Spanish American Institute Press, 1937), 15.

Woody Guthrie, "My Ideas about the Use of People's Songs in the Pro- ~ve Party Movement to Elect Henry Wallace and Glen Taylor," typed ~cript, January 9, 1949, and January 11, 1949, manuscripts series 1, box ~der 17, pp. 1–7, Woody Guthire Archives, Woody Guthrie Center, Tulsa, ~oma.

Davidson, "Current Attitudes toward Folklore," 48–49.

Davidson, *Still Rebels, Still Yankees*, 134.

Donald Davidson, *Big Ballad Jamboree* (Jackson: University Press of Mis- ~i, 1996), 108.

Davidson, *Big Ballad Jamboree*, 12–25.

Joseph Bruce Gorman, *Estes Kefauver: A Biography* (New York: Oxford ~rsity Press, 1970), 43–46, 74–101, 197–98.

Gorman, *Estes Kefauver*, 47–53.

Farm and Fun Time radio program recordings, 1948–1949, tape reels, ~D. Campbell Collection of Tennessee Hilltoppers with Curly King Radio ~s," part 2, manuscripts 1 folder, RWB 8005–8008, AFS 26816–26819, AFC ~007, American Folklife Center, Library of Congress.

Jack Anderson and Fred Blumenthal, *The Kefauver Story* (New York: Dial ~ 1956), 117–18; Charles L. Fontenay, *Estes Kefauver: A Biography* (Knox- ~University of Tennessee Press, 1980), 152.

Penny Parsons, *Foggy Mountain Troubadour: The Life and Music of Curly* ~r (Urbana: University of Illinois Press, 2016), 57.

~. Charles Fontenay, "Announce Candidacy Now, Kefauver Urged," *Ten- ~n* (Nashville), December 13, 1952, 1, 16.

~. "Music Popularity Charts: Record Reviews," *Billboard*, March 8, 1952,

~. Larry Dean and His Virginia Playboys, "Estes Is Bestes: Kefauver Presi- ~al Fight Song (Marrs-Renfro)," Rich-R-Tone Records 1039A, 1952, 45 rpm ~d. The song was cowritten by Jimmy Renfro, who was associated with the ~Memory Valley Boys band. "Country & Western (Folk) Record Reviews," ~ard, August 16, 1952, 38.

~. Charles L. Fontenay, "'Kefauver for President'—That's Ryman Rallying ~onight," *Tennessean* (Nashville), December 12, 1951, 1; "Kefauver to At- ~Huge Rally Here," *Tennessean* (Nashville), May 3, 1956, 6; "Hank to Vote," ~ssean* (Nashville), July 31, 1960, 6.

10. Andrew Lytle, "The Hind Tit," in *I'll Take My Stand*

11. Donald Davidson, "A Mirror for Artists," in *I'll Take*

12. Donald Davidson, "The Critic's Almanac: The Wo *Tennessean* (Nashville), November 9, 1930, 26.

13. Donald Davidson, "The Critic's Almanac: The Wo *Tennessean* (Nashville), November 9, 1930, 26.

14. Dan D. Emmett, "I Wish I Was in Dixie's Land," sh Firth, Pond, 1860), Duke University Digital Collection: .edu/digitalcollections/hasm_n0807/#info.

15. Daniel Bryant, *Bryant's Songs from Dixie's Land, C and Melodies of the Bryant Brothers* (New York: R. M. d Nathan, "Dixie," *Musical Quarterly* 35, no. 1 (January 19 Hutchison, *New Southern Studies: Apples and Ashes: Liter the Confederate States of America* (Athens: University o chap. 4.

16. Karen L. Cox, *Dreaming of Dixie: How the South W Popular Culture* (Chapel Hill: University of North Carol

17. Allen Tate, letter to contributors to the volume, J *erary Correspondence of Allen Tate and Donald Davidson* Georgia Press, 1974), 406–7.

18. *The Oxford Encyclopedia of American Literature* (C sity Press, 2004), s.v. "The Fugitives and Southern Ag Bedford Clark, 88.

19. Guthrie T. Meade, Richard Spottswood, and D *Music Sources: A Biblio-Discography of Commercially Re* (Chapel Hill: Southern Folklife Collection, Universi Chapel Hill Libraries / John Edwards Memorial Forui

20. Cox, *Dreaming of Dixie*, 9–33.

21. Stoneback, "The Box, the Glittering Strings" 16

22. Murphy, *Rebuke of History*, 205–6.

23. Donald Davidson, "Current Attitudes toward I *lore Society Bulletin* 6 (1940): 44–51. This essay was u reprinted in his *Still Rebels, Still Yankees and Other Ess* ana State University Press, 1957), 128–51.

24. Davidson, "Current Attitudes toward Folklore

25. Max Horkheimer and Theodor Adorno, *The I Philosophical Fragments* (Stanford: Stanford Univers

26. Davidson, "Current Attitudes toward Folklor

42. "Oklahomans Picnic," *Van Nuys (CA) News*, May 26, 1952, 2. On Los Angeles country music television, see Peter La Chapelle, *Proud to Be an Okie: Cultural Politics, Country Music, and Migration to Southern California* (Berkeley: University of California Press, 2007), 83–84, 119.

43. E. W. Kentworthy, "Shall the Best Handshaker Be Nominated?," *New York Times Magazine*, May 27, 1956, 11, 68.

44. "Hillbilly Musician Aides Adlai," *Edwardsville (IL) Intelligencer*, May 19, 1956, 1; "Estes Charges Political Chiefs Gang Up on Him," *Tampa Bay Times*, May 25, 1956; United Press Telephoto, "Sen. Estes Kefauver Campaigning against Stevenson," *Philadelphia Inquirer*, May 27 1956, 1.

45. Gorman, *Estes Kefauver*, 264.

46. Davidson, *Big Ballad Jamboree*, 41.

47. Davidson, 145.

48. Davidson, 145.

49. Davidson, 28–29.

50. William Howard Moore, "Was Estes Kefauver 'Blackmailed' during the Chicago Crime Hearings? A Historian's Perspective," *Public Historian* 4, no. 1 (Winter 1982): 11–12.

51. Davidson, *Big Ballad Jamboree*, 42.

52. Davidson, 162.

53. Tricia Jenkins, "Country Music Tradition and Thomas Jefferson's Agricultural Ideal," *Popular Music and Society* 29, no. 1 (February 2006): 37–50; John Buckley, "Country Music and American Values," *Popular Music and Society* 6, no. 4 (1978): 293–301; Jeremy Hill, *Country Comes to Town: The Music Industry and the Transformation of Nashville* (Amherst: University of Massachusetts Press, 2016), 93–98.

54. See, for instance, *No Depression* editor Grant Alden's analysis in Steve Carney, "Country Music Is Now 'Music of the Suburbs,'" *Los Angeles Times*, March 8, 2002, F38.

55. Pamela Fox, "Coal Miners' Daughters," in *Natural Acts: Gender, Race, and Rusticity in Country Music* (Ann Arbor: University of Michigan, 2009), 113–44.

56. *New Encyclopedia of Southern Culture: Volume 9, Literature* (Chapel Hill: University of North Carolina Press, 2008), s.v. "Literature," by M. Thomas Inge, 1–16; "Fugitives and Agrarians," by M. Thomas Inge, 73–75; and s.v. "Southern Gothic," by Benjamin F. Fisher IV, 145–51.

57. Randolph Paul Ryan, *The Braided Dream: Robert Penn Warren's Late Poetry* (Lexington: University Press of Kentucky, 2015), 1–18; *New Encyclopedia of Southern Culture*, s.v. "Robert Penn Warren," by Ladell Payne, 456–57;

Kristopher Tapley, "New Crop of Message Films," *New York Times*, April 9, 2006, sect. 2, 16; Robert Penn Warren, *Who Speaks for the Negro?* (New Have, CT: Yale University Press, 2014).

58. *New Encyclopedia of Southern Culture*, s.v. "Donald Davidson," by William Pratt, 238–39.

59. *New Encyclopedia of Southern Culture*, s.v. "Cleanth Brooks," by Thomas Daniel Young, 197–98.

60. Wendell Berry's anti-industrial vision is probably best exemplified in his classic work, *The Unsettling of America* (San Francisco: Sierra Club Books, 1977); Wendell Berry, "The Pleasures of Eating," in Holly George Warrne, ed., *Farm Aid: A Song for America* (Emmaus, PA: Rodale, 2005), 189–90. *The Unsettling of America* has gone through many editions since it was first published. Paul Murphy discusses Berry's connection with the original Agrarians in *Rebuke of History*, 264–72. Murphy wants to link Berry with a tolerant earth-and-soil-based conservatism, although I would argue Berry is more generally known and widely trumpeted by the environmental left. Wendell's tendency to write for left-affiliated publications such as the *Nation* or left-of-center magazines such as the *Atlantic* certainly does nothing to dispel this association.

61. Murphy, *Rebuke of History*, 118–12, 131–39, 151–78.

62. Murphy, *Rebuke of History*, 222–45; Evan M. Davis, "Simon Would Oppose Humanities Nominee," *Southern Illinoisan*, November 9, 1981, 1; Mark Pinsky, "The Embattled William Bennett," *Boston Globe*, December 11, 1981, 2. The Bradford nomination was enough to enrage even conservative columnist George F. Will. See Will, "A Shrill Assault on Mr. Lincoln," *Washington Post*, November 29, 1981, https://www.washingtonpost.com/archive/opinions/1981/11/29/a-shrill-assault-on-mr-lincoln/453b1986-761e-4a86-9b71-759ce0729f87/.

63. Twelve Southerners, *I'll Take My Stand*, xli.

64. Twelve Southerners, 111–13, 239.

65. Donald Davidson, *The Tennessee: The New River: Civil War to TVA* (New York: Rinehart, 1948), 237.

66. Edward Shapiro argues convincingly in "The Southern Agrarians and the TVA," *American Quarterly* 22, no. 4 (Winter 1970): 791–806, that the views of many of the Agrarian writers on the TVA evolved and changed over time and that many were initially in support of the TVA. However, when viewing the larger scope of Agrarian writing from the New Deal, collected in *The Southern Agrarians and the New Deal: Essays After I'll Take My Stand*, ed. Emily S. Bingham and Thomas A. Underwood (Charlottesville: University Press of Virginia,

2001), one comes to very different conclusion. The Agrarians were, as the editors note in their introduction, trying to influence New Deal policymakers by writing—quite prolifically, in journals of policy and national affairs. However, their goal was not to enhance the jobs programs and social safety net sought by liberals, but rather to unravel it in favor of policies that promoted small-scale, subsistence-oriented agriculture.

67. Emily S. Bingham and Thomas A. Underwood, introduction to *Southern Agrarians and the New Deal*, 4.

68. Eddy Arnold, *It's a Long Way from Chester County* (Old Tappan, NJ: Hewitt House, 1969), 16.

69. Minnie Pearl with Joan Dew, *Minnie Pearl: An Autobiography* (New York: Pocket Books, 1980), 249–50. On Barkley, see James Libbey, *Alben Barkley: A Life in Politics* (Lexington: University Press of Kentucky, 2016).

70. Johnny Cash with Patrick Carr, *Cash: The Autobiography* (Harper: New York, 1997), 18–19.

71. Cash, *Cash*, 20.

72. Loretta Lynn with George Vecsey, *Coal Miner's Daughter* (New York: Vintage Books, 1976), 11.

73. Charley Pride with Jim Henderson, *Pride: The Charley Pride Story* (New York: William Morrow, 1994), 46–47.

74. Naomi Judd, *Love Can Build a Bridge* (New York: Villard Books, 1993), 101.

75. Trace Adkins, *A Personal Stand: Observations and Opinions from a Free-thinking Roughneck* (New York: Ballantine Books, 2007), 99; Charlie Daniels, *Ain't No Rag: Freedom, Family, and the Flag* (Washington, DC: Regnery, 2003), xv.

76. Merle Haggard with Tom Carter, *Merle Haggard's My House of Memories* (New York: Cliff Street Books, 1999), 49–63.

77. Randy Owen, *Born Country*, 36–37.

78. Waylon Jennings, *Waylon: An Autobiography* (Chicago: Chicago Review Press, 1996). 9.

79. See, for instance, Reba McEntire, *Reba: My Story* (New York: Bantam Books, 1994), 163.

80. Charlie Daniels, *Never Look at the Empty Seats: A Memoir* (Nashville: Thomas Nelson, 2017), 7, 18–23.

81. Lynn, *Coal Miner's Daughter*, 2–3, 32.

82. Lynn, 128.

83. Dolly Parton, *Dolly: My Life and Other Unfinished Business* (New York: Harper, 1994), 53–54.

84. Shania Twain, *From This Moment On* (New York: Atria, 2011), 103–4.

85. See, for instance, McEntire, *Reba*, 163. Lee Greenwood lionizes Sam Walton, founder of Walmart, in his polemic *Does God Still Bless the USA? A Plea for a Better America* (Mustang, OK: Tate, 2012), but focuses mostly on Walton's rags-to-riches story, emphasizing what he sees as Walton's hard work and business acumen.

86. Adkins, *A Personal Stand*, 26–27.

87. Willie Nelson with Turk Pipkin, *The Tao of Willie: A Guide to the Happiness in Your Heart* (New York: Gotham Books, 2006), 143–45.

88. Owen, *Born Country*, 41.

89. Willie Nelson with Bud Shrake, *Willie: An Autobiography* (New York: Simon and Shuster, 1998), 308.

90. Willie Nelson with David Ritz, *It's A Long Story: My Life* (New York: Little, Brown, 2015), 306.

91. Nelson, *It's A Long Story*, 307.

92. Daniels, *Never Look at the Empty Seats*, 30–31.

93. Owsley, "The Irrepressible Conflict," in *I'll Take My Stand*, 68–69, 74–76; Adkins, *Personal Stand*, 37.

94. Adkins, *Personal Stand*, 37.

95. Owsley, "The Irrepressible Conflict," in *I'll Take My Stand*, 77–79.

96. Adkins, *Personal Stand*, 40–41; Andrew Lytle, *Bedford Forrest and His Critter Company* (Nashville: J. S. Sanders, 1992).

97. Adkins, *Personal Stand*, 38–39.

98. Adkins, 41.

99. Murphy, *Rebuke of History*, 202–3.

100. Although, at the time of the NEH appointment, opponents pointed to Bradford's involvement with the Wallace campaign in 1972, he appears to have been actively involved in 1968 as well. Murphy, *Rebuke of History*, 227–35; Mike Sowell, "Wallace 'Got Too Strong, They Got Scared,' Says Bradford," *Irving (TX) Daily News*, May 16, 1972, 1; Michael A. Lutz, "Wallace Says His Foes 'Are Sounding Like Me,'" *Abilene (TX) Reporter-News*, September 17, 1968, 36, 38.

Chapter 7

1. This rally description is drawn largely from the story, photo, and captions connected with Bob Ingram, "Wallace Bears Down on Race Issue in Opening Campaign," *Montgomery Advertiser*, February 16, 1958, 1–2. My suggestions about Pearl's routine are based on a clip of Pearl warming up the crowd for

Wallace at another outdoor rally in front of the same banner in 1958: Ray Jones, "Minnie Pearl Stand-Up while Opening for George Wallace in the 1958 Campaign for Governor of Alabama," https://www.youtube.com/watch?v=a H8jCaLhU-k, YouTube, June 10, 2011, video, 3:05.

2. Ingram, "Wallace Bears Down," 1–2.

3. Roy Baham, Jamelle Folsom, and E. Jimmy Key, *The Strawberry Pickers* (Nashville: Southern Arts, 2000), 35–39.

4. Roy Baham, Jamelle Folsom, and E. Jimmy Key, *The Strawberry Pickers* (Nashville: Southern Arts, 2000), 35–39.

5. "Folsom Urges Race Hate End in Yule Speech," *Anniston (AL) Star*, December 26, 1949, 1.

6. Carl Grafton and Anne Permaloff, *Big Mules & Branchheads: James E. Folsom and Political Power in Alabama* (Athens: University of Georgia Press, 1985), 31. On Folsom-Long associations, see, for instance, Lyle C. Wilson, "A New Huey Long?," *Pittsburgh Press*, March 27, 1948, 9. The "black-belt" region was named for its rich dark soil, but later took on additional meaning because of the larger number of African Americans transported there during slavery.

7. "Alabama Election," *Life*, June 3, 1946, 43. Biographers Grafton and Permaloff argue that Folsom was aware of Long and O'Daniel passing buckets, but the mop-and-suds focus seems uniquely Folsom's.

8. Michael Cohen, *American Maelstrom: The 1968 Election and Politics of Division* (Oxford: Oxford University Press, 2016), 237.

9. "Big Jim Folsom to Speak Here," *Cullman (AL) Democrat*, April 4, 1946, 1, 4.

10. "A Southern Liberal," *Economist*, May 17, 1947, 765.

11. Steve Flowers, *Of Goats and Governors: Six Decades of Colorful Alabama Political Stories* (Montgomery, AL: New South Books, 2015), 7.

12. Grafton and Permaloff, *Big Mules & Branchheads*, 56–58.

13. Stetson Kennedy, "Will the South Really Revolt?," *Gazette and Daily* (York, PA), March 2, 1948, 17.

14. "J. E. (Big Jim) Folsom Dies," *Los Angeles Times*, November 22, 1987, A42.

15. "Future of Voting Status of Negroes Is Issue," *Ashville (NC) Citizen-Times*, November 5, 1946, 3; "Boswell Code Tops Election for Alabama," *Anniston (AL) Star*, November 4, 1946, 1.

16. "Ladies Will Get Jobs in Folsom Government," *Anniston (AL) Star*, September 10, 1946, 2.

17. "Folsom Urges Race Hate End in Yule Speech," *Anniston (AL) Star*, December 26, 1949, 1.

18. Baham, Folsom, and Key, *The Strawberry Pickers*, 10–11, 19.

19. Grafton and Permaloff, *Big Mules & Branchheads*, 59; "Candidate for Governor," *Cullman Democrat*, March 5, 1942, 1.

20. Baham, Folsom, and Key, *Strawberry Pickers*, 13–29, 113–20.

21. Baham, Folsom, and Key, *Strawberry Pickers*, 26, 35–40, 102, 122.

22. "Folsom Says His Program is Possible," *Anniston (AL) Star*, May 30, 1946, 1.

23. Later political adversary John Patterson described this scene in Warren A. Trest, *Nobody but the People: The Life and Times of Alabama's Youngest Governor* (Montgomery, AL: NewSouth Books, 2008), 220–21.

24. Quoted in Grafton and Permaloff, *Big Mules & Branchheads*, 67.

25. Grafton and Permaloff, *Big Mules*, 91–92, 98–99; George E. Sims, *The Little Man's Big Friend: James E. Folsom in Alabama Politics, 1946–1958* (University: University of Alabama Press, 1985), 147.

26. Grafton and Permaloff, *Big Mules & Branchheads*, 102–8.

27. Grafton and Permaloff, 128.

28. Paul E. Deutschman, "Outsize Governor," *Life*, September 15, 1947, 59–66.

29. Sims, *Little Man's Big Friend*, 96–97, 101.

30. "Alabama's Jim Folsom Stumps Again to Defeat Legislature," *Cumberland (AL) Evening Times*, December 24, 1947, 9.

31. Grafton and Permaloff, *Big Mules & Branchheads*, 127.

32. "Strawberry Pickers Get Jobs with Folsom Regime," *Anniston (AL) Star*, January 29, 1947, 1.

33. Grover C. Hall Jr., "Folsom Uncorks Opening Talk around Capital," *Montgomery Advertiser*, January 26, 1954, 1–2.

34. Rudy Abramson, "Big Jim Is Out in Front in Face for Alabama Governor," *Tennessean* (Nashville), January 28, 1962, 13.

35. "Hit Tunesmith to Be at Rita," *Longview (TX) News-Journal*, February 14, 1954, 12; Bruce Henderson, "Hillbilly Record Demand Continues Heavy in Texas," *Corsicana (TX) Daily Sun*, December 18, 1954, 3; Sims, *Little Man's Big Friend*, 130.

36. Nathan D. Gibson with Don Pierce, *The Starday Story: The House that Country Music Built* (Jackson: University Press of Mississippi, 2011), 14.

37. "This Week's Best Buys," *Billboard*, December 5, 1953, 28.

38. "Big Jim," *Anniston (AL) Star*, January 29, 1954, 4; "Top C & W Records," *Billboard*, January 30, 1954, 45.

39. Gibson, *Starday Story*, 20; "Folk Talents and Tunes," *Billboard*, January 9, 1954, 34.

40. Geoffrey Birt, "1,000 Curious Flock to Ramer for Folsom Talk," *Montgomery Advertiser*, February 14, 1954, 20.

41. See, for instance, "Folsom, String Band, Heard by Audience in Alexandria," *Anniston (AL) Star*, February 17, 1954, 2; and "No Such Swap," *Montgomery Advertiser*, December 31, 1954, 4. On the *y'all* including African Americans, see Sims, *Little Man's Big Friend*, 219.

42. W. Bradley Twitty, *Y'All Come: "Big Jim" Folsom* (Nashville: Hermitage Press, 1962), 20.

43. Grafton and Permaloff, *Big Mules & Branchheads*, 95–88.

44. Bob Ingram, "Folsom Denies Advocating 'Sectional' State Program," *Montgomery Advertiser*, June 8, 1954, 1.

45. Grafton and Permaloff, *Big Mules & Branchheads*, 177.

46. *Branchheads* refer to the small, lowland tributaries that run through parts of Alabama and North Carolina. Over time the term came to refer to the poor whites who lived in rural areas. Carl Grafton, "Branchheads," *Encyclopedia of Alabama*, http://www.encyclopediaofalabama.org/article/h-1636.

47. "Bing-Come-Lately," *Life*, January 11, 1954, 57.

48. *The Encyclopedia of Country Music: The Ultimate Guide to the Music* (New York: Oxford University Press, 1998), s.v. "Arlie Duff," by Don Roy, 154–55. Artists who have recorded the song also include Bill Monroe, Faron Young, Glen Campbell, Buck Owens, George Jones, and Porter Wagoner.

49. "Hank Williams Day," *Billboard*, October 2, 1954, 41; Frank Andersen, "Crowds Pack Cramton Bowl to Close Hank Williams Days," *Montgomery Advertiser*, September 22, 1954, 1; Joe Azbell, "60,000 Friends, Fans of Hank See Memorial," *Montgomery Advertiser*, September 22, 1954, 1.

50. Azbell, "60,000 Friends, Fans of Hank See Memorial," 1.

51. Andersen, "Crowds Pack Cramton," 1.

52. Bob Cohn, "Unusual Tactics Pep Up Politics," *Montgomery Advertiser*, March 11, 1962, 46.

53. Sims, *Little Man's Big Friend*, 114.

54. Cohn, "Unusual Tactics Pep Up Politics," 46.

55. Cohn, "Unusual Tactics Pep Up Politics," 46; "Gubernatorial Hopefuls Set Up Activity," *Montgomery Advertiser*, February 14, 1958, 1; Warren A. Trest, *Nobody but the People: The Life and Times of Alabama's Youngest Governor* (Montgomery, AL: NewSouth Books, 2008), 221–22. Gosdin was a cousin of Vern Gosdin, who had a number of country hits in the 1970s and '80s.

56. Bob Ingram, "Owen Pledges He Will Save Segregation," *Montgomery Advertiser*, March 1, 1958, 1.

57. Cohn, "Unusual Tactics Pep Up Politics," 46.

58. George Wallace, *Stand Up for America* (Garden City, NY: Doubleday, 1976), 10–70.

59. Baham, Folsom, and Key, *Strawberry Pickers*, 80; Dan T. Carter, *The Politics of Rage: George Wallace, the Origins of the New Conservatism, and the Transformation of American Politics* (New York: Simon & Schuster, 1995), 75.

60. Carter, *Politics of Rage*, 76.

61. Lesher, *George Wallace: American Populist*, 82–83; Carter, *Politics of Rage*, 81–82.

62. Marshall Frady, *Wallace: The Classic Portrait of Alabama Governor George Wallace* (New York: Random House, 1968), 110. See also Parker Ramsay's excellent blog post on the connections between Wallace and Folsom, "Montgomery, 1958," *Harping On: Thoughts from a Recovering Organist*, June 22, 2016, https://parkerramsay.com/2016/06/22/montgomery-1958/. In 1971, Wallace would marry Folsom's niece, Cornelia Snively, whose mother had briefly served ceremonially in 1947 as the state's First Lady at the request of her brother Big Jim, who was then a widower.

63. Carter, *Politics of Rage*, 82.

64. George Wallace Jr., *Governor George Wallace: The Man You Never Knew* (n.p.: Wallace Productions, 2011), 328.

65. Carter, *Politics of Rage*, 84–85.

66. Bob Ingram, "Wallace Bears Down on Race Issue in Opening Campaign," *Montgomery Advertiser*, February 16, 1959, 1–2.

67. Quoted in Wallace, *Stand Up for America*, 54.

68. George Prentice, "Wallace Hits Hard across Center State," *Montgomery Advertiser*, May 1, 1958, 1–2; "Wallace on Stump Tour," *Montgomery Advertiser*, May 20, 1958, 1–2; Ed Cony, "Alabama Hoedown: Few Issues Split Them So Governor Candidates Lean on Hillbilly Music," *Wall Street Journal*, May 6, 1958, 1.

69. "Spotlight on Politics: Harrison Says Road Funds Wasted on Favored Areas," *Montgomery Advertiser*, April 4, 1958, 2.

70. Quoted in Cony, "Alabama Hoedown," 1.

71. "Barton to Speak Here on July 4," *Courier News* (Blytheville, AR), June 27, 1944, 1; Charles L. Fontenay, "'Kefauver for President'—That's Ryman Rallying Cry Tonight," *Tennessean* (Nashville), December 12, 1951, 1. Morgan performed on behalf of Kefauver in the Democratic presidential primaries of 1952 and 1956, while Grammer and Snow hit the trail for him in 1960.

72. Fontenay, "Kefauver for President," 1; "2500 Tickets Sold for Rally," *Tennessean* (Nashville), June 19, 1956, 4; "Hank to Vote," *Tennessean* (Nashville), July 31, 1960, 6.

73. Anthony Badger, "The South Confronts the Court: The Southern Manifesto of 1956," *Journal of Policy History* 20, no. 1 (2008): 126–42.

74. See, for instance, Grant Blum, "Overflow Crowd Cheers Wallace in Address Here," *La Crosse (WI) Tribune*, March 29, 1972, 1.

75. "Minnie Pearl Cost Wallace $12,000 Total," *Anniston (AL) Star*, June 8, 1958, 2; Wayne Greenhaw, *Watch Out for George Wallace* (Englewood Cliffs, NJ: Prentice-Hall, 1976), 111.

76. Frady, *Wallace*, 121. Dan T. Carter discusses the debate about Wallace's phrasing in detail in a footnote in *Politics of Rage*, 96. On the cost of the Gosdin band, see Cony, "Alabama Hoedown," 2.

77. Jack Cardwell, "Ballad of Big Jim Folsom" (Jimmy Rogers [sic: Jimmy Dean]), and Roland Johnson, "Y'All Come" (A. Duff), Cinema JR-33-104C-NBOW-2548 and -2549, [ca. 1962], 45 rpm record.

78. Jack Cardwell with Luke McDaniels Orchestra, "Big Jim Folsom" (Arthur Clements), Le Noir Records 45–25, 45 rpm record; Randy McNutt, *King Records of Cincinnati* (Charleston, SC: Arcadia, 2009), 14.

79. Grafton and Permaloff, *Big Mules & Branchheads*, 230–31.

80. Bob Ingram, "Wallace Pledges to Fight Mixing in Alabama Schools," *Montgomery Advertiser*, March 11, 1962, 1–2; "Here Are the Candidates in Top Races," *Anniston (AL) Star*, April 29, 1962, 6.

81. "All Candidates Stepping Up Speaking Dates This Week," *Montgomery Advertiser*, March 18, 1962, 2.

82. Bill Jones, *The Wallace Story* (Northport, AL: American Southern, 1966), 43.

83. Text of Wallace's 1962 inaugural speech in Robert Torricelli and Andrew Carroll, eds., *In Our Own Words: Extraordinary Speeches of the American Century* (New York: Washington Square, 2000), 228–31.

84. Carter, *Politics of Rage*, 142–51, 174–94, 256–63.

85. "Lulu Belle and Scotty Join Rally for Preyer," *Daily News Times* (Burlington, NC), D1. Preyer's politics are discussed in Robert Rodgers Korstad and James Leloudis, *To Right These Wrongs: The North Carolina Fund and the Battle to End Poverty and Inequality in 1960s America* (Chapel Hill: University of North Carolina Press, 2010), 76–79.

86. "Landslide Buries Preyer," *Asheville (NC) Citizen-Times*, June 28, 1964, 1.

87. Dollie L. Smith, "Lulu Belle Has New Type of Career," *Republic* (Columbus, IN), January 28 1975, 14.

88. Wallace, *Stand Up for America*, 108–10.

89. Rex Thomas, "Big Shows Lure Alabama Vote," *Tennessean* (Nashville), May 1, 1966, 103.

90. "Meet the Fellows Who Are Entertaining the Crowds," *Wallace Record*, April 17, 1966, 13, insert in the *Montgomery Advertiser*; Ray Jenkins, "Mr. and Mrs. Wallace Run for Governor of Alabama," *New York Times*, April 24, 1966, 28–29.

91. C. J. Hartley quoted in James Gregory, *The Wallaces of Alabama* (Chicago: Follette, 1975), 93. Lurleen, however, was from the Tuscaloosa area, which may have also buoyed her candidacy.

92. Stephan Lesher, *George Wallace: American Populist* (Reading, MA: Addison-Wesley, 1994), 371–77; Nina Simone, "Mississippi Goddam," *Forever Young, Gifted, and Black: Songs of Freedom and Spirit*, compact disc, Sony BMG Music Entertainment 81451474413.

93. Carter, *Politics of Rage*, 318–20.

94. Lesher, *George Wallace: American Populist*, 267–68.

95. Lloyd Rohler, *George Wallace: Conservative Populist* (Westport, CT: Praeger, 2004), 58, 72, 81, 445; Lesher, *George Wallace: American Populist*, 445; James T. Wooten, "Wallace's Rallies Blend Evangelism, Music and Salesmanship," *New York Times*, March 13, 1972, 28; Andrew Bernard, "Celebrities Flocking to Candidate's Camps," *Pittsburgh Post-Gazette*, August 26, 1968, 2; John Grissim, "I'm Still Not Sure It Wasn't Planned," *Rolling Stone*, May 28, 1970, 14; Blum, "Overflow Crowd Cheers Wallace," 1.

96. "Wallace's Army: The Coalition of Frustration," *Time*, October 18, 1968, 41; George Lardner Jr., "Wallace Campaign Already Has Passed Expectations," *Shreveport Times*, September 15, 1968, 13.

97. Gurney Norman, "A Kentuckian at the Wallace Rally," in *One Lord, One Faith, One Cornbread*, ed. Fred Nelson and Ed McClanahan (Garden City, NY: Anchor Press/Doubleday, 1973), xx–xiv.

98. Bill Boyarsky, "Country Music Vote: Is It Unruh's Tune?," *Los Angeles Times*, July 13, 1970, 3.

99. Tom Wicker, "In the Nation: Wallace's Powerful Medicine," *New York Times*, December 12, 1967, 46.

100. Carter, *Politics of Rage*, 294–300.

101. Richard Moss, *Creating the New Right Ethnic in 1970s America: The Intersection of Anger and Nostalgia* (Lanham, MD: Farleigh Dickinson University Press, 2017), 32, 163–64; Richard C. Haney, "Wallace in Wisconsin: The Presidential Primary of 1964," *Wisconsin Magazine of History* 51, no. 4 (Summer 1978): 259–78.

102. Dan Sewell, "George Wallace's Last Campaign Aims to Reshape His Legacy," *Los Angeles Times*, February 18, 1996, http://articles.latimes.com/1996-02-18/news/mn-37296_1_george-wallace.

103. William Greider, "Wallace Is Shot, Legs Paralyzed," *Washington Post*, May 16, 1972, A1.

104. "10,000 Attend Rally for Wallace," *Montgomery Advertiser*, June 12, 1972, 1.

105. "Led by Tammy Wynette: Musical Benefit Held for Wallace," *Weirton (WV) Daily Times*, June 12, 1972, 2.

106. "Platform Seems One McGovern Can Stand On," *Minneapolis Star*, July 12, 1972, 3; James Risser, "Antibusing Platform Voted Down," *Des Moines Register*, July 12, 1972, 1.

107. "George Wallace Road Show Brings Back Vaudeville," *Colorado Springs Gazette-Telegraph*, March 3, 1976, 51; Carter, *Politics of Rage*, 455–61.

108. Charles L. Hughes, *Country Soul: Making Music and Making Race in the American South* (Chapel Hill: University of North Carolina Press, 2015), 133–37; Neil Bibler, "'Country Charlie' Rides High," *Tennessean* (Nashville), July 30, 1967, Sunday Showcase section, 4.

109. Jimmy Johnson, "Billy Goats, Baseball Mean Fame for Rodriguez, Pride," *Sun-Telegram* (San Bernardino, CA), November 11, 1973, D1.

110. Joe Brown, "Fender's Nitty-Gritty," *Washington Post*, February 23, 1983, B7; "Freddy Fender, 69," *New York Times*, October 5, 2006, sect. 1, 41; Jim Patterson, "Legend Freddy Fender Gets Kidney," *Monitor* (McAllen, TX), December 12, 2001, 27.

111. Kathleen Dalton, *Theodore Roosevelt: A Strenuous Life* (New York: Vintage, 2004), 314.

112. Elise K. Kirk, *Music at the White House: A History of the American Spirit* (Urbana: University of Illinois Press, 1986), 181–82.

113. Archie Green, "Hillbilly Music: Source and Symbol," *Journal of American Folklore* 78, no. 309 (Summer 1965): 214.

114. Kirk, *Music at the White House*, 221.

115. "Dances Raise Over a Million," *Pittsburgh Press*, January 31, 1940, 2.

116. Gene Autry with Michael Herskowitz, *Back in the Saddle Again* (New York: Doubleday, 1978), 53. On Autry's later conservatism, see Peter La Chapelle, *Proud to Be an Okie: Cultural Politics, Country Music, and Migration to Southern California* (Berkeley: University of California Press, 2007), 142; and George Bush, "Remarks at Fundraising Dinner," September 19, 1991, Los Angeles, California, Public Papers of the Presidents, Weekly Compilation of Presidential Documents no. 27, Lexis-Nexis.

117. "Eisenhower, Autry Talk about Golf," *Philadelphia Inquirer*, June 18, 1953, 1.

118. "Labor Leader Raps GOP at Hillbilly Event in Meridian," *Clarion-Ledger*

(Jackson, MS), May 26, 1954, 16. Diane Pecknold has written extensively about this event; see Pecknold, *The Selling Sound: The Rise of the Country Music Industry* (Durham, NC: Duke University Press, 2007), 79–80, 84.

119. Sam Johnson, "Stevenson Hits McCarthy Case as Shameful," *Clarion-Ledger* (Jackson, MS), May 27, 1954, 1; "Ike Being Shoved About, Says Adlai," *Indianapolis News*, May 27, 1954, 2; James F. Wolfe, "Adlai's Ear Is Attuned to Rural Rhythm—Western Style," *Kansas City (MO) Times*, May 27, 1954, 13.

120. "Country Music Can Mix with Politics, but Not Vice Versa," *Kansas City Times*, June 8, 1954, 4.

121. Charles M Hills, "High Court 'Seeks' South's Aid in Segregation—Stevenson," *Clarion-Ledger* (Jackson, MS), May 27, 1954, 1; Wolfe, "Adlai's Ear," 13.

122. "Hillbilly Musician Aides Adlai," *Edwardsville (IL) Intelligencer*, May 19, 1956, 1; "Estes Charges Political Chiefs Gang Up on Him," *Tampa Bay Times*, May 25, 1956, 1.

123. "Lopez Mateos, Truman at Texas Barbecue," *Los Angeles Times*, October 19, 1959, 2.

124. Frances Lewine, "Lyndon, Ludwig Swap Banter at Texas Barbecue" and "Van Cliburn Entertains Chancellor," *Shreveport Times*, December 30, 1963, 5A.

125. Joe McGinnis, *The Selling of the President* (San Francisco: Byliner, 1969; 2012), loc. 1679–1799. On Acuff and Ritter's campaign work, see, for instance, "Few Cheer Agnew in Ky.," *Tennessean* (Nashville), October 20, 1968, 11, and "Name of the Game in Texas: Woo Wallace Vote," *Los Angeles Times*, October 24, 1963, 27.

126. James K. Batten, "Nixon, Wallace Split Tennessee," *Tallahassee Democrat*, September 23, 1968, 2.

127. Harry S. Dent, *The Prodigal South Returns to Power* (New York: John Wiley & Sons, 1978), 109–10; Carter, *Politics of Rage*, 363–64.

128. "Baker to Stump for Nixon Bid," *Tennessean* (Nashville), October 28, 1968, 12.

129. "Nixon Closes Texas Visit: Plays 'Eyes of Texas' in Austin," *Galveston (TX) Daily News*, November 3, 1968, 12.

130. "National Week of Unity," *Academy of Country Western Music International News*, January 1970, 1.

131. Robert Hilburn, *Johnny Cash: The Life* (New York: Little, Brown, 1976), 383–85.

132. Lesher, *George Wallace: American Populist*, 403; Matthew D. Lassiter, *The*

Silent Majority: Suburban Politics in the Sunbelt South (Princeton, NJ: Princeton University Press, 2006), 121–97.

133. Richard Nixon, "Proclamation 4007—Country Music Month, 1970," September 25, 1970, *American Presidency Project*, Gerhard Peters and John Woolley, University of California, Santa Barbara, https://www.presidency .ucsb.edu/documents/proclamation-4007-country-music-month-1970.

134. See, for instance, Marie Law, "Merle Haggard Is Big CMA Winner," *Jackson (TN) Sun*, October 16, 1970, 36; Frank Jackman, "Does Nixon Dig Country?," *Abilene (TX) Reporter-News*, October 21, 1971, 79.

135. Pecknold, *The Selling Sound*, 221.

136. "George Wallace Rally," political ad, *La Crosse (WI) Tribune*, March 28, 1972, 22.

137. Charles L. Hughes, "'I'm the Other One': O. B. McClinton and the Racial Politics of Country Music in the 1970," in *The Honky Tonk on the Left: Progressive Thought in Country Music*, ed. Mark Allan Jackson (Amherst: University of Massachusetts Press, 2018), 131.

138. "Muskie Involves Country Western Singer McClinton in Whistle Stop Tour," *Pittsburgh Courier*, March 4, 1972, 13; "Rosey Grier Loves All," *Palm Beach Post*, February 22, 1972, C3.

139. Mike Curb Congregation, "Nix Now Rally Song" (Jerry Jerome), MGM Records, PK 1007 72 L 3913, 1972, 45 rpm record; Joyce Haber, "Miss Chaplin Told Sharing a No No!," *Los Angeles Times*, August 17, 1972, F15. See also Amira Nader, Why Nixon Declared October Country Music Month," *Studio 360* (blog), WNYC, October 28, 2014, https://www.wnyc.org/story/sideshow -richard-nixon-declared-october-country-music-month/.

140. La Chapelle, *Proud to Be an Okie*, 143.

141. James Conaway, "Why Sammy Davis Jr. Threw His Weight behind Nixon," *Philadelphia Daily News*, October 25, 1972, 34.

142. "Bob Ingram, "Elliot Pledges Effort to Gain Racial Peace," *Montgomery Advertiser*, January 22, 1966, 1.

143. "Hank Williams Jr. Signs $500,000 Recording Contract," *Jackson Sun*, March 6, 1970, 31.

144. Dee Marquee, "Under the Marquee," *Montgomery Advertiser*, November 8, 1964, 39.

145. "Young George Wallace Launched Singing Career with Contact," *Fort Lauderdale News*, July 8, 1973, 47.

146. "Blount Signs Singers for Two Rallies," *Anniston (AL) Star*, October 22, 1972, 9.

147. Merle Haggard with Peggy Russell, *Sing Me Back Home: My Story* (New York: Simon & Schuster, 1983), 239–44.

148. "Grand Ole Opry to Open New Home," *Lebanon (PA) Daily News*, March 16, 1974, 14.

149. Ronnie Pugh, *Ernest Tubb: The Texas Troubadour* (Durham, ND: Duke University Press, 1996), 260, 285.

150. Jim Squires, "Nixon Takes His Act to the Grand Ole Opry," *Chicago Tribune*, March 17, 1974, 1, 7; Associated Press, "Nixon Opry Performer," *Odessa (TX) American*, March 17, 1974, 1; United Press International, "Nixon Serenades Pat at Gala Opry Opening," *Fort Lauderdale News*, March 17, 1974, 1. Footage of the event can be viewed at the Critical Past archive, http://www.criticalpast.com/stock-footage-video/nixon+opry.

Chapter 8

1. The event took place October 19, 2016, in North Las Vegas and was covered by Las Vegas television stations. Coverage included Sandy Lopez, "Hillary Clinton Makes Surprise Appearance at North Las Vegas Debate Party," *Las Vegas Review-Journal*, October 19, 2016, https://www.reviewjournal.com/ncategorized/hillary-clinton-makes-surprise-appearance-at-north-las-vegas-debate-party/; and Adrian Carrasquillo, "Clinton Energizes Vegas Latinos—with Vicente Fernandez and Los Tigres del Norte," BuzzFeed News, October 19, 2016, https://www.buzzfeed.com/adriancarrasquillo/clinton-energizes-vegas-latinos-with-vicente-fernandez-and-l. Videotape of the event was available at Totomxlv, "Los Tigres del Norte dan su apoyo a Hillary Clinton," YouTube, October 20, 2016, video, 9:26, https://www.youtube.com/watch?v=DklMTqZp0uE.

2. Megan Messerly, "Nevada Democrats Won the Battle; Trump Won the War," *Las Vegas Sun*, November 9, 2016, https://lasvegassun.com/news/2016/nov/09/nevada-democrats-won-the-battle-trump-won-the-war/.

3. David A. Corbin, *The Last Great Senator: Robert C. Byrd's Encounters with Eleven U.S. Presidents* (Washington, DC: Potomac Books, 2012), 9, 15–18.

4. Robert C. Byrd, *Robert C. Byrd: Child of the Appalachian Coal Mines* (Morgantown: West Virginia University Press, 2005), 392–94.

5. Byrd, *Child of the Coal Mines*, 422; Corbin, *Last Great Senator*, 160.

6. Al Gore, *The Eye of the Storm: A People's Politics for the Seventies* (New York: Herder and Herder, 1970), 193–200.

7. Gore, *Eye of the Storm*, 202.

8. "Demo Nomination Received by Gore," *Kingsport (TN) Times*, August 5, 1938, 1, 8.

9. See Bill Turque, *Inventing Al Gore* (Boston: Houghton Mifflin, 2000), 4–21.

10. Kyle Longley, "White Knight for Civil Rights? The Civil Rights Record of Senator Albert A. Gore, Sr.," *Tennessee Historical Quarterly* 57, no. 2 (Fall 1998): 114–31; Gore, *Eye of the Storm*, 1–36, 107–40.

11. Ed Vulliamy, "Observer Profile: Tipper Gore: Lady in Waiting," *Observer* (London), January 30, 2000, 27; "Gore Campaign Chooses Rock Songs," ABC News, August 16, 2000, http://abcnews.go.com/Politics/story?id=123115& page=1.

12. Jim Powell, "State Road Department Fires Hillbilly Band Leader for Performing at McCarty's Rallies," *Tampa Morning Tribune*, May 3, 1952, 1, 3; "Sharp Attacks on Warren and SRD," *Palm Beach Post*, April 11, 1952, 12.

13. "Hillbilly Music to Stay as a Help to Campaigners," *Tampa Bay Times*, February 22, 1952, 14.

14. Powell, "Road Department Fires Hillbilly Band Leader," 3.

15. "Davis Quartet Reportedly on State Payrolls," *Shreveport Times*, January 12, 1961, 1.

16. "The History of Political Songs and Jingles in Tennessee," online exhibit, Albert Gore Research Center, Middle Tennessee State University, accessed December 15, 2018, http://www.mtsu.edu/gorecenter/political-songs -tennessee-jingles.php.

17. "Cash Heads Cutrer's Election Bid," *Tennessean* (Nashville), June 22, 1976, 5.

18. Frank Sutherland, "Gore Gains Slim Victory in 4th District," *Tennessean* (Nashville), August 6, 1976, 1; "State's YAF Puts Weight behind Cutrer," *Tennessean* (Nashville), July 24, 1976, 15.

19. Jim O'Hara and Robert Sherbourne, "Johnny Cash Endorses Gore," *Tennessean* (Nashville), February 13, 1988, 1.

20. Jack Hurst, "Out in the Boondocks, Ritter Tracks a Fox," *Tennessean Magazine*, May 31, 1970, 12; Jack Hurst, "Sen. Gore's Forgotten Where His Homesite Is, Ritter Says," *Tennessean* (Nashville), July 2, 1970, 12; "Ritter Gives War, Home Views," newspaper clipping, July 12, 1970, Tex Ritter name file, Country Music Hall of Fame; Texas Jim Cooper, "Tex Ritter in the Twilight Years," *JEMFQ* 13, no. 46 (summer 1977): 82; Vivien Green Fryd, "That Sad Twang of Mountain Voices: Thomas Hart Benton's *Sources of Country Music*," in *Reading Country Music: Steel Guitars, Opry Stars, and Honky-Tonk Bars*, ed. Cecelia Tichi (Durham, NC: Duke University Press, 1998), 264–65; Larry Daughtrey, "Ritter, Robertson to Run," *Tennessean* (Nashville), January 6, 1970, 2.

21. "Johnny Cash Will Help Tex Ritter in Campaign," *Jacksonville Sun*, April 21, 1970, 3.

22. Wendell Wilson, "Candidates Court Voters," *Clarksville (TN) Leaf-Chronicle*, July 16, 1978, 1.

23. Gail McKnight, "Field of Seven Has Only Outsiders Looking In," *Tennessean* (Nashville), August 2, 1992, 28.

24. Chris Goertzen, "George Cecil McLeod: Mississippi's Fiddling Senator and the Modern History of American Fiddling," *American Music* 22, no. 3 (Autumn 2004): 339–79; "Palmer Wins Judge's Post," *Hattiesburg (MS) American*, June 3, 1970, 6.

25. "State Dairy Spokesmen See Crisis from Federal Policies," *Clarion-Ledger* (Jackson, MS), February 6, 1973, 10; "Training Program Set Here," *Clarion-Ledger* (Jackson, MS), March 15, 1973, 11.

26. Norm Draper, "The Fiddlin' Senator Is Nashville Bound," *Clarion-Ledger* (Jackson, MS), February 14, 1979, 39.

27. "Mrs. Lulu Bell Wiseman," *Ashville (NC) Citizen-Times*, April 10, 1974, 17; Dollie L. Smith, "Lulu Belle Has New Type of Career," *Republic* (Columbus, IN), January 28, 1975, 14.

28. John Parris, "Lulu Belle and Scotty Were Country Music Pioneers," *Ashville (NC) Citizen-Times*, September 8, 1974, 1, 6.

29. "Woman's Switched Voted Helped to Turn Back ERA," *Rocky Mount (NC) Telegram*, April 17, 1975, 1.

30. Allen Rich, "Kinky Friedman Campaign for Governor Visits Anna, Ft. Worth," *North Texas E-News*, July 5, 2006, http://www.ntxe-news.com/cgi-bin/artman/exec/view.cgi?archive=21&num=35238.

31. Matt Labash, "Kinky Friedman Runs for Governor," *Weekly Standard*, October 23, 2006, http://www.weeklystandard.com/kinky-friedmanbr-runs-for-governor/article/13954.

32. Maria Recio and Anna M. Tinsley, "Kinky Friedman on Texas Politics: 'Yeah, I'm Done,'" *Star-Telegram* (Fort Worth), July 5, 2014, http://www.star-telegram.com/news/politics-government/article3864293.html.

33. Stephen L. Betts, "Sammy Kershaw Running for Louisiana Lt. Governor Again," *Boot*, May 3, 2010, http://theboot.com/sammy-kershaw-lt-governor-louisiana/.

34. Ben Jacobs, "More Bernie, Less Trump: Is This How Democrats Will Win Montana's Special Election?," *Guardian*, May 21, 2017, https://www.theguardian.com/us-news/2017/may/21/montana-special-election-rob-quist-bernie-sanders-rally.

35. Eliza Relman, "Democrats Are Reckoning with Losing to Candidate

Who 'Body-Slammed' a Reporter the Day before the Election," *Business Insider*, May 26, 2017, http://www.businessinsider.com/democrats-gianforte-quist-loss-montana-2017-5.

36. Benjamin S. Schoening and Eric T. Kasper, *Don't Stop Thinking about the Music: The Politics of Songs and Musicians in Presidential Campaigns* (Lanham, MD: Lexington Books, 2102), 141–95.

37. Art Harris, "Candidate Jimmy Carter: Rock's Good Ol' Boy," *Rolling Stone*, December 4, 1975, http://www.rollingstone.com/politics/news/candidate-jimmy-carter-rocks-good-ol-boy-19751204.

38. Charlie Daniels, *Never Look at the Empty Seats: A Memoir* (Nashville: Thomas Nelson, 2017), 83.

39. Matt Yancey, "Charlie Daniels Concert Helps Carter," *Hattiesburg (MS) American*, May 18, 1976, 19.

40. "Grand Ole Opry Stars Turn Out for President," *Pensacola (FL) News*, January 4, 1980, 3.

41. "Nelson, Carter Duet," *Indianapolis News*, September 15, 1980, 4.

42. Francis X. Clines, "About Politics: Calling the Tune to Call Democrats," *New York Times*, October 31, 1980, A18; "Reagan's Kickoff for Re-election Is Star-Studded," *St. Louis Post-Dispatch*, September 2, 1984, 15.

43. Peter La Chapelle, *Proud to Be an Okie: Cultural Politics, Country Music, and Migration to Southern California* (Berkeley: University of California Press, 2007), 143.

44. James P. Gannon, "Is This the Real George Bush?," *Des Moines Register*, July 31, 1988, 18.

45. Joe Edwards, "Country Stars Sing Praises of Candidates," *Tennessean* (Nashville), March 6, 1988, 8; Jo Mannies and Fred W. Lindecke, "Bush Stumps Here," *St. Louis Post-Dispatch*, November 14, 1991, 1, 16.

46. "Bush Stomps with Music Stars," *Marion (OH) Star*, September 30, 1992, 17.

47. Thomas Goldsmith and Robert K. Oermann, "Brooks Rolls to the Top," *Tennessean* (Nashville), October 3, 1991, 1D.

48. Corbin, *Last Great Senator*, 152.

49. Schoening and Kasper, *Don't Stop Thinking about the Music*, 172–74.

50. Robert Edwards and Sara B. Hansen, "Branson Sings Dole's Tune," *Springfield (MO) News-Leader*, June 13, 1996, 1, 4.

51. O'Hara and Sherbourne, "Johnny Cash Endorses Gore," 1; Edwards, "Country Stars Sing Praises," 8.

52. John T. Davis, "KSD Hosts Cheney Celebration," *Advocate-Messenger* (Danville, KY), October 6, 2000, 3. Michael Finnegan and Megan Garvey,

"Bush Predicts He'll Take Arkansas," *Los Angeles Times*, October 17, 2000, A18; Bonna De la Cruz, "Music Row's Loyalties Split over Candidates," *Tennessean* (Nashville), October 25, 2000, A14.

53. 'Schoening and Kasper, *Don't Stop Thinking about the Music*, 183–84; Cruz, "Music Row's Loyalties Sjplit," A14.

54. Paul Farhi, "The Spoils of Antiwar," *Washington Post*, May 22, 2003, C1, C4; David Segal, "Dixie Chicks Bare Their, Uh, Souls," *Washington Post*, April 25, 2003, C1, C3; Chris William, "Stars and Strife," *Entertainment Weekly*, May 2, 2003, 22–29; Anne Hull, "Uncowed Cowgirls," *Washington Post*, August 8, 2003, C1, C8; Betty Clarke, "The Dixie Chicks," *Guardian*, March 12, 2003, https://www.theguardian.com/music/2003/mar/12/artsfeatures.pop androck.

55. Don Walker, "Chicks Bashers Send a Message," *Shreveport Times*, March 16, 2003, 5B; Geoff Boucher, "Fans Not Buying Chicks' Apology," *Los Angeles Times*, March 19, 2003, E4.

56. David de Sola, "Musicians Mobilize for and against President Bush," CNN.com, August 30, 2004, http://www.cnn.com/2004/ALLPOLITICS/08/29/gop.music/index.html.

57. Bonna de la Cruz, "Political Parties Take the Stage at the Trap on Two Evenings," *Tennessean* (Nashville), September 28, 2004, B3; Thomas M. Sipos, "Emmylou Harris, Nashville Stars Kerry-oke for John Kerry," *Hollywood Investigator*, July 8, 2004, http://www.hollywoodinvestigator.com/2004/kerryoke.htm.

58. See Jonathan Easley, "The Coveted Willie Nelson Endorsement," *Salon*, May 20, 2011, https://www.salon.com/2011/05/20/willie_nelson_campaign_endorsements/; Erin Duvall, "Willie Nelson Supports Obama while Country Colleagues Rally for Romney," *Boot*, November 5, 2012, http://theboot.com/willie-nelson-obama/; and Patrick Doyle, "Willie Nelson Talks Beto O'Rourke and Why He Feels Sorry for Ted Cruz," *Rolling Stone*, September 19, 2018, https://www.rollingstone.com/music/music-news/willie-nelson-talks-beto-orourke-ted-cruz-726684/.

59. Paul Cobler and Jonathan Tilove, "Beto O'Rourke, with Willie Nelson, Belts Positive Message to Massive Austin Crowd," *Statesman* (Austin, TX), September 29, 2018, https://www.statesman.com/news/20180929/beto-orourke-with-willie-nelson-belts-positive-message-to-massive-austin-crowd.

60. Daniel Kreps, "John Rich Pens John McCain Anthem 'Raising McCain,'" *Rolling Stone*, August 1, 2008, https://www.rollingstone.com/music/news/john-rich-pens-john-mccain-anthem-raising-mccain-20080801; John Mc-

Cormack, "The McCain-Palin Tradition," *Weekly Standard*, October 17, 2008, http://www.weeklystandard.com/the-mccain-palin-tradition/article/26537.

61. Daniel Kreps, "Bluegrass Legend Ralph Stanley Endorses Obama: 'We Need a Change,'" *Rolling Stone*, October 3, 2008, https://www.rollingstone.com /music/news/bluegrass-legend-ralph-stanley-endorses-obama-we-need-a -change-20081003; Eric Zorn, "Bluegrass Legend Backing Obama," *Chicago Tribune*, October 5, 2008, Chicagoland section, 2.

62. Peter J. Boyer, "The Appalachian Problem," *New Yorker*, October 6, 2008, https://www.newyorker.com/magazine/2008/10/06/the-appalachian -problem.

63. Clerk of the House of Representatives, "Statistics of the Presidential and Congressional Election" (Washington, DC, 2005), 58.

64. Asawin Suebsaeng, "A Comparative Analysis of Bands Rocking the Democratic and Republican National Conventions," *Mother Jones*, September 6, 2012, http://www.motherjones.com/politics/2012/09/rock-bands-re publican-democratic-national-conventions/; Ted Johnson, "Paul Simon, Demi Lovato to Perform on Opening Night of Democratic Convention," *Variety*, July 25, 2012, http://variety.com/2016/music/news/paul-simon-demi-lovato -democratic-national-convention-1201822403/.

65. Colleen Glanton, "The Stars Are All Aligned," *Chicago Tribune*, November 1, 2012, 3.

66. *CBS This Morning*, "Ted Cruz: 'My Music Tastes Changed on 9/11,'" You-Tube, March 24, 2015, video, 1:24, https://www.youtube.com/watch?v=nik -UstmCjw.

67. Jon Freeman, "Hank Williams Jr. and Charlie Daniels: Inside Their Defi-ant Politics," *Rolling Stone*, June 23, 2017, https://www.rollingstone.com/coun try/news/hank-williams-jr-charlie-daniels-conservative-politics-w488739. For Daniels's op ed writing, see the archive at CNSNews.com: https://www .cnsnews.com/author/charlie-daniels.

68. "Hank Williams Jr.: 'I Don't Give a Sh-t about the Election,'" *Rolling Stone*, February 3, 2016, https://www.rollingstone.com/music/news/hank-wil liams-jr-i-dont-give-a-sh-t-about-the-election-20160203.

69. Ryan Bort, "Toby Keith Is Not a Trump Supporter," *Newsweek*, January 18, 2017, http://www.newsweek.com/toby-keith-not-trump-supporter-544205.

70. Jon Bernstein, "'Country Music Has Become Apolitical': Why Have Acts Kept Quiet on the Election?," *Guardian*, November 3, 2016, https://www.the guardian.com/music/2016/nov/03/country-music-election-politics; "Politi-cal Content: Off Limits," *Country Aircheck*, October 3, 2016, 1.

71. Tom Tiede, "Wallace Invades Deep North," *Times and Democrat* (Orangeburg, SC), July 31, 1968, 3.

72. On Trump's attention-courting strategies and the social media universe, see, for instance, Alexis C. Madrigal, "What Facebook Did to American Democracy," *Atlantic*, October 12, 2017, https://www.theatlantic.com/technol ogy/archive/2017/10/what-facebook-did/542502/.

73. Nicholas Ballasy, "Trace Adkins 'Apathetic' toward Trump, Clinton," interview by Nicholas Ballasy, YouTube, video, 3:14, https://www.youtube.com /watch?v=3−QL4WOpRA.

74. Trace Adkins, *A Personal Stand: Observations and Opinions from a Free-thinking Roughneck* (New York: Ballantine Books, 2007), 101.

75. Adkins, *A Personal Stand*, 159.

76. Adkins, 213, 269.

77. CNN, "Country Star Trace Adkins on Politics," interview by Anderson Cooper, *Big 360*, September 18, 2010, YouTube, video, 4:26, https://www.you tube.com/watch?time_continue=224&v=1VXCfZBgT0I.

78. Country 97.1 HANK FM, "Trace Adkins—Being a Grandpa, Donald Trump, and American Ninja Warrior [Artist Interview]," May 3, 2016, YouTube, video, 4:32, https://www.youtube.com/watch?v=QOPOS2GVrQM.

79. "Country Star Trace Adkins Spotted in Old Town on Inauguration Day," *Red Brick Town*, January 21, 2017, accessed July 12, 2018, http://redbricktown .com/2017/01/country-star-trace-adkins-spotted-old-town-inauguration -day/.

80. Joseph Hudak, "Trace Adkins on Pressure to Drink, Soul-Searching New Album," *Rolling Stone*, March 31, 2017, https://www.rollingstone.com /country/features/trace-adkins-on-pressure-to-drink-soul-searching-new -album-w474294.

81. Bill Nance, "James Brown May Meet Protest at Grand Ole Opry," *Courier-News* (Bridgewater, N.J.), March 8, 1979, 13; "Frank Sinatra Shines at Grand Ole Opry," *Arizona Daily Star*, May 13, 1976, D12.

82. See, for instance, the essays in *Hidden in the Mix: The African American Presence in Country Music*, ed. Diane Pecknold (Durham, NC: Duke University Press, 2013).

83. Helpful in understanding LGBTQ issues and the complicated sexual and gender identities of fans and performers is Nadine Hubbs, *Rednecks, Queers, and Country Music* (Berkeley: University of California Press, 2014).

84. Stacy Harris, "Kosher Country: Success and Survival on Nashville's Music Row," *Southern Jewish History* 2 (1998): 113–14; Bill Williams, "Friend-

ships Balking Recruitment Drive in Nashville, Says AGAC," *Billboard*, April 6, 1968, 3.

85. Johnny Cash, *Man in Black* (New York: Warner Books, 1976), 193; Johnny Cash with Patrick Carr, *Cash: The Autobiography* (New York: Harper-Collins, 1997), 308–12; Charlie Daniels, *Never Look at the Empty Seats: A Memoir* (Nashville: Thomas Nelson, 2017), 171–74. This doesn't mean that Cash's relationship with his Jewish manager, Saul Holiff, was always a smooth and respectful one, as evidenced in Jonathan Holiff's documentary *My Father and the Man in Black* (New Chapter Productions, 2012).

86. Harris, "Kosher Country," 112–16. On Holiff, see Julie Chadwick, *The Man Who Carried Cash: Saul Holiff, Johnny Cash, and the Making of an American Icon* (Toronto: Dundurn, 2017).

87. Ruth Ellen Gruber, "Towering over the Country Western Scene," *JTA*, September 25, 2008, https://www.jta.org/2008/09/25/culture/towering-over-the-country-western-scene; Bryan Stone, "Ride 'Em Cowboy: Kinky Friedman and the Texas Jewish Mystique," *Journal of Jewish History* 1 (1998): 23–42.

88. "New Album Pays Tribute to Shel Silverstein, the Songwriter," *All Things Considered*, NPR, July 3, 2010, https://www.npr.org/templates/story/story.php?storyId=128214655.

89. Danielle Berrin, "Actress Mare Winningham Brings 'Jewgrass' to Arkansas," *Jewish Journal*, August 17, 2007, https://jewishjournal.com/culture/arts/15241/; Joe Buchanan, concert and personal conversation with author, December 8, 2018, Henderson, Nevada.

90. Jen Miller, "Jewish Bluegrass," Smithsonian.com, September 23, 2009, https://www.smithsonianmag.com/arts-culture/jewish-bluegrass-142370768/; Chuck Dauphin, "Nefesh Mountain on Combining Bluegrass with Jewish Identity," *Billboard*, March 22, 2018, https://www.billboard.com/articles/columns/country/8257602/nefesh-mountain-interview.

91. Nathaniel Popper, "Comic Pushes Limits in Antisemitic Sing-Along," *Jewish Daily Forward*, August 13, 2004, http://www.forward.com/articles/5116/.

92. Bob Allen, *George Jones: The Life and Times of a Honky Tonk Legend* (New York: Carol Publication Group, 1994), 304.

93. Jack Hurst, "Four 'Old Dogs' of Country Turn to Their Generation," *Chicago Tribune*, September 22, 1999, sect. 5, p. 7.

94. Country Music Association, *Today's Country Music Market*, 2015, http://www.cmaworld.com/wp-content/uploads/2015/08/CMA-Country-Music-Market-820150.pdf.

95. Tom Roland, "CMA Study: Hard Times Create New Opportunities for

Country Music with Minorities, Youth," *Billboard*, May 3, 2016, https://www.billboard.com/articles/columns/country/7356724/cma-study-country-music-minorities-youth.

96. Jonathan Bernstein, "After Vegas Shooting, Country Music's NRA Ties Show Signs of Fraying," *Rolling Stone*, October 5, 2017, https://www.rollingstone.com/country/features/nra-country-music-alliances-weakening-after-las-vegas-shooting-w507289; "Artists," NRA Country website, accessed July 20, 2018, https://www.nracountry.com/artists.

97. Josh Eells, "Eric Church: The Defiant One," *Rolling Stone*, July 25, 2018, https://www.rollingstone.com/music/music-features/eric-church-desperate-man-nashville-country-700750/.

98. Yvonne Gonzalez, "Delay in Nevada Gun Buyer Law Draws Protests outside Court Hearing," *Las Vegas Sun*, February 23, 2018, https://lasvegassun.com/news/2018/feb/23/judge-hears-arguments-in-lawsuit-over-stymied-gun/; Sandra Jauregui, "Many of Us Survived, but 58 Didn't," Facebook, September 28, 2018, https://www.facebook.com/sandrajaureguinv/posts/1053980208118104.

99. Nick Murray, "Agriculture Wars," *Viewpoint Magazine*, March 12, 2018, https://www.viewpointmag.com/2018/03/12/agriculture-wars/.

INDEX

Page numbers in italics refer to figures.

329